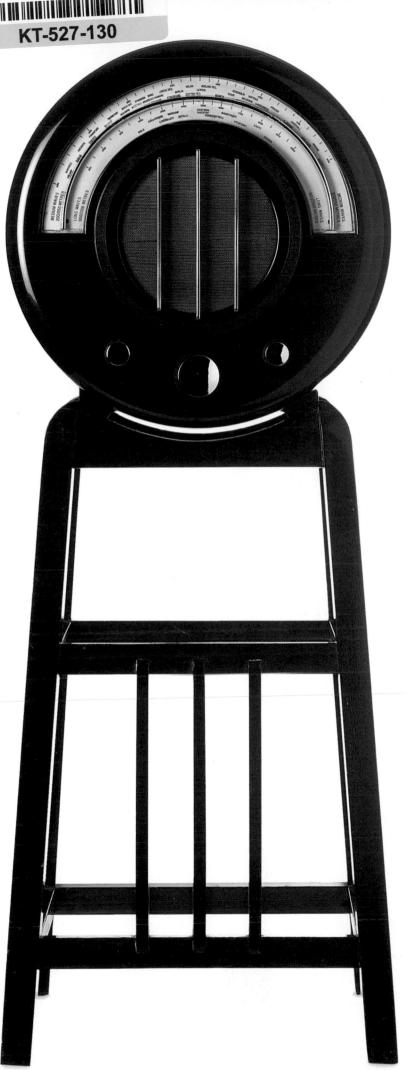

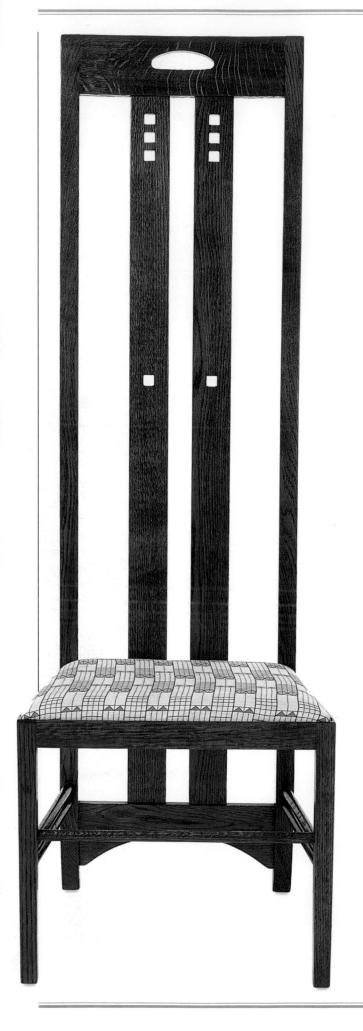

A DORLING KINDERSLEY BOOK First published in Great Britain in 1996 by Dorling Kindersley Limited, 9 Henrietta Street, London WC2E 8PS

To Jules and Joseph for their help and patience, and Mum and Dad for their support.

Senior Editors Janice Lacock, Louise Candlish
Senior Art Editor Tracy Hambleton-Miles
Project Editor Jo Evans
Art Editor Dawn Terrey
Editors Jane Sarluis, David T. Walton
Designer Carla De Abreu
Design Assistant Stephen Croucher

Senior Managing Editor Sean Moore Art Director Peter Luff

Production Manager Meryl Silbert Picture Researcher Jo Walton DTP Designer Zirrinia Austin

Photography Dave King, Steve Gorton, Andy Crawford

Consultants Robert Opie, Professor Jonathan M. Woodham

National Design Museum Review Panel

Susan Yelavich, Assistant Director for Public Programs Gillian Moss, Curatorial Chair, and Assistant Curator, Textiles Department

Deborah Sampson Shinn, Assistant Curator, Department of Applied Arts and Industrial Design

Joanne Warner, Assistant Curator,

Wallcoverings Department

Caroline Mortimer, Special Assistant to the Director

Copyright © 1996 Dorling Kindersley Ltd, London Text copyright © 1996 Michael Tambini Reprinted in 1997

All rights reserved. No part of this publication may be reproduced, stored in a retrieval system, or transmitted in any form or by any means, electrical, mechanical, photocopying, recording, or otherwise, without prior permission of the copyright owner.

A CIP catalogue record for this book is available from the British Library

ISBN 0 7513 0338 0

Reproduced by Colourscan, Singapore Printed and bound in Italy by A. Mondadori, Verona

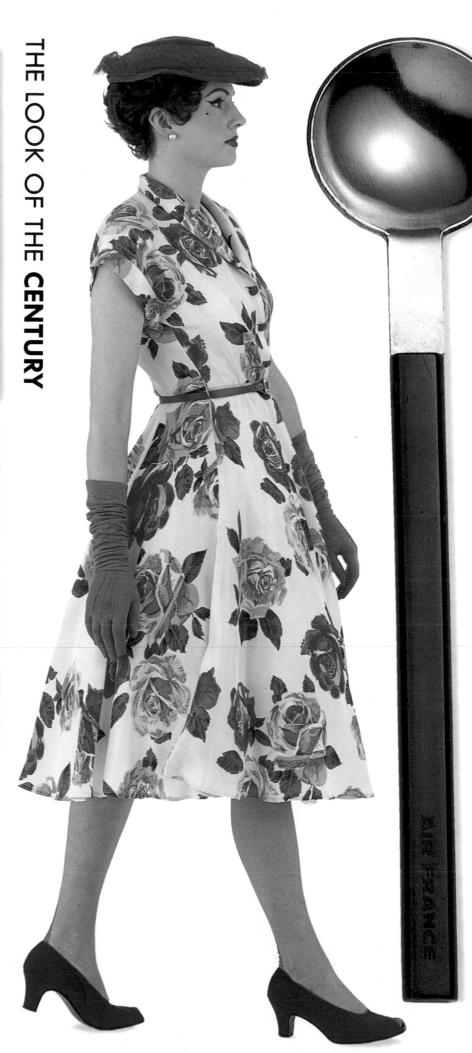

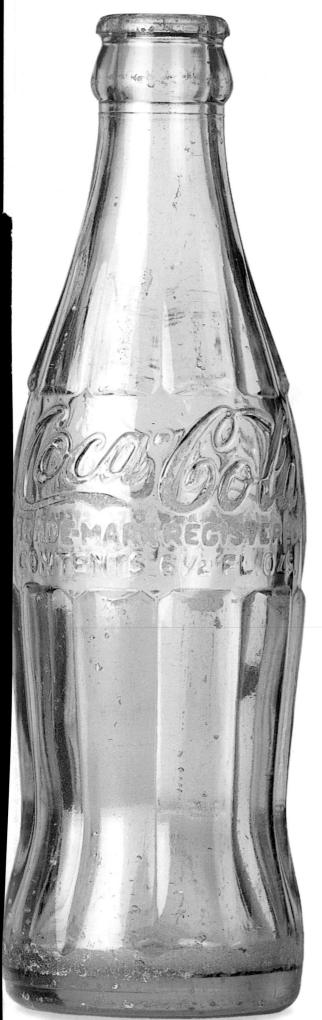

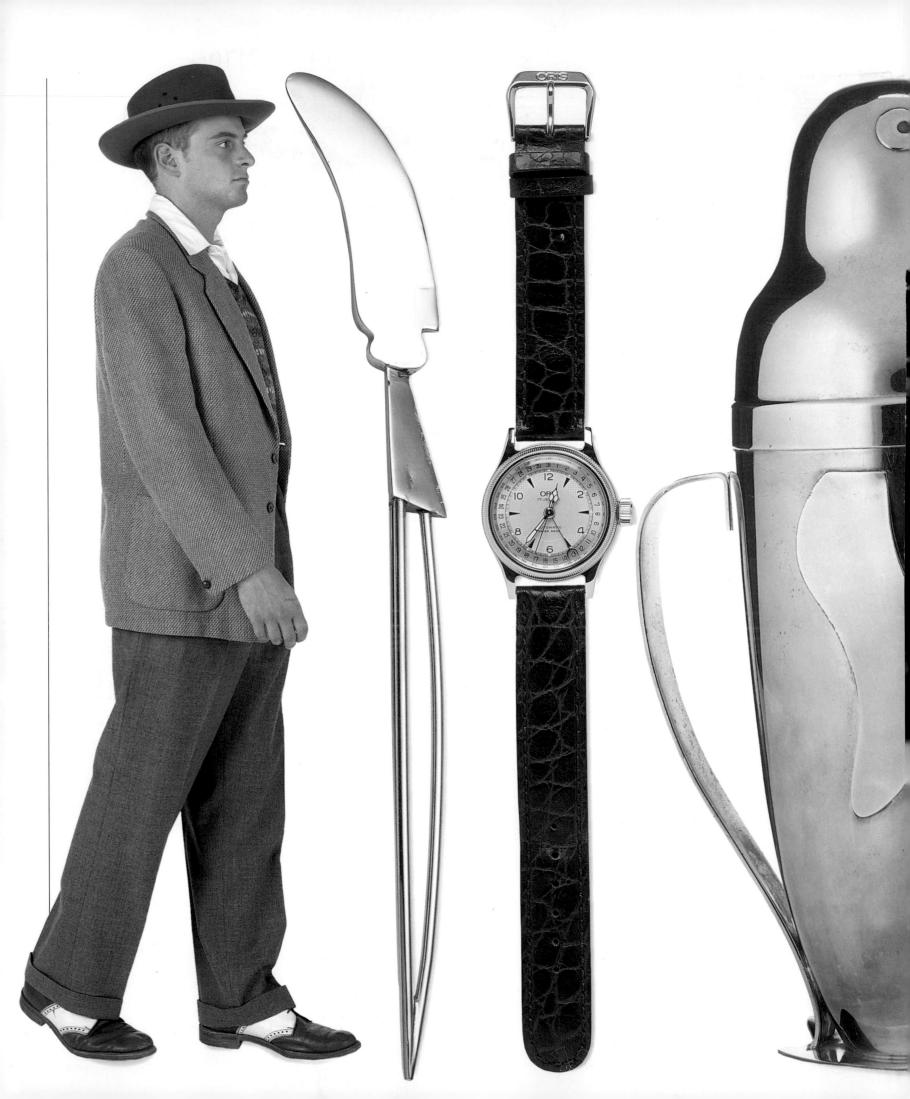

ACCESSORIES 132-57

Childrenswear 134-37

Women's daywear 138-39

Men's daywear 140-41

Haute couture 142-45

Shoes 146-47

Hats 148-49

Watches 150-51

Fountain pens 152-53

Make-up 154-55

Jewellery 156-57

LEISURE 158-69

Swimwear 160-61

Sports equipment 162-63

Cameras 164-65

Guitars 166-67

Jukeboxes 168-69

TRANSPORT 170-89

Bicycles 172-73

Scooters 174-75

Motorcycles 176-79

Cars 180-89

THE OFFICE 190-205

Desks & chairs 192-93

Office equipment 194-95

Desk accessories 196-97

Typewriters 198-99

Computers 200-01

Photocopiers & fax machines 202-03

Adding machines 204-05

GRAPHICS, ADVERTISING, & PACKAGING 206-51

Typefaces 208-11

Corporate ID 212-15

Magazine covers 216-19

Record covers 220-21

Posters 222-31

Packaging 232-51

A-Z OF DESIGNERS

252-75

GLOSSARY 276-77

INDEX 278-86

ACKNOWLEDGMENTS

287-88

FOREWORD

The word "manmade" must characterize the look of much of our environment over the past hundred years. Human inventiveness and, increasingly, human consumption of products invented by others, has gathered pace, even though the great powerhouse of the last decades of the century — Japan — has deliberately slowed the galloping mania of shorter and shorter product lifecycles. Its falter resulted from the great recession of the 1980s, and almost coincides with the first of the movements that have targeted conspicuous waste: greenism, anti-exploitationism, portent of gloomism. This revaluation of the need for products is the moral lens through which we can look at the environment and the artefacts that we have made for a century.

Are we proud of this century? Have most lives been improved by it, and, especially interesting to the designer, have we changed most people's capacity to judge the aesthetics and the functional achievements of the common culture?

This book's look at the products of a century shows stylistic movements in the form and the detail of products, just as clearly as an examination of a century of painting, literature, or fashion would. Every one of those movements threw up style leaders, and these are inevitably the declared heroes of our look at the century. There is, of course, a vastly larger number of unsung heroes who are the engineers and designers of the great majority of the artefacts — which are the real landscape of the time. Our heroes are often only the hothouse keepers, breeders of the new flora in that landscape.

Even so, it is the hothouse that makes the brightest colours and the rarest blooms and so inevitably we look for them to give this book the focus and the brightness that will form our remark on what a century has done.

On perhaps a more prosaic level, there are changes in the size of common products and the effect of manufacturing technology on their availability – through the cost, longevity, and form of things.

The radio exemplifies this perfectly. Originally, it was wooden-cased; then in everlasting Bakelite; later, it was vastly changed in size to hand-held; and by 2000 it will still be available but virtually absent from sight — the only trace a slender wire and a plug in the ear.

We've seen incomprehensible prejudices that affected many products' looks overnight: as recently as the 1950s, it was de facto forbidden to make anything other than park railings in the colour green — the omnipotent buyers dictated it to be unlucky — until Citroën sold a 2-CV, and then anything could be green. And as the century closes, the greatest effect on how things look is undoubtedly from man's inhumanity to man — the computer.

Of course, we all know how labour-saving and entertaining they are, but their inhumanity lies in their theft of many personal skills and, of course, employments. All that aside, their effect on product form and construction is profound and highly visible.

If you can imagine it, if you can depict it on your

screen, then you can have it.

The look of communications has and is dramatically changing, the demands of the media far outstripping the producer's ability to care for long about the look. The message – and its effectiveness – is the force.

But the optimists among us know that there are more and more young — and older — designers who are skilled and who can use these tools.

For the form maker of the commonplace, we've had a good – the best – century.

Paustn

Founder of Pentagram Design, London

INTRODUCTION

Our world is changing at a dizzying speed and technology is racing ahead so quickly that many of us are overwhelmed by the multitude of new designs and inventions that are available: videophones, cable television, solar-powered cars, virtual reality, the Information Superhighway.... Yet so many of the things we take for granted, or even feel are becoming outmoded, were the stuff of dreams just 100 years ago. You have only to look at the two New York street scenes below to see the astonishing progression in clothing, transport, and architecture. In fact, change has been this century's only constant. As well as the technical advances that science has contributed to the product designs of the 20th century, designers and craftspeople have also been influenced by a bewildering succession of movements, from Art Nouveau to Post-modernism, Bauhaus to Psychedelia. Some, such as De Stijl, were relatively shortlived and affected only a limited number of countries, while others, such as Art Deco, lasted longer and had international exponents.

The following pages, which are divided by decade, give a concise introduction to the most important of these movements and their key designers, as well as some of the most interesting developments and innovations from each era.

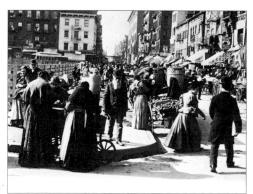

New York, 1900

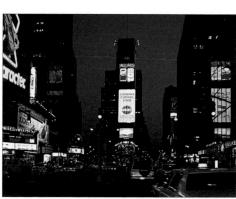

New York, 1996

At the dawn of the 20th century, a frenetic series of momentous advances in technology was making a major impact on society. The internal combustion engine, the electric motor, and the rudiments of telecommunication allowed manufacturers to aspire to hitherto unimaginable heights of efficiency. Previously handmade goods could now be made more quickly and cheaply by machine, undermining the role of craftsmanship.

The machine was also revolutionizing the domestic world and, with the advent of the radio, telephone, and television, it was to redefine completely "communication" at home and at work. The assembly line drastically accelerated the production of vehicles, making the motor car affordable to a much wider

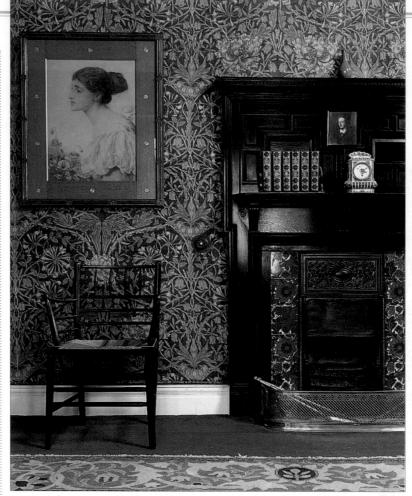

Arts and Crafts interior

The walls of this room at Wightwick Manor in Wolverhampton, England, are lined with William Morris' Honeysuckle printed linen; other items are by his followers.

market. In 1903, the Wright brothers realized the centuries-old dream of flight by travelling 40 metres (131 feet) through the air in their petrol-driven bi-plane. Just six years later, Louis Blériot flew his little monoplane 42 kilometres (26 miles) across the English Channel from France to England. Within 30 years, flight

> would be available to anyone with money, with regular passenger flights crossing the world.

ARTS AND CRAFTS MOVEMENT

Although a product of the Victorian age, the Arts and Craft movement left a legacy that extended deep into the 20th century. The primary concern of its central figures was that "machine-age" manufacturers were driven by quantity rather

Gustav Stickley chair

This beautifully crafted wooden and leather chair was made in 1904–05. Typical of Stickley's work, it was produced using mechanical processes. than quality. The movement's most influential designer and theorist was William Morris (1834-96). His company, Morris and Co., produced a wide range of items, including furniture, stained glass, wallpaper, fabrics, and pottery. For Morris, art and craft had equal status and his designs utilized the skills of craftsmen and artists in collaboration. Arts and Crafts work is characterized by medieval and gothic references; Morris wanted the craftsman's hand visible in the work, differentiating it from the machine-made. The robust, simply constructed furniture

left the joints exposed, and in metalwork the hand of the craftsman was visible in the textural hammerwork. Morris believed that good design was uplifting and would contribute to a happier society — a belief shared by the Modernists in the 1920s. Although the Arts and Crafts movement began in Britain, there were European and American counterparts. Workshops, or guilds, following Morris' precepts sprang up in many countries. While American designers, such as Gustav Stickley, followed the British model closely, many Europeans moved away from the fundamental tenets of the Arts and Crafts movement and

more readily embraced

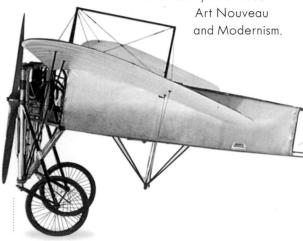

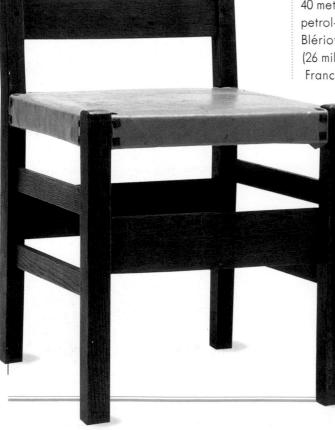

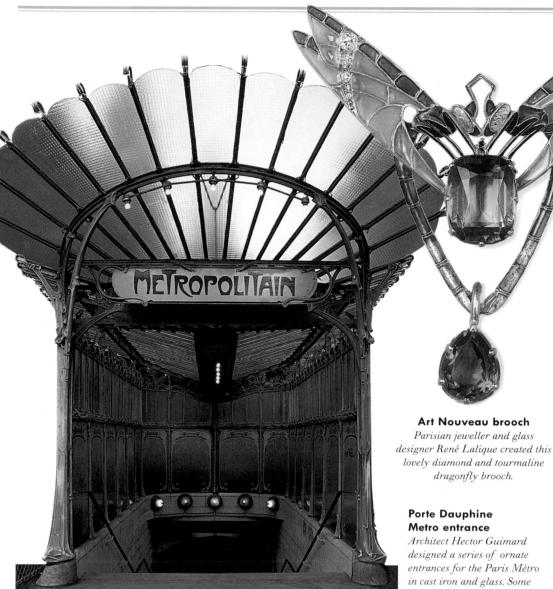

ART NOUVEAU

By 1900, the dominant movement of the decade, Art Nouveau, was already established, born of the Arts and Crafts movement and the 19th-century Aesthetic movement. Its exponents were much more willing to embrace the use of new materials and mass production than their Arts and Crafts counterparts. While they also drew on the past, they shared an enthusiasm for the future that set them apart from the preceding movement. The name is derived from art dealer Samuel Bing's shop, L'Art Nouveau, which opened in Paris in 1895. Leading designers from around Europe were invited to display their work there, including the Belgian Henry van de

including the Belgian Henry van de

Velde (furniture), the American Louis Comfort Tiffany (glassware), and Frenchmen Emile Gallé (glassware) and René Lalique. The latter was one of the key exponents of Art Nouveau. His exquisite jewellery, often based on plant or insect motifs, used glass, semi-precious stones, and gold.

Although Art Nouveau developed in

remain intact today.

idiosyncratic ways in many countries (it was closely related to Jungendstil in Germany, Secession in Austria, and Stile Liberty in Italy), the fluid, organic style is easily recognizable. The dominating characteristic is the whiplash curve that influences both

Cast-iron washstand

This highly ornate British wash basin, dating from 1903 to 1911, demonstrates the curving, organic lines of Art Nouveau. Its majolica tiles are typical of the time.

Blériot's Type XI aeroplane

The plane that Louis Blériot flew over the English Channel in 1909 was constructed from linen stretched over a wooden frame, supported by wire braces. the form and the surtace decoration of the object.

Its organic fluidity was inspired by nature, particularly plant-life.

There are also references to past traditions, such as Celtic art and Rococo, to be found in the style. Art Nouveau could be interpreted either naturalistically or abstractly and its principles could be applied to the design of anything from architecture to jewellery.

The most important work took place in France, Belgium, Austria (see p.12), and Scotland.

THE GLASGOW SCHOOL

In Scotland, the Glasgow School, a small, but widely recognized group of designers, led by the architect and designer Charles Rennie Mackintosh, was producing work that combined the functionalism of Arts and Crafts with the decorative exuberance of Art

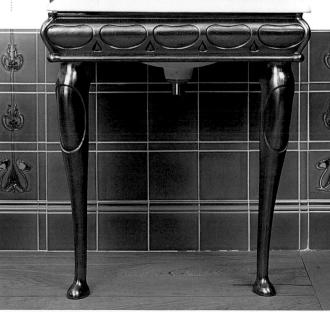

exhibitions showing work from many

Josef Hoffmann was one of the leading figures in the group of Viennese artists and architects known as the Vienna Secession. Although most of the art of the Secession was fundamentally Art Nouveau in style, its design is remembered for a more geometric approach to decoration. The Secession published its own journal, Ver Sacrum, and held regular

WIENER WERKSTÄTTE

international artists.

In 1903, Hoffmann formed the Wiener Werkstätte with Koloman Moser. This association of workshops owes much to the Arts and Crafts guilds. The Wiener Werkstätte was responsible for producing fine pieces of jewellery, metalwork, textiles, furniture, and architecture. Its designers occupied ground between the decorative Art Nouveau and the austere Modernism that was beginning to influence the appearance of objects.

THE MACHINE AESTHETIC

As the century progressed, designers became less concerned with the crafts aesthetic and favoured instead the aesthetic of the machine. In 1917, a group of Dutch painters, architects, designers, and philosophers formed a collective called De Stijl ("The Style"). Moving away from natural form in architecture and design, the De Stijl group attempted to find a visual language to express a new machine aesthetic by using a limited

Coca-Cola bottle

Based on the shape of the cola nut, the Coca-Cola bottle was redesigned in 1915 (see p.213) and has remained virtually unchanged since.

Execlaior Auto-cycle

By 1914, all the major components of the modern motorcycle were already in place; the designs that followed represented a process of

> colour palette and geometric shapes and lines only. Of all the work, perhaps Gerrit Rietveld's Red-and-blue chair of 1918 (see p.33) comes closest to achieving this aim. Constructed from standardized lengths of machine-finished wood, it is devoid of all unnecessary ornamentation. De Stijl's influence extended throughout Europe, particularly to the Constructivists in Russia (see p.15) and the Bauhaus in Germany (see right). In Italy, the Futurists, who included poet Filippo Marinetti (1876-1944) and artist Giacomo Balla (1871-1958) also glorified

The industrialist Henry Ford had founded the Ford Motor Company in 1903, and over the next few years he developed a system of mass production that was to have a permanent effect on the design process: the standardization of parts for easy assembly and, in 1913, the moving assembly line. When these principles were applied to the car on the world's roads was a Model T. Mass production made goods affordable to a much wider market, but also left factory workers with a feeling of alienation. Their role in manufacturing was reduced to an anonymous, repetitive task. Some now took up William Morris' argument that the only escape was a return to craftsmanship; but the momentum in fact, increased as the century progressed. However, the quality of life of the average worker began to be improved by the introduction of a plethora of time- and labour-saving devices, such as washing machines, hair dryers, and irons.

ELECTRICITY

The majority of these new-fangled devices did not really save time, but they did save labour, making housework less tiring. Many of the products were electrically UNIVERSAL

Electricity in the home

As this advertisement shows, by 1917 a variety of electrical appliances was available for the home. With the decrease in the number of domestic servants, housework could be made easier with these devices, which spread across the US and Europe as electricity became more widely available.

A

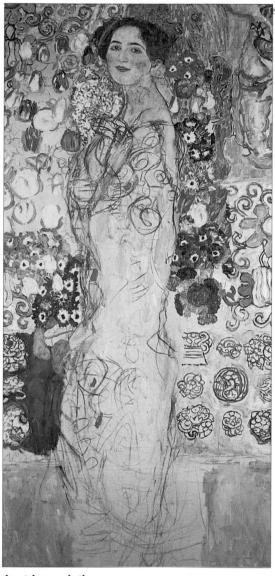

Austrian painting

Gustav Klimt provided a bridge between Art Nouveau and fine art. His richly decorative paintings, with large blocks of flat pattern and heavy use of gilt, were firmly based in the traditions of the Vienna Secession. Entitled Portrait of a Lady, this painting from 1917–18 is unfinished.

operated. A relatively new commodity at the beginning of the century, electricity was as yet unavailable to most homes. However, the promise of a clean, odourless energy source, bright lighting at the flick of a switch, and the attraction of new inventions like the electrically powered vacuum cleaner made electricity such a worthwhile investment that it was quickly taken up throughout the western world.

THE BIRTH OF CORPORATE IDENTITY

In Germany at this time, Peter Behrens was established as artistic director of the electrical manufacturer AEG (Allgemeine Elektricitäts-Gesellschaft). The company recognized the need to unify its design, and Behrens' standardization and interchangeability of components were crucial to AEG's success. The clearest example of this is his kettle designs

from 1909, which allowed for 80 variations from just three basic models (see p.74). Behrens also ensured that there was continuity in all other elements of the company's output, from architecture to advertising. AEG had taken on a corporate identity – a feature to be copied by other companies in the future. Behrens employed some of the most avant-garde designers, including Walter Gropius, Mies van der Rohe, and Le Corbusier. Their work has had an enormous impact on product design and has greatly influenced the debate about art and technology.

THE BAUHAUS

In 1919, an art school was formed in Germany known as the Bauhaus. Under the directorship of Walter Gropius it became one of the most influential art schools of this century, active until 1933. Its simple aim was to train artists to work for industry, and although its achievements can easily be exaggerated, it has left a lasting impression on 20th-century design. Using modern industrial materials, stripped down to their basic elements and without added decoration, Bauhaus designers attempted to make products that avoided historic reference. Their aspirations were not always achieved. Marcel Breuer's famous Wassily chair (see p.33) has many of the characteristics associated with the Bauhaus

The Bauhaus building

Walter Gropius designed the new school building at Dessau in 1925. It has become a symbol of Modernism, with its emphasis on steel, glass, and concrete, and has had a great impact on the development of 20th-century architecture.

style – made from tubular steel and with a stripped-down geometric form. Yet its construction still owes more to the craftsman than the machine. The Bauhaus' greatest success was its teaching methods, which have been copied the world over. Gropius attracted highly respected painters, including Wassily Kandinsky (1866–1944), Josef Albers, and Paul Klee (1879–1940), to teach the foundation course. Celebrated architects such as Marcel Breuer and Mies van der Rohe also taught there.

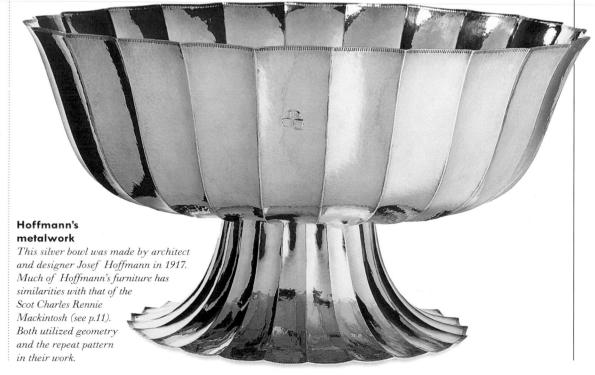

At the influential 1925 Exposition Internationale des Arts Décoratifs et Industriels Modernes held in Paris, the Swiss architect Le Corbusier designed one of the pavilions, naming it L' Espirit Nouveau. This was a model of Modernism: its plain white walls, concrete frame, and large expanses of glass were all unified by an uncompromising geometry. The inside was fitted out with commercially available, unpretentious furniture including the

bentwood Thonet armchair (see p.32). However, the Exposition is remembered less for the functionalism of Le Corbusier's contribution and more for the look that the rest of the exhibits in the other pavilions encapsulated. For it was from this exhibition that the term "Art Deco" was derived.

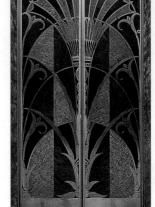

Elevator door

The decorative panelling on these elevator doors in the Chrysler building is characteristically Art Deco, with its use of overlapping curves and contrast provided by different wood grains.

ART DECO

This decorative style
was inspired by non-western art,
particularly that of Africa and Egypt,
made popular by the discovery in
1922 of Tutankhamun's tomb by
Howard Carter. Diaghilev's Ballets

Russes (which first danced in Paris in 1909) and the Cubist paintings of Pablo Picasso (1881–1973) and Georges Braque (1882–1963) captured the imagination of designers. However, Art Deco was not a design movement, but rather a shared approach to styling. The interplay of geometric forms; abstract patterns of zig-zags, chevrons, and sunbursts, rendered in brilliant colours; and the use of bronze, ivory, and ebony were all common features. Criticized by some for its opulence, it was seen to distract from the purist theories expounded by the Modernists. Furniture designers such as Jacques-Emile Ruhlmann (who designed the interior of one of the pavilions at the 1925 Paris Expo) used exotic veneers and ivory inlays in a rich, decorative scheme. He was inspired by 18thcentury design, but updated the look by using geometry and modern materials.

Art Deco did not remain the preserve of the wealthy. Indeed, new, inexpensive materials such as Bakelite were flexible and popular. In Britain, Wells Coates used Bakelite to great effect in his radio designs (see p.56). In architecture, coloured glass and chromium

created the Art Deco look at relatively low cost and was used successfully in public buildings such as the Odeon cinemas. The cinema itself played an important role in popularizing the Art Deco style, through the exterior architecture and the plush interiors of the picture palaces.

In New York, the greatest monument to Art Deco architecture was William van Alen's Chrysler Building. This skyscraper expresses the glamour of Art Deco both in its interior and exterior decoration and forms. The semi-circular pinnacles were faced in Nircosta metal to create gleaming white surfaces reminiscent of platinum (the metal most frequently chosen for contemporary jewellery).

Many famous designers who had made their names with products featuring the Art Nouveau style now adapted their designs to the new look. For example, René Lalique switched from his trademark organic-looking jewellery to Art Deco glassware, including car mascots, perfume bottles, and statuettes.

1920s' FASHION

In the 1920s, the Charleston became the first of many dance crazes to sweep America. To perform such energetic dancing

Art Deco architecture

In 1930, New York witnessed the completion of two contrasting Art Deco skyscrapers, the Chrysler Building and the Empire State Building. Public reaction to the more ornate Chrysler was mixed, but no-one could deny that the building provided a startling change to the previous skyline.

This exuberant bronze and ivory figure on an onyx plinth was cast from a model by Ferdinand Preiss. It is typical of Art Deco figurines, which frequently featured acrobatics and dancing.

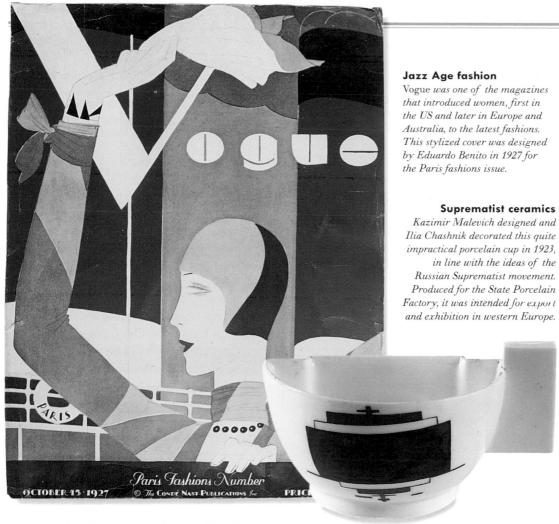

dresses had to be worn shorter to allow for greater freedom of movement. Young women, known as "flappers", began to cut their hair into short bobs, and often wore cloche hats or berets. Designer Coco Chanel created a look to accompany women's new-found sense of confidence. Adapting men's clothes, she promoted a flat-chested, boyish silhouette, frequently worn with flamboyant costume jewellery, but above all designed for comfort and style, and to radiate youth.

THE JAZZ AGE

Popular entertainment also influenced public taste. Jazz, which evolved in New Orleans at about the turn of the century, was now mainstream popular music. With the development of swing in Chicago, there were large ensembles playing with written orchestration. Benny Goodman, Count

Photographic advances

Photography was popularized by the Brownie and the Vest Pocket Autographic Kodak cameras, and, by the 1920s, was an increasingly common hobby. The Leica A went into production in 1924 and was the first widely used 35mm camera, producing goodquality black-and-white shots. Basie, Artie Shaw, and Glenn Miller were all major musicians. The interior of Radio City Music Hall in New York, which opened in 1932, was designed in an Art Deco style by Donald Deskey using a jazz motif. Similar patterns were used in textiles, wallpaper, and ceramics.

SUPREMATISTS, CONSTRUCTIVISTS, AND VKHUTEMAS

In Russia, a desire similar to that of the Dutch De Stijl designers (see p.12) inspired a number of artists, among them the painter Kazimir Malevich, to attempt to find a universal rolationship between geometric forms and pure colour. Their work, termed Suprematism, was more concerned with aesthetics and geometry than with functionality. It was superseded by less abstract Constructivist design. The Constructivists, who included the graphic designers El Lissitzky and Aleksandr Rodchenko, eschewed fine art and were committed to the notion of putting art to the service of the emerging socialist state. In 1920, Constructivist ideas strongly influenced the VKhUTEMAS, a newly opened avant-garde design school in Moscow. (Its name is an abbreviation of Higher State Artistic and Technical Workshops.) Like the Bauhaus (see p.13), the school's aim was to train artists for industry. It shared many of the characteristics of the German school; indeed, Wassily Kandinsky and El Lissitzky were active in both organizations. One of the teachers at VKhUTEMAS, Aleksandr Rodchenko, designed furniture for the Workers' Club at the 1925 Paris Expo. Textiles produced by his wife Varvara Stepanova (1894–1958) and Lyubov Popova (1889–1924) were also put into production. However, of the many furniture prototypes created by the school, not one became an industrial reality.

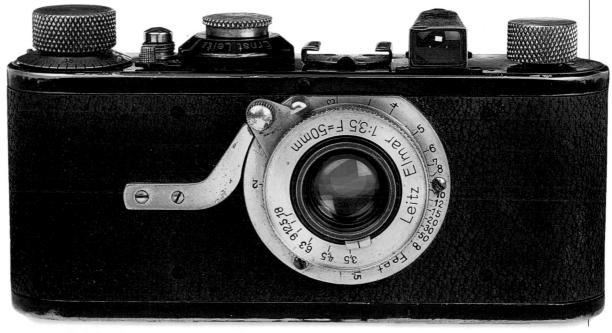

Since the beginning of the century, designers had been experimenting with hydro- and aerodynamics. Based on studies of the shape and movement of fish and birds, it was discovered that boats and aircraft could be made more efficient by smoothing and curving the bows or fusilage. In 1933, the Douglas DC1 appeared as a commercial passenger aircraft. Strikingly different from its cumbersome predecessors, it had a streamlined monocogue structure, integrated wings, and a stressed aluminium skin that was strong enough not to need bracing wires. Along with the Boeing 247, it marked the beginning of modern passenger flight. In 1934, Chrysler launched its new streamlined car, the Airflow. Designed by Carl Breer, it was the result of thorough research into aerodynamics. Its curved unitary body, with sloping windscreen and extended tail, was so different from previous cars that the public did not take to it and manufacturing stopped after just three years. However, the car was an engineering success and contributed much to the appliance of aerodynamics to car design, paving the way for car designers such as Ferdinand Porsche to create their aerodynamic sports cars.

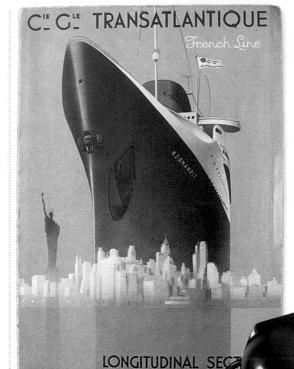

1930s' shipping poster

With transatlantic travel becoming popular, product designers such as Loewy and Teague were influenced by the streamlining of ocean liners, as shown on this poster.

of industrial machinery — no attempt had been made to make it pleasing to look at or easy to use. Loewy, using a full-size clay model to achieve the desired effect, enclosed all the working parts within a smooth, unifying body. The duplicator was a great commercial success and, in the US, designers began applying streamlining to a whole range of domestic appliances. Although the restyled products suggested improved efficiency, sometimes all that had changed was the housing.

AMERICAN STREAMLINING

Streamlining suggested speed, efficiency, and, most of all, modernity. Like Art Deco, it had a commercial imperative, for it became obvious that the consumer was attracted, if not to the Airflow, then to other streamlined products. The first sure evidence of this came

S/S NORMAN

in 1929 when Raymond Loewy redesigned the Gestetner duplicator (see p.202). Until then, it had been a typical

M-10000

example

Ergonomic design

Henry Dreyfuss designed for the human form, and in 1937 he collaborated with engineers to develop this telephone, making it supremely practical as well as stylish.

City of Salina train

This, the first American streamlined train, was designed in 1935. The torpedo-shaped front and rear ends and the enclosed chassis reduced wind resistance.

UNDERGROUND

London Underground maps

The original maps showing the routes on the London Underground followed a traditional geographical approach (left). Then, in 1933, Henry Beck persuaded the newly formed London Transport to adopt a diagrammatic map (below). The vertical, horizontal, and 45-degree angles betray Beck's training as an electrical draughtsman. Besides being easy to read, the main advantage is that the map permits the crowded central area to be enlarged in relation to the outlying areas. The hugely successful map has been imitated around the world.

Us INDUSTRIAL DESIGN

Raymond Loewy was one of the most successful designers ever to work in the US. Essentially a stylist, he was responsible for redesigning the look of numerous products, including the Coldspot Super Six refrigerator (increasing sales by 400%), the Lucky Strike cigarette packet, the Silversides Greyhound bus, and the Shell

Oil company logo (see p.68, 240, and 212). When it came to streamlining, American designers led the way: in addition to Loewy, Norman Bel Geddes, Walter Dorwin Teague, and Henry Drevfuss all made contributions that influenced design throughout the world.

developed a design theory concerned less with styling and more with the relationship between the machine and the operator. He believed that for a machine to be efficient it had to be adapted to people. He developed this theory into a study of ergonomics (how humans relate to objects) and anthropometrics (the study of body size and strength). Dreyfuss' reputation

SWEDISH MODERN

Although Art Deco and American streamlining dominated the 1930s, a quite separate style was evolving in Scandinavia that was to be of increasing international importance during the 1940s and '50s.

The term "Swedish Modern" was coined following the New York World's Fair in 1939. Kev designs during the 1930s were the ceramics of Wilhelm Kåge, the glassware of Kaj Franck, and the furniture of Alvar Aalto. The look was characterized by a soft,

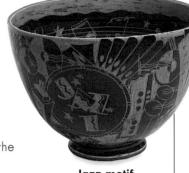

Jazz motif

Victor Schreckengost's 1931 punch bowl is an example of the continuing popularity of jazz.

organic, natural feel influenced by traditional Scandinavian design and a human scale.

BAKELITE AND NEW MATERIALS

In the 1930s, Alvar Aalto and Marcel Breuer both experimented with new forms of machineprocessed wood such as plywood. Interest in other new materials was strong and centred on Bakelite. Invented and patented in 1907 by the Belgian-born inventor Leo Baekeland, this was one of the first plastics to be used extensively. Its malleable properties were the perfect expression of the smooth, sleek contours of a streamlined product. Initially, it was used as a substitute for wood or ivory and was carved into shape from blocks. As designers began to exploit its own unique properties, it was moulded into myriad shapes and used for electrical products. Bakelite, the

> gave freedom to designers to style and restyle artefacts.

Bakelite products

Bakelite was used for a wide range of goods. The Radio Nurse (shown left) was designed by the Japanese sculptor Isamu Noguchi in 1937 after the sensational Lindbergh kidnapping in the US. It consists of a microphone in the baby's room and a receiver shaped like a stylized nurse's head. The four-valve mains radio from 1950 was nicknamed "the Toaster".

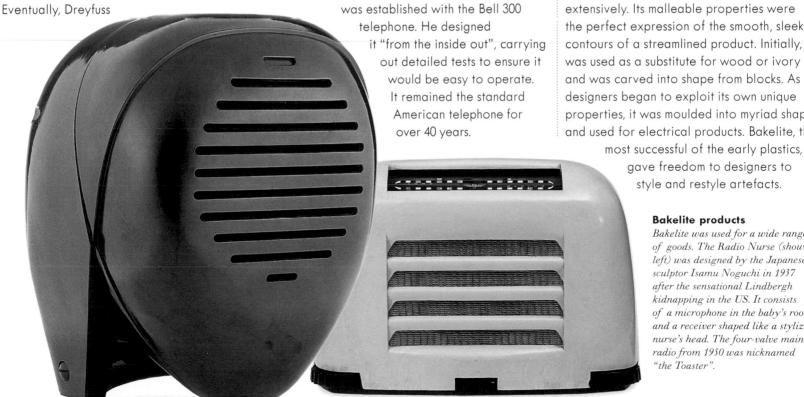

World War II had a major impact on product design and manufacturing. Countries involved in the hostilities were quick to restrict the use of raw materials, and factories themselves were frequently turned over to military

were frequently turned over to military production. In 1941, Britain introduced a Utility scheme in an attempt to ration the use of scarce resources. The Design Panel, which had Gordon Russell as its Chairman, was charged with approving designs for production. The panel followed principles

derived from the Arts and Crafts movement, but was also influenced by the European Modernists. The furniture was required to be strong and attractive, but not wasteful in the use of materials. Some materials, such as silver and aluminium, were completely restricted or not available and even dyes for textiles had to be approved through the Utility programme.

AUSTERITY DESIGNS

Of course, it was not only in Britain that government placed controls on manufacturing. In most of Europe, Japan, and the US, government restrictions prevented the unnecessary use of scarce materials. In Germany, under the Schönheit der Arbeit ("Beauty in Work") programme, designers adopted an Arts and Crafts style, similar to that of Britain, with a particular emphasis on vernacular or rustic designs. In the US and Japan, industries were cut back and price controls were put in place. Designers

were put to work on a range of government commissions and often given an unexpected opportunity to try out new materials. This experimentation paid dividends after the war as designers applied the new materials to the products they created for the domestic market. The results of these austerity measures were severely pareddown consumer products made from the most basic materials. Although they were low cost and by and large well made, they tended to be drab and lacked any sense of flair or luxury. In many countries, the regulations

lasted long after the end of the war and consumers soon became impatient with the continuing restrictions.

NEW-LOOK FASHION

It was, therefore, hugely refreshing when Christian Dior showed off his first Paris collection in 1947. Women, desperate to escape from the sensible clothes of the war

War posters

During wartime, the governments of all the participating countries were quick to commission graphic designers to produce information and propaganda posters. Many encouraged women to work in factories, on farms, or to join the forces.

years, embraced
the "New Look" —
powerfully feminine,
with softly rounded
bodices, tight waists,
long, very full skirts,
and high-heeled
shoes. With rationing
still in place in many
parts of Europe,
the yards of fabric
required to construct
the huge skirts were

mostly unobtainable. Not all women loved the look, and some, who saw it as extravagant and indulgent, picketed the House of Dior, further adding to Dior's reputation. Nevertheless, the more elegant style quickly gained popularity and manufacturers tried to produce something akin to Dior's vision but using less fabric. For men too, shapeless wartime suits were replaced with a narrower silhouette.

TO FIGHT

and constraint, Dior's "New Look" made a powerful impact. His clothes made women feel feminine again.

Dior's "New Look"

After years of rationing

ITALIAN DESIGN

In Italy in 1946, former helicopter designer Corradino d'Ascanio designed the Vespa scooter for Piaggio (see p.175). This exciting, streamlined, modern vehicle became a symbol of postwar ricostruzione and attracted worldwide sales. After the war, Italy consolidated its design practice, eventually becoming a world leader. Companies such as Fiat, Olivetti, and Cassina employed avant-garde designers to make products that would hold their own in the world of international commerce.

NEW MATERIALS

Plastics became increasingly important materials after World War II, and their use has significantly changed the way things look. Before then, they had been

> regarded as substitutes only, but after the

war, many designers deliberately chose to exploit the properties of particular plastics for individual projects. The following are just a few examples. Acrylic, such as Perspex, had been discovered in the 1930s and was put to use in furniture design and as a lightweight replacement for glass. See-through films, such as PVC, were used

to produce waterproof mackintoshes and umbrellas. Nylon was utilized by the American forces for parachutes. In 1942, Earl Tupper introduced lightweight polyethylene containers with airtight lids. Known as Tupperwear, they were available in a range of pastel colours and were both flexible and hardwearing.

One of the most exciting developments

was in the use of plastics for modern chairs. The pioneers of this work were the American architect Charles Eames, together with his wife Ray, and Eero Saarinen. During the war, Eames had worked with glass-reinforced polyester to

make radar domes for aircraft. By applying the knowledge he had acquired from this work to chair design, he produced a one-piece moulded seat shell supported on wire legs, which was known as the DAR chair, in 1948. Unlike the Womb chair produced earlier by Saarinen (see p.35), Eames' chair was left uncovered so the glass-reinforced plastic construction was exposed. Many

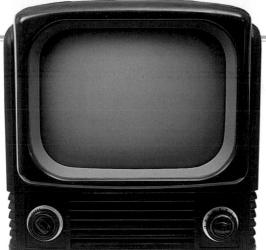

Early television set

This television set by Bush has a Bakelite case moulded into a shape reminiscent of the Art Deco radios produced a decade earlier.

RADIO AND **TELEVISION**

Radio stations had started broadcasting in the early-1920s and domestic radio became more popular during the following decade. However, it was only with the outbreak of World War II that the various warring governments realized radio's potential for disseminating information

and propaganda both to their own civilians and to the enemy.

After the war, television began to make an impact on domestic life. A television transmitter had been demonstrated by John Logie Baird in 1926, but it was not until the late-1930s that cathode ray tubes were capable of receiving high-definition broadcasts. As with radios and record players, early televisions were housed in traditional cabinets that gave them the appearance of items of furniture, with no indication as to the true purpose. As the technology improved, designers began experimenting with new materials and finding solutions more fitting to the function. Bakelite could be moulded, initially to fit the shape of the screen and subsequently to find expressive forms.

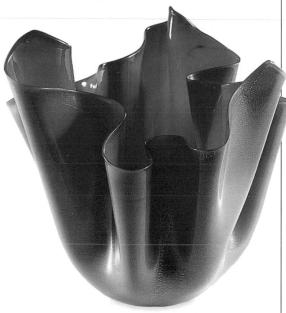

Unconventional vase

Italian designer Paolo Venini combined his bold sense of colour and texture with traditional glass-making techniques to produce the Handkerchief vase. First made in 1946, the design became enormously popular.

Eames' DAR chair

manufactured by Herman

Miller from 1950. It was based

on an earlier model entered by

Eames for a competition held by the

Museum of Modern Art, New York.

This fibreglass chair

with wire legs was

The inferno that was World War II had given way to the chill of the Cold War, played out by the capitalist US and the communist Soviet Union. Competition between the two political systems came to be symbolized by the space programme: the frantic race between the superpowers to become leaders in space exploration. The Soviets took the initiative: in 1957, they launched Sputnik 1, the first satellite to orbit the earth, and, in 1961, the Soviet cosmonaut Yuri Gagarin became the first man in space. Just eight years later, American Neil Armstrong took his "giant leap for mankind" by walking on the Moon. Science, space travel, and science fiction became an all-

> consuming obsession. Scientific motifs came to be associated with modernity and appeared everywhere.

CONSUMERISM

In the 1950s, car design in the US took on a new, extravagant look. Inspired by aircraft and rockets, Harley Earl of General Motors began to alter the shape of cars in a way that expressed the postwar confidence of American society. His cars were wide, low, and very long. They had lavish interiors, imaginative tail fins, masses of chromium, wraparound windscreens, and came in striking colours. During this time, the

controversial strategy of planned obsolescence emerged in the US. By introducing small stylistic changes, companies could launch

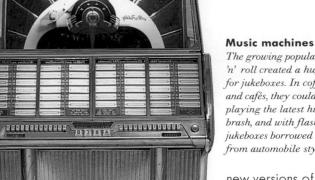

The growing popularity of rock 'n' roll created a huge demand for jukeboxes. In coffee bars and cafés, they could be heard playing the latest hits. Big, brash, and with flashing lights, jukeboxes borrowed shamelessly from automobile styling.

new versions of their products each year, thereby appealing to those conscious of social status by making last year's model stylistically obsolete. Of greater concern was the decision to build in physical obsolescence,

so that through a lack of actual durability the product only had a limited lifespan. The debatable defence of this huge waste of resources was increased employment.

INTERNATIONAL STYLE

a machine

In contrast to the cynicism of planned obsolescence, some companies, most notably Braun in Germany and Saab in Scandinavia, began to design and market goods on the basis of their durability. In 1955, the Swiss industrial designer, sculptor, and painter Max Bill (1908–) co-founded the Hochschule für Gestaltung in Ulm in Germany. Bill had studied at the Bauhaus and his aim was to continue that school's rationalist approach to design. This revival of the Modernist style took the search for

Youth culture

The 1950s marked the emergence of a vibrant new teen culture with its own dress, behaviour, music, and language. Singers like Elvis Presley and film stars like James Dean became role models to this affluent consumer group.

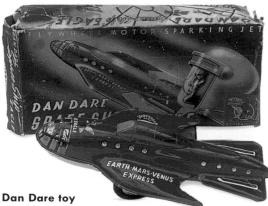

Many manufacturers saw enormous opportunities for product development in the space obsession, and geared product design to this market. A whole range of toys, for example, featured Dan Dare, the hero of the British comic the Eagle (founded in 1950).

aesthetic further than before; it required design to be forward-looking, reflecting modern life, and embracing technology. This functionalist approach, which is often referred to as the International Style, was most clearly represented in product design by the Ulm school. Financed by commissions, the school had close links with industry. Among its first and most important commissions was a series of radios and phonographs for Braun by Hans Gugelot and Otl Aicher. This helped formalize Braun's reductionist design philosophy, and the continued collaboration between Gugelot and Dieter Rams of Braun brought about the development of the "black box syndrome" in modern design. Anything unnecessary to the

function of the product was stripped away. Clean lines, durability, balance, and unification were key requirements. All Braun products are clearly related, often finished in glossy white or black, with the company logo visibly marked on the casing.

TRANSISTORS

One of the most significant developments in the look of electronic equipment was the invention

of the transistor in 1947 by Bell Laboratories. Made from silicon and only requiring a low electric current to function, these small, robust components were used for items such as radios, televisions, and record players, in which they replaced the cumbersome vacuum tube. The Tokyo Telecommunications Engineering Corporation (later known as Sony) produced the first mass-produced transistorized pocket radio in 1955, and in 1959 developed the first all-transistorized television with a 20-cm (8-in) screen. The diminutive size of the transistor gave designers the freedom to miniaturize all other electronic appliances.

An insect on metal legs
Arne Jacobsen's 1951 Ant chair is one
of many 1950s' furniture designs that
incorporated steel rods or steel wire.
Harry Bertoia's Diamond chair and
Ernest Race's Antelope (see p.36) are
others. Jacobsen's chair is still
much copied today.

IMPORTANT COUNTRIES

The 1950s marked a high point in 20th-century Italian design. Designers such as Gio Ponti, Marco Zanuso, Marcello Nizzoli, the Castiglioni brothers, "Pinin" Farina, and Ettore Sottsass achieved great success for themselves and Italian companies such

as Olivetti, Artemide, and Brionvega. Elsewhere, Denmark became a major player on the international design stage, noted for its mass-produced furniture, luxury silverware, and innovative textiles and wallpapers. Denmark's Scandinavian neighbours Finland and Sweden were also enjoying much design success.

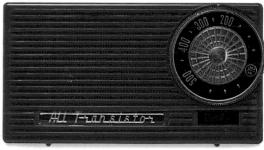

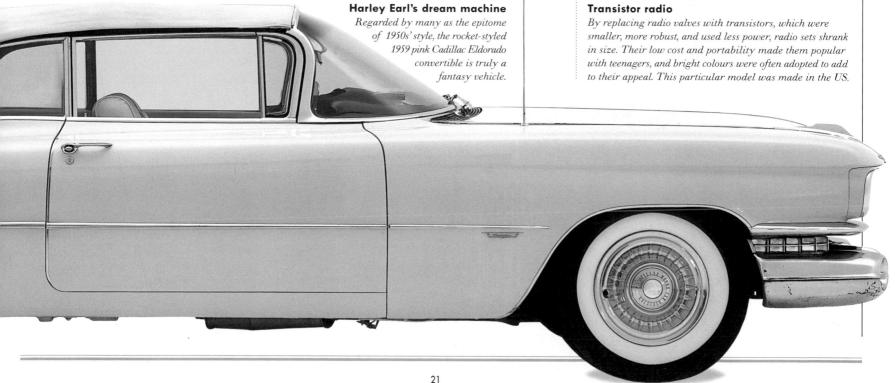

During the 1960s, the postwar baby boomers were growing up, and en masse they created a powerful new army of consumers. They were coming of age in a period of unparalelled,

obsolescence is created by the rapid advances

in technology; built-in obsolescence is no

unrestrained optimism and self-belief: the war, and the postwar austerity, was over; humans were in space and would soon walk on the Moon; the first heart transplant had taken place; and 60 years after the first flight across the English Channel, Concorde would be flying faster than the speed of sound across the Atlantic Ocean. "We live," one commentator said, "in a throwaway society,

Black-and-white textile

Danish furniture and textile designer Verner Panton designed this Op Art fabric in 1961.

of the International Style relevant?" So began the rejection of Modernism, which was no longer able to meet the demands of this eager new force of consumers, who wanted change and variety in the place of permanence and uniformity. Most of all, they wanted a look they

> could call their own, that divorced them from their parents, and that reinforced the gap that had grown between the pre- and postwar generations.

Mass consumerism

During this period, the power of advertising, particularly on television, led to the birth of mass consumerism.

Manufacturers quickly recognized the buying

power of the teenage population and began to create products aimed specifically at the youth market. A combination of new materials, new shapes, new technology, and new colours vied for the attention of these affluent young people. This manifested itself in all areas of design: in the motor car industry, the Mini (see p.185) was born; in fashion, the miniskirt appeared (see p.139); and in graphics, Wes Wilson produced his barely legible posters (see p.229). There were myriad radical furniture designs: Danish designer Verner Panton produced his bright red moulded plastic stacking chair (see p.37), and Gunner Aagaard Anderson (1919–) of Denmark created his polyurethane Armchair, an extraordinary item that looks like - and, in fact, is - a huge

Youth movements abounded, each had its own music, its own dress code, and its own visual language. One, Psychedelia, was a short-lived but incandescent revivalist movement that had a farreaching influence. The Psychedelic

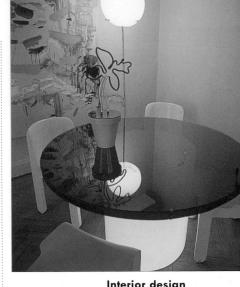

Interior design

This 1960s' domestic dining area shows the contemporary fascination with plastics, transparent materials, bright colours, and soft shapes.

Space-age clothes

In 1969, models displayed the latest Martian wigs by French coiffeur Jean-Louis St Roch. "Space-age" clothes were made popular by Pierre Cardin and Courrèges.

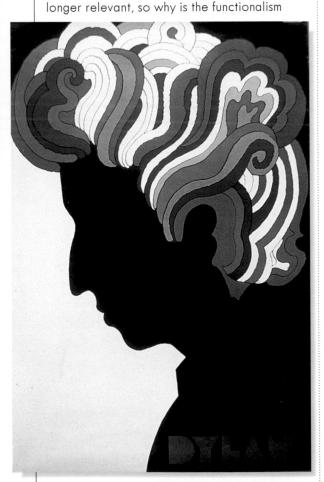

Psychedelic poster for the Dylan album

Bob Dylan has himself become an icon of the 1960s. Illustrated here by Milton Glaser in 1966, Dylan's hair is rendered as a pattern of colourful psychedelic swirls.

designers of the day rejected Modernism out of hand. Where the Modernists looked only to the future for inspiration, Psychedelia looked anywhere and everywhere, often through the blur of hallucinogenic drugs. Its artists sought inspiration back at the beginning of the century, incorporating aspects of Art Nouveau and the Vienna Secession into their work; they looked to the East, and as far into the past as Ancient Egypt for references; and they looked at their own world, creating a visual drug-inspired language that was aimed at a select audience.

1960s' FASHION

In the world of fashion, one of the names that stands out above the others is Mary Quant.

Rejecting haute couture, she aimed her designs at the young, and produced inexpensive and fun clothes. She remains best-remembered as the designer responsible for introducing the miniskirt and hot pants to Britain.

The space age continued to influence fashion, and designers created outfits in futuristic materials, typified by Courrèges' "silver-foil" suits.

POP ART

Fashion and art have had a huge influence on product design, and no art movement has had a greater impact on commercial design than Pop Art. Pop artists such as Andy Warhol, Jasper Johns (1930–), Roy Lichtenstein (1923–), and Robert Indiana were turning the art world on its head by drawing the everyday into their studios and recycling it as ironic, irreverant art. Andy Warhol openly celebrated American consumerism in his repeat-image paintings of iconic images of popular culture, be it Campbell's soup tins or Elvis Presley, Ironically, manufacturers themselves began to use Pop Art in product design, marketing, and advertising.

> So much so that it soon became a part of everyday life, with, for example, Robert Indiana's "LOVE" image appearing on 40 million postage stamps. Other fine art movements, notably Op Art, were also taken up by product

and textile designers.

In Europe, the Italian designers had taken the lead role on the international stage, and many acknowledged the influence of the Pop artists in their work. Joe Colombo. Ettore Sottsass, and Marco Zanuso, freed from the constraints of

Modernism, took on board the playfulness of the age, and began to toy with the new themes. Their work,

dubbed "Radical" or "Anti-Design", drew on popular taste. Joe Colombo experimented with plastic for his furniture designs, as did Sottsass in such classics as the vividly styled orange-red and yellow

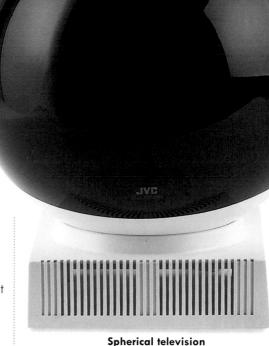

JVC's Videosphere from 1970 has a plastic case and looks like a spaceman's helmet, reflecting public interest in space travel while also challenging traditional shapes.

Valentine typewriter (see p.199). The Italian designers more or less rescued plastic from its reputation as cheap and therefore undesirable, an image that had grown from its use in disposable designs such as the Bic Biro (see p.197). Few could fail to see the beauty and sophistication of Marco Zanuso and Richard Sapper's plastic Grillo telephone, regardless of its material (see p.127). Other Italian designers were making a contribution with innovative furniture designs.

Two of the most famous are the Sacco chair by

Gatti, Paolini, and Teodoro, a stuctureless,

polystyrene-filled bag

that is now regarded as the first beanbag chair (see p.38); and the Blow Armchair by de Pas, d'Urbino, and Lomazzi, an inflatable plastic chair that relied on air for its shape and comfort. These radical Italian designers in turn influenced the Post-

modernist designers of

the following decades.

Pop artist Robert Indiana's LOVE ring was made in gilded

1970–79

Italy continued as a centre for design excellence into the 1970s and as a leader in Radical design. Many of its chief designers are linked to the most important movement of the decade – Post-modernism.

POST-MODERNISM

The term can be applied to many aspects of our lives, cultural and social, but has particular

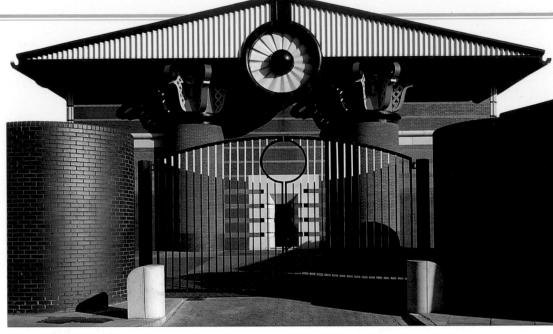

Post-modernist architecture

Architect John Outram's pumping station at Blackwall, Isle of Dogs, London, is a classic example of Post-modernist architecture. Many structures described by this term feature elements borrowed from the architecture of older periods, such as classical columns and pediments.

relevance in the world of art, architecture, and design. It is essentially a rejection of everything entailed in Modernism, which detracters argue is elitist, unintelligible, unattractive, and unappealing. The Post-modernist's aim was to popularize the highbrow, and to make the intellectual accessible. Exponents borrowed freely from history, reworking the colour, texture, or material, often as a witty parody of the original source. While many of the most important protagonists of Postmodernism are Italian, it is a truly international movement. Its leaders include Ettore Sottsass, whose work is typified by the Carlton sideboard (see p.124); the American architect Robert Venturi,

Furniture in Irregular Forms

This wooden chest of drawers is one of the best-known pieces by Shiro Kuramata and was created for Fujiko in 1970 at a time when Japanese design was being recognized as an innovative force on the international stage. It is shaped like an elongated "S".

who designed the classic Post-modernist building Chestnut Hill House in Pennsylvania; and Michele de Lucchi, who created the prototypes shown here. The Post-modernists rejected the Modernist's Utopian aims and their search for a universal aesthetic, and instead looked to create a visual language that was made

up of signs, visual metaphors, references to the past, and to the work of other designers. As a result, the Post-modernists have been accused of continuing the elitism they despise by assuming an understanding of the references made in their work, and for the prevalence of "in-jokes".

Another criticism that has been leveled at Post-modernism is that it has been manipulated by the forces of commerce, and has produced little more than an

incoherent mishmash of styles. By the 1970s, manufacturing allowed for limited production,

Fan prototype

Although de Lucchi's colourful prototypes (see also right) never went into production, they encouraged more decorative, fun product design.

and for all types of products to be tailored to accommodate the demands of a small market. This caused a shift in emphasis away from mass production and towards meeting the needs of the individual.

SPORTS CARS

Another important area of Italian design influence in the 1970s is the sports car. The decade saw the birth of the supercar, with Italian manufacturers Lamborghini, Ferrari, and Lancia competing with the likes of Porsche, so manufacturers began to look at more fueleconomic alternatives.

Japan began to emerge as a main player in motorcar design in the 1970s and more so in the field of motorbike design, an area now dominated by the Japanese through the efforts of Yamaha, Honda, Suzuki, and Kawasaki. The Japanese also led the world in the development of new technology and by the 1970s many of its manufacturing companies, such as Nikon, Olympus, Sony, and Sharp, were growing in commercial stature. Their

> goods typically featured a "high-tech" look. In graphic design, fashion, and furniture production, too, young Japanese designers were increasingly being recognized as playing an important international role. They were among the first to

recognize and exploit the value of computer technology in the design process.

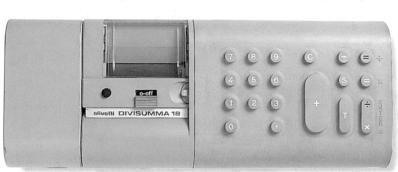

Olivetti Divisumma 18

A leading exponent of Italian design, Mario Bellini has produced many stylish products for Olivetti. This brightly coloured calculator is typical of his work, featuring as it does an expressive surface created by the rubber "skin".

Triumph, and Jaguar to produce the sleekest, lowest, fastest, most powerful car in the world. Cars such as the Lamborghini Countach were capable of 0-60mph (0-96km/h) in 5.1 seconds, and had a top speed of 187mph (301km/h). However, the spiralling petrol prices that resulted from the Oil Crisis of 1973, made petrolthirsty cars less popular, and

THE MICROCHIP

The theory behind the microchip, one of the most important inventions of the century, was originally devised by an American, Jack Kirby of Texas Instruments. Its development meant that electronic components could be reduced unimaginably in size. By 1970, for example, thousands of components could be printed

Ferrari 365 GT4 Berlinetta Boxer

In production from 1973 to 1976, only 387 Boxers were built. At the time of launching, it was hyped as one of the fastest GT cars ever built. In fact, it was slower than the on top of a single silicon chip measuring only 5mm (1/4in) square. Without this invention, a personal computer would take up the space of a living room and a pocket calculator would be the size of a small car. Microchip technology is now commonplace in the household and workplace: in telephones, washing machines, video recorders, and cars. In industry, its use has seen the monotonous tasks of the production-line worker slowly being taken over by robots.

A classic example of the application of

Toaster prototype

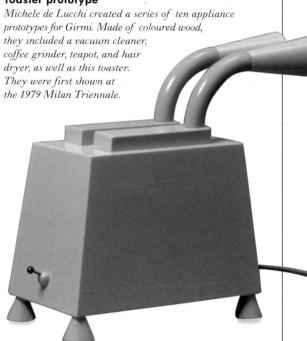

microchip technology is the Sony Walkman personal stereo (see p.62), which was introduced in 1979. It was originally thought might not be successful, yet it was an instant success, and spawned numerous imitators.

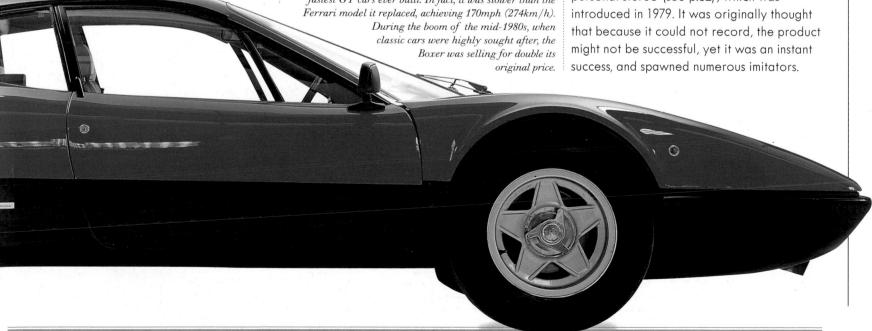

Technological advances produced many changes in the penultimate decade of the 20th century. The computer age had definitely arrived and designers were increasingly utilizing sophisticated programmes to carry out many aspects of product design that had traditionally been drawn or made by hand. For graphic designers, too, the new technology created myriad new possibilities for manipulating typesetting and image reproduction.

COMPUTER TECHNOLOGY

Home computing began slowly to take off in the 1980s, accelerating astonishingly into the 1990s. The first personal computer (PC) had been developed by IBM in the late-1970s, and was introduced as the IBM PC in 1981. However, the real breakthrough came with the introduction of the Apple Macintosh in 1984 (see p.200). It improved the user-friendliness of the home computer, and introduced the now ubiquitous mouse.

The compact disc (CD), which first appeared in 1982, has revolutionized the music industry. CDs record information digitally as a series of numbers. This stored information is read and translated by a laser beam, which allows the music to be reproduced clearly. The CD has now all but replaced the vinyl disc in most homes.

Sound is not the only type of information

ABC DEF GH

A S G

·* 0 #

that can be recorded on CDs; they are also able to store text and pictures, and even video sequences. This ability is utilized in the CD-ROM player. Invented in 1985 by the Dutch electronics manufacturing giant, Philips, this innovation was jointly marketed with Sony. Basically a CD adapted for use with a computer, a CD-ROM can store one thousand times as much information as a floppy disc.

Cellnet mobile telephone

Portable telephones have evolved from large and cumbersome units into sleek, pocket-sized instruments. It has been predicted that their rapidly increasing popularity will one day see the disappearance of fixed-point telephones. The initials ROM stand for "Read-Only Memory", indicating that the information can only be read, not added to or changed. The CD-ROM did not conquer the domestic market until the 1990s.

THE GLOBAL VILLAGE

The term "global village" began to be used as new technology made possible instant communication with virtually any part of the world. Fax machines became a familiar part of the office, and modems and electronic mail (e-mail) enabled people to

Marketing phenomenon

In less than ten years the compact disc has established itself as the pre-eminent method of sound recording for the home entertainment market, despite being more expensive than the vinyl recordings that it superseded.

communicate cheaply and instantly via computer. Satellites were developed in the US in the 1960s by NASA, the National Aeronautics and Space Administration, and by the 1980s thousands of satellites orbiting the earth were being used for telecommunications and broadcasting. Another invention, the cellular, or portable, telephone, first developed in 1979 by the Swedish company Ericsson, became commonplace during the 1980s.

Modern vase

is confounded by its actual sturdiness. This three-legged vase seems precariously balanced on the tapered, slanting feet. However, the sheer weight of the glass makes the structure rigid and stable.

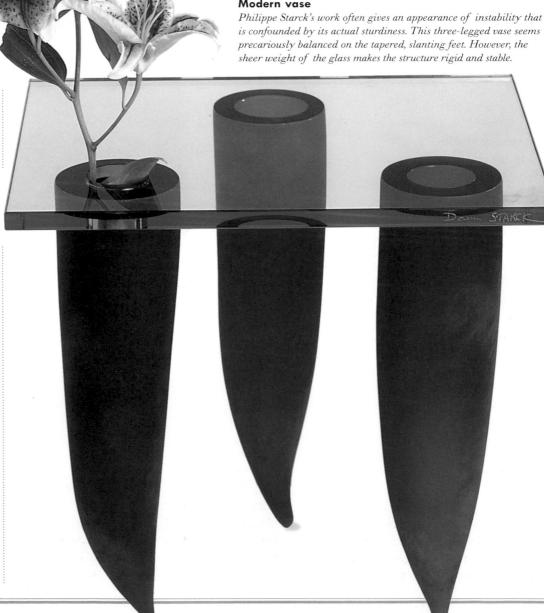

PUNK AND BRITISH DESIGN

In the late-1970s, Britain saw the appearance of a new, aggressive street style - Punk that was, in tamer forms, to have an influence on graphics, fashion, and culture in the 1980s. In fashion, Vivienne Westwood's 1981 Pirate collection (see p.145) translated the Punk look into successful high-street fashion and marked the revival of British fashion as an international force. Punk also had a great influence on newwave graphics, exemplified in Britain by Jamie Reid's controversial record covers for the Sex Pistols, and in Terry Jones's i-D magazine. Something of the shock appeal of Punk is also evident in the furniture of Ron Arad (see p.254), and the industrial designs of Daniel Weil (see p.57).

MEMPHIS

Undoubtedly, the most important design group of the decade was Memphis. It was started in Milan by Ettore Sottsass after he left the radical Studio Alchimia in 1980. He surrounded himself with a group of international architects and furniture, fabric, and ceramics designers, including Andrea Branzi, Martine Bedin, George Sowden (1942-), Peter Shire, Michael Graves, Javier Mariscal (1950-). Michele de Lucchi, and Matteo Thun. They first showed their work at the 1981 Milan Furniture tair, where it was an immediate success, although some critics attacked it for being tasteless. A Post-modernist group, Memphis borrowed from an eclectic variety of sources, including anything from classical architecture to 1950s' kitsch. It made startling and innovative use

of bold, often

outrageous,

Eat/Drink cutlery This functional yet attractive cutlery set was designed in 1980 for people with limited strength. The design of the knife is such

that pressure is applied with the arm rather than just the wrist.

colouring, and laid more emphasis on the look and meaning of the object than on its practical usage. What started out as a polemical venture proved to be an enormous commercial success. However, the ideas of the Memphis group, which typified the more excessive aspects of Post modernism, were quickly exhausted.

UNIVERSAL DESIGN

In total contrast, the industrial design consultancy Ergonomi Design Gruppen was founded in Sweden in 1979 by Maria Benktzon (1946-) and Sven-Eric Juhlin (1940-) to specialize in the ergonomic design of everyday tools. A key interest was design for people with limited physical abilities, and one of the group's

best-known designs is a range of cutlery called Eat/Drink, which clearly embodies the design philosophy that

"the need and desires of the user shall form the basis of the project".

Despite being the focus of increasing concern through the 1980s and '90s. universal design, or design for disability, as it is also known, is still a largely neglected area. Attention is likely to increase as the population balance shifts with more people living into old age. Computer technology is also increasing access and creating opportunities for all people. For example, despite having been "disabled" at the age of 20 by a crippling disease that left him unable to walk, speak, or write, the eminent

British physicist

Stephen Hawking has been enabled to work by communicating through a voice synthesizer and computer.

SOCIAL CONSCIENCE

"Design for need" started as an international conference that took place in London in 1976. It pointed to the growing feeling that design should be addressing issues relating to the

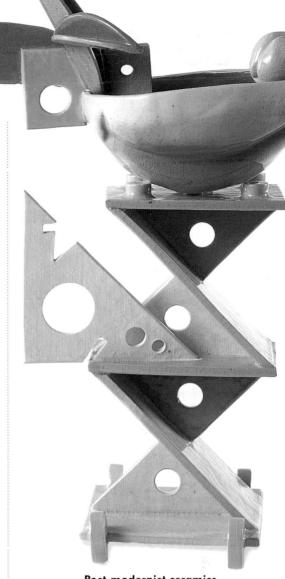

Post-modernist ceramics

Peter Shire, who was a member of Fittore Sottsass' Memphis group, is noted for his eccentric ceramic designs. The California Peach Cup, made in 1980, is typical of his work and a good example of Post-modernist design.

environment, ecological concerns, and special problems occurring in underdeveloped countries. The problem was that design had for too long been concentrating on production and consumerism. A series of ecological threats in the 1980s provoked designers into focusing more clearly on green issues. One result was a move towards designing products that could be recycled. This began to feed through to affect all areas of design. For example, the French designer Philippe Starck, who became one of the most celebrated designers of the 1980s, created his Louis 20 stacking chairs (see p.193) with the legs screwed rather than glued to the body, so that the parts could be separated and recycled. Designers began to realize that they had an important role to play in finding solutions to large-scale world problems.

THE 1990s

On a visit to Africa in the early 1990s, Trevor Baylis, a British inventor, became aware of the importance of radio for communicating information to remote communities that lacked an electric power supply. Although many village communities had radios, they were more or less redundant, as the batteries were prohibitively expensive. This meant valuable

information, particularly relating to health, did not always reach those who needed it most. Baylis' response was to invent a clockwork radio that could generate enough power to be self-sufficient. In collaboration with

a manufacturer, he

BayGen Freeplay radio Trevor Baylis' clockwork radio was launched in 1995. It shows how knowledge that has been available for generations can be used as effectively as new technology.

produced a model that is now being successfully used across Africa. The clockwork radio highlights two of the most important design imperatives for the 1990s: ecology and communication.

ECOLOGICAL CONCERNS

Some designers in the 1990s have been concerned with undoing the damage that humans have inflicted on the planet with the mass industrialization of the

19th and 20th centuries, or at least with trying to stem future damage.

In 1985, scientists discovered that there was a dangerously large hole in the ozone layer. They contended that if it was permitted to grow, the temperature of the planet would increase with catastrophic effects.

Governments responded with atypical speed, collaborating with the Montreal Protocol – signed in 1987 and reinforced in 1990 -

> and imposing controls on items such as aerosols and refrigerators that contained potentially harmful

chlorofluorocarbons (better known as CFCs). It became clear in the 1970s and '80s that the world's resources are being exhausted at a rate that can not be sustained. Fossil fuels will not

> last for ever, so designers are beginning to explore solutions that may slow down and even stop

the depletion of raw materials. For example, alternative sources of energy are being devised: solar cars have been developed in Australia and elsewhere, and the electric car, once an inventor's dream, is now a reality. In response to the rapid depletion of the forests caused by the ever-increasing demand for paper and wood, alternative forms of

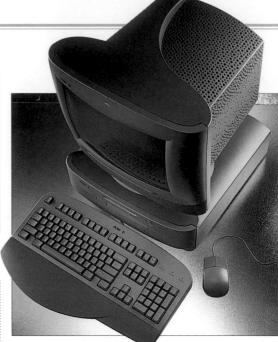

Ergonomic design

As more people work at home, computer companies are improving the external appearance of their products in response to customers' wishes for better-looking machines.

communication and information storage are being developed in addition to using more recycled paper. However, the idea of a paperless office, relying solely on electronic storage, is still a long way from being realized.

RECYCLED GOODS

Built-in obsolescence is beginning to be replaced by a more responsible approach to product durability. As well as incorporating more recycled materials into their products, designers are creating more energy-efficient

products that can be recycled or repaired. A well-designed car is one that uses little fuel, produces few emissions, lasts a long time, can be easily

New-look packaging

At the close of the century, as products become more sophisticated and refined, their appearance remains the essence of their success or failure. Pepsi Cola illustrated the continued importance of packaging in 1996, when it spent \$40,000,000 on changing the colour of its most famous product.

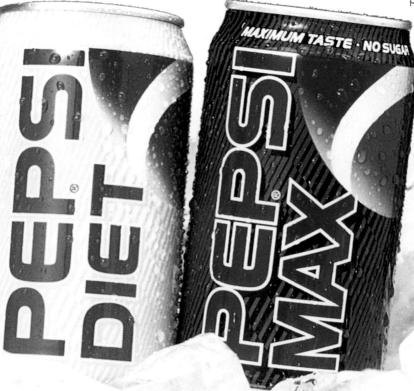

repaired, and at the end of its life can be broken down with the component materials either being recycled or disposed of safely. In the rapidly advancing computer industry, the trend is now to create machines that can be upgraded to keep up with new developments, rather than having to replace the whole machine.

ADVANCES IN MASS COMMUNICATION

The 1990s have also seen the most astonishing advances in communication. The Internet and the Information Superhighway promise to have as much impact on our lives as the invention of

Modern architecture

Kansai International Airport, situated on the Bay of Osaka, Japan, was designed by Renzo Piano. It has been built on a manmade island and has its own train running the length of its 1.6km- (1 mile-) long terminal.

the telephone, the television, or the motor car. All you need is a computer to have instant access to information databases around the world. For example, from your own living room in Paris or Sydney or Munich, you could access the Smithsonian Institution in Washington DC, or have a guided virtual tour of the Natural History Museum in London. At this relatively early stage in its development, it is impossible to guess just how great its impact will be on the

21st century, just as no-one could have guessed in 1900 how great the impact of Alexander Graham Bell's telephone would be on our personal and working lives.

THE FUTURE

In the final decade of the century, scientific and technological developments are not slowing down; they are increasing with mind-boggling rapidity. The changes that will take place in the next century will be even more marked than those that took place in the last. Although it is impossible to predict exactly what the future

will bring, there are some indicators. For example, machines are being created that are a mere half a millimetre in diameter and which can be injected into the veins to clear blood clots. The Hubble telescope is sending back photographs that are rewriting our understanding of the universe (scientists now estimate that there are 50 billion galaxies in the universe, not ten billion as was previously thought) and may reawaken interest in space exploration. In the transport industry, there is talk of a revolutionary new generation of superjets, superseding Concorde and flying outside the earth's atmosphere. They will make transglobal flights possible in a fraction of the time they currently take. With the end of the Cold War, the scaling down of the Arms Race, and the unification of Europe, there is an opportunity for greater

international co-operation, and for the world to become a safer place. And with the continuing brilliance and increasing moral responsibility of scientists and designers, we enter the next century with every reason to be optimistic.

Recycled storage unit

Jane Atfield's shelving unit, made from plastic recovered from used washing-up liquid bottles, is an example of the growing trend among designers to produce furniture and other products from recycled materials.

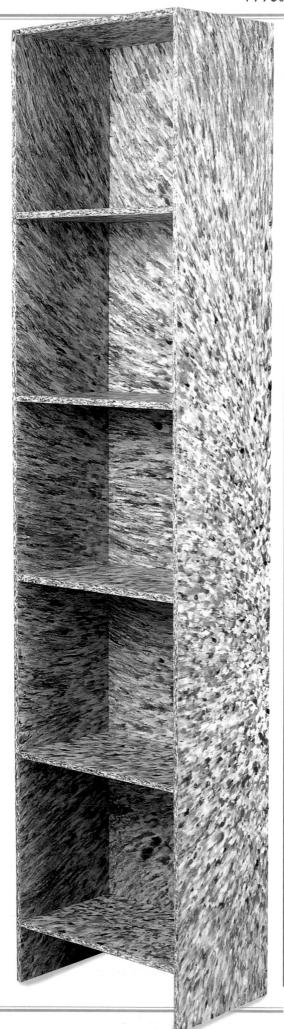

THE LIVING ROOM

Chairs

Sofas

Coffee & side tables

Vases

Bowls

Candlesticks

Lighting

Radios

Television sets

Music systems

Tape machines

CHAIRS

IT IS POSSIBLE TO TRACE all the major themes of 20th-century furniture design through the look, construction, and materials of the chair. Whether it is made from modern or traditional means, the chair has been used by designers to make statements about their personal design philosophy. Gerrit Rietveld's Red-and-blue chair from the late 1910s says more about spatial harmony than it does about sitting in comfort. Charles and Ray Eames, on the other hand, used advanced technology and applied ergonomic theory to make chairs that were better able to support the human body (see p.37). By the 1960s, furniture designers were exploring a less deterministic approach: the Sacco chair, for example, allows each sitter to shape the chair to fit his or her body (see p.38).

Thonet chair 1902-03

Michael Thonet was an extremely successful mass producer of chairs. His revolutionary manufacturing process, developed in the 19th century, used steam to bend solid wood into ready-made components, which could be assembled later. The design, which reduces the chair to a simple structure, is an early example of machine aesthetics.

Specifications

Country: Austria Material: Bentwood

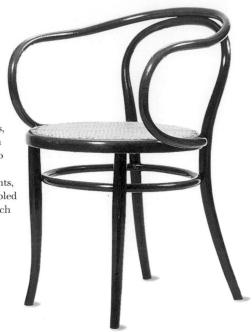

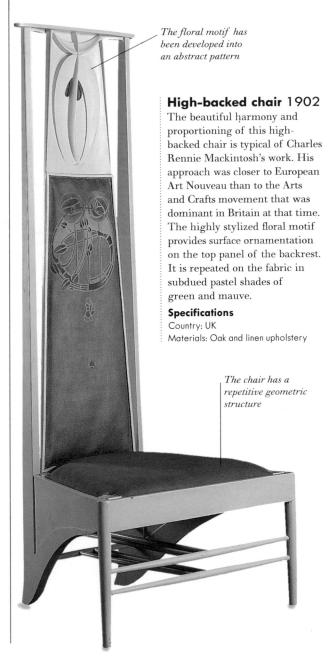

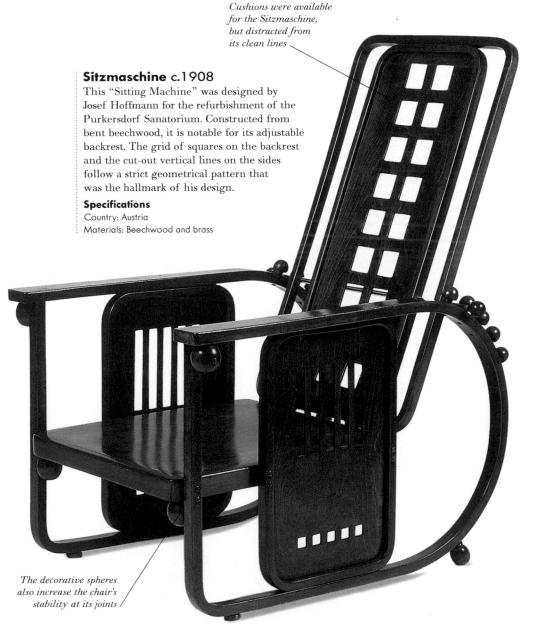

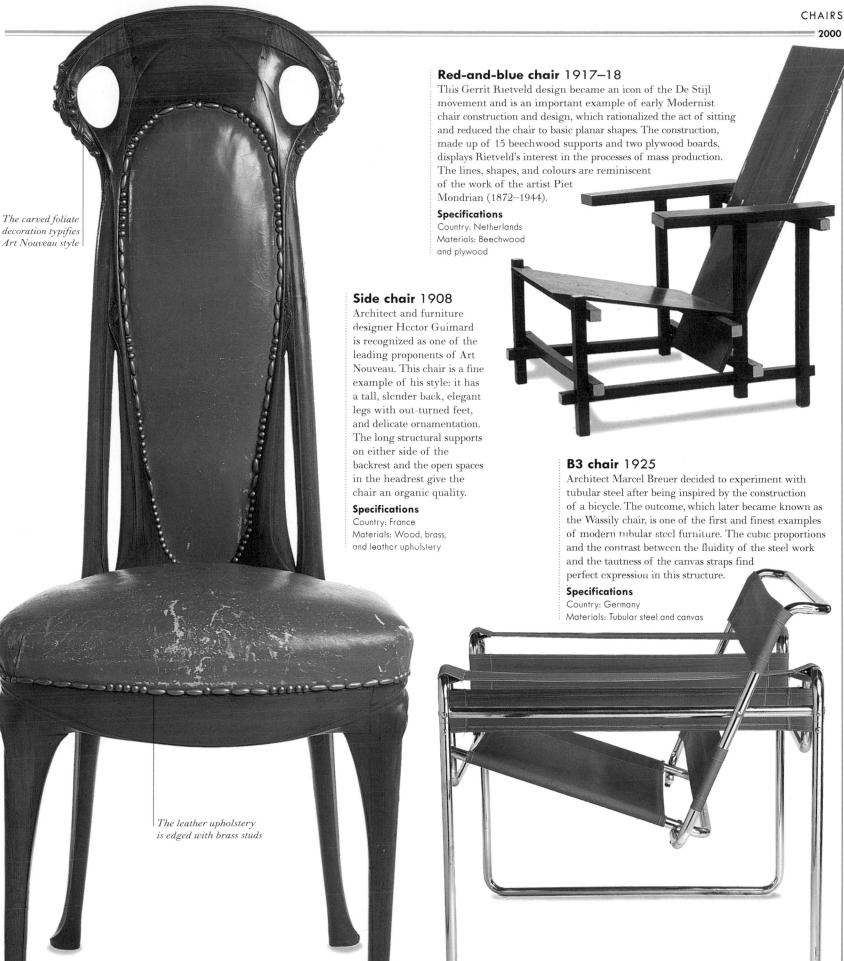

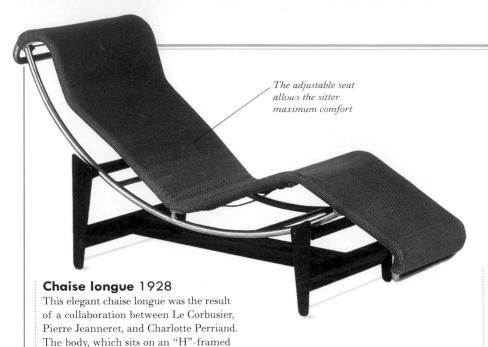

Specifications

Country: France

Materials: Tubular

steel and leather

Lloyd Loom

This poster advertises the classic Lloyd Loom furniture suite of sofa, two chairs, and foot stool, displayed against an elegant, colourful Art Deco interior backdrop. The text emphasizes one of the chief advantages of the company's woven fibre — it was versatile enough to be dyed any of a variety of colours.

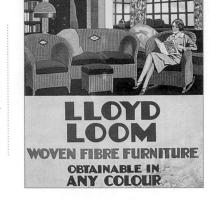

Gent's chair 1931

The cane furniture produced by Lloyd Loom was particularly popular in the 1920s and '30s. The company was founded in 1919 by an American, Marshall B. Lloyd, who invented a method of weaving a cane-like material from twisted paper and wire. This chair is part of a suite comprising Gent's and Lady's chairs and a sofa.

Specifications

The buttonedleather cushions are traditionally manufactured Country: US Materials: Woven fibre and wood

Barcelona chair 1929 Mies van der Rohe's chair was designed for the King and Queen of Spain for the opening ceremony of the 1929 International Exhibition in Barcelona. Its modern appearance retains the sense of luxury and ceremony associated with traditional thrones. The frame is made from two flat, chrome-plated steel bars, which cross over to provide back and leg supports. Specifications Country: Germany

base, is made from tubular steel. An early

example of ergonomic design, the chair

combines graceful lines with the

innovative use of industrial materials.

Paimio chair 1932

Materials: Steel and leather

This armchair was designed by Alvar Aalto for the Tuberculosis Sanatorium at Paimio, Finland. Aalto spent a number of years developing the techniques that would allow his uncompromisingly modern designs to be realized. With the Paimio, he shows that moulded plywood has all the properties suited to modern furniture design.

Specifications

Country: Finland Materials: Laminated birch and birch plywood

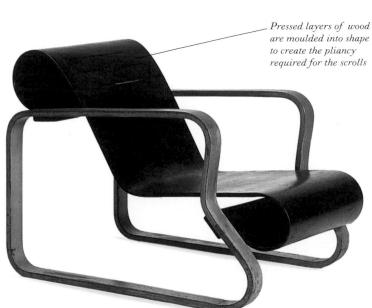

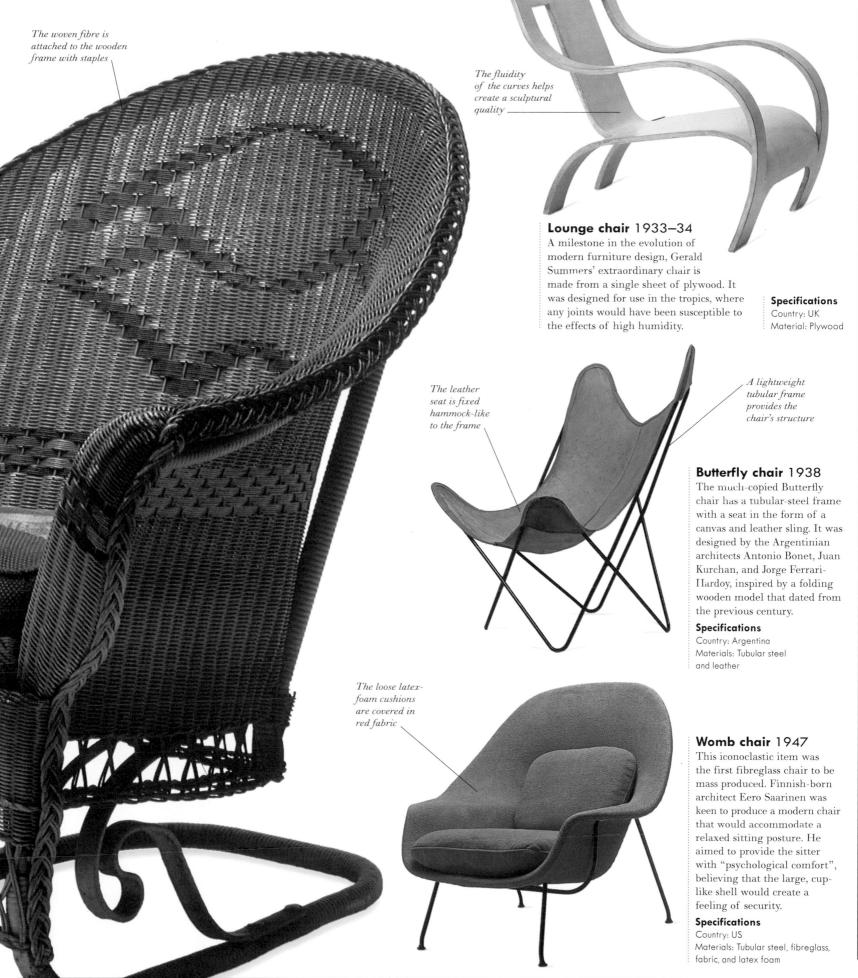

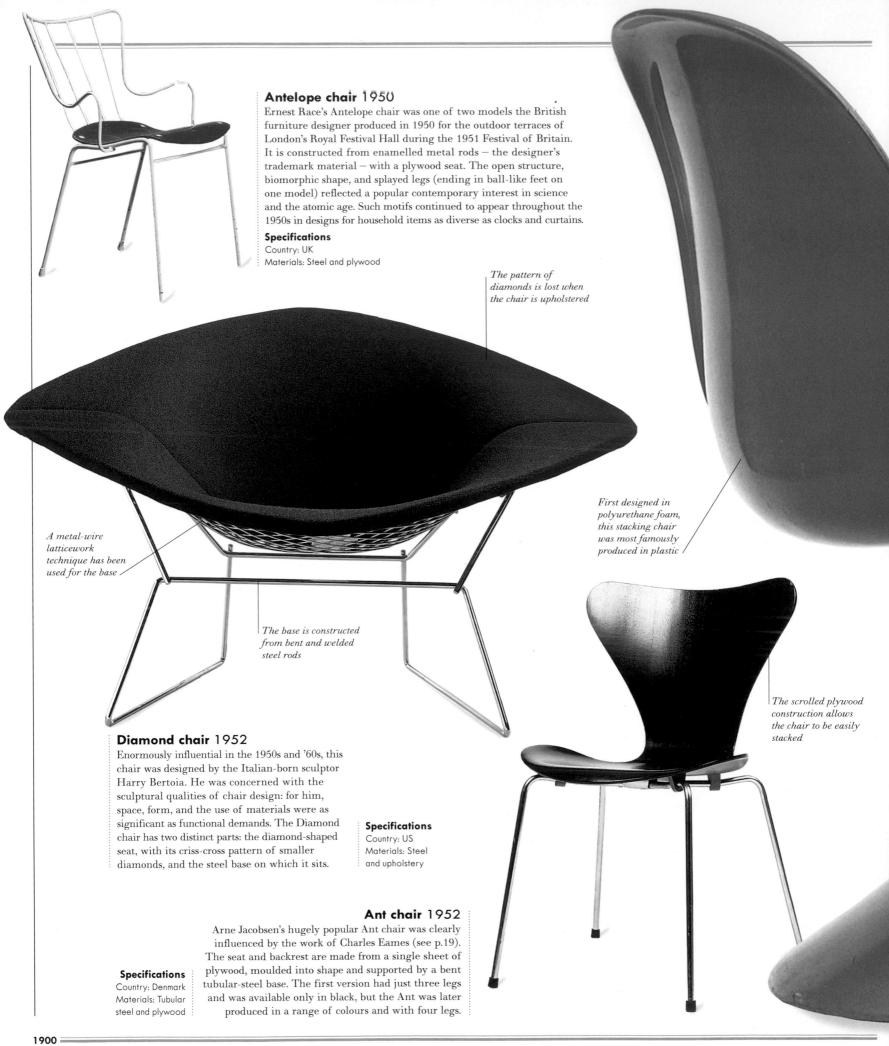

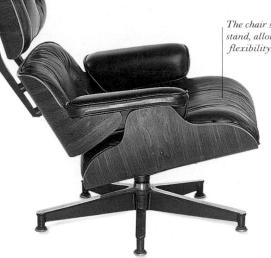

The chair swivels on its stand, allowing considerable flexibility and comfort

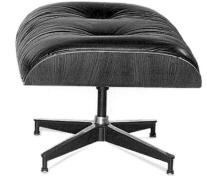

Lounge chair and ottoman 1956

This complicated piece of furniture involves three plywood shells padded with upholstery and joined by aluminium supports. Unquestionably placed at the luxury end of the market, the chair was originally designed by Charles and Ray Eames as a birthday gift for film director Billy Wilder.

Specifications

Country: US Materials: Plywood, aluminium, rubber, and leather upholstery

"READY-MADE" STOOLS

Achille and Pier Giacomo Castiglioni's Mezzadro stool is clearly influenced by the "ready-made" sculpture of Marcel Duchamp (1887–1968). The stool consists

of a brightly coloured, enamelled metal tractor seat attached by a wing-nut to a cantilevered bent steel support with a wooden footrest. The original stools, at first considered too radical to be put into production, did not have holes in the seat and had a dark metal base. This revised version did not appear until the 1970s.

The name derives from the Italian Mezzadro, meaning "tenant farmer".

Mezzadro stool 1957

Stacking chair 1960-67

The Danish designer Verner Panton is credited with having created the world's first single-piece plastic chair. This unusual cantilevered chair, produced in a range of vivid colours, has become an icon of the 1960s. The original versions were produced in 1960, but it was seven years before technical problems were resolved and the chair was put into commercial production. Strong, comfortable, and with a glossy, brightly coloured finish, the piece is a tribute to the unique properties of plastic.

Specifications

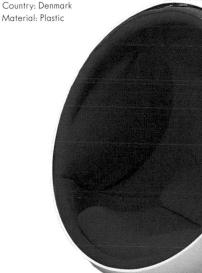

Ball chair 1963-65

Finnish designer Eero Aarnio used state-of-the-art manufacturing processes to produce his space-age Ball, or Globe, chair. It is made from a fibreglass ball, cut in section, and swivels on an aluminium base. It was often equipped with speakers or telephone.

Specifications

Country: Finland Materials: Fibreglass,

aluminium, and upholstery

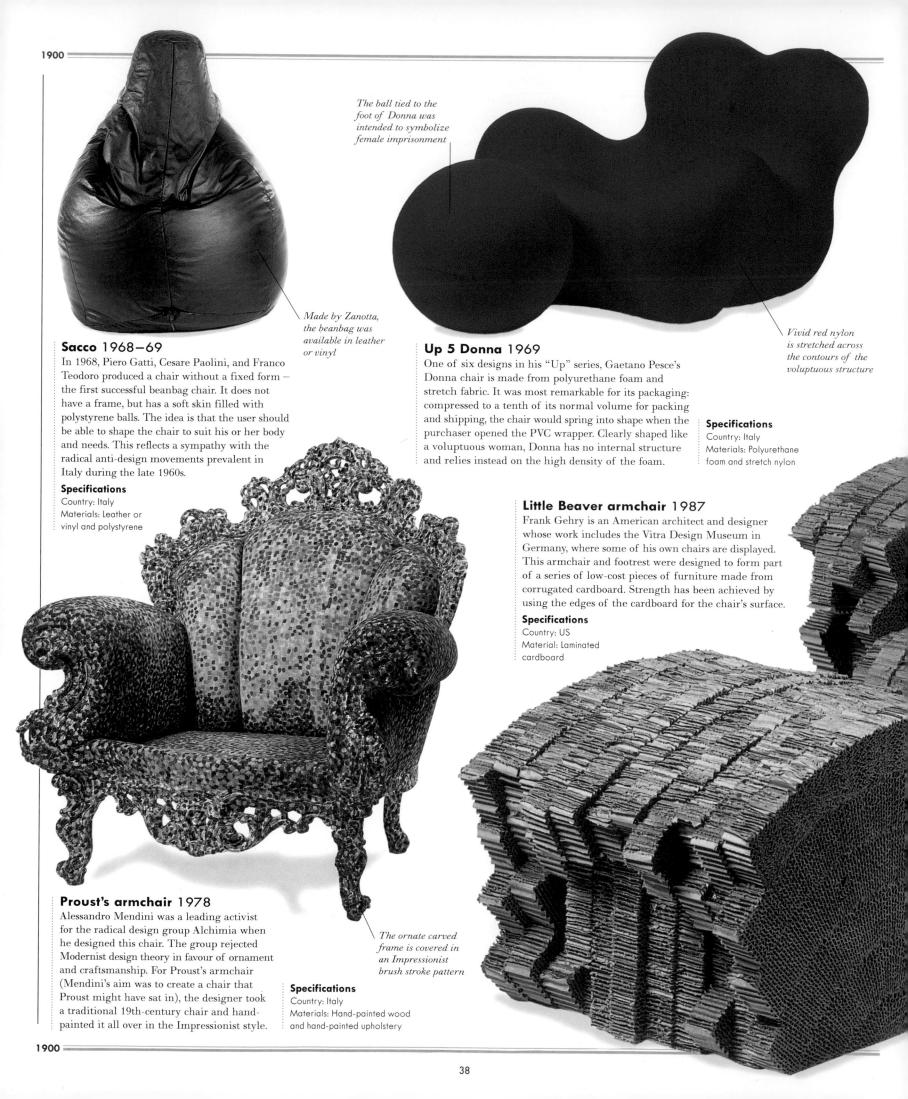

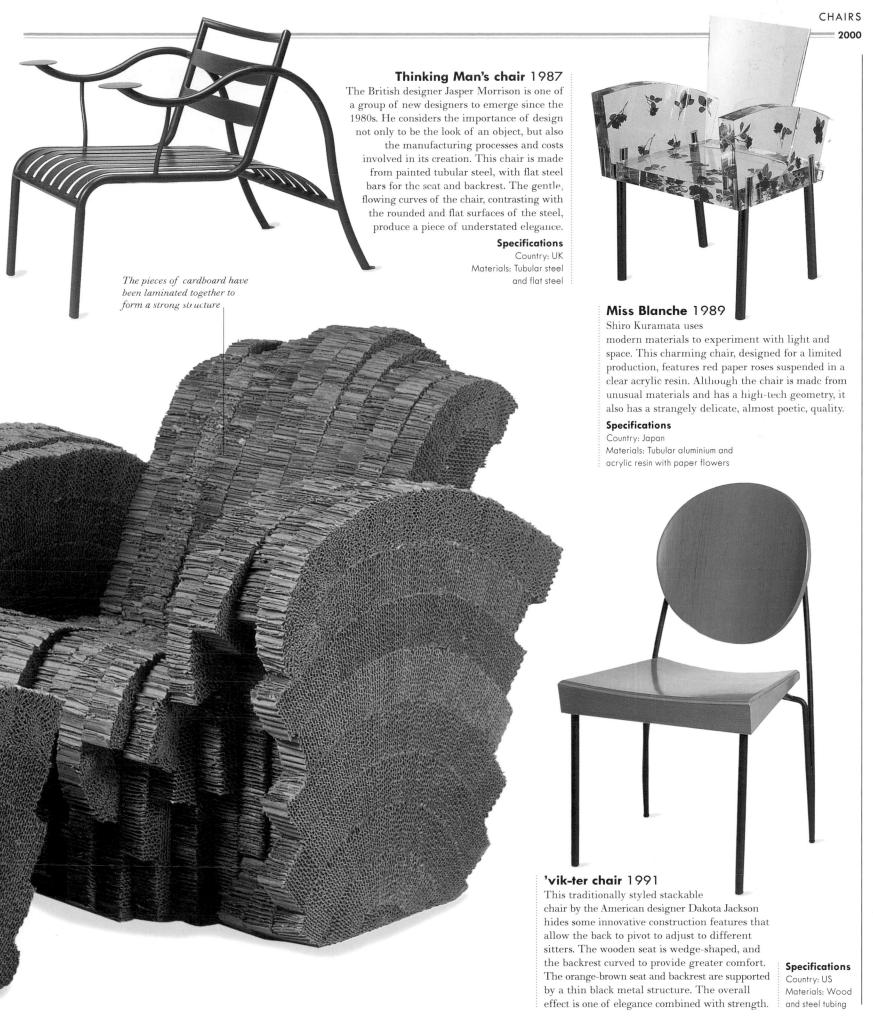

Canapé LC2 (Petit Confort) c.1928

This sumptuous leather and tubular steel settee is the two-seater version of the famed Grand Confort Petit Modèle armchair by Le Corbusier, Pierre Jeanneret, and Charlotte Perriand. A Modernist interpretation of the 19th-century overstuffed armchair, Grand Confort Petit Modèle was also available in other forms. These included a wide. single-seater "female chair", which allowed the sitter's legs to be crossed with ease. "Great Comfort" refers to the enormous leather cushions.

Specifications

Country: France Materials: Leather, foam, and chromium-plated steel

> The steel framework seems slight in contrast with the vast cushions

D70 1953

Italian architect Osvaldo Borsani founded the Tecno SpA Design company to build his sophisticated furniture designs. The D70 divan bed was one of a pair, the other being the lounge chair, P40, reputedly capable of 486 seating positions. The D70 made no such extravagant claims, but its multiholed side-plates meant that the interchangeable back and seat could each be set in several different positions. The sofa can be opened out and used as a bed or closed up for storage.

Specifications

Country: Italy Materials: Steel frame and foam cushions

The gentle curves of the upholstery prevent the divan from looking too mechanical

SOFAS

IN ANY LIVING ROOM, the sofa is the dominant piece of furniture, in which aesthetics and comfort are of equal importance. It is frequently used by designers as a vehicle for making a design statement — a conduit through which they can express their individual philosophies. Canapé LC2 (Petit Confort) by Le Corbusier, Jeanneret, and Perriand is a superb example of a sofa that successfully balances all of these concerns: it is elegant and inviting in appearance, supremely comfortable to sit on, and as uncompromisingly Modernist as its creators intended it to be.

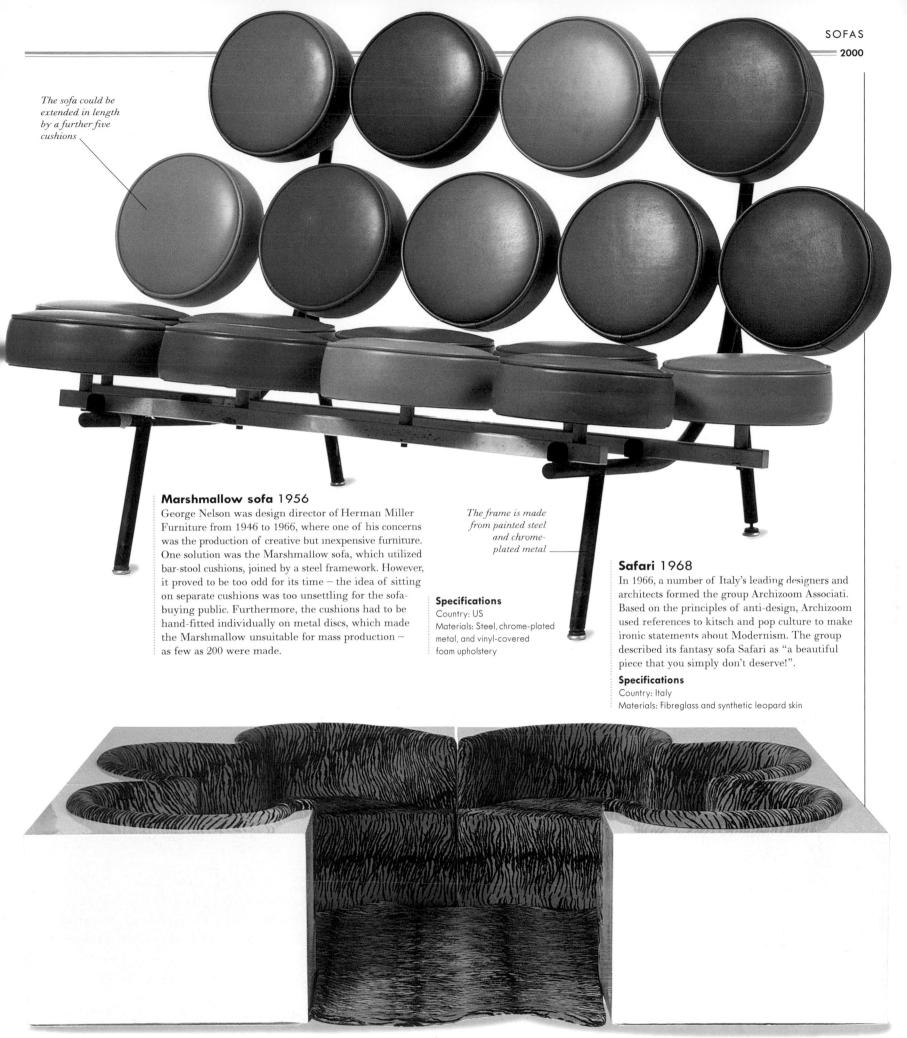

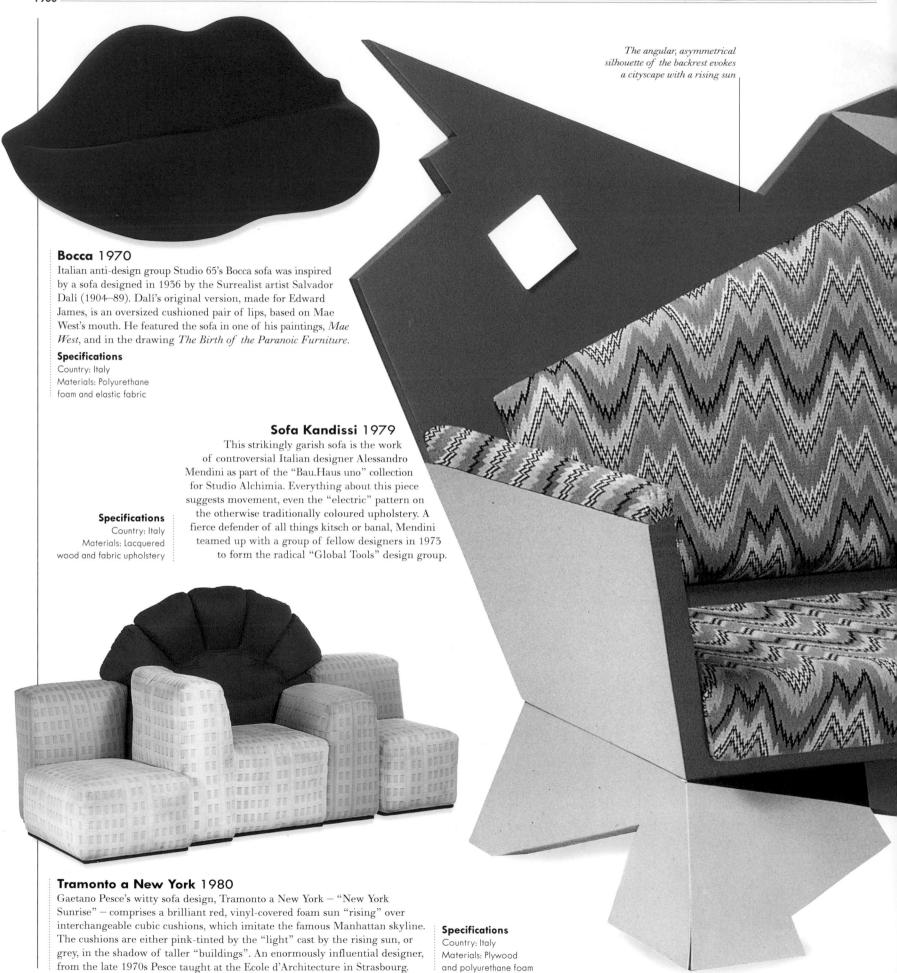

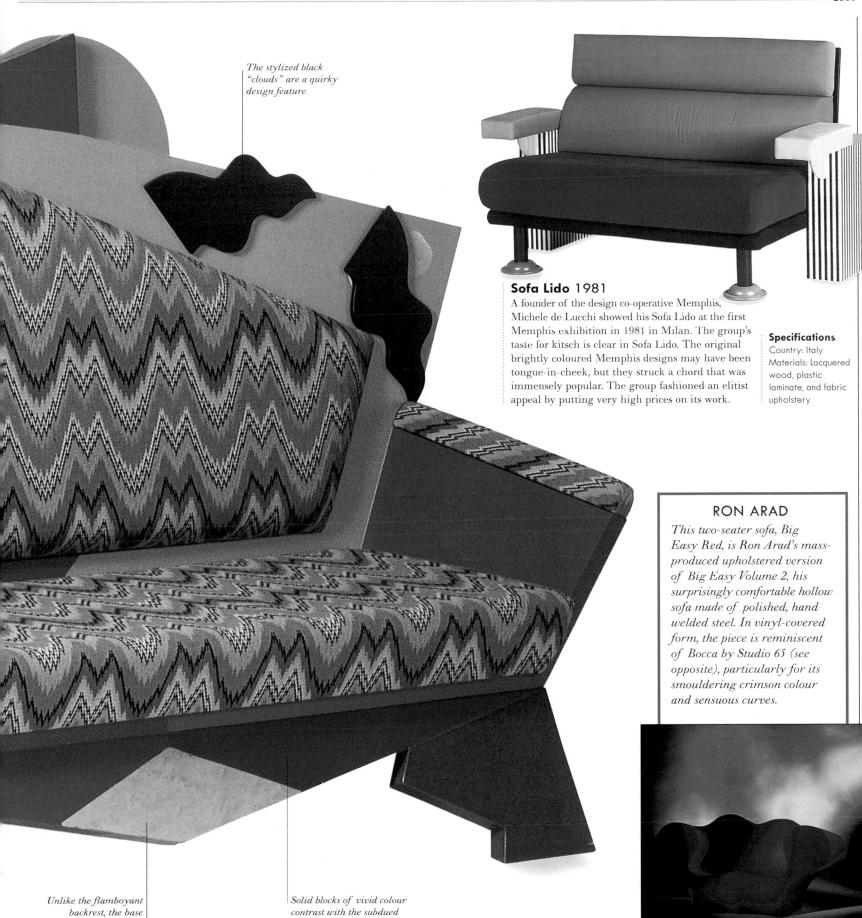

2000

Big Easy Red, 1989

shades and zany patterning

of the upholstery

of the sofa is a

symmetrical structure

COFFEE & SIDE TABLES

IN THE EARLY PART of the century, the search for pure form found expression in Jacques-Emile Ruhlmann's hand-crafted furniture, made to commission using expensive materials. Eileen Gray, also active in France at that time, was allied with the Parisian avant-garde, who were experimenting with new materials and solutions. Donald Deskey's furniture echoes the American aesthetic that was emerging in 1929 and was to peak in the streamlined 1930s. Isamu Noguchi's and Carlo Mollino's strong biomorphic designs

of the late 1940s were influenced by the work of Charles Eames. In the 1970s, there

was a renaissance of traditional forms, and it was against this backdrop that the radical, anti-establishment Memphis group came together.

Guéridon en palissandre c.1922

Jacques-Emile Ruhlmann was one of the foremost French furniture makers of this century. Specializing in luxury, highly crafted furniture, his classic pieces simplified traditional forms and lent a timelessness to modern design. Ruhlmann was famous for his use of veneers and inlays, and those skills are visible in this beautifully constructed table. Its simplicity is belied by closer inspection of the two table-top surfaces, which reveal a complicated grain effect.

Specifications

Country: France Height: 50cm (19½in) Materials: Rosewood and ivory De Lucchi's enthusiastic use of decorated plastic laminate is typical of Memphis designers

E-1027 adjustable table 1927

Designed by Eileen Gray as part of a commission for a villa in Roquebrune, France, this table demonstrates a progressive attitude to the forms and materials of the Machine Age.

Specifications

Country: France Adjustable tabletop height: 53—89cm (30—35in) Materials: Tubular steel and glass

Occasional table c.1929

Produced by Deskey-Vollmer, a partnership formed in 1927 between Donald Deskey and Phillip Vollmer, this table is a good example of Deskey's design. His interest in innovative materials and techniques is exemplified by the aluminium strapwork base, and the abstract still life of the enamelled top is evidence of his training in fine art.

The legs and neck of the table are made from blue enamelled tubular metal

Specifications

Country: US
Height: 61cm (24in)
Materials: Aluminium, enamelled
metal, and wood

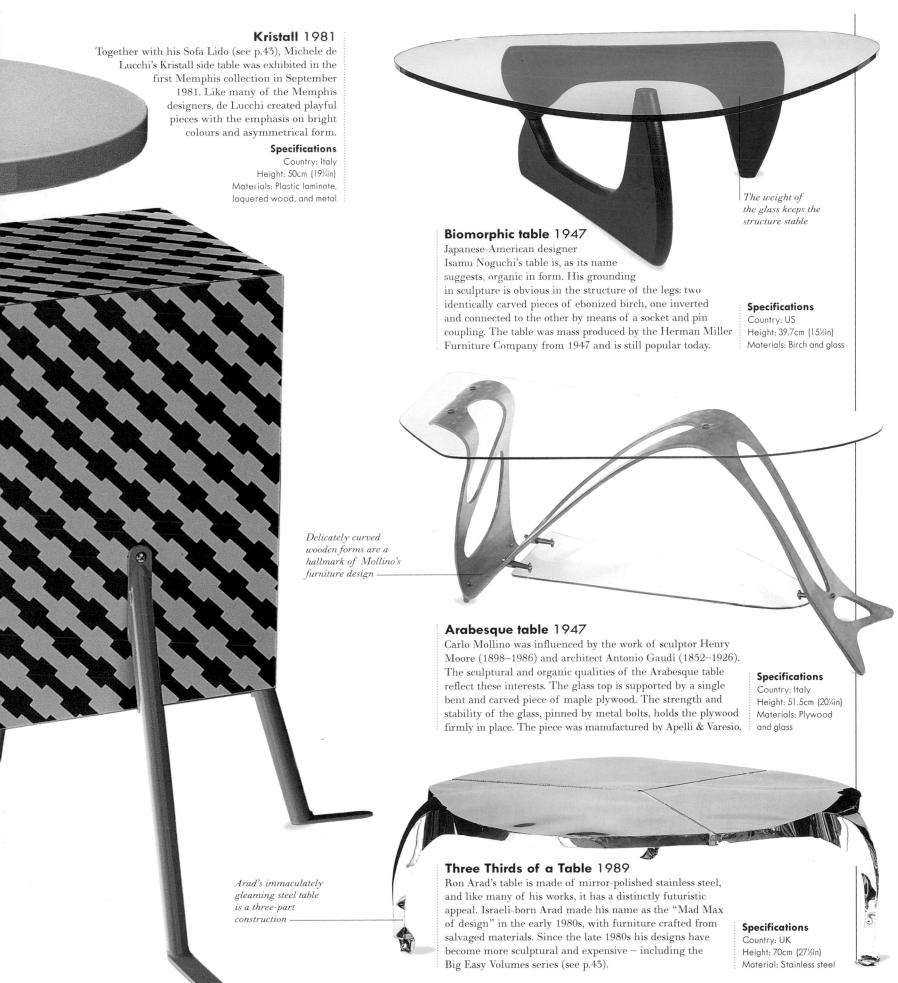

VASES

DISPLAYING FRESH FLOWERS in the home brings natural beauty to an otherwise manmade environment. Whether plainly understated or flamboyantly decorative, the vessels that hold flowers are, above all else, designed to enhance the splendour of their contents. During the 20th century, vases have provided inspiration for an extraordinary diversity of designs, from the sculptural, organic forms crafted by Art Nouveau designer Hector Guimard to the simplest, most functional pieces typified by Enzo Mari's double vase (see p.49). While a variety of materials have been used, from solid silver to lightest plastic, the outstanding tradition of the

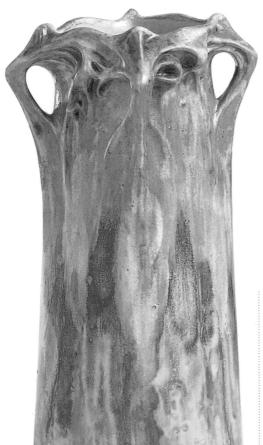

glassblower's skill is ever-present.

Peacock vase c.1900

Louis Comfort Tiffany was the outstanding producer of Art Nouveau glassware. He developed a method of manipulating colour into his blown glass vases to produce an iridescent effect.

These glassworks were known by the trademark Favrile (French for "handmade"), and were enormously popular in the US and Europe.

Specifications

Country: US Material: Favrile glass Height: 33.7cm (13½n)

Ceramic vase 1908

When the French porcelain manufacturer Sèvres undertook to modernize its output, it employed a number of progressive artists. Among them was Hector Guimard, a renowned Art Nouveau designer best-known for his entrances to the Paris Métro. This was one of a number of vases Guimard produced for the company.

Specifications

Country: France Material: Porcelain Height: 26.5cm (10½in)

Organic forms

are characteristic

of Guimard's work

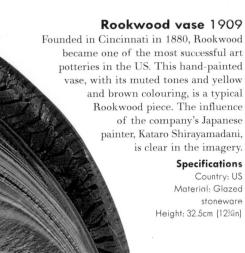

Founded in Cincinnati in 1880, Rookwood became one of the most successful art potteries in the US. This hand-painted vase, with its muted tones and yellow and brown colouring, is a typical Rookwood piece. The influence of the company's Japanese painter, Kataro Shirayamadani, is clear in the imagery.

Specifications

Country: US Material: Glazed stoneware Height: 32.5cm (123/in)

> Dark tones characterize the Rookwood style

Rose flute 1926

This extremely refined, blown glass rose flute was produced by the Austrian company Lobmeyr. Its lines are restrained and unadorned, the long, delicate bowl of the vase tapering almost to a point. The design emphasizes the transparent and fragile nature of glass.

Specifications

Country: Austria Material: Blown glass Height: 12.7cm (5in)

> Three layers of glass have been used to produce the subtly changing colours

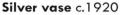

Dagobert Pêche designed this widebowled solid silver vase for the Wiener Werkstätte. It stands on a fluted base and has a naturalistic floral motif in relief on the surface. Pêche's work came to represent an alternative to the strictly geometric designs originally produced by Josef Hoffmann and Koloman Moser for the Wiener Werkstätte.

Specifications

Country: Austria Material: Silver Height: 23.9cm (9½in)

Ruba Rombic 1928

Reuben Haley's Art Deco vase, produced by the Consolidated Lamp and Glass Company, has a complex multiplane shape influenced by Cubism. It is made of green glass that has been blown-moulded into shape. The name is derived from Rubyiay (meaning "poem") and Rhomboid (meaning "irregular shape").

Specifications

Country: US Material: Moulded, cased glass Height: 38cm (15in)

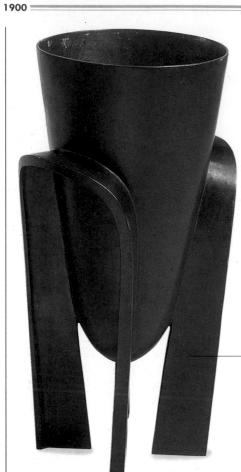

Bronze vase 1930

The work of German designer Margot Kempe, this heavy bronze vase is cone-shaped, with a rounded base. The vessel is supported by two inverted "u"-shaped legs. An important teacher of ceramics after World War II, Kempe arrived in the US via Ecuador in 1947. She taught at the renowned pottery studio Greenwich House, New York, until 1978.

Specifications

Country: Germany Material: Bronze Height: 47cm (18½in)

> The heavy, dark material and unfussy design make this an austere piece

> > The irregular contours of the glass mimic the folds in a handkerchief_

In the 1930s, the Swedish company Orrefors Glasbruk employed three artists, Simon Gate, Edvard Hald, and Vicke Lindstrand, to work on its ornamental glass production. Their output included this green vase. Made in thick glass, it has a simple, geometric shape that tapers off towards the base. On one of the four sides, there is a flowing figure of a cross-legged woman, who seems to be floating in water.

Specifications

Country: Sweden Material: Glass with acid-etched decoration Height: 16.2cm (6½in)

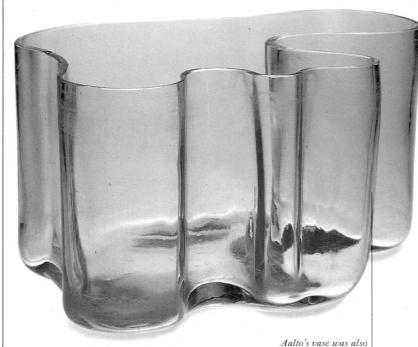

Savoy vase 1936

Designed for the Helsinki Savoy Hotel, and produced by Karhula Glassworks, this vase is by Alvar Aalto, one of the pioneers of a biomorphic style of furniture. The organic shape is inspired by natural forms, and by the work of artists such as Joan Miró (1893-1983). The glass was blow-moulded into shape, and the walls vary in thickness.

produced in brown,

green, and azure blue

Specifications

Country: Finland Material: Blown, moulded glass Height: Not known

Handkerchief vase 1946

In 1921, Paolo Venini became a partner in a Murano glassmaking company, known now as Venini & Co. Originally, it concentrated on traditional Venetian forms, but eventually, under Venini's direction, adopted more progressive styles. One of the designers, Fulvio Bianconi, worked with Venini to produce this Handkerchief vase. It is made from a square of glass, which is shaped into an irregular form in a manner that inspired its name.

Specifications

Country: Italy Material: Blown glass Height: 21cm (81/in)

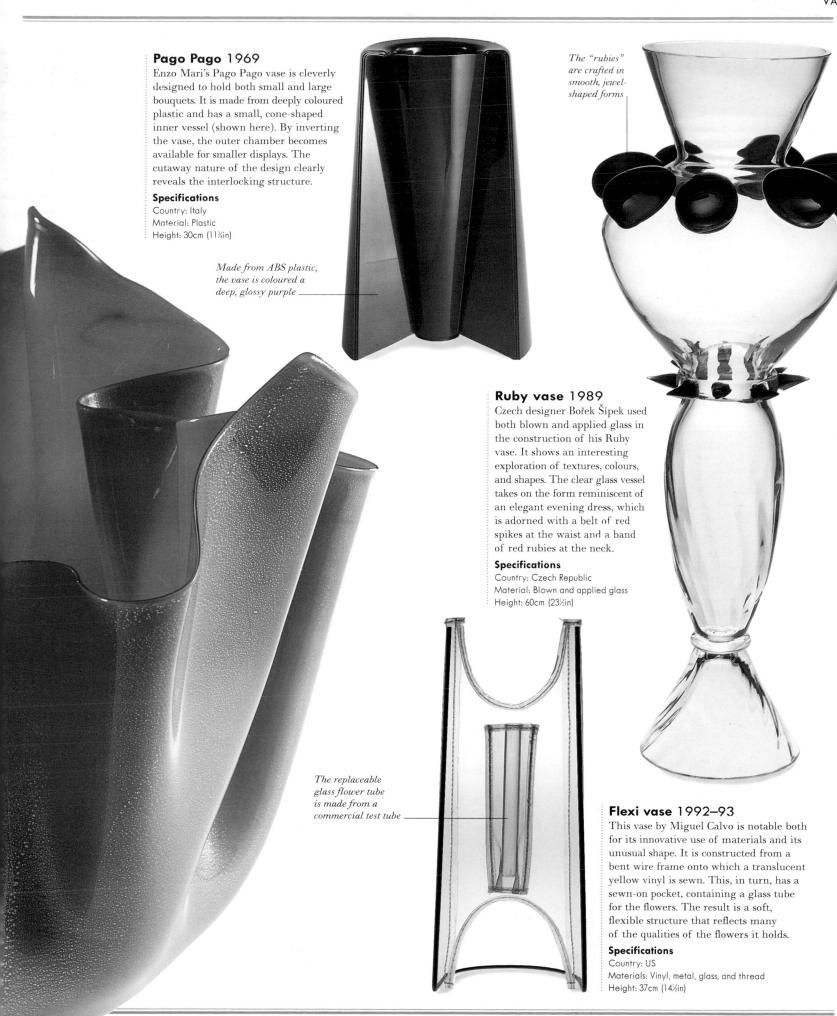

BOWLS

A WIDE RANGE OF MATERIALS and a variety of styles have contributed to the wealth of extraordinary and beautiful bowls produced over the past century. Bowls may serve a functional purpose as containers, but they are frequently intended to be purely ornamental. An expression of the designer's artistic philosophy is often discernible in the form and decoration of the product. Josef Hoffmann, for example, used hammered silver to express the hand of the craftsman, while keeping the bowl free of unnecessary ornamentation. In contrast, Lella and Massimo Vignelli used inexpensive synthetic materials to produce household goods that challenged the principles of functionalist design and celebrated the fresh ideas of an emerging pop culture.

Dragonfly c.1900

One of a limited production, this delicate centre-piece is by the Royal Copenhagen Porcelain Factory. Perched on the edges of the rim is a pair of dragonflies, whose outstretched wings form the elegant handles.

Specifications

Country: Denmark Material: Porcelain Widest point: 31cm (12in)

Oval fruit bowl 1917

The architect and craftsman Josef Hoffmann designed this fluted silver bowl for the Wiener Werkstätte. The hammered finish enhances the silver by providing a softly textured surface. The sympathetic use of materials, classical proportions, and lack of ornamentation are typical of the work produced by the Wiener Werkstätte.

Specifications

Country: Austria Material: Silver Widest point: 39cm (15½in)

Bowl and stand 1926

Edvard Hald designed this attractive glass bowl for the Orrefors Glasbruk, where he was artistic director from 1924 to 1935. It is engraved with the flat, stylized outlines of four seated women and is typical of Hald's work at this time. He had spent four years in Paris studying under Henri Matisse (1869–1954), whose paintings of nudes clearly influenced this piece.

Specifications

Country: Sweden Material: Glass Diameter: 17.8cm (7in)

Flavio Poli was awarded many prizes for his glassworks, including the Compasso d'Oro in 1954. This heavy, hand-blown glass bowl demonstrates Poli's bold use of sharply contrasting colours.

Specifications

Country: Italy Material: Glass Widest point: 19cm (7½in)

The glass is shaped to resemble a shell

Jazz 1930-31

In 1930, the American
Jazz Age was in full swing.
Viktor Schreckengost's punch
bowl is decorated with stylized
images of New York life. The
sgraffito designs were made by
scratching through a thin layer of
black clay over white ground before
applying the glaze. The interior is
decorated with musical notations.

Specifications

Country: US Material: Glazed ceramic Diameter: 42.2cm (16½in)

Earthenware bowl 1947

The painted black lines and geometric shapes on this bowl are suggestive of an industrial skyline. Detroit-born artist John Foster was probably inspired by the city's major industrial and commercial status. He produced this piece at a time when the automobile industry was recovering from its wartime concentration on the production of armaments.

Country- US Material: Stoneward Diameter: 23.2cm (9in)

Produced by Heller Designs, New York, this compartmentalized fruit bowl was created by Italian design team Lella and Massimo Vignelli. The use of plastic, which could be easily formed in bright and unconventional colours, is typical of Italian design of the 1960s.

Plastic allows a greater freedom of colour and form

Specifications

Country: Italy Material: Plastic Diameter: 41cm (16in)

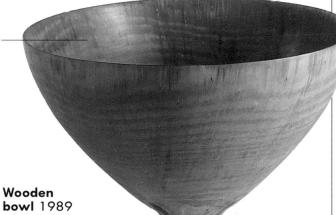

Wooden

Ronald Kent makes his exquisite bowls from Norfolk Island pine. Each bowl is a work of art, individually produced on a lathe and turned until it is extremely thin and translucent. Kent then works on the surface with sealant and fine sandpaper to enhance the natural grain and colour of the wood.

Specifications

Country: US Material: Pine wood Diameter: 37cm (14½in)

American-born designer Hilton McConnico created this bowl for the established French glassware manufacturers Daum. In an amusing reference to nature, the stem, made from green pâtede-verre, is shaped in the form of a cactus plant. The bowl itself is made from a clear thin glass, which is actually pierced by the cactus stem.

Specifications

Country: France Material: Glass Diameter: 30cm (11¾in)

CANDLESTICKS

ALTHOUGH THE FIRST COMMERCIALLY VIABLE electric light bulb, or incandescent bulb, was invented by Thomas Edison in 1879, electric lighting in the home was a luxury beyond the reach of all but the most wealthy for many decades. Instead, paraffin or gas lamps were used along with candlelight. With the eventual widespread introduction of affordable electric lighting, candlesticks were relegated to creating atmospheric lighting for the dining table or used for religious and ceremonial purposes. During the last two decades of the 20th century, candlesticks have once again become fashionable decorative objects in the home. This has encouraged designers to invent new forms and to experiment with different materials to produce objects in a variety of contemporary and classical styles.

Chamberstick 1905

The symmetrical

identical angular

Rectangular-shaped

base is typical of Art Deco styling

candle holders

branches and central

post are topped with

This brass chamberstick was made by the German designer, Paul Haustein, who was best-known for his enamel work of the 1920s. Intended for use in the bedroom, it is typical of the handicraft work influenced by the European Arts and Crafts movement.

Specifications

Country: Germany Height: 9.6cm (4in) Material: Brass

> The tiered, geometrical pattern is repeated on each component of the candelabrum

of his decorative work, it illustrates the transition between the naturalistic forms of Art Nouveau and

Candelabrum c.1902

Josef Maria Olbrich was a leading member of the

Wiener Werkstätte. This

two-armed pewter piece is typical of his use of curved

organic shapes. Like much

the more abstract geometry of Art Deco.

Specifications

Country: Austria Height: 36cm (14in) Material: Pewter

> The restrained. slender stick exhibits fluid lines

Bubble candlesticks 1930s

During the 1930s, the Chase Brass and Copper Company was the most successful American producer of chrome and nickel domestic utensils and accessories. These Art Deco candlesticks consist of a polished sphere sitting on a deep blue square of glass mounted on a chromium base.

Specifications

Country: US Height: 7cm (2%in) Materials: Chrome-plated metal and glass

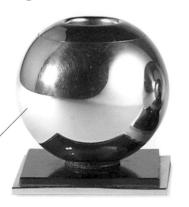

Candelabrum 1928

This candelabrum was produced by silver manufacturers Reed and Barton, which had started to produce pewterware in 1903. One of a pair, the candelabrum's lines are uncompromisingly geometrical and the overall design is functional and devoid of excessive ornamentation.

Specifications

Country: US Height: 21cm (8in) Material: Pewter

> The polished surface is highly reflective

1900

Thi th with for are

Candlestick 1959

This amusing candlestick was designed for Boda by Erik Höglund. It is made in thick, clear blown glass with a heavy base. Applied to either side of the body are two short arms with four-fingered hands, which are raised in jubilant fashion.

Specifications

Country: Sweden Height: 12cm (4¾in) Material: Glass

> The polished finish has a pinkish tinge

Crane 1988

Matthew Hilton's sensuously curved candlestick is made from polished cast aluminium, although it was also available in bronze. It stands on a flared base, from which it develops into an elongated "S"-shape. The zoomorphic form, in this case derived from the neck of a crane, is carefully controlled and balanced.

Specifications

Country: UK Height: 42cm (16½in) Material: Cast aluminium

Light passing throught the translucent finish illuminates the internal structure

Cat's eye 1991

This award-winning candle-holder, also available in blue, was designed by Laura Handler for Design Ideas. It is made up of ten separate units, each made from frosted glass. The overall size and appearance of the finished item is dependent upon the number of units used and how they are interconnected. Here, the units have been formed into a slightly curved triangular shape.

Specifications

Country: US Height: 4.8cm (2in) each unit Material: Cast glass The elegant shape is inspired by the graceful arch of the bird's neck

CANDLESTICKS IN THE 1990s

has seen a revival of interest in candlesticks, and shops selling a dazzling array of candles and receptacles in which to put them. These include original and traditional candlesticks, sconces, lanterns, floorstanding candelabra, garden lamps and pots, chandeliers, and bowls for floating candles. Some of the most popular designs are reinterpretations of Gothic wrought iron and pewter pieces, while ethnic influences can be seen in many of the wooden, ceramic, and papiermâché candlesticks. From the austere to the whimsical, each style attests to the enduring charm of the flickering flame.

The final decade of the century

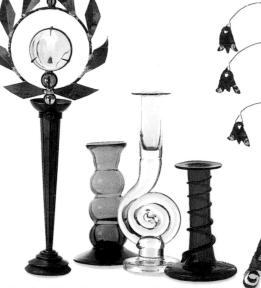

Candlestick with Napoleonic wreath

Selection of glass candlesticks

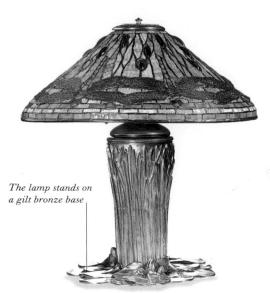

Dragonfly c.1900-10

Typical of the Art Nouveau work produced by the Tiffany Studios, Clara Driscoll's design employs a theme from nature. A series of dragonflies is positioned around the edge of the shade, and the stem is also inspired by an organic form – waterlilies.

Specifications

Country: US Materials: Glass, gilt bronze, and lead Height: 67.5cm (26½in)

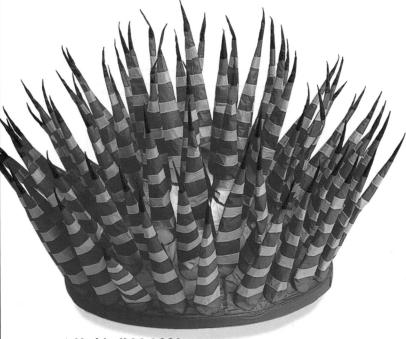

Urchin IL36 1991

GoldmanArts describes its products as "hysterical architecture". This is one of several inflatable lamps designed by Jonathan Goldman. The gently swaying, colourful, and playful nylon structures are intended to resemble a sea urchin as it moves in the ocean's current. The lamp's soft shades have no structural support — a small fan both inflates the shade and cools the bulb.

Specifications

Country: US Materials: Rip-stop nylon fabric and metal Diameter: 64cm (25in)

P H Artichoke 1958

Poul Henningsen's lamp is designed to prevent glare whilst maximizing reflected light. Overlapping "leaves" achieve this by spreading the light over a large area. Manufactured by Louis Poulsen & Co., it was originally designed to hang in public spaces.

Specifications

Country: Denmark
Materials: Copper, steel,
and enamelled metal
Height: 69cm (27in)

LIGHTING

EARLY SHADES WERE DESIGNED simply to hide the mechanics of the light bulb. However, Louis Comfort Tiffany's stained-glass lampshades cast a soft, colourful light in the room and were beautiful objects in their own right. The move towards a machine aesthetic, through Art Deco and later Modernism, produced lighting designed with geometric forms. The functional design of George Carwardine's 1933 Anglepoise lamp allowed the user to aim the light directly onto the work area. New materials such as plastic became popular for lighting in the 1950s, and, since then, the use of low-voltage technology has allowed greater flexibility.

Winner of the Premio Compasso d'Oro prize at the 1967 Milan Triennale, Vico Magistretti's table lamp, manufactured by Artemide, has an adjustable light. Its name, Italian for "eclipse", refers to the way the light is eclipsed as it revolves.

Specifications

Country: Italy Material: Enamelled metal Height: 19cm (7½in)

The free-standing lamp may be wall-mounted by hinges on its base

Anglepoise 1933

George Carwardine, the designer of the century's most successful desk lamp, was an automobile engineer by profession. Utilizing his engineering skills, his design uses hinges that mimic the joints in a human arm. The Anglepoise is flexible, balanced, and able to hold any position. As this example dates from about 1960, its design differs slightly to the original model.

Specifications

Country: UK Materials: Steel, enamel, and plastic Height: 90cm (35½in) extended

Copper "leaves"

wash the room

in a warm light

Tizio 1972

Low-voltage lamps started to become popular in the 1970s. Richard Sapper's high-tech table lamp is a classic example. A transformer housed in the base greatly reduces the voltage, which is then conducted through the metal arms to power the lamp, eliminating the need for internal wiring. The result is a slender, elegant structure: finely balanced and, with its heavy transformer, perfectly stable.

Specifications

Country: Italy Materials: ABS plastic and aluminium Height: 118cm (46½in) extended

Carwardine's hinged system has been widely copied, particularly for office use

The adjustable and movable arm allows the lamp

to fold flat

Ferdinand Porsche is from a family of renowned designers, best-known for its contribution to the automobile industry. Made by PAF, his low-voltage halogen table lamp has sensors that electronically regulate the light. The switch is luminous.

Specifications

Country: Italy Material: Plastic Height: 63.5cm (25in) extended

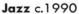

RADIOS

THE EARLIEST RADIOS, known as crystal sets, had their workings left totally exposed, and the listener was required to wear headphones. It was not until the late 1920s that radios were designed to incorporate all the components within a single housing. Initially, these resembled items of furniture, but with the introduction of plastics, they began to acquire a visual language of their own. In 1955, Sony launched its first transistor radio and with it began the journey towards

miniaturization. Today, it is possible to make radios only a few millimetres wide.

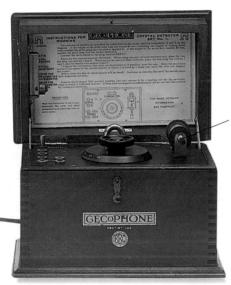

Winding the handle brings a tiny wire into contact with a crystal, enabling it to receive radio waves

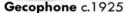

Using a horn to amplify sound was a huge advance on the early crystal sets, for which headphones were necessary. Apart from the horn, the parts were housed in a plain wooden box, which was better suited to the domestic environment.

Specifications

Country: UK
Height: 16cm (6¼in)
Materials: Wood and metal

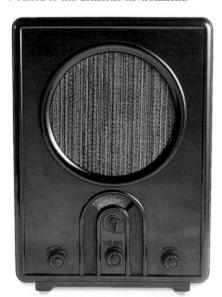

Volksempfänger VE 301 1928-33

As with the VW Beetle (see p.182), the design for this radio was endorsed by Adolf Hitler. The model number refers to the date Hitler became Chancellor – 30 January, 1933. The Volksempfänger, meaning "people's radio" bears a symbol of the Third Reich under the dial. For propaganda reasons it was not possible to receive transmissions from abroad on this set.

Specifications

Country: Germany Height: 39cm (15½in) Materials: Bakelite and fabric

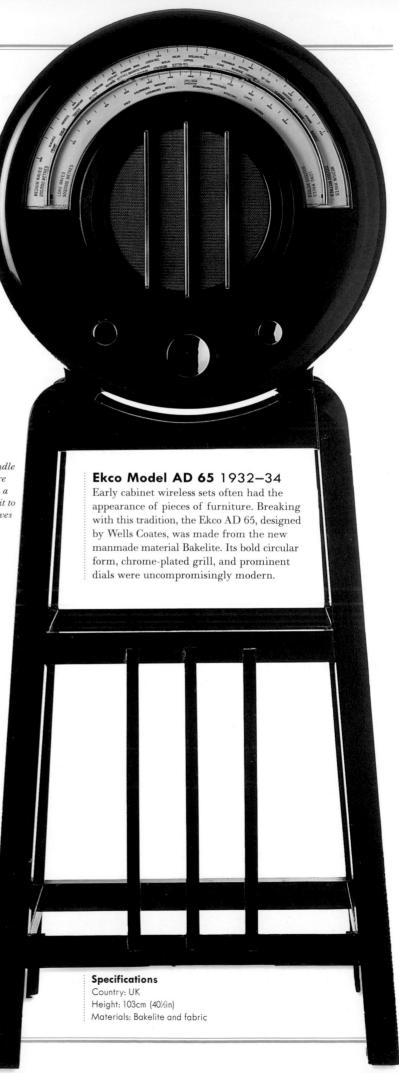

Pye radio early-1930s

The loudspeaker grille gave designers the opportunity to develop a visual identity for their company. Pye used a stylized sunburst, which was a popular Art Deco motif. The trademark also served as decoration, which increased the radio's aesthetic appeal.

Specifications

Country: UK Height: 41cm (16in), Materials: Wood and Bakelite

Ekco Type U122 1950s

Plastics radically changed the appearance of radios, which became available in a range of colours and shapes. This process was aided by the miniaturization of the receiver through advances in valve technology.

Specifications

Country: UK Height: 22cm (8½in) Material: Bakelite

Braun SK 25 1955

In 1954, Fritz Eichler was hired by Artur Braun to modify the company's product range by adopting a more functionalist approach. The basic plastic shell and simple controls of the SK 25 typify the rationality that has come to be associated with Braun products.

Specifications

Country: Germany Height: 15.5cm (6in) Materials: Plastic and metal

Brionvega Ls 502 1964

In the 1960s, Richard Sapper and Marco Zanuso were commissioned by Brionvega to design a series of radios and televisions. The Ls 502 folding radio, an early example of the application of transistor technology, was a battery-powered portable designed to go anywhere. For easy transportation, the radio folded up to make a small box.

Specifications

Country: Italy Height: 12.5cm (5in) Materials: Plastic and metal

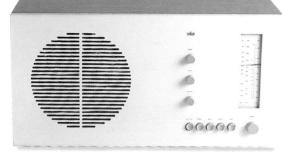

Super RT 20 1961

The range of stereophonic equipment that Dieter Rams designed for Braun in the 1950s and '60s was all executed in the same austere, functionalist style. The Super RT 20 had many of the same characteristics as his earlier Phonosuper record player (see p.61).

Specifications

Country: Germany Height: 25.5cm (10in) Materials: Plastic, metal, and wood

Hitachi KH-434E 1970s

This portable radio is typical of the wide range of electronic consumables produced in Japan. With its competitive prices, Japan now dominates the radio market. This model can be powered either by battery or electricity.

Specifications

Country: Japan Height: 11cm (4½in) Material: Plastic

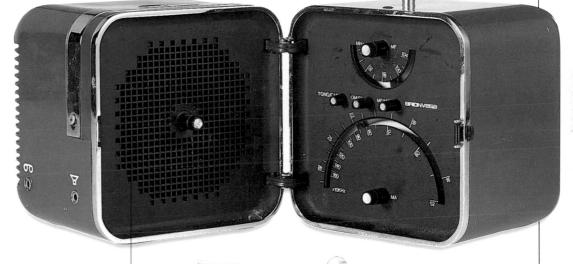

One side of the radio housed the speaker, the other the receiver

Radio in the Bag, 1981

RADICAL RADIO

Daniel Weil's Bag Radio, part of his degree show at the Royal College of Art, London, challenges traditional notions of how a radio should look. Instead of hiding the components within a solid shell, Weil has chosen to display them in a transparent PVC bag. The exposed workings, combined with the splashes of colour, provide a quirky decorative quality.

Televisor 1926

The world's first demonstration of television, or "visual wireless", was given by Scottish inventor John Logie Baird (1888-1946) in 1926. However, his mechanical Televisor, with its small screen positioned on the right, could not broadcast sound and pictures together.

Country: UK Materials: Metal and Bakelite Height: 56cm (22in)

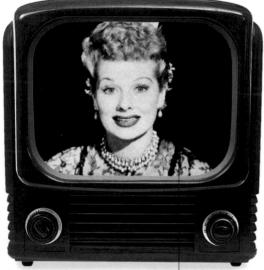

Bush TV12 1949

In the 1930s, mechanical television models that used cathode ray tubes to project electrons onto the screen. Bush, were widely available.

The hit show I Love Lucy appeared on television screens from 1951

Specifications

IN A BROCHURE aimed at its retailers, manufacturer E.K. Cole Ltd. predicted that 1939 would go down in history as "Television Year". In fact, it was the radio that dominated homes, as people

avidly followed the year's historic international events. Since then,

however, the television set has made a greater impact on our

domestic lives than almost any other 20th-century invention. In

early form, its sheer size made it the dominant item in any room,

but the miniaturization of electronic components in the 1950s

facilitated its transformation from large, bulky wooden box to

the slim, slickly styled consumer desirable we know today.

TELEVISION SETS

Country: UK Material: Bakelite housing Height: 42cm (16½in)

Mullard 1950s

By the 1950s, the television set was part of the furniture - in some cases, literally so. With its two wooden doors, this Mullard set had the appearance of a cabinet, to be opened when its services were required and disguised when not. Its impressive size indicates the dominant presence that television had established in the home as the century entered its second half.

Specifications

Country: UK Material: Wood Height: 89.3cm (351/4in)

sets were replaced by electronic Early sets cost as much as a car, but, by 1949, less expensive models, such as this Bakelite television by

The large, chunky controls typify the

uncomplicated

styling of the set

Sony TV8-301 1959

Original in its design, as well as technically innovative, the TV8-301 was the world's first all-transistor television and established Sony as the world leader in electronics. Sony was able to utilize the miniaturized parts it had developed for its pocket transistor radios to develop this remarkable-looking portable set.

Specifications

Country: Japan Material: Metal Dimensions: Not known

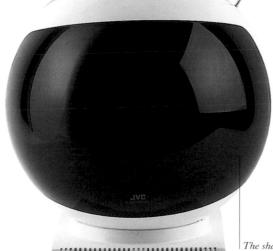

The shape and colouring are reminiscent of an astronaut's helmet

The screen can be both protected and disguised behind cabinet doors

JVC Videosphere 1970

In an effort to distance plastic from its disposable associations, designers used it for expensive consumer items like television sets. A radical rethink of the traditional television shape, the Videosphere looks like a spaceman's helmet, reflecting public interest in space travel. In 1969, 600 million people had tuned in to watch man walk on the Moon.

Specifications

Country: Japan Material: Plastic Height: 28cm (11in)

Sony KV-28 WS 1(S) 1995 Millions of dollars are now spent by electronics companies in an effort to produce the highest-quality television set with the most desirable

to produce the highest-quality television set with the most desirable appearance and price. There has been a vast range of technological innovations in the 1980s and '90s, including the development of flat-screen and wide-screen televisions, exemplified by this sleek, angular Sony wide-screen model.

Specifications

Country: Japan Material: Plastic Height: 55.2cm (21¾in)

VIDEO CASSETTE RECORDERS

Philips N-1500, 1971

Although a monochrome video recorder was developed in 1956 and a colour recorder in 1959, the Philips N-1500, with its mechanical clock, was the first commercially successful video recorder.

Ferguson Videostar, 1980

After the 1970s' "video war" between Sony and Matsushita (the latter's VHS tapes won the day), video recorders, like the Videostar, became technically more sophisticated. However, they remained bulky appliances.

Panasonic NV-HD650, 1990

Highly styled, slimline video machines like this Panasonic Ni-cam have dominated the 1990s. Features include remote control, multi-programme operations, long play facilities, and bar-code programming.

CAMCORDERS

Sony camcorder, 1980

Before the development of the camcorder – a video camera and recorder combined in a portable unit – the recording of moving images involved a 16mm camera or, later, the smaller, more versatile 8mm camera. Although early camcorders were large and unwieldy, they did enable the user to play back recordings immediately through the viewfinder and to edit recordings simply and instantly.

MUSIC SYSTEMS

MECHANICAL, WIND-UP DISC PLAYERS were introduced in 1886 by Emile Berliner, who coined the term "gramophone". Their sound quality was better than the cylinder versions they replaced and the discs could be mass produced. The huge amplifying horns meant that these first machines were uncased, but designers soon reduced the size of the motor and developed the internal horn, so the whole unit could be housed in a single cabinet. In 1956, Braun transformed the look of the radio-record player with the Phonosuper SK4; with its clear plastic lid and detached speakers, it became the industry standard. Bang & Olufsen's 1972 Beogram 4000 was one of the most sophisticated turntables ever produced, only to be superseded in the 1980s by the compact disc player. Today, digital technology threatens the vinyl disc with obsolescence.

Pathé gramophone c.1908

This gramophone was designed as a piece of furniture — something that would be given pride of place in the home. A clockwork motor is housed beneath the turntable in a wooden box, which has a carved decorative edging. The influence of Art Nouveau can be seen both in the carving and the attractive, flower-shaped horn. This style of horn was known as "Morning Glory" after the flower.

Specifications

Country: France Height: 67cm (26½in)

Selecta portable 1920s

Portable gramophones changed little in style from the 1920s to 1950s. This example, housed in its own carrying case, is wound by a spring and has an internal horn. Records can be stored in a pocket under the lid.

Specifications

Country: UK Height: Not known

Bermuda Dansette 1950s By the 1950s, popular music had become a major industry

had become a major industry. With the advent of rock 'n' roll, teenage culture was taking off and new commercial opportunities were beginning to emerge. The Dansette, with its colourful, modern styling, was aimed at this youthful market.

Specifications

Country: UK Height: 60cm (23½in)

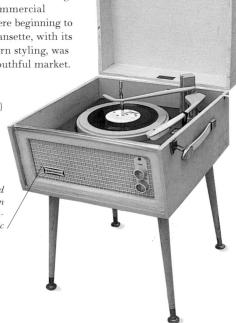

CD TECHNOLOGY

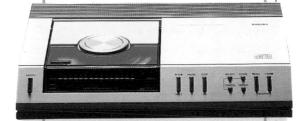

Philips compact disc player, 1983

In a joint venture in 1979, Philips and Sony developed the compact disc. Sound is recorded onto an aluminium plate in the shape of millions of tiny micro-cells, known as "pits". It is then reproduced by a laser beam scanning across the surface of the disc as it spins, and sending a signal back to the player for decoding. The first compact disc player was launched in Japan in October 1982, and in Europe in March 1983. This Philips CD 200 was one of the earliest models available, designed to be compatible with more traditional hi-fi systems.

The horn amplifies sound picked up by the stylus

Graphophone c.1900

The cylinder phonograph was developed by Thomas Edison in 1878. Initially it was sold for dictation, but companies soon turned to the more profitable line of music. The Graphophone worked by picking up vibrations from a cylinder through a stylus, which was connected to an amplifying horn. With this system it was possible to make home recordings, but the sound quality was poor.

Specifications

Country: US/UK Length of stand: 29cm (11½in)

> The use of slick, metallic silver-grey represents a departure from the black styling of the 1980s

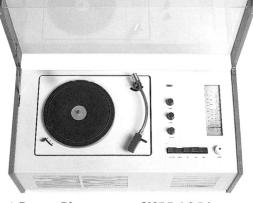

Braun Phonosuper SK55 1956

Also known as "Snow White's Coffin", the SK55 was exhibited at the XI Triennale in Milan in 1957, when Braun was awarded the grand prize. Designed by Dieter Rams and Hans Gugelot, it is a fabulous piece of minimalist design. The clear Plexiglass lid was an innovative concept that radically influenced the hi-fi industry.

Specifications

Country: Germany Height: 24cm (9½in)

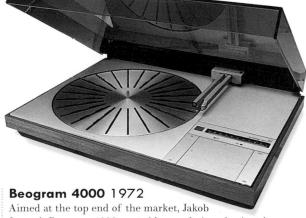

Jensen's Beogram 4000 turntable was designed using the most sophisticated electronics and precision engineering. It was the first record player to have an electronically operated tangential arm, which gives superior sound quality. Widely acclaimed as a state-of-the-art product, it is featured in prominent museum collections.

Specifications

Country: Denmark Height: 10cm (4in)

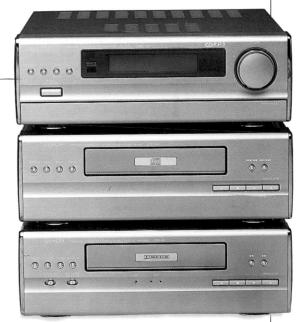

Denon Stacking System D-90 1995

The compact disc has become so popular that in the 1990s most music systems do not include a record player. Integrated stacking systems, like this D90 by the British company Denon are the most common. This system includes receiver, compact disc player, and cassette tape deck, each styled in the smart silver grey that characterizes Denon products.

Specifications

Country: UK Height: 30cm (11¾in)

TAPE MACHINES

Valdemar Poulsen's Telegraphone, the first magnetic sound recorder. However, it was not until the 1930s and the invention of plastic magnetic tape that tapeplaying machinery became a practical proposition. The appearance of the machine itself has changed and adapted as technology has advanced. Early reel-to-reel tape machines looked plain, utilitarian, and prohibitively bulky; however, since the launch of Philips' Compact Cassette in 1963, machines have became more portable, more streamlined, and more inventive in design.

Reel-to-reel tape machine 1950

Traditional reel-to-reel, or open-reel, tape machines like this 1950 model had their origins in a system called the Magnetophon, produced by AEG Telefunken in 1935. The design determined the shape of tape recorders into the 1960s and '70s, with the basic flat, top-loading system challenged only by the introduction of the front-loading rack systems.

Specifications

Country: Not known Material: Not known Width: 36.2cm (14/in)

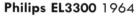

In 1963, Philips introduced the world's first compact tape cassette. This blank cassette measured just 10cm (4in) and could play back both stereo and mono recordings. It was launched with the first cassette recorder, which was also the first truly portable battery-operated recorder.

Specifications

Country: Netherlands Material: Polystyrene housing Width: 11.5cm (4½in)

Yamaha TC800D 1975

In the mid-1970s, Yamaha commissioned Mario Bellini to design a new cassette recorder. The result was this innovative wedge-shaped "Natural Sound Stereo Cassette Deck". The recorder has a pitch control that can vary the tape speed, and a Dolby noise reduction system.

Specifications

Country: Japan Material: ABS plastic housing Width: 30.5cm (12in)

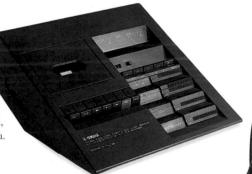

PERSONAL STEREOS

The world's first personal stereo, the Walkman, was launched by Sony in 1979, pioneering a major new product in the audio industry. The Walkman uses advanced micro-electronics to produce high quality, unwavering sound from the smallest possible unit. This original model has an anodized-aluminium housing. Personal stereos have become even more portable, incorporating lightweight plastic housing and smaller headphones.

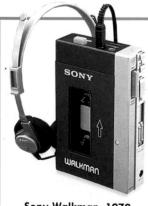

Sony Walkman, 1979

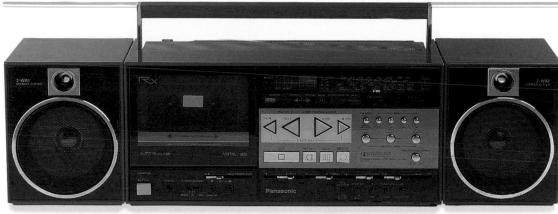

Panasonic ghetto blaster 1980s

"Ghetto blaster" is a generic term derived from the young urban population that was attracted to a particular type of large, portable music system. Produced in hard-edged black or, like this Panasonic model, brightly coloured, these rectangular boxes often have detachable speakers. Even though they are battery-operated, they produce a powerful sound.

Specifications

Country: Japan Material: Plastic housing

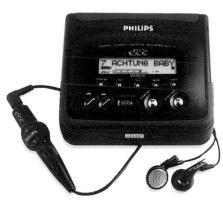

Philips DCC170 1995

In 1992, Philips introduced the Digital Compact Cassette system, an innovation in digital sound recording. The technological sophistication is reflected in the hardworking design of the housing, with its numerous function buttons.

Specifications

Country: Netherlands Material: Plastic housing Width: 11cm (41/4in)

Matsui STR323 1996

The 1990s have witnessed the return of softer styling in tape machinery, with rounded forms and pastel colours recalling 1930s streamlining and the car designs of Harley Earl. As the Matsui STR323 shows, the hi-tech features that were given pride of place on models like the Yamaha TC800D have been hidden in favour of retro styling.

Specifications

Country: Japan Material: Plastic housing Width: 42.5cm (16¾in)

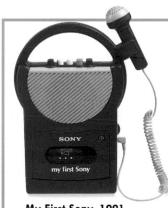

My First Sony, 1991

CHILDREN'S TAPE MACHINES

Low-cost electronics made it possible for companies to develop and manufacture inexpensive tape machines specifically for children. My First Sony is a typical example of the kind of tape machines that attract young users. It is chunky, vividly coloured, and has inviting hands-on features - children can use the microphone to record their own sounds or to sing along to music played on a cassette. The styling of this machine has a cheerful, unisex appeal; often, however, machines directed at the young female market are designed in softer pastel shades.

KITCHEN &

DINING ROOM

Cookers

Refrigerators

Washing machines

Coffee makers

Kettles

Toasters

Food processors

Cutlery

Tea & coffee sets

Dinner services

Glassware

Drinks accessories

Dining furniture

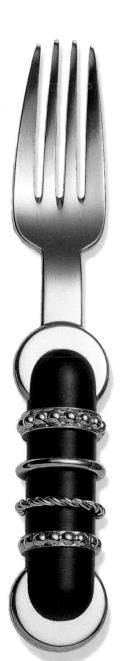

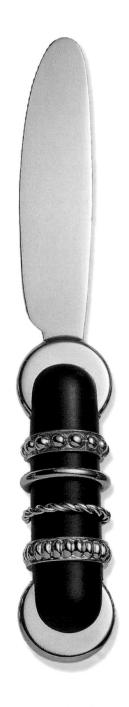

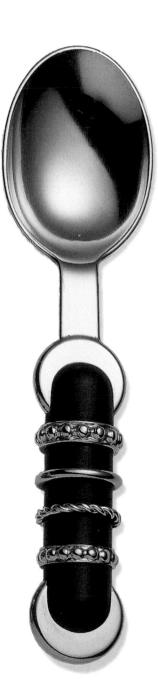

COOKERS

EARLY GAS STOVES resembled the heavy cast-iron ranges of the 19th century. Later, they were raised on slender legs – a feature that emphasized the lighter mechanics of the gas appliance. Designs for electric cookers, introduced in the 1920s, tended to emulate their gas counterparts, and by the end of the 1930s, a standard type had been established that was to endure in popularity for decades. This compact, flat-topped stove formed a continuous surface with the kitchen worktop. Today, technical advances make it possible to combine electric oven and gas hob or vice versa, an innovation that coincides with a flexible new kitchen aesthetic catering to the individual's taste.

COMPACT KITCHEN

Designed for the Italian manufacturer Boffi by Joe Colombo, this self-contained mobile mini kitchen consists of a two-ring electric hob,

The Metropolitan c.1910

By the 1900s, many urban households had access to a gas supply. This gas stove, constructed from cast-iron, is typical of early kitchen appliances. It has a crude, industrial appearance and would have been difficult to operate. Later, enamel replaced the rust-prone cast-iron finish.

Specifications

Country: UK Height: 84cm (33in)

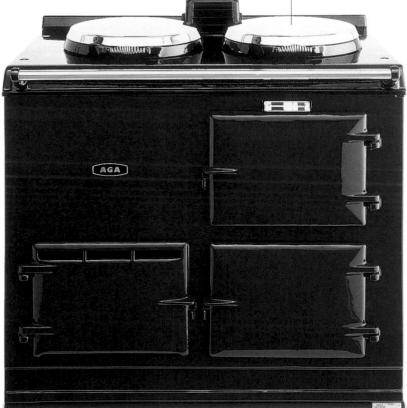

Country: UK Height: 85cm (33½in)

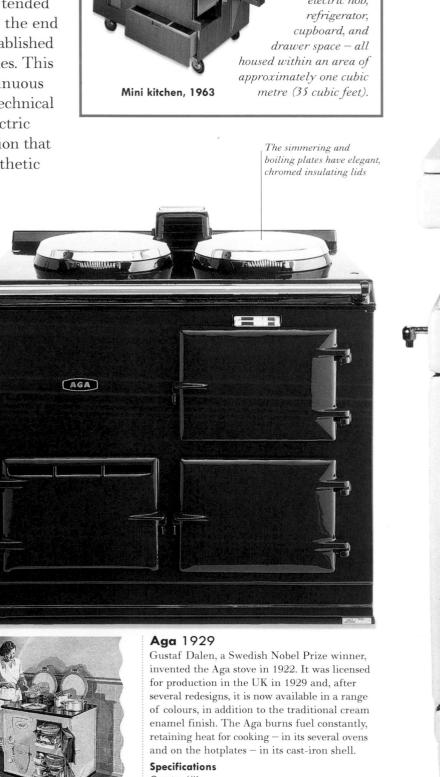

New World cooker 1950s

Designed for the modern home, this cream enamelled cooker is representative of the standard type established in the late-1930s – a flat-topped box that fitted into the continuous horizontal work surface of the fitted kitchen. It has four hotplates, a grill, a plate-rack, and a thermostatically controlled oven.

Specifications

Country: UK Height: 142cm (56in)

> Saucepans can be stored on hooks at the top of the tree

FAST FOOD

Microwave oven, 1955

The ceramic hob can be detached from the main stove unit

Kitchen Tree 1984

Designed by Stefan Wewerka for Tecta, the Kitchen Tree is the ultimate in space cconomy, comprising a sink, three electric hotplates, a work surface, storage basket, and hanging facility - all extending from a central column. Wewerka's asymmetrical design breaks with convention, challenging the ubiquitous fitted kitchen.

Specifications

Country: Germany Height: 196cm (77in)

Neff B1441 oven and hob 1996

The integral oven and hob unit is no longer the standard in cooker design. The two parts can be bought separately and the kitchen layout manipulated to suit the consumer's requirements. Top-of-the-range built-in ovens offer a range of user-friendly features, including a heat-reflective glass oven door, slender bar handle, pushaway control knobs, and illuminated dials.

Specifications

Country: Germany Height: 58.9cm (23in)

STREAMLINING

This refrigerator was designed by Raymond Loewy for the US mail order firm Sears Roebuck. Its streamlined, pressed-steel styling resembles the bodywork of a car. The rounded corners and gleaming white finish created a new "hygienic" look that was widely copied by other manufacturers.

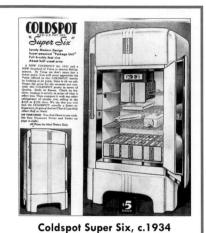

00

Small-capacity fridge 1930s

Made by The British Thomson-Houston Company, this refrigerator is typical of early models. Although it is large and heavy, the cold storage area is small, with the motor occupying considerable space. The two dials at the top of the fridge operate the on/off mechanism and the temperature control.

Specifications

Country: UK Height: 132cm (52in)

The heavy motor takes up the bottom half of the housing

Prestcold fridge late - 1950s

This Prestcold refrigerator is clearly influenced by Raymond Loewy's Coldspot Super Six. Its shape demonstrates many of the characteristics of the automobile industry's products. The gently curving lines, the handle, and the badge-like logo in the right-hand corner are all reminiscent of car styling.

Specifications

Country: UK Height: 119cm (47in)

> Bold primary colours identify these as 1990s fridge/freezers

REFRIGERATORS

AT THE TURN OF THE CENTURY, for those lucky enough to have one, refrigerators were simply wooden cabinets housing ice boxes. The first domestic refrigerators appeared in 1913. These were cumbersome and had relatively small storage spaces. Some had the cooling mechanism mounted outside the appliance, above the food compartment, earning them the nickname "the beehive". For a long time Europeans considered refrigerators to be an unnecessary luxury. In the US, refrigerators were far more popular with consumers (sixty per cent of the population owned one by 1941) and, as a result, many design features originated there. Since the 1950s, refrigerators and freezers have been available in a much wider range of styles, colours, and configurations.

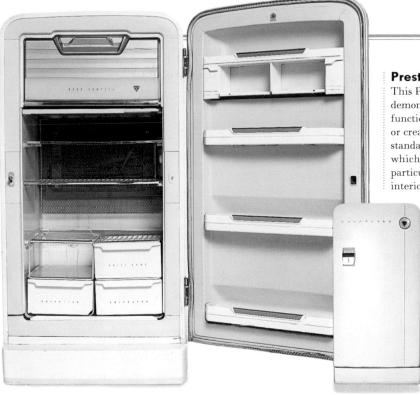

Prestcold fridge 1950s

This Prestcold refrigerator demonstrates a move away from the functional, hygienic-looking white or cream finish that had become standard. The inside is light blue, which, along with pink, was particularly popular. The spacious interior is compartmentalized to

separate different food types. A small freezer section is for frozen foods, which had started to become readily available after World War II. The exterior's rounded corners, refined graphics, and square handle give it a modern look.

Specifications

Country: UK Height: Not known

During the first half of the 20th century, many homes relied on insulated chests or cupboards to keep food products temporarily cool and fresh. These had to be refilled daily with ice.

Insulated cupboard

The unusual styling includes a red base plinth and a pyramid-like "roof" complete with flag

Smeg SP16 1995

During the 1980s the vogue was for refrigerators to be invisible, hidden behind decor panels in fitted kitchens. The Italian manufacturer Smeg is one of a number of companies that is challenging this in the 1990s: its large-capacity fridges and freezers are produced in bold primary colours. The overall shape maintains a simple geometry with clean lines.

Specifications

Country: Italy Height: 164cm (64½in)

Amana SRD526SW 1995

Traditionally, the US market has favoured larger capacity refrigerators than have been standard in Europe. However, large models, like this side-by-side Amana unit, which measures 91cm in width (35¾in), are steadily gaining popularity with Europeans. The model includes an external cold water and ice dispenser.

Specifications

Country: US Height: 174cm (68½in)

Zanussi Wizard fridges 1987

Roberto Pezetta's unconventionally shaped Post-modernist refrigerators were designed for Zanussi and were not a commercial success. Pezetta used architectural references to produce an appliance that proudly asserts its own identity.

Specifications

Country: Italy Height: 163.5cm (64½in)

Early washtub 1920s

Before electricity became widely available, washtubs were hand-operated. There were numerous ways of agitating the wash, including pounding, squeezing, and rocking, which were all very labour intensive. This machine is driven by a handle linked to a central paddle that churns the laundry.

Early mangle 1920s

From the beginning of the century, most households would have been equipped with a mangle. This was used to squeeze water out of wet laundry and to smooth linen. There were many different styles of mangle, both free-standing and table-mounted. This one is fixed to a hinged roller-frame, which folds downwards to convert into a table.

WASHING MACHINES

WASHING MACHINES HAVE BEEN AVAILABLE in one form or another for over 200 years. Before the widespread use of electricity, they were aimed at the industrial market, and those who could afford to sent their clothes to public laundries. Early tubs had to be filled manually with pre-heated water, and then turned by hand. Until the introduction of the twin tub, with its separate drum for spinning, saturated clothes had to be passed through a mangle or wringer. Exemplified by the Rolls Duo-Matic, the twin tub remained in common use until as recently as the 1980s, as acceptance of the less labour-intensive front-loading machine was surprisingly slow. As discreet in styling as they are powerful in performance, frontloaders now dominate the market. The latest models keep the impact on the environment to an absolute minimum, attesting to the eco-conscious attitudes of the 1990s' consumer.

Protos washtub c.1930

Throughout the century, advertisements for domestic appliances have tended to exaggerate their labour-saving properties. This advertisement for the Protos electric washtub implies that the machine will relieve the drudgery of washday, giving the housewife the freedom to pursue other interests.

Kenmore Toperator 1933

Designed by Henry Dreyfuss and sold through the Sears catalogue, the Toperator shows the growing importance of styling in domestic appliances. Finished in mottled green enamel with chrome trim, the sleek, streamlined body conceals the mechanics.

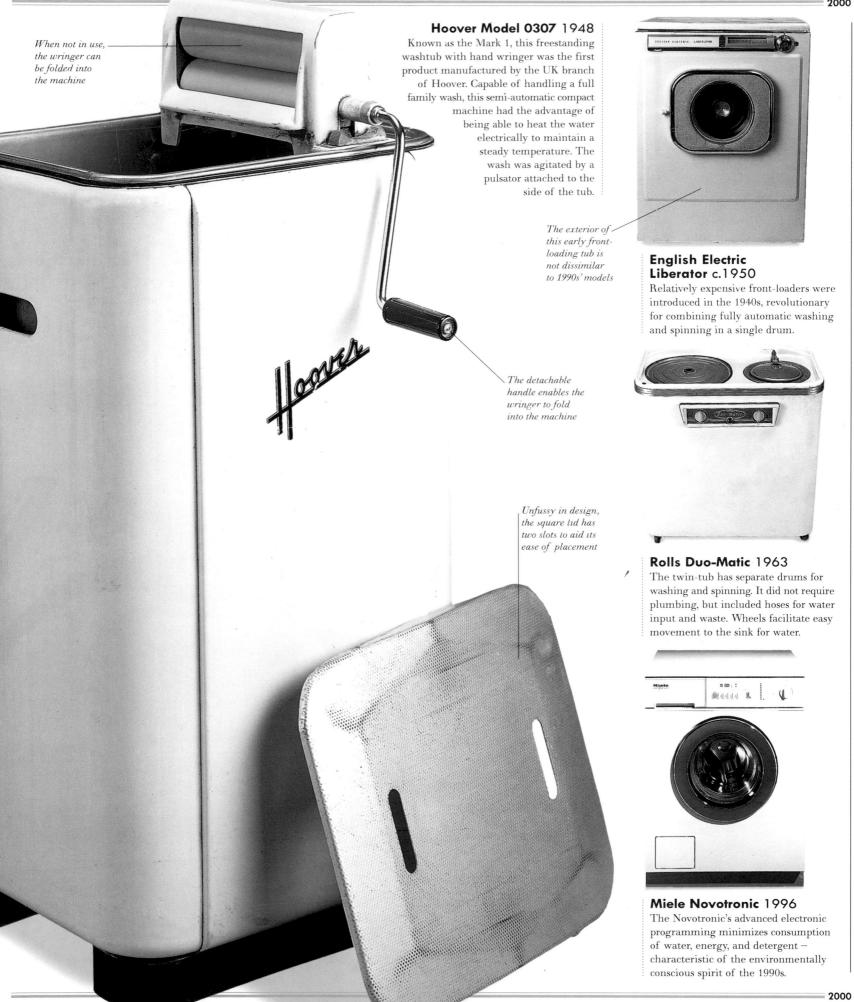

Moka Express 1933

The enduringly popular Moka Express coffee maker was first designed and manufactured in the 1930s by Alfonso Bialetti. This octagonal-shaped percolator is cast in aluminium and has a plastic handle. It continues to be manufactured today by Alberto Bialetti, grandson of Alfonso.

Specifications

Country: Italy Materials: Aluminium and Bakelite Height: 20.2cm (8in)

COFFEE MAKERS

and usually very precise — techniques for preparing their favourite beverage. This is reflected in the rich assortment of coffee machines available, which includes percolators, drip-pots, vacuum pots, cafetières, and capuccino makers. One of the most popular is Alfonso Bialetti's Moka Express, still favoured by Italians for its excellent, strong espresso. Among the modern pots, the elegant Filumena 2 by Sabattini best embodies the simple, formal aesthetics that perfectly suit the ritualistic nature of coffee-making.

Wear-Ever coffee pot 1934

Lurelle Guild was employed by a number of companies in the 1930s to design aluminium kitchen utensils. The form of this well-proportioned cylindrical coffee pot clearly expresses function. Designed by Guild to be manufactured easily, the pot is made from aluminium, with the handles moulded in Bakelite.

Specifications

Country: US Materials: Aluminium and Bakelite Height: 28cm (11in)

> The plastic arm holds the coffee maker above the flame

Glass coffee makers have traditionally been considered more sanitary than their metal equivalents Hot water is drawn from the lower bowl and mixes with the coffee grounds As the lower bowl cools, a vacuum is formed, and the coffee is filtered back into it

Finel coffee pot 1957

The work of Finnish interior and industrial designer Antti Nurmesniemi, and a product of Wärtsilä, the Finel pot has a cylindrical metal body that narrows towards the top. It is finished in bright red enamel, with a black plastic handle.

Specifications

Country: Finland
Materials: Enamelled metal and plastic
Height: 18.8cm (7½in)

"CONA" coffee maker 1957

This attractive, hour-glass shaped coffee maker is by British industrial and graphic designer Abram Games. The heat-resistant glass bowls are suspended from a plastic arm, which is mounted on a polished metal base.

Specifications

Country: UK Materials: Glass and plastic Height: 29.6cm (11½in)

The shape of the lid suggests the top of an architectural column

Cafetière 1986

Aldo Rossi began working with Alessi in the early 1980s. His method of working is to present the technicians with outline sketches, rather than finished plans. From these, some of Alessi's most successful coffee makers have been created. This cafetière shows Rossi's passion for architecture—the lines and proportions of the machine have clearly been inspired by classical columns.

Specifications

Country: Italy Materials: Stainless steel and glass Height: 22cm (8½in)

The innovative, radiating spiral design prevents the handles from overheating

GAGGIA

Although the first espresso machine was patented in 1902 by Italian Luigi Bezzera, the process of forcing hot water through a filter of ground coffee beans was popularized internationally by Milan-based Achille Gaggia in the late 1940s. His purpose-built domestic espresso machine, with its piston and lever system, was introduced in 1948, and became an essential ingredient in the 1950s' cult of the coffee-bar.

Gaggia espresso machine, 1990

The body of the pot is tall and slender, with unfussy, elegant lines

Filumena 2 1985

Filippo Alison's design for the tall, elegant Filumena 2, manufactured by Sabattini, was motivated by the Neapolitan tradition of coffee making, which involves using the grounds twice. Coffee is made by first filtering the water through previously used grounds, before passing it through fresh grounds to produce a strong and aromatic drink.

Specifications

Country: Italy Material: Silver-plated brass alloy Height: 27cm (10½in)

Copper kettle 1909

One of the most successful and influential projects by the proffeeling Ourman designer Peter Behrens was the range of kettles he introduced in the early years of the century. There were three basic body shapes: octagon, cylinder, and half-oval; three different colours: brass, copper, and nickel; three types of finish: hammered, dragged, and plain; two lid designs, two handle shapes, and two plinth styles. They were all interchangeable, so that 81 different kettle combinations were possible, though only 30 were marketed.

Specifications

Country: Germany Materials: Plated hammered copper and wicker

KETTLES

EARLY ELECTRIC KETTLES were hazardous appliances: the metal heating element was not waterproof and had to be fitted beneath the base of the kettle. Immersable elements first appeared in 1921 - some 30 years after the first kettle was produced by the American company Carpenter Electric Co. However, the electric version never completely replaced the traditional hob kettle, which enjoyed a new lease of life in the 1980s, when Alessi produced its "Kettle with a Bird-shaped Whistle". The company has since sold more than 100,000 of these a year.

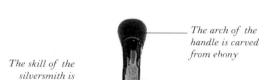

evident in the delicate decoration

Silver kettle 1920s

When Danish silversmith Georg Jensen died in 1935, the New York Daily Herald called him "the greatest craftsman in silver of the last three hundred years". This hot water pot from the 1920s is a fine example of his craft. Although the solid silver pot could be lifted from the base to be filled, to pour water it was pivoted forward on its two side arms. The stand included an integral oil lamp that heated the water.

Country: Denmark Materials: Silver and ebony

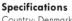

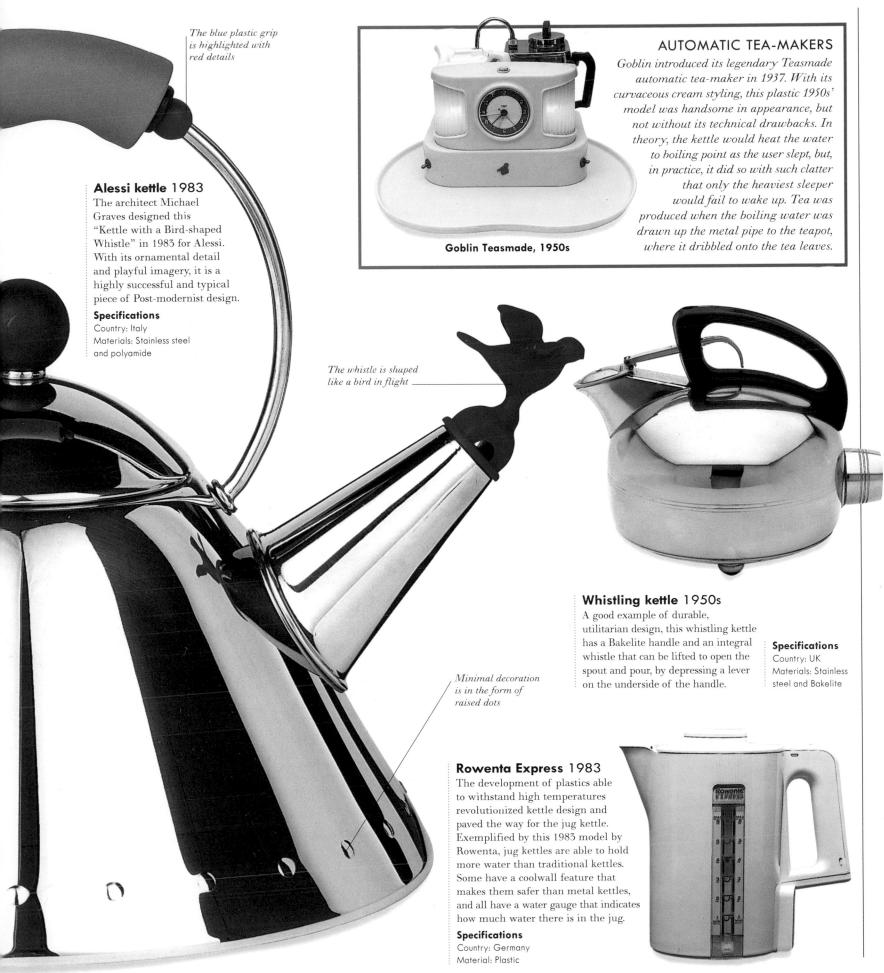

TOASTERS

THE AUTOMATIC POP-UP TOASTER was the invention of American mechanic Charles Strite. His pioneering appliance had a spring device that was operated by thermocontact, which ejected the toast at a set time. There were earlier electric toasters, but these were not thermostatically controlled and had to be watched to avoid burning. Today, burnt toast is a thing of the past, with electronic timing control enabling toasters to be set to suit any taste.

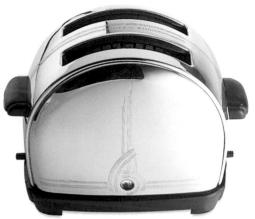

Sunbeam Model T-9 1937

The "Sunbeam silent automatic toaster", created by George Scharfenberg, was patented as an "ornamental" toaster, revealing its dual purpose as a practical household appliance and status symbol. Pop-up toasters were available in the US long before they appeared in Europe.

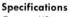

Country: US Materials: Chrome and Bakelite

Toast-O-Lator mid-1930s

An innovative solution to toasting both sides of the bread at once was the Toast-O-Lator — the bread was grilled as it travelled from one side of the machine to the other on a mini conveyor belt. Another quirky feature was the eyehole that allowed the process to be monitored.

Specifications

Country: US Materials: Chrome and Bakelite

Universal 1920

Designed as a centre-piece for the dining room table, the Universal toaster was more advanced than earlier machines. Although it could only toast one side of the bread at a time, it turned the bread to toast the second side. The bread was held against a heated metal element by the decorative front plate.

Specifications

Country: US Materials: Metal and wood

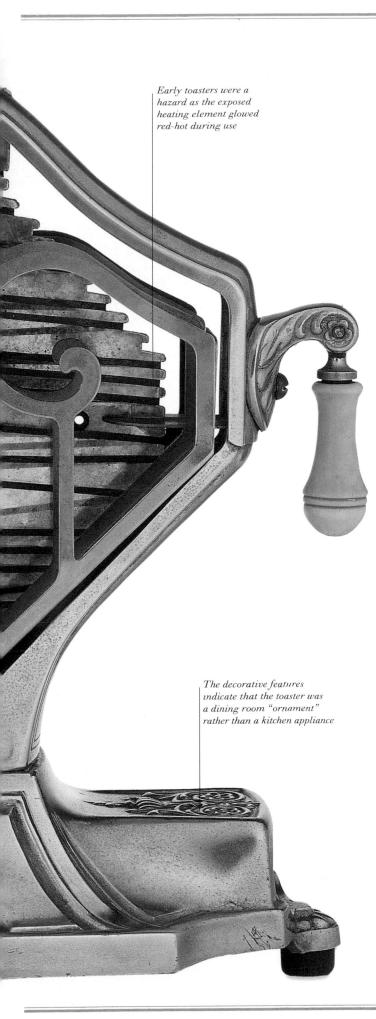

Pye Toaster 1950

Created by Hawkins, this toaster has a Bakelite base and handle designed to protect the user against the heat. The aerodynamic design recalls the American passion for streamlining. Drop-side toasters of this type were superseded in the 1950s by an American invention, the pop-up toaster.

Specifications

Country: UK Materials: Chrome and Bakelite

Dualit 1950s

This classic stainless steel toaster is still available today in two-, four-, and six-slice versions. It was originally intended for use in the catering trade, but is now a sought-after, domestic design icon. It has not changed since its inception in the 1950s, a tribute to its timeless design.

Specifications

Country: UK Material: Stainless steel

Breville Sandwich Toaster 1980–90

Kitchen gadgets, such as sandwich toasters and waffle irons, became popular in the 1970s. The Breville toasts, cuts, and seals the sandwich. The plain white exterior reflects the idea that modern kitchen appliances should be both hygienic and functional.

Specifications

Country: UK Material: Plastic

Kenwood Coolwall 1990

So-named because even during use the sides do not get hot, the Coolwall toaster offers a range of novel features, including electronic timing control. Housed in a sleek, white shell, the Coolwall is the epitome of rationalized styling for domestic appliances, an approach pioneered by Braun in the 1950s.

Specifications

Country: UK Material: Plastic

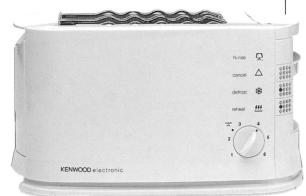

FOOD PROCESSORS

EARLY FOOD MIXERS tended to be scaled-down versions of industrial appliances from the commercial kitchen. They were reliable, but difficult to operate as they were not designed for domestic use. This industrial form continued until the 1950s, when the mixers began to show stylistic references to motor cars, regarded then as symbols of modernity. At the end of the century, small, versatile, robust, easy-to-use machines, with a vast array of functions, are the norm and are better suited to the modern kitchen.

The unadorned, industrial styling of this early mixer gives it the look of a machine tool

Domestic mixer 1918

Typical of early domestic mixers, this model has a simple, functional design, free from any ornamentation. The frame is hinged to allow the mixer to be turned horizontally. It is a smaller, less complex version of an industrial machine, designed purely to mix.

Specifications

Country: France Material: Metal

Kenwood Chef 1948

The first Kenwood Chef model retains the industrial features associated with early food mixers. Its metal casing has a rounded form, giving the appliance a solid, heavy appearance, which was criticized for identifying work with housework.

Specifications

Country: UK Materials: Metal, Bakelite, and porcelain

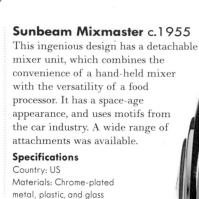

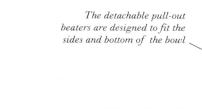

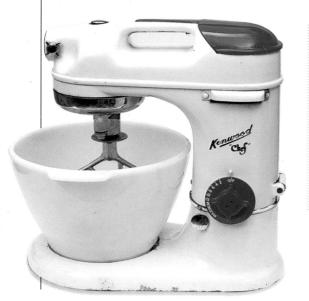

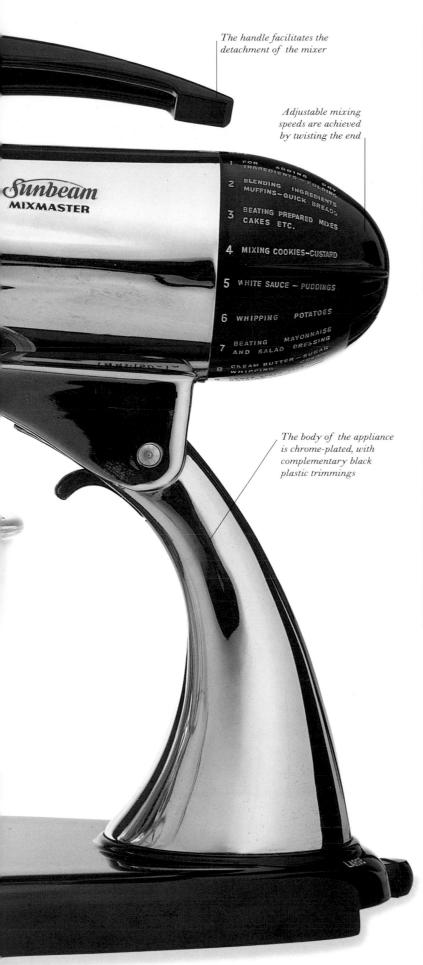

Kenwood Chef 1960

Kenneth Grange's redesign of the Kenwood

Chef (see opposite) represents a trend in the late-1950s away from industrial styling and towards a more user-friendly domestic aesthetic. As kitchen appliances became more commonplace, designers began to create a new look for the domestic machine. Grange believed that the design of a product should be incorporated in its manufacture, with the designer as innovator as well as stylist. The lines are crisper than the 1948 model, with a single plastic moulding to house the machinery.

Specifications

Country: UK Material: Plastic

> The redesigned Kenwood Chef has harder edges and sharper lines than the original

Magimix c.1978

The compact Magimix marked a radical departure in food processor design. Devised to carry out a wide range of functions without having to change attachments, it replaces previous mixers with just one bowl and four blades. It takes up little space in the kitchen as the bowl is housed above the stand. The bowl is made of hard-wearing lexan, the same material used for the windows of aircraft, making it dishwasher-proof and impossible to shatter.

Specifications

Country: France Materials: Plastic and shatterproof lexan

Soft colours and elegant lines typify Braun's skilful styling of domestic appliances

Braun **Multipractic** 1983

In the 1950s, the bowl and stand arrangement of Braun's electric kitchen machine was similar to that of the Kenwood Chef. In 1983, Braun introduced a new look with the Multipractic. Its design is closer to that of the Magimix than previous mixers. The sleek machine has a covered bowl that slots into grooves in the stand.

Specifications

Country: Germany Material: Plastic

MAGIMIX FOOD PROCESSOR

CUTLERY

BESIDES ITS OBVIOUS UTILITARIAN purpose, cutlery – or flatware as it is sometimes known – also plays an aesthetic role in 20th-century living. The look of a dining room or restaurant table can be greatly enhanced by the cutlery settings. The production of metal utensils has a long tradition, particularly in England, reflected here in David Mellor's Pride service from the late-1950s. Since World War II, there has been an increase in the use of plastics in cutlery, particularly in the design of disposable items. The Post-modernist designers of the 1980s and '90s have reintroduced ornament into cutlery: Matteo Thun's decorative Hommage à Madonna elevates knives, forks, and spoons from mere utensils to objects of contemplation.

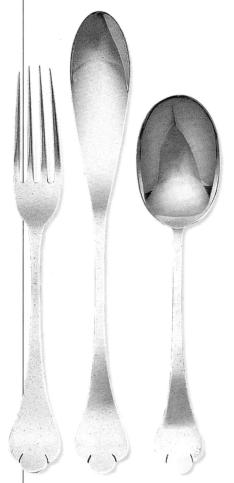

Silver cutlery c.1908

Charles Rennie Mackintosh designed this cutlery for Miss Cranston's Ingram Street Tearooms in Glasgow. The service is simply decorated with a flared floral motif at the end of each piece; otherwise, a clean, gently elongated line is maintained.

Specifications

Country: UK Material: Silver plate Length of knife: 21cm (81/4in)

American Modern 1950

This service was designed by Russel Wright to complement his enormously successful American Modern dinnerware (see p.86). Characterized by disproportionately long handles (in contrast to the abbreviated fork prongs), each piece has been stamped from a single sheet of stainless steel.

Specifications

Country: US Material: Stainless steel Length of knife: 22cm (83/4in)

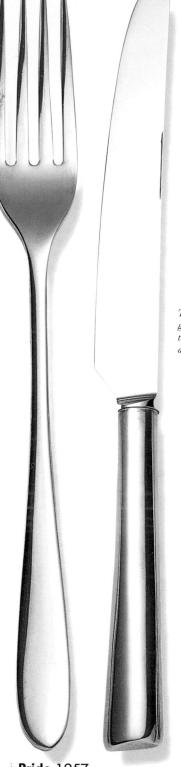

Pride 1957

David Mellor comes from Sheffield, the centre of the British steel industry and a city renowned for its flatware. This was his first endeavour at cutlery design for the manufacturers Walker and Hall. Although the style is restrained, the light, slender pieces are without decoration. The service was also produced with contrasting celluloid handles. Pride's success was confirmed in 1957, when it received one of the first British Design Council awards.

Specifications

Country: UK Material: Silver plate Length of knife: 21.5cm (8½in)

DISPOSABLE PLASTIC CUTLERY

Made from polystyrene, this ingenious disposable picnic set was created by the French designer Jean-Pierre Vitrac in 1979. Plastic has been used as an alternative to wood, metal, and glass since the 19th century, but it has only been with the development of new plastics, such as PVC (polyvinyl chloride), polystyrene, and perspex that we have seen its full potential. Manufactured by Diam, this bright red, lightweight set is easy to stack and store. The knife, fork, spoon, cup, and plate are joined together - so nothing can be lost in transit - and are then separated by the user.

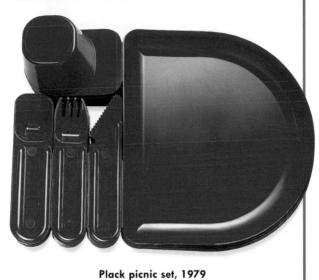

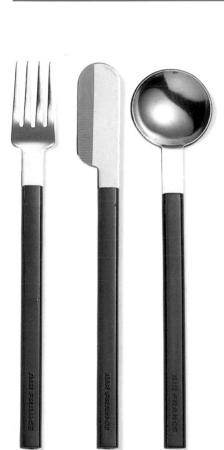

CEI airline cutlery c.1978

In 1952, Raymond Loewy founded the influential Compagnie d'Esthetique Industrielle (CEI) in his native Paris. The company designed this flatware for Air France in the late 1970s. The simple, matching geometry creates an elegant, yet functional, service.

Specifications

Country: France Materials: Metal and plastic Length of knife: 16cm (61/kin)

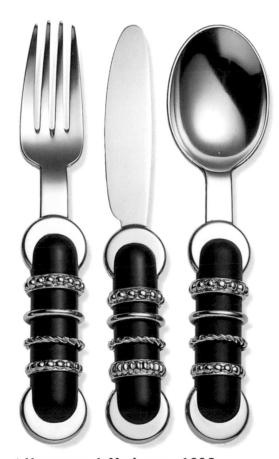

Hommage à Madonna c.1985

Since the 1980s, Post-modern designers have been responsible for putting symbolism and metaphor back into design. In his Hommage à Madonna service, made by WMF, Austrian ceramicist and designer Matteo Thun applies luxurious decoration to an everyday object, making reference in the process to the famous performer's flamboyant style.

Specifications

Country: Germany Materials: Gilded brass and PVC plastic Length of knife: 18cm (7in)

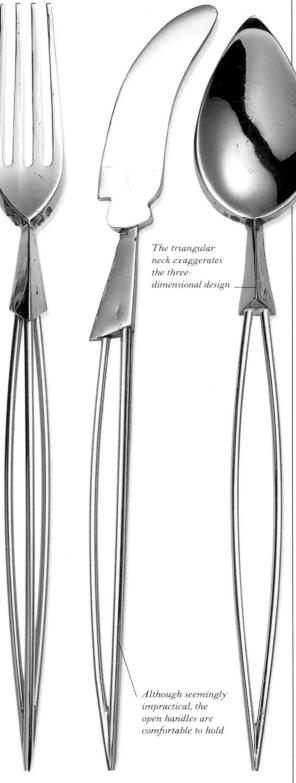

Open-handle cutlery 1991

This is a delightful cutlery service from the Czech designer Bořek Šípek. The heads of each piece are made from stainless steel, while the handles are crafted from gold-plated wire. Instead of the solid form conventionally favoured for flatware, Šípek has chosen to leave the handles open, each gently bowing in the middle and finishing in a point.

Specifications

Country: Czech Republic Materials: Stainless steel and gold plate Length of knife: 20.5cm (8in)

TEA & COFFEE SETS

THROUGHOUT THE WORLD, tea drinking is more than just a source of light refreshment, it is an opportunity for ceremony and ritual. Perhaps it is for this reason that so much attention has been paid to the production of tea and coffee services, with contributions made by some of the world's best-known designers. A great diversity of materials has been used, from traditional earthenware to silver, iron, copper, and glass; one of the most celebrated sets, Jan Eisenloeffel's fine Arts and Crafts service, is made from brass. Some designers have applied their artistic concepts to product design, although, as

of the most celebrated sets, Jan Eisenloeffel's fine Arts ar Crafts service, is made from brass. Some designers have applied their artistic concepts to product design, although Kazimir Malevich's half cup demonstrates, these are not always practical. In terms of public popularity, it is often the traditional designs, such as Royal Doulton's best-selling Old Country Roses (see p.84), that prove to be the most enduring.

Brass tea service 1900-03

The Dutch designer Jan Eisenloeffel trained as a goldsmith and silversmith and later went on to study under Fabergé (1846–1920) in St. Petersburg. His work expresses control and harmony: this brass tea service is beautifully made in the Arts and Crafts tradition, with decoration kept to a minimum. A similar set was exhibited to wide acclaim at the first International Arts and Crafts Exhibition, held in Turin in 1902.

The details of craftsmanship are left exposed to view

Specifications

Country: Holland Materials: Brass, rattan, and ebony Height of tea kettle: 22.5cm (8½in)

Silver tea service 1928

Jean Puiforcat's tea services from the 1920s and '30s are characterized by their simple geometry. He was interested in a mathematical principle known as the Golden Section, which provided a system of proportion for his work.

Specifications

Country: France Materials: Silver and walnut Height of teapot: 11.4cm (4½in)

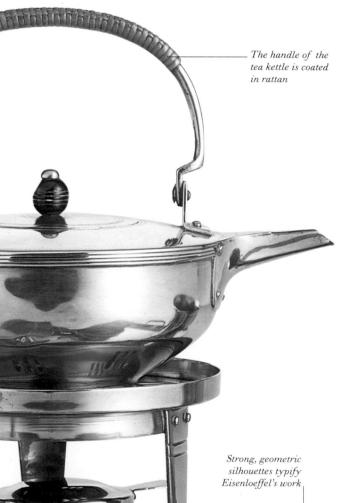

RUSSIAN AVANT-GARDE WORK

Kazimir Malevich was an important avant-garde artist working in Russia during the Revolution.
His key concept, Suprematism, attempted to reduce images to universal geometric forms and pure colour. This porcelain cup, although serviceable, is more a statement of those beliefs than a practical proposition.
The enamelled decoration was done by one of Malevich's own students, Ilia Chashnik.

Half cup, 1923

Bizarre coffee set 1929

The British ceramic designer Clarice Cliff is well-known for her brightly coloured, jazzy designs. She came to fame in the 1920s and '30s, when she was art director for the Wilkinson's Burslem pottery in Staffordshire. Her geometric patterns are firmly associated with the Art Deco style.

Specifications

Country: UK
Material: Ceramic
Dimensions: Not know

2000

Russian sugar bowl and cream pitcher 1920-25

These two items by Zinaida Kobylestskaya have all the hallmarks of Russian avant-garde design of the early 1920s. The fragmented, semi-abstract images of agricultural and industrial scenes, together with the hammer and sickle, had a powerful symbolic resonance for the post-revolutionary citizens of Soviet Russia. Fragments of cogs, which were used as the State Porcelain Factory trademark, can be seen on both lids.

Specifications

Country: USSR
Materials: Porcelain with enamelled decoration
Height of sugar bowl: 10.6cm (4//in)

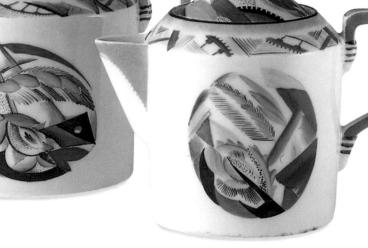

Decoration is limited to a simple pattern of three engraved parallel lines

Japanese teapot and sugar bowl c.1930s

Nowhere is the serving of tea more ritualized than in Japan, where it has been raised to an art form of great ceremony. This teapot and sugar bowl were produced for export to the West. The decoration and geometric styling show the influence of Art Deco.

Specifications

Country: Japan Material: Ceramic Height of teapot: 16.1cm (6½in)

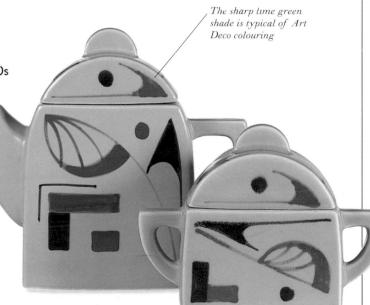

1900 =

84

This inventive, streamlined tea service by Luigi Colani is produced here in white porcelain, but was also available in black or gold.

The service was commissioned by Rosenthal for its Studio Line. The flowing forms have an organic quality, particularly evident in the teapot and milk jug, which together seem to relate like an adult and child.

Specifications

Country: Germany Material: Porcelain Height of teapot: 10.7cm (4½in) The teapot handle is positioned near the centre to maximize ease of pouring

Alessi tea service 1983

In the 1980s, Alessi commissioned a series of tea services that elevated functional objects to high art. Oscar Tusquets' silver set cleverly combines the flowing forms of the handles with angular, cut-away spouts.

Specifications

Country: Italy Material: Silver

Height of teapot: 19cm (7½in)

The choice of black glaze more often associated with coffee drinking - is an unusual one

Village tea set, 1986

American architect and designer Robert Venturi is a leading proponent of Post-modernism. His theories are played out in this 1986 tea service for Swid Powell. References can be seen to classical and vernacular architecture, combined with colours and shapes that could be derived from theme parks and fun fairs.

DINNER SERVICES

THE 20TH CENTURY HAS SEEN the introduction of a profusion of interesting dinner service designs alongside traditional, high quality porcelain sets. During the 1920s, many designers, including Clarice Cliff in the UK (see p.83), chose earthenware in preference to porcelain. At the end of the 1930s, Russel Wright's name became famous for his American Modern service, which was revolutionary for its "mix and match" coloured glazes and organic shapes. Eva Zeisel was another leading contemporary ceramic designer at work in the US, and she too embraced new, more organic shapes. Other designers have retained a formal geometry, and, in the hands of Post-modern designers like Aldo Rossi, dinnerware has taken on humorous architectural motifs.

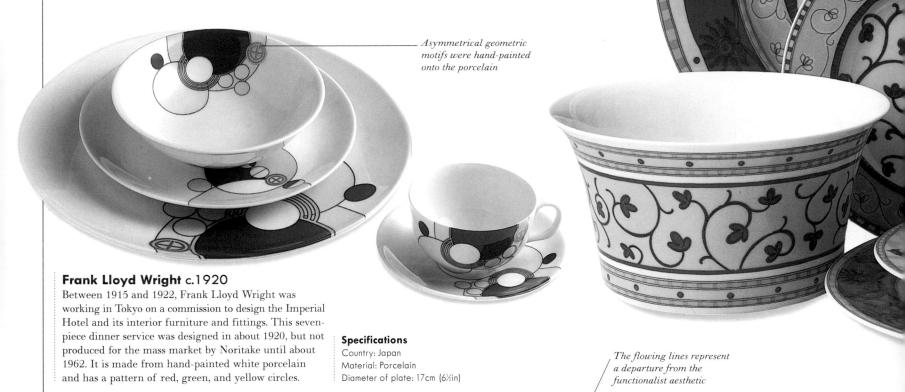

Shown here in Seafoam Blue, each piece came in a choice of six colours

American Modern 1937

Although Russel Wright's unusually shaped dinner service was thought to be daring when it was first introduced in 1939 by Steubenville Pottery, it sold a phenomenal 80 million pieces over 20 years. The soft curves and the use of muted colours that could be mixed and matched, create an informal quality.

Specifications

Country: US Material: Glazed earthenware Diameter of plate: 25.2cm (10in)

Museum 1942-45

This dinner service was the first modern porcelain service to be produced in the US. It was designed by Hungarian ceramicist Eva Zeisel following a recommendation from the Museum of Modern Art, New York, and was produced by the Shenango Company for Castleton China, Inc.

Specifications

Country: US Material: Porcelain Diameter of saucer: 17cm (6½in)

British designer Tricia Guild (1947—) is well-known for her radiant colour compositions. She was commissioned by Rosenthal to provide the decoration on the elegant Idillio service, designed by Paul Wunderlich (1927—). In Bokara she has produced a dazzling pattern of colours in bold reds and yellows.

Specifications

Country: Germany Material: Porcelain Diameter of plate: 27cm (10½in)

Early poster

PYREX

Invented by scientists working for the American Corning Glass Company, these heat-resistant, low-expansion oven dishes were first available for baking and roasting in 1915. Early Pyrex examples used thick glass and were without handles. However, they were easy to clean and were suitable as oven-to-tableware.

Decoration is provided by a pattern of circles and squares

Il Faro Finestra 1994

Architect and designer Aldo Rossi produced this dinner service for Rosenthal. In it he incorporates architectural shapes to humorous effect, making coffee pots as lighthouses, sugar bowls as beach huts, and salt cellars as obelisks. The decoration on this Finestra variation was created by the Indonesian artist Yang (1953—).

Specifications

Country: Germany Material: Porcelain and glass Diameter of plate: 31cm (12in)

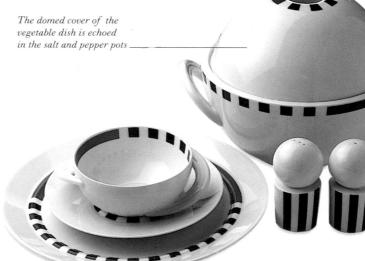

The lively illustrations feature a variety of household items

Homemaker 1955

Designed by Enid Seeney for the Ridgeway Potteries, this informal and self-conscious dinner service was clearly aimed at young consumers. The shape of the service remains traditional compared, for example, with Russel Wright's American Modern, but its quirky drawings of modern furniture are typical of the 1950s.

Specifications

Country: UK Material: Glazed ceramic Diameter of plate: 25.5cm (10in)

Cupola Strada 1990

The white Cupola dinner service was designed by Mario Bellini and introduced in 1988 as part of the German company Rosenthal's Studio Line. This particular version, featuring black and grey decoration by Yang, appeared in 1990. By adopting a geometric approach, Bellini has produced a well-balanced and extremely attractive service.

Specifications

Country: Germany Material: Porcelain Diameter of plate: 26cm (10½in)

Wine glass c.1900

This elegant wine glass may have been made by the Belgian firm Val Saint Lambert. Around its surface, an interwoven pattern of tendrils forms an almost abstract pattern. The floral decoration is typical of Art Nouveau style.

Specifications

Country: Belgium or France Height: 14.6cm (5¾in)

Decanter c.1920

Designed by Harald Nielsen and manufactured by Georg Jensen Sølvsmedie, this decanter has a silver stopper and stand. The intricate detail of the silver vines, fruit, and pods contrasts well with the heavy glass.

Specifications

Country: Denmark Height: 28cm (11in)

Decanter and glass 1953-59

This highly textured olive green decanter and glass set was produced by the Swedish company Boda. The designer, glassware and metalworker Erik Höglund, adopted a mould-blown technique to create a relief pattern featuring human figures on the surface of the glass.

Specifications

Country: Sweden Height of decanter: 14.4cm (5%in)

Calici Natale goblet 1990

For centuries, the tiny Venetian island of Murano has been famous for its glassmaking. This elegant goblet was produced there by the Carlo Moretti Studio. Its long, deep bowl has a finely textured surface and rests on a blue base.

Specifications

Country: Italy

and decanter c.1910

Produced in Austria, or Bohemia, this wine glass and decanter feature a beautifully coloured leaf motif in yellows, browns, and pinks, with gilded outlines. The classic geometric proportions of the long stem on the glass are echoed in the neck of the decanter.

Specifications

Country: Austria Height of decanter: 32.5cm (12¾in)

echoes that on lip

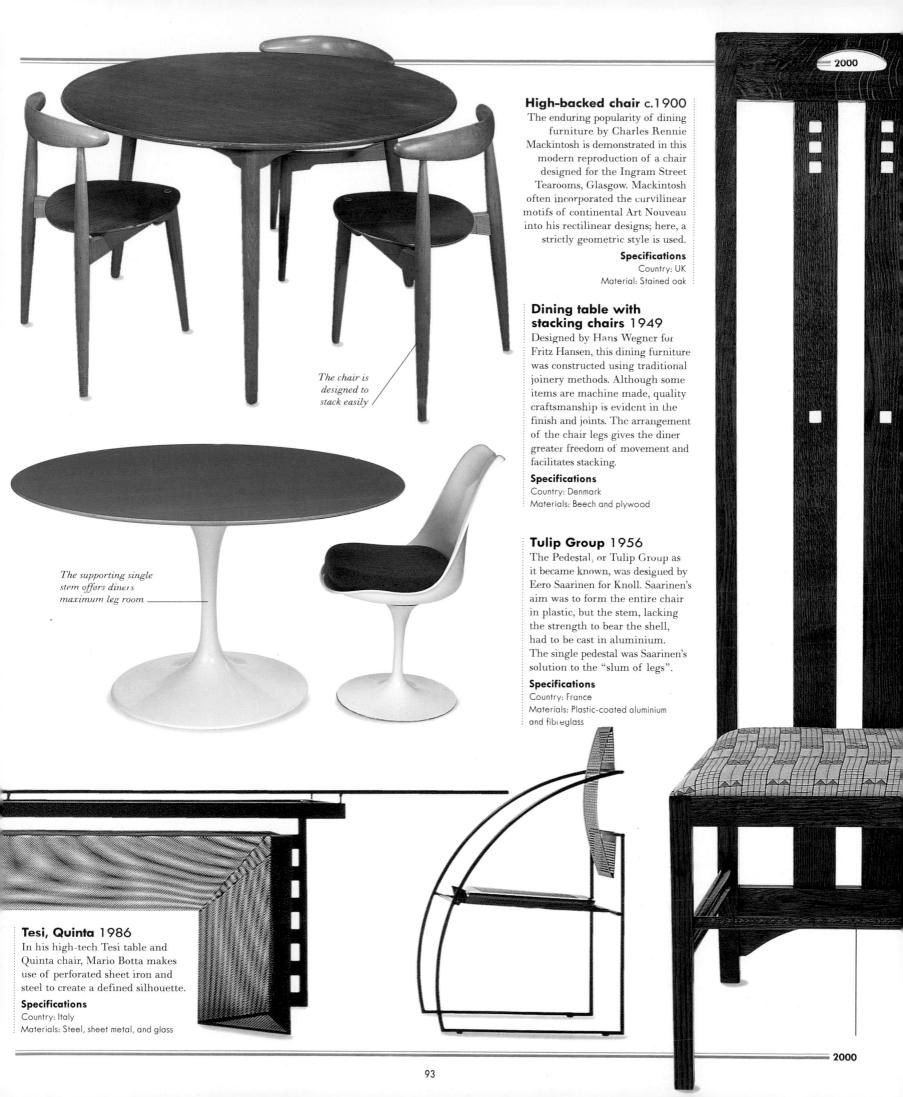

BATHROOM, BEDROOM, & NURSERY

Bathrooms

Toothbrushes

Razors

Perfume bottles

Hair dryers

Beds

Prams

Toys & models

Games & outdoor toys

Dolls

1900

LOW-LEVEL FLUSH TOILETS

1930s' toilet

The cistern of this 1930s' Art Deco toilet is low level and completely enclosed, a combination that is still preferred by most bathroom designers today. The toilet bowl is made from white porcelain and has a wooden seat.

BATHROOMS

THE EARLIEST BATHROOMS were a luxury afforded only by the wealthy, but improved plumbing and an increased concern for hygiene led to their inclusion in most homes by the 1920s. Wood gave way to shiny, white non-porous materials, such as ceramic tile and enamelled cast iron. By the 1930s, suite ensembles appeared in various colours, enthusiastically adopted in plastic form in the 1950s. Later, shower units were installed, and matching accessories became available.

Flush toilet 1902

This high-level flush toilet was manufactured by the Scottish company Shanks, and the washdown closet by Oneas. The decorative, hand-painted, floral transfer print is a British county council pattern, used for public conveniences only. The castiron cistern rests on two sunflower brackets.

Specifications

Country: UK Height with cistern: 228cm (89½in) Materials: Porcelain, cast iron, nickel, and mahogany

The toilet seat is carved from mahogany

Needle shower c.1910

This luxurious early shower earns its name from the six perforated, horizontal bars from which water is sprayed with force. Designed predominantly for male use, this large, cage-like shower was referred to as the "morning bracer".

Specifications

Country: UK Height: 222cm (87½in) Material: Brass

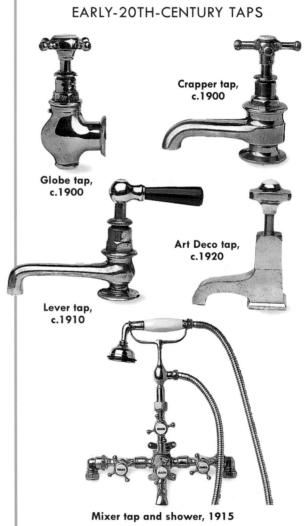

Early-20th-century taps were often made from brass or nickel. Spouts varied in shape and size: the Globe tap has a short, downward-pointing spout most suitable for baths, whereas the Crapper tap has a long-reach spout. Four-finial heads were most common, until the lever type was introduced for easier use. Mixer taps, such as the French example shown here, facilitated the control of the water temperature and the use of a shower head.

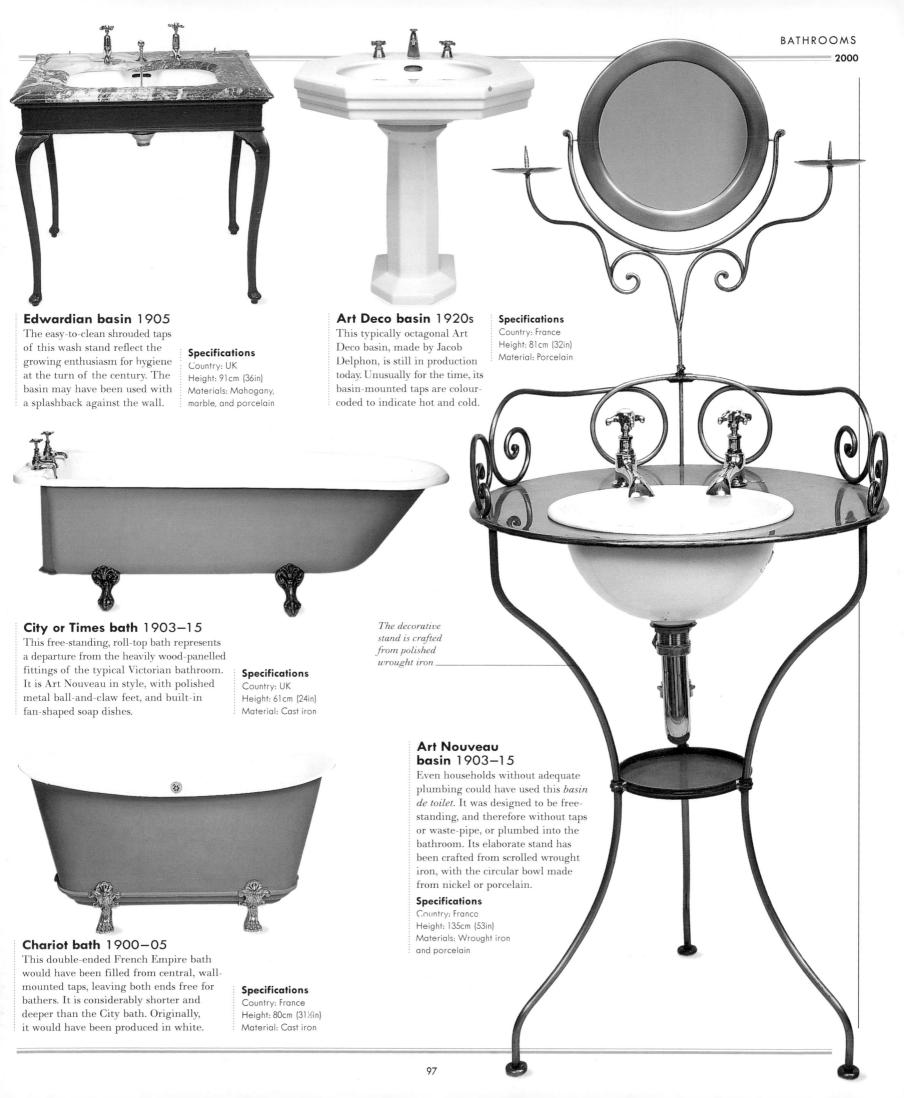

Pampas basin 1970s

The 1970s witnessed a proliferation of coloured bathroom suites. This pedestal basin by Armitage Shanks is fitted with gold-plated taps, with plastic dome heads.

Specifications

Country: UK Height: 78cm (30¾in) Material: Porcelain

Pampas toilet 1970s

Low-flush toilets were a standard feature in most modern bathrooms by the 1970s. The untidy flushing mechanism is completely enclosed, and the chain no longer necessary.

Specifications

Country: UK Height: 78cm (30¾in) Materials: Porcelain and plastic

Belvedere toilet 1996

pan in one body, retaining the low-flush

principle. Its smooth, streamlined shape

gives the unit a sculptural, futuristic quality, which fits discreetly into the bathroom. It is finished in a hardwearing white glaze, which is easy to clean.

PONTI SUITE

Advertising poster, 1953

Gio Ponti was one of Italy's foremost modern designers, influenced both by classicism and the products of the Wiener Werkstätte. In 1953, he designed this bathroom suite for Ideal-Standard, each item carefully shaped and refined to express its function. The hand basin is particularly successful: the stand tapers towards the curve of the sink to give it perfect support and balance, and the sink itself has a flat surround on which toiletries can be placed.

This elegant toilet conceals the tank and : Specifications

Country: Italy Height: 78cm (30¾in) Material: Vitreous china The gleaming white finish enhances the sculptural quality of the bathtub

Shower 1980s

In the 1980s, British manufacturer Aqualisa produced a range of "power showers", that were designed to massage and invigorate the body. The shower includes two body jets, with adjustable water force.

Specifications

Country: UK Height: 44cm (17½in) Materials: ABS plastic and chrome-plated brass

Belvedere bath 1996

This stylish free-standing bathtub provides the bather with total comfort and convenience; even the concealed water outlet is within easy reach. The suite is designed by design group Sottini for Ideal-Standard.

Specifications

Country: Italy Height: 68cm (26¾in) Material: Reinforced acrylic

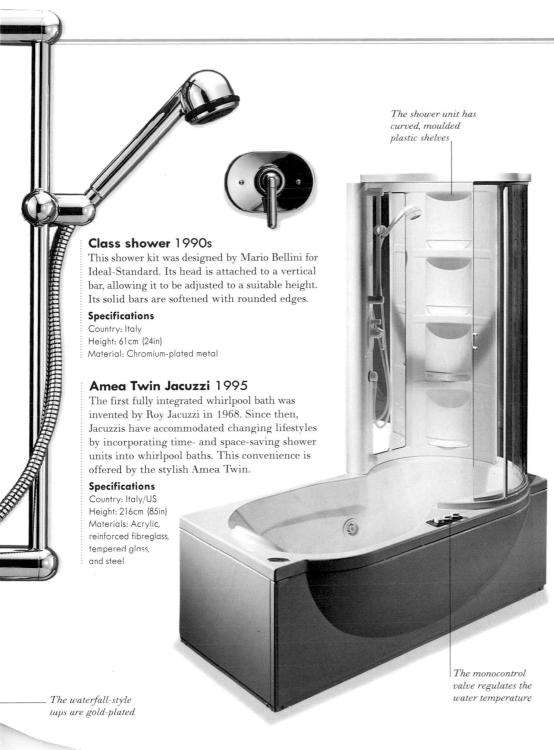

The base is

positioned

off-centre

LATE-20TH-CENTURY TAPS

Designed by Mario Bellini as part of the Class range for Ideal-Standard, the singlelever mixer shown here has appeared in museum exhibitions. It utilizes ceramic disc technology to allow full pressure water with minimum lever movement. Similarly efficient, the Dallas basin mixer can be fully activated in just a quarter turn. Chrome- and gold-plated taps remain

favourites in the 1990s, although ceramic and plastic, as used for this dome tap, have become popular alternatives.

Dallas basin mixer, 1990s

Single-lever

Dome tap

1990s

mixer, 1990s

STARCK SUITE

This bathroom suite was inspired by the most basic functional objects - buckets, tubs, and hand-pumps. The basin has a pearwood surround, and the bath a built-in towel rail.

Philippe Starck bathroom, 1990s

Belvedere basin 1990s

This wall-hung basin is fixed to the wall by its semi-pedestal, allowing it to be positioned at varying heights. The suite is produced only in white, indicating the general preference for simplicity of colour and form in the final decade of the century.

Specifications

Country: Italy Height: 62cm (24½in)

Materials: Vitreous china, chromium, and gold

TOOTHBRUSHES

FOR THE MODERN CONSUMER, selecting a toothbrush is no easy matter. There is a bewildering range to choose from: "designer" brushes, such as Philippe Starck's Fluocaril; brushes with flexible heads; brushes with multi-angled or multi-coloured bristles; electric brushes; and brushes in any colour combination. Before 1953, it was simpler, for that was the year in which plastic-handled, nylon-bristled toothbrushes were first mass-produced. In 1900, the choice was even easier: comparatively expensive, ivory-handled brushes were affordable only by the well-to-do.

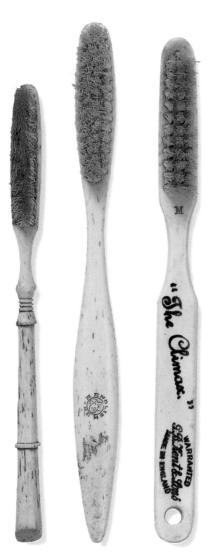

Early toothbrushes c.1900s

Although toothbrushes had been used for several centuries, by the beginning of the 20th century, they remained expensive items made of bone and bristle, expected to last for a long time. The shape of the handle was much the same as the standard one used today, but the bristle heads were about twice as long as modern versions.

Plastic toothbrushes 1930s—'40s
The first plastic toothbrushes were made in the 1930s, but on a small scale. These brushes retained the long heads of their forerunners. Nylon bristles began to replace natural bristles in the late 1940s, but it was not until the plastic handle and nylon bristles were married in 1953 that the toothbrush as we know it was born. Natural bristles continued to be used, marketed as "pure", and therefore healthy, but nylon was cheaper, longerlasting, and available in various thicknesses—and so prevailed.

Radius 1984

St

0

natural

pure

with

Designed in the US by Kevin Foley and James O'Halloran, the plastic Radius brush is a successful attempt to rethink established toothbrush design. In three sections, with its large head echoed in the middle thumb plate and wide, rounded handle, the Radius is ergonomically designed to allow the user to apply firm pressure to the teeth while brushing. The size of the head allows pressure to be distributed over a larger area than is conventionally possible.

The broad contours of the handle allow the fingers a strong grip

> The handle measures 4.3cm (1½in) at its widest point

TRAVEL TOOTHBRUSHES

The handle of this early plastic travel toothbrush formed a zigzag shape when it was opened, making it difficult to use for cleaning any but the inside front teeth. Today, travel toothbrushes tend to be constructed in separate sections, with the thick hollow handle often doubling up as the casing for the head and neck.

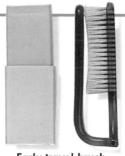

Early travel brush

Although a popular design feature, flexible heads have little functional value

Fluocaril 1989

Available in a range of subtle, translucent colours, the plastic handle of Philippe Starck's gorgeous Fluocaril toothbrush is sculpted in his trademark flame motif. Bearing Starck's signature on its neck, the item has become known as the ultimate "designer" toothbrush. Starck's intention seems to have been to create something beautiful out of an existing functional design; even so, the handle is remarkably comfortable and well-balanced.

0

Electric toothbrush 1990

The most radical innovation in 20th-century toothbrush design is the electric model, first seen in the early 1940s and widely used in the 1950s and '60s. Pressure can be applied in effective degrees to all teeth, without the necessity to "brush" manually.

Modern toothbrushes 1980s-'90s

While plastic has enabled designers to mould handles into any shape, there is little difference between the basic design of these brushes and that of 1950s' plastic models. Designers now compete over the details: the most eyecatching colours, the most comfortable grip, the optimum angle and reach, and the best bristle combination.

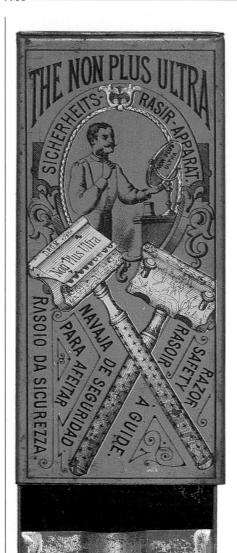

PHILIPS ELECTRIC RAZORS

Philips Philishave, c.1950

Philips razors differ from the standard system of most electric razors, which have a rotating foil head. The battery-operated Philishave has two or three bladed discs, which spin, catch, and cut the beard.

Non Plus Ultra 1910

The safety razor was a remarkable invention: it had a disposable double-edged blade that did not need stropping, and, since only a small sliver of the blade was exposed, serious cuts were impossible. The first safety razor was patented in 1895 by King Camp Gillette, who set up the Gillette Safety Razor Company in 1900. By 1910, Gillette had many rivals, including the ornate Non Plus Ultra.

Specifications

Country: Not known Material: Metal Length: 10cm (4in)

The lined grooves on the Bakelite casing give an improved grip

Braun **\$50** c.1950

Max Braun first developed the S50 electric razor in 1938, but World War II delayed production until 1951. The streamlined body, which tapers elegantly to the electric lead, suggests efficiency and fits comfortably in the hand. The cream colouring is highly unusual; men's razors are produced almost exclusively in black, grey, or silver.

Specifications

Country: Germany Materials: Bakelite and metal Length: 11.3cm (4½in)

RAZORS

ALTHOUGH, BY MODERN STANDARDS, the "safety razors" available at the beginning of the century did not live up to their name, they were, in fact, a considerable improvement on the "cut-throat" razors that they replaced. Since then, however, the development of wet shave blades has gone from strength to strength, with manufacturers competing to produce a closer, safer, more comfortable shave. New features have been launched regularly over the last three decades: the first twin-bladed razor in 1971; swivel heads and disposables in 1975; lubricating strips in 1986; and protective bars in 1992. Radical progress has also been made with the electric razor. Experiments with mechanized shaving began in the early years of the century, but it was Colonel Jacob Schick who, in 1928, patented the first electric razor to be widely accepted. Today, there is a plethora of sleekly styled and multi-functional models for men and women.

DISPOSABLE RAZORS

Plastic, which first appeared in the US in the 1930s, made possible mass-production of a huge array of items, and began a craze for cheap, disposable artefacts. In 1953, Baron Bich introduced the first disposable ball-point pen, the Bic (see p.197). Its phenomenal success encouraged him to turn his attention to razors. He cut the existing blade in half and used the funds saved in manufacturing to produce a cheap plastic handle. The result was the world's first disposable razor, launched in 1975. All the major manufacturers, including Gillette, quickly introduced their own versions.

Philips Ladyshave Aqua 1990s

The key difference between this electric razor and a men's model is the styling. Very few women's razors are made in black, whereas the vast majority of men's are black or a similarly sombre, "masculine" colour. Women's razors are invariably coloured pastel or white — here a marbled green has been used. The curvaceous shape is also intended to be womanly.

Specifications

Country: Netherlands Material: Plastic Length: 14.7cm (5%in)

Creazioni Cavari c.1987

The sleek, modern Creazioni Cavari range of "designer" razors was created by Ernesto Spicciolato and Dante Donegani. All three razors — from left to right, Sauro, Spazio, and Samurai — are produced in matt black. The solid brass handles of the Sauro and Samurai have a pleasing weightiness, while the Spazio, made from coated aluminium, is as light in weight as it is slender in form.

Specifications

Country: Italy
Material: Anodized metal
Length: Sauro 17cm (6¾in); Spazio
18cm (7in); Samurai 15.5cm (6in)

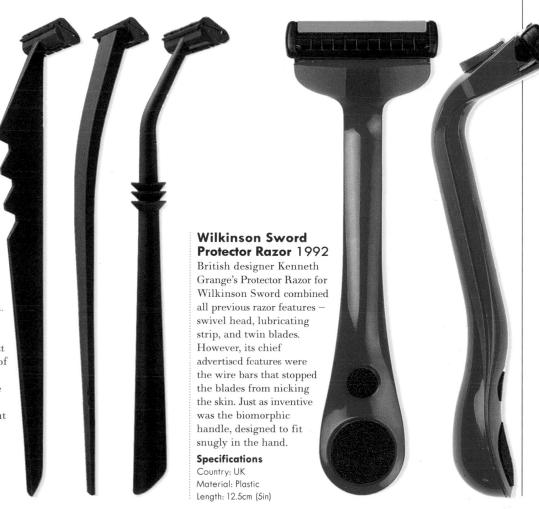

PERFUME BOTTLES

NOWHERE IS PACKAGING more important than in the perfume industry. When Baron Bich, encouraged by the successes of his disposable pens, razors, and lighters, developed a cheaply packaged scent, it failed miserably. The public wanted glamour, sophistication, and expense – a combination never better evoked than when Marilyn Monroe, asked what she wore in bed, replied, "Chanel N° 5", and sent sales of the perfume rocketing. Despite the ultimately decisive power held by the advertisers, a great deal of energy is expended both in the concoction of the scent itself and in the design of the bottle. This can range from the nostalgic, floral excesses of Zenobia to the spare, unfussy angularity of classic Chanel.

Chanel N° 5 1921

The Chanel N° 5 bottle has changed 15 times since it was introduced by Coco Chanel in 1921, but remains the essence of simplicity. It is square, with a plain wedge stopper and a minimal white label. There are nine stages involved in sealing the fragrance in its bottle, including the placement of the waxdrawn "CC" at the neck.

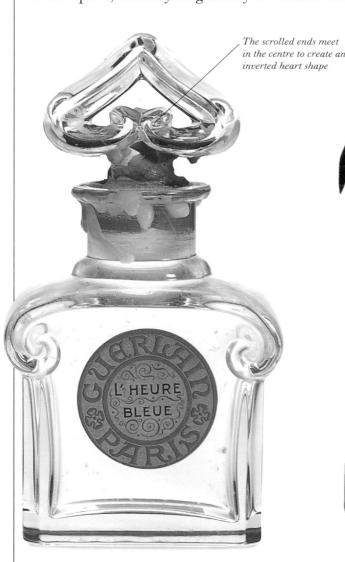

L'heure bleue 1912

In 1912, Pierre Guerlain created L'heure bleue, a blend of roses, irises, vanilla, and musk that was typical of the romantic perfumes produced by this famous parfumier. The Baccarat glass bottle reflects this romanticism. With its inverted heart-shaped stopper, Art Nouveau swirls at the shoulders of the bottle, and delicately drawn label, the design suggests sensuality.

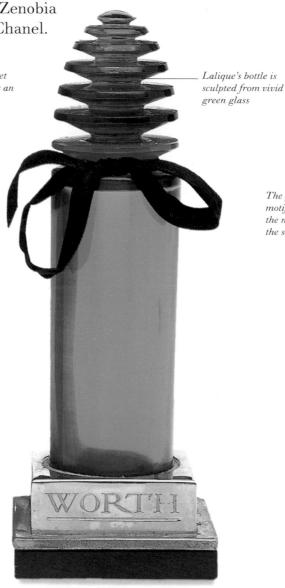

Worth 1920

René Lalique designed this classic, statuesque perfume bottle for Worth. Lalique was a multi-talented designer, sculptor, and jeweller, but it is for his work in glass that he is best-known. He was a prolific designer of jewellery, perfume bottles, vases, bowls, lighting, car mascots, and tableware.

Zenobia pre-1925

The design of this bottle is resonant of nostalgia for the 19th century. Every element is intended to suggest a sweet, natural, floral fragrance, from the rather syrupy name, Sweet Pea Blossom, to the combination of pastel colours used on the label and the pink bow tied around the neck of the bottle.

Jabot 1939

Created by Peter Fink, director of design for couturier Lucien Lelong in Paris, this bottle for the fragrance Jabot is a wonderful flight of fancy. The stopper is finished in the shape of a knotted bow and the base of the bottle resembles the skirts of a petticoat fanned out across the floor.

Lauren 1981

Reminiscent of Chanel N° 5 in its spareness, this bottle by Ben Kotyuk for Ralph Lauren suggests the preciousness of the scent by the very thickness of the glass that protects it.

Elsa Schiaparelli rivalled Coco Chanel as the most famous couturier in Paris in the 1930s. She launched her own perfumes - Shocking, in 1938, and Le Roy Soleil in 1945. The bottle for Le Roy Soleil was designed by Salvador Dalí, with whom Schiaparelli collaborated on several occasions. This poster, which advertises the fragrance, was the work of Marcel Vertes.

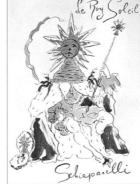

Poster for Le Roy Soleil

The bottle is stored in a container styled as a soup tin

DNA 1993

Just as 1950s' design was influenced by public interest in space travel and science fiction, so the name and bottle design of this perfume reflects the 1990s' interest in genetics. The bottle is shaped like the double helix form of DNA.

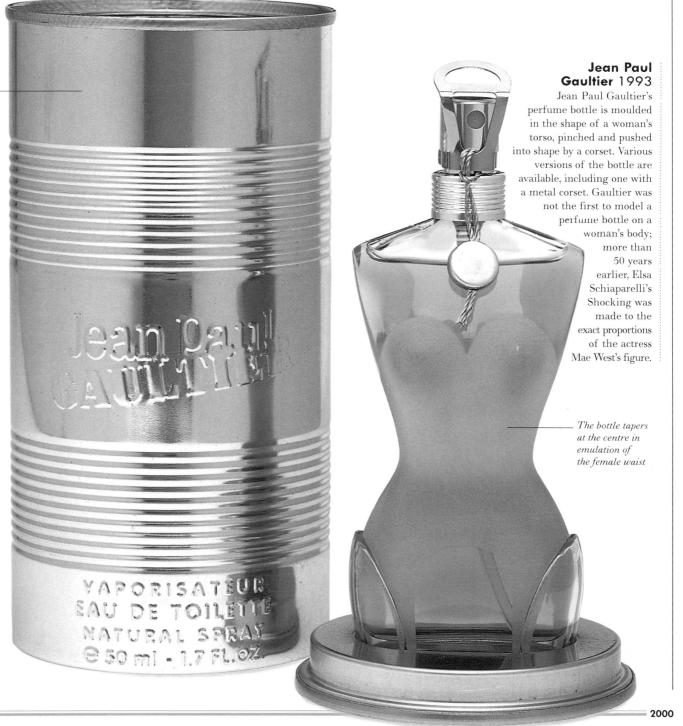

HAIR DRYERS

THE EARLY PART OF THE CENTURY witnessed the introduction of three revolutionary elements in hairstyling: synthetic hair colouring, developed in 1909 by chemist Eugene Schueller, who later founded the L'Oreal company; "the perm", a method of giving hair a lasting curl; and the electric hair dryer. The latter was first designed and manufactured in Wisconsin, US, in 1920, and became one of the most desirable electrical gadgets of the following decades. Early models, including the first hand-held dryers of 1925, were made of aluminium, stainless steel, or chromium. Modern versions, with their proliferation of attachments and sophisticated controls, are invariably produced in plastic.

HMV HD1 1946

0

The bulbous curves of the head and base, and the lack of a projecting nozzle show the influence of streamlining in this design, popular since the 1930s. Unlike the more versatile handheld models, this dryer has its own stand, which enables the user to devote both hands to styling.

Specification

Country: UK Height: 24cm (9½in) Material: Plastic

Annonimination of the second s

The dryer is secured. on an adjustable stand

AEG 1927

(see p. 212).

The chrome-plated dryer pictured on this AEG stamp exemplifies Peter Behrens' view that good products should be practical but elegant. This characterizes all of his work at AEG, including the pioneering corporate identity programme

Supreme 1938

Bakelite offered the manufacturers of electrical goods some excellent advantages. It was relatively cheap to produce, could easily be moulded into shape, and acted as an efficient heat insulator. The Supreme hairdryer, produced by L.G. Hawkins & Co. Ltd., is a fine example of Bakelite design. The pistol-shaped casing is held together by screws, allowing access for maintenance, and the handle can be unscrewed for storage.

Specifications

Country: UK Height: 22cm (8¾in) Material: Bakelite

Specifications

Country: Germany Height: Not known Material: Melamine

This compact, bright red hair dryer was redesigned in 1936 by Herbert Marloth for Siemens-Schuckertwerke AG. The casing is made from the tough, glossy plastic melamine. It has a simple cylindrical shape, with an expanded area to house the electric motor. The case is held together by six screws, which can be removed for maintenance.

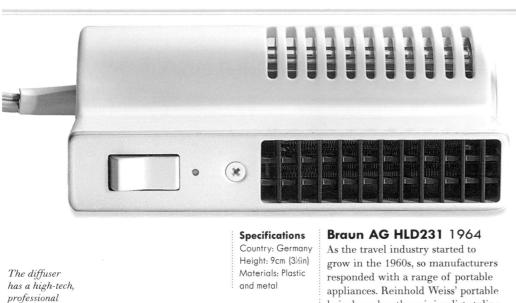

grow in the 1960s, so manufacturers responded with a range of portable appliances. Reinhold Weiss' portable hair dryer has the minimalist styling associated with Braun's personal care products. The case is made from light grey plastic, with a white switch, and the only colour is a single dot of orange to indicate the "on" position.

MEN'S STYLING

"Air Clip", 1970

For many years, hairstyling for men relied either on the skilled scissor control of the barber or on the use of manually operated clippers. When electric clippers were introduced, they ensured a close, precise haircut. This "Air Clip", an unfussy, functional design by Henry Dreyfuss, includes a hose to draw the cut hair away.

Sassoon's name features
prominently on the dryer in
his trademark gold lettering

Vidal Sassoon VS-500UK 1995

Vidal Sassoon is one of the world's best-known hairdressers. He made his name during the 1950s and '60s with his radically geometric hairstyles, and has since expanded into product development. This powerful turbo hair dryer has a 15cm-(6in)-long spiked attachment called a diffuser, or "volumizer", which diffuses air in the hair to give the style maximum body. The black and gold styling successfully suggests value and luxury.

Specifications

appearance

Country: UK Height: 19.2cm (7½in) Material: Plastic

The basic nozzle can be swiftly detached and replaced The handle widens at its base to offer the user a comfortable grip

BEDS

of beds as they have to other items of furniture, yet the bed usually sets the style and tone for the whole room. This is especially true of the elaborate Art Nouveau and Art Deco pieces, represented here by beds designed by Frenchmen Louis Majorelle and Louis Sognot. These imposing forms must have dominated the rooms in which they were placed. The latter's pale green Art Deco bed recalls the first-class cabins of the great ocean liners. A more modest and functional approach to bedroom furniture is

evident in the designs of Kho Liang Ie and Carlo Mollino. More recently, Toni

Cordero's striking Sospir recalls the long tradition of four-poster beds.

The ormolu (gilt bronze) mounts are inspired by floral images

Louis Majorelle was a key exponent of the Ecole de Nancy Art Nouveau style. Unlike their Parisian counterparts, who tended towards abstraction, these designers favoured a literal interpretation of nature. Majorelle's double bed, produced in his factory, displays the flowing lines and elegant carving that earned him such critical acclaim.

Specifications

Country: France
Dimensions: Not known
Materials: Mahogany and gilt bronze

Double bed 1930

Louis Sognot designed the bedroom furniture for the Maharajah of Indore's palace, which was built and decorated by German architect Eckart Muthesius. The materials, symmetry, proportion, and restricted ornamentation of the bed are typical of Art Deco styling.

Specifications

Country: France Dimensions: h 110cm (43½in), w 325cm (128in), I 218cm (86in) Materials: Chromium and glass

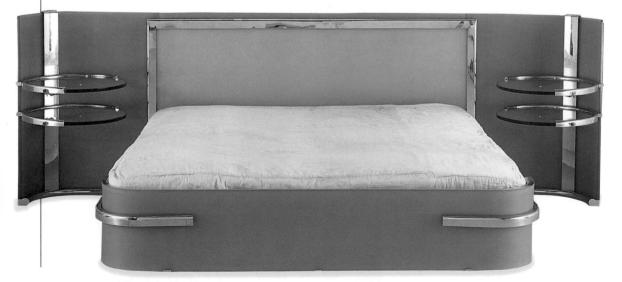

MACKINTOSH BEDROOM

Majorelle's design

uses the grain of the

wood to emphasize

the curves

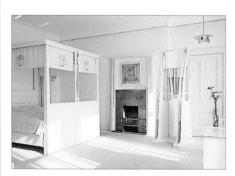

Bedroom at Mackintosh house, c.1906

Charles Rennie Mackintosh designed the entire interior schemes for a small number of homes. This bedroom in one of his own Glasgow houses features his characteristic painted white furniture with Celtic-inspired motifs.

Utility cot, 1942

UTILITY FURNITURE

In Britain, World War II brought about harsh restrictions in the use of raw materials. In response, the Board of Trade established a Design Panel under the chairmanship of Gordon Russell. Its solution to the problem was Utility furniture. Although it aspired to be inexpensive, yet well designed and of a high quality, in reality the furniture was often drab — largely because of the lack of materials. The design of the furniture owed much to the Arts and Crafts movement.

Single bed unit 1970

In this unit, created by Kho Liang Ie, the bed is enclosed by an "L"-shaped surround of painted cupboards and shelves. A fitted light is included in the design.

Specifications

Country: Holland Dimensions: w 165cm (65in), I 198cm (78in) Materials: Marble, wood, stainless steel, and perspex

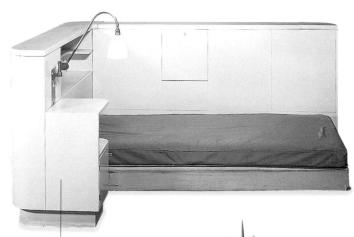

Bunkbed c.1954

Carlo Mollino's simple wooden bunkbed has no decoration aside from the brass fittings. However, two wooden coat hangers have been fitted and there is a small laminated table attached to the lower bunk.

Specifications

Country: Italy Dimensions: h 213cm (84in), w 85.5cm (34in), I 195cm (77in) Materials: Oak, brass, and laminated plastic

The spearlike rods topped with mythical symbols guard the bed

Sospir 1992

Toni Cordero designed the Sospir double bed for the Italian furniture company Sawaya & Moroni. It has a metal and wooden structure with twin headrests, but its most dramatic features are the four corner lances. Made from bamboo, these come with a variety of decorative finials.

Specifications

Country: Italy
Dimensions: h 210cm (83in), w 174cm (68½in),
I 235cm (92½in)
Materials: Metal, wood, and bamboo

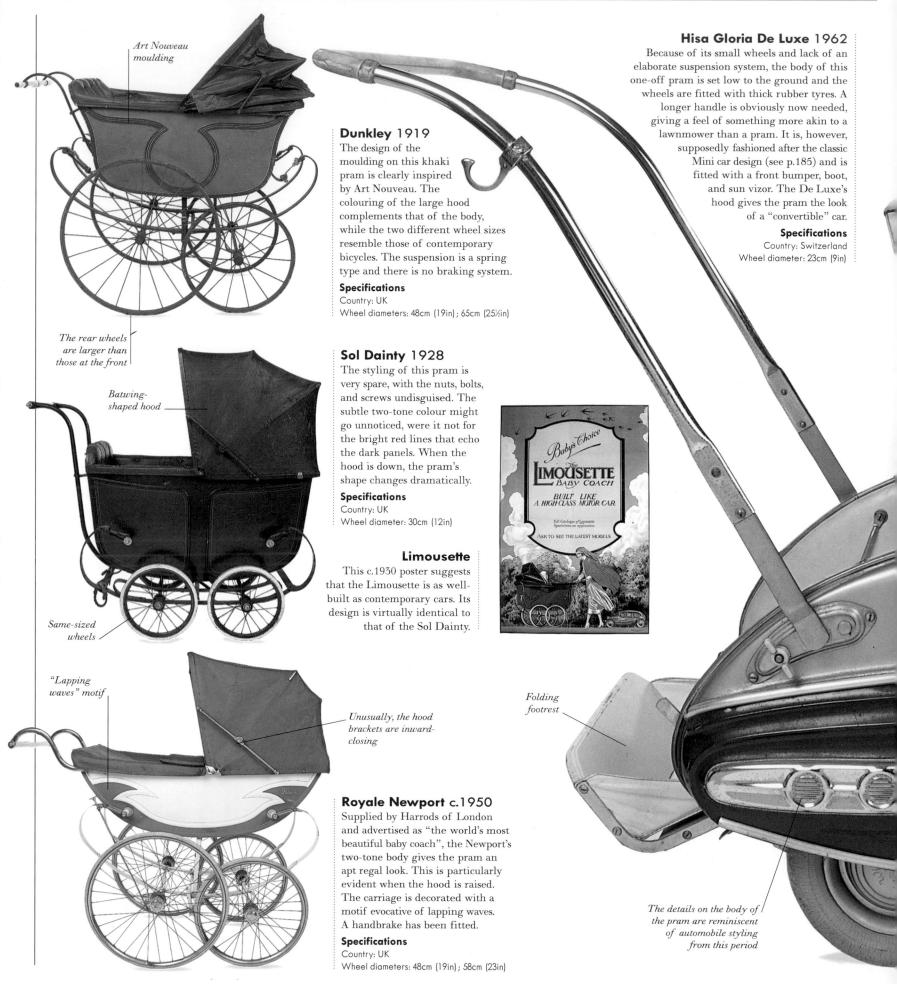

PRAMS

Thick rubber tyres have been used instead of a

suspension system

THE STORY OF BABY CARRIAGE DESIGN in the 20th century is one of remarkably little change during the first 60 years, followed by a radical redesign to adapt to women's changing lifestyles. During the first period, babies and toddlers were usually transported by heavy, bulky perambulators, while smaller-wheeled pushchairs were used for

older children. Everything changed
with the introduction of the

Maclaren buggy, patented
in 1965. This lightweight,
collapsible pushchair
allowed parents to
transport children
much more easily
and could even
fit into a car
boot or the
hold of an
aeroplane.

CONVERTIBLE PUSHCHAIRS

Although heavier and less compact when folded than an E-type buggy, the convertible pushchair offers a convenient means of responding to the changing needs of a growing child. Newborn babies can travel in safety in the carry-cot attachment, and this can be replaced with the bucket-seat for a baby able to support its own head.

BUGGY INNOVATIONS

Owen Finlay Maclaren, a retired aeronautical engineer, sold his first lightweight, small-wheeled, aluminium buggy in 1967. His revolutionary design incorporated two "X"-shaped hinges, which, when folded, made the buggy flatter and narrower. The buggy could be folded with just one hand and one foot, and was a huge commercial success. Later versions (this example is from 1994) have various refinements, including improved brakes, reclining seats, and swivelling wheels.

2000

Maclaren E-type buggy, 1994

Magic lantern c.1900

Projection devices have been available since the 17th century. This lantern was made by Ernst Plank at the turn of the century. Although intended for children, its oil-powered lamp gave little concession to safety.

Specifications

Country: Germany Height: 17cm (6½in) Material: Tin

Clockwork ship 1904

Produced by Bing, this delightful clockwork ship is propelled by winding it up through one of the funnels. It has an adjustable rudder, and a support bracket that allows it to be displayed.

Specifications

Country: Germany Height: 21.5cm (8½in) Material: Tin

TOYS & MODELS

ALTHOUGH BY THEIR VERY NATURE toys and models belong in the nursery, many have also become collector's items for adults, particularly train sets and model cars. These are ingenious designs and by no means mere copies of the original full-scale items. Constructional toys were popularized early

in the century by Frank Hornby, whose Meccano kits were later rivalled by Lego (from the Danish leg godt, meaning "play well").

Steiff teddy bear c.1905

The teddy bear gained its name following US President Theodore (Teddy) Roosevelt's refusal to shoot a bear on a 1902 hunting expedition, prompting a New York toy shop to display a stuffed bear labelled "Teddy's Bear". The cinnamon-coloured bear shown here was made by the Felt Toy Company, which in 1906 became the famous Steiff.

Specifications

Country: Germany Height: 70cm (28in) Materials: Mohair plush and wood-wool stuffing

Noah's Ark c.1900

Noah's Ark, complete with wooden animals, was considered a respectable toy for children to play with on Sundays, because of its biblical connections. The Ark continues to inspire toy designers today.

Specifications

Country: Germany Height: 54cm (211/4in) Material: Wood

Meccano 1910

Frank Hornby's Meccano is one of the century's great success stories. An infinite variety of vehicles and objects could be built using fully interchangeable components. In 1926, coloured parts became available, and, later, electric motors were introduced.

Specifications

Country: UK Height: Not applicable Material: Nickel-plated metal

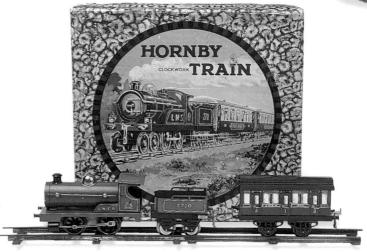

Hornby train set 1920s

By the 1920s, clockwork trains had been in existence for over 30 years, but increased in popularity when Meccano models were widely promoted in toy shops and in *Meccano Magazine*. This model is made from pressed tin, and runs on purpose-built tracks.

Specifications

Country: UK Height: 9cm (3½in) Material: Tin

Dinky cars 1930s

Meccano began to produce small, die-cast model cars in 1933. They were christened "Dinky" after the Scottish slang word meaning "small and neat". An enormous number of vehicles were produced until the company closed in 1980.

Specifications

Country: UK Length: 9cm (3½in) Material: Die-cast metal

Lego 1958

Developed since the 1930s and born in 1958 in the form we recognize today, the Lego brick was designed by Ole and Godtfred Kirk Christiansen. Increasingly specialized pieces have made construction possibilities endless.

Specifications

Country: Denmark Height: Not applicable Material: Plastic

Scalextric 1950s

Designed by Fred Francis, the first Scalextric cars were clockwork. Later, electric motors and hand-held controls allowed the cars to be raced at furious speeds. This track was produced in 1968 by Tri-ang.

Specifications

Country: UK Length of car: 12cm (4¾in) Material: Plastic

Based on the character from the film Forbidden Planet, Robby has a clockwork motor that allows him to walk, and his eyes to flash. A typical 1950s' robot, with his humanoid appearance, Robby was produced by the Japanese company, Ko-Yoshiya.

Specifications

Country: Japan Height: 22.5cm (8¾in) Material: Tin plate

Transformer robot 1980s

These multi-jointed, armoured warriors by Hasbro transform from robots into destructive vehicles. With its seven missiles, the Turbomaster, shown here, reflects the popularity of aggressive, sci-fi inspired toys.

Specifications

Country: UK Height: 18cm (7in) Material: Plastic

Playmobil 1 2 3 1990s

Playmobil 1 2 5 provides a wide variety of brightly coloured, safety-conscious toys for infants, which feature figures, animals and vehicles. More challenging versions are designed for older children.

Specifications

Country: Germany Height: Not applicable Material: Plastic

Power Rangers, 1994

First introduced to enhance the profits of a popular television series, toys based on well-known characters have become an inevitable part of television merchandising. In 1992, the relaunch of 1960s Thunderbirds toys caused so much interest among thirtysomethings that the range sold out with unprecedented speed.

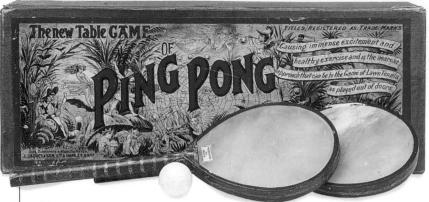

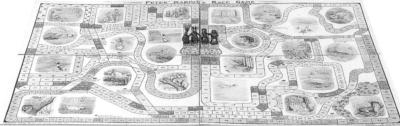

Ping Pong 1905

This game was launched in 1905 by Jacques and Hamley Bros., the name deriving from the sound of the bat hitting the ball. The bats are beautifully crafted using two sheets of vellum, with the long handles shaped more like lawn tennis rackets than the abbreviated modern table tennis bats we now use. The illustrated box promises "immense excitement and healthy exercise".

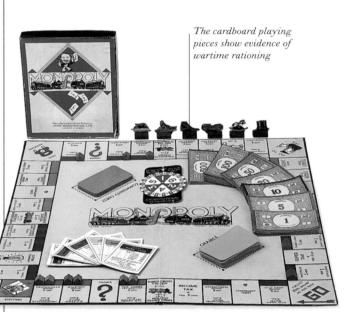

Monopoly 1934

Invented by Charles B. Darrow, Monopoly was based on the street names of Atlantic City. It was successfully marketed by switching the location to any major world city, and is now the world's best-selling copyrighted board game. This British example dates from the 1940s.

Specifications

Country: US Length of board: 49cm (19in) Materials: Cardboard, metal, and plastic

Country: UK

GAMES & OUTDOOR TOYS

THERE IS OFTEN LITTLE to distinguish between adults' and children's games. Board games in particular have long been established as favourites with all age groups; most recently, Trivial Pursuit was designed to test and expand knowledge in an enjoyable format. Other games have been conceived with the purpose of promoting physical exercise and good sportsmanship, the most notable being

Ping Pong, now a recognized competitive sport. Perhaps the most significant change in toy design, and the cause of the greatest upheaval in children's play, has been the arrival of computer games. First seen in the 1970s and now showcases for highly complex computer graphics, these stimulate sharp hand-eye coordination, but have been criticized for encouraging a sedentary lifestyle.

Thick rubber wheels emulate the look of

real racing car tyres

The body of the

car is made of

scrap steel

Modern versions of Subbuteo are issued with a marked-out pitch

Subbuteo 1947

Invented by Peter Adolph, the first game of table football was introduced in Britain in 1947 during severe post-war rationing, and included a piece of chalk and instructions to mark out a pitch on an old blanket. Cardboard players were available in 24 team colours, allowing every child to own his favourite team. Since then, millions of fans have formed special leagues, and even organized a Subbuteo World Cup. This British example by Waddingtons dates from 1995.

Specifications

Country: UK Width of pitch: 64cm (25in) Materials: Fabric, plastic, and net

The rooms of the house are laid out around the board

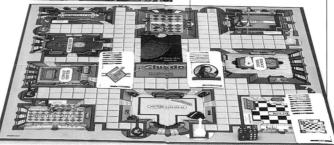

Cluedo 1949

Space Hopper 1950

Devised by Anthony Pratt and designed by his wife in 1944, Cluedo was launched in 1949. The design of this world-famous game differs between countries, although the current British version remains the same as the original. This German set is from 1993.

Specifications

Country: UK Length of board: 49cm (191/in) Materials: Metal, cardboard, and plastic

Pathfinder pedal car 1949

Length: 160cm (63in)

The much-loved Space Hopper was introduced at a time when space exploration was becoming a realistic possibility, and science fiction films were drawing large audiences. The cylindrical ears act as handles for the child, who sits astride the inflated body and bounces.

Specifications

Country: France Height: Variable Material: Rubber

Trivial Pursuit 1982

Designed by Canadian Michael Wurstlin, Trivial Pursuit is played worldwide. Each player answers six categories of trivia questions, filling his or her circular playpiece with a coloured plastic segment at each success. This circular design is echoed on the board.

Specifications

Country: Canada Length of board: 51cm (20in) Materials: Plastic and cardboard

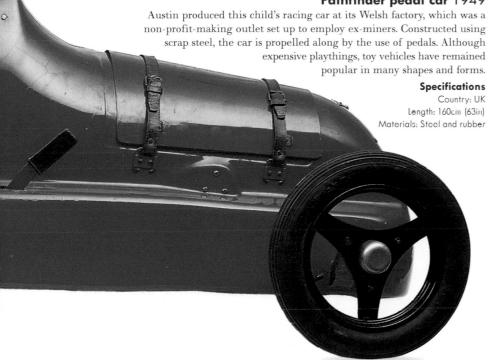

Nintendo Gameboy

COMPUTER GAMES

By the 1980s, advances in computer technology meant that games programmes could be played on hand-held computers, such as Gameboy by the Japanese company Nintendo. The Sony Playstation, formulated

Sony

Playstation

DOLLS

UNTIL THE 20TH CENTURY, dolls were typically modelled on adults, often with elaborate wigs, glass eyes, and eyelashes made from human hair. "Baby" dolls were simply smaller versions, and even after the turn of the century very few dolls were made to resemble real babies — the best-known being George Borgfeldt's Kewpie doll. It was in the 1930s that doll design really took off, with more and more models being mass produced. Baby dolls were fashioned to look increasingly realistic, and to sound and even function like real babies; by the 1960s, dolls could cry and wet their nappies. Adult dolls did not fall out of

Lead weights in the eyelids allow the doll

The Kewpie

trademark is

printed on a

prominent

paper label

to "sleep"

favour. Barbie and Action Man, first popular in the 1960s, have since been redesigned to appeal to new generations of children.

Tyrolean dolls early-1950s

Designed by Käthe Kruse, this pair of dolls was manufactured by the famous German Rheinische Gummi- und Celluloid-Fabrik and both bear the trademark turtle label. The factory also made celluloid heads for export to the UK and US, which would be used on composition or stuffed bodies. Celluloid was cheap, easy to use, and lightweight. Its drawbacks were its flammability, its crushability, and its tendency to fade in light.

Specifications

Country: Germany Material: Celluloid

Downy hair is

suggested by a subtle layer of spray paint

The dolls are beautifully dressed in traditional Tyrolean costume

My Dream Baby is dressed in a cream silk baby robe

Schilling doll c.1900

Relatively large at 60cm (23½in), Stephan Schilling's adult doll is dressed as an English nanny. Parts of the body are made from composition (pulped wood or a paper-based mixture), with upper arms, legs, and mid-torso made from cloth stuffed with straw to allow greater movement. More expensive dolls of the time had a softer stuffing, such as animal hair.

Specifications

Country: Germany
Materials: Composition with straw-stuffed fabric

Kewpie c.1913

Designed by Joseph Kallus and manufactured in the US by George Borgfeldt, this small doll was based on the illustrations of Rose O'Neill featured in the *Ladies Home Journal*. The body and head were cast from liquid clay in a single piece, with arms added afterwards. This is a rudimentary design, with definition of the simple form achieved by the painted finish.

Specifications

Country: US Material: Bisque

My Dream Baby mid-1920s

Manufactured in bisque and composition, Armand Marseille's design is clearly intended to look like a real baby, with chubby legs and a button nose. The arms and legs are moved by means of elasticated string joints, and the large head is painted to give the impression of soft baby hair. Because the facial features were hand-painted, each doll was a unique item.

Specifications

Country: Germany

Materials: Bisque head with composition body and limbs

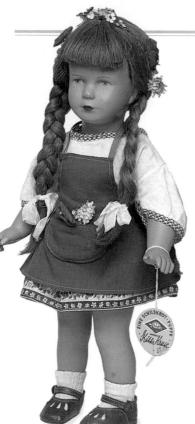

THE CHANGING STYLE OF BARBIE

Probably the most famous of all dolls, Barbie started life in the 1950s as Lilli, after a risqué German newspaper cartoon character. She first appeared as Barbie in 1959. US manufacturer Mattel's designers have been kept busy ever since as Barbie has metamorphosed through fashion changes of the past 40 years. Whilst the early Barbies were highly coiffed, heavily made-up ladies, the modern doll is a younger, wholesome, all-American girl, with open face, wide eyes, and smiling lips. Thirty centimetres (11¹/4in) tall and made from moulded plastic, with nylon hair rooted into the head, Barbie has hard bent arms and rigid legs. However, flexibility is offered in the jointed hips and swivel waist. Barbie's passion for clothes has ensured a stunning variety of outfits and accessories to fill her pink Barbie wardrobe, each reflecting her ever-changing lifestyle.

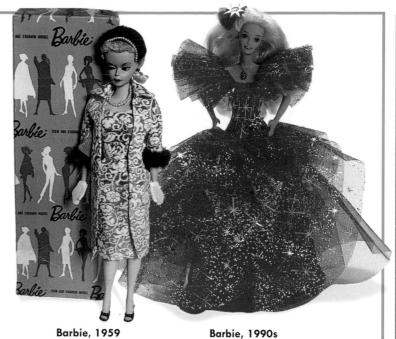

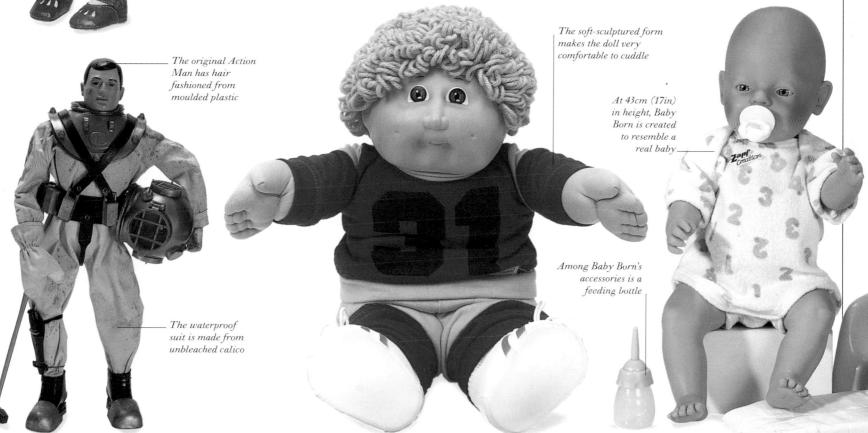

Action Man 1964

First produced in 1964 in response to the realization that boys also enjoy playing with dolls, Action Man – or G.I. Joe, as it was known in the US – was multi-jointed to allow him to be positioned in all manner of soldiering positions. The doll was later re-styled as a "global adventurer", and was most recently updated and relaunched by Hasbro in 1993.

Specifications

Country: US Material: Plastic

Cabbage Patch Kid 1983

Between 1985, when they first caught the public imagination, and 1996, when Mattel updated and relaunched them for a new generation, more than 77 million Cabbage Patch Kids were "adopted" by children across the world. Created by Xavier Roberts of the Original Appalachian Artworks, Inc. in Cleveland, Georgia, each soft-bodied doll has individual physical details that make it unique.

Specifications

Country: US Materials: Vinyl and polyester

Baby Born 1989

Designed by Victor M. Pracas and manufactured by Zapf, Baby Born has proved to be one of the most successful dolls of the 1990s, with over three million sold before 1996. Its lifelike appeal rests in the multitude of "bodily functions", which include eating, crying, and soiling its nappy. Joints at the hips, shoulders, and neck allow realistic flexibilty and movement.

Specifications

Country: Germany Material: Plastic

AROUND THE HOME

Wallpaper

Textiles

Storage

Telephones

Clocks

Vacuum cleaners

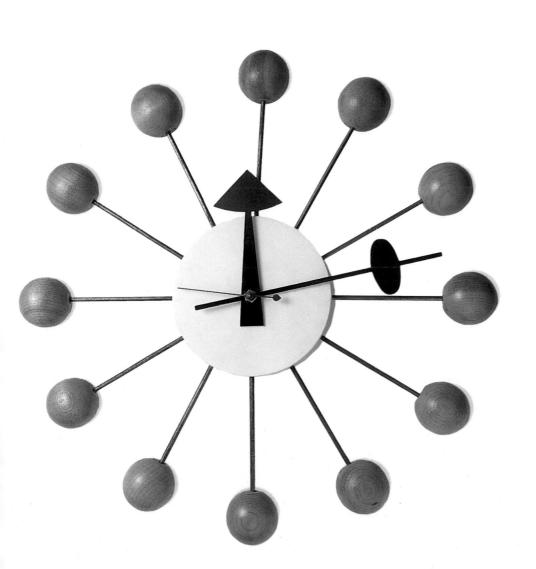

WALLPAPER

SINCE WORLD WAR II, wallpaper producers have been under commercial pressure from the paint industry, which has offered consumers a wide and inexpensive selection of colours in a variety of finishes. In response, new types of wallpapers have been developed, including self-adhesive

paper and, in the 1950s, vinyl paper. To breathe more life into the craft of wallpaper design, manufacturers have frequently commissioned highly respected artists to create compositions for them: these include exuberant floral patterning, science-inspired imagery, and abstract designs.

Block-printed and flocked wallpaper c.1900

Flock wallpaper, with its richly textured finish and appearance of velvet, has been produced since the 17th century. In this example from Züber et Cie, the designer has used a symmetrical floral pattern of red flock over a gold ground.

The Cedar Tree c.1910

This flamboyant design by Louis Stahl was done for British wallpaper manufacturers Sanderson's. The combination of rich colours, fine detail, and solid black ground is a striking one. This paper, hand-printed from carved woodblocks, was still in production in 1957.

Blossom Garden c.1930

Particularly admired for her textile and ceramic designs, Felice Rix was a member of the Wiener Werkstätte and studied under Josef Hoffmann. Her Blossom Garden wallpaper design features a fine pattern of grasses and flowers, machine-printed on an beige ground.

Television 1951

By the 1950s, television ownership was rapidly growing, with over 19 million sets bought in the US by 1952. This screen-printed wallpaper from 1951 represents an enthusiastic response to the new medium. The designer, Mildred Coughlin McNutt, has created an image evocative of the many faces of television – sport, theatre, music, and urban life.

Kyoto Petals 1960

This design by Raymond Loewy was one of several in Sanderson's Centenary Collection. Composed of an abstract pattern of softly coloured rectangles and circles, it was produced in five different colourways. Gio Ponti was also among those to contribute to the collection.

WALLPAPER BORDERS

This illustration from a 1930s' wallpaper catalogue demonstrates the great revival in borders, either block-printed or sprayed, during the 1920s and '30s. Art Deco lent itself particularly well to this form of decoration. First popular in the final decades of the 19th century, borders retained their place on British walls into the 20th century, thanks to the guidance of the Wallpaper Manufacturers' Association.

Vive la Liberté 1972

This composition by the Swiss artist Jean Tinguely (1925—) for the German company Marburger shows freedom from typical imagery in the use of an unexpected sampling of objects found in modern life. These have been overlaid onto a metallic surface.

Laura Ashley wallpaper 1980

This restrained pattern for the Laura Ashley company consists of a small floral motif printed in blue on a crisp white background. The company was founded by Laura Ashley in the 1950s and has developed a range of products that evoke English country life.

TEXTILES

THERE HAS BEEN A PARTICULARLY STRONG LINK throughout the 20th century between craft and design in the development of textiles. Often, the designers themselves are trained weavers or printers, and they bring this hands-on experience to the design process. At the weaving workshops of the Bauhaus, for instance, there was a firm belief in craft-based design being used to support industrial weaving. Painters have also asserted a powerful influence on fabric design. Raoul Dufy has made a direct contribution; the impact of Paul Klee (1879–1940), who taught at the Bauhaus from 1920 to 1931, is evident in the work of Gunta Stölzl, herself an experienced hand-weaver; and the work of Paris-based Ruth Reeves was influenced by her contact with the Cubists. Modern textile designers, such as Collier Campbell, have continued the link with the world of fine art by adopting a distinctly painterly approach to their pattern-making.

Hunting 1920

Raoul Dufy is best-known for his paintings, but he was also an influential textile designer. After studying in Paris, he became associated with the couturier Paul Poiret (see p.142), who set him up in a studio. In addition to the fabrics produced for Poiret, Dufy created bold, decorative textiles, including Hunting, for the Lyons silk company Bianchini-Férier.

Wallhanging 1927-28

In 1927, Gunta Stölzl took charge of the Bauhaus weaving workshop, where she had studied under the Swiss artist and teacher Johannes Itten (1888–1967). His influence is evident in the mixture of textures, shapes, and colours in this piece. Itten encouraged artists to exploit the expressive value of contrasting colours, in this case reds and greens.

Manhattan 1930

Between 1922 and 1928, Ruth Reeves studied in Paris under the artist Fernand Léger (1881–1955), and became familiar with Cubist painting. This influence was later brought to fruition in her textile designs. The cotton print Manhattan was designed for the New York decorating company, W. & J. Sloane. It depicts a lively view of the city, with sky-scrapers, boats, aeroplanes, and factories.

Chevron moquette 1935

Commissioned by Frank Pick, who was responsible for London Transport's corporate identity, this plush fabric was designed by Enid Marx for seating on the trains. Marx produced a number of durable fabrics using tonal variations and abstract patterns of chevrons, stripes, and circles.

Coral Fotexur c.1960

The work of Tibor Reich epitomizes the design concept of the 1950s and '60s. His richly textured and coloured fabrics include designs for Concorde and Lotus cars. The innovative Fotexur system comprised designs, in large repeating patterns, based on Reich's photographs of natural objects.

Spectrum 1969

The prolific Danish designer Verner Panton created this textile for the Swiss firm Mira-X. Its strictly geometric layout is in keeping with the abstract op art movement of the 1960s, which was concerned with optical illusions, often in the semblance of movement.

Surrey textile 1951

In 1949, the Council of Industrial Design initiated a programme of pattern-making based on images drawn from the structure of crystals, in preparation for the 1951 Festival of Britain. The programme, known as the Festival Pattern Group, reflected a growing interest in science. Marianne Straub's Surrey textile, produced by Warner & Sons, is typical of the work produced.

Gabon 1982

French designer Nathalie du Pasquier has designed a large number of fabrics for Memphis, the influential Italian design group. This example uses a series of irregular shapes to make up a complex, colourful pattern. Pasquier's eclectic work draws on influences as diverse as non-Western culture to comic book illustrations.

Côte d'Azure 1983

British designers Susan Collier and Sarah Campbell created Côte d'Azure for their Six Views Collection, which received the Duke of Edinburgh's Design Award. Their work is typified by its painterly quality and use of bright colours. Designing dress and furnishing fabrics for Yves Saint Laurent (see p. 144) and Terence Conran has contributed to their international reputation.

Swedish textile c.1960

Astrid Sampe was head of the Textile Design Studio at Nordiska Kompaniet, Stockholm, from 1937 to 1971. This severely geometric design is typical of Sampe's later work. She described this fabric, with its simple grid coloured with blocks of red, yellow, and orange, as "Mondrianist" in style (see p.33).

STORAGE

PROVIDING SPACE and protecting items in storage are the key priorities for designers of sideboards, shelving units, and wardrobes. However, many of these functional pieces have become objects of desire in their own right. Changes in design ethos can be traced through the century, from Gustave Serrurier-Bovy's wooden cabinet, which communicates the craftsmanship of Art Nouveau, through the tongue-in-cheek exercises of Memphis, to Jane Atfield's Made of Waste shelving, which expresses the environmental concerns of the 1990s.

Fruitwood dining cupboard c.1900-10

A classic example of Art Nouveau designer Serrurier-Bovy's work, this cupboard stores its contents behind geometrically styled wooden doors with brass fittings.

Specifications

Country: Belgium Materials: Fruitwood and brass Height: 203cm (80in)

Edelstahl container 1927

Designed by Marcel Breuer in 1927, simplicity is the essence of these "precious steel" drawers. With the ideals of the Bauhaus behind its design, it achieves a compatibility between art and mass production.

Specifications

Country: Germany Material: Steel Height: 100cm (39½in)

Carlton sideboard 1981

Ettore Sottsass showed his "programmatic" shelving unit-cum-room divider in the first exhibition by his furniture design group Memphis in Milan in 1981. The show created a stir, and this piece has come to be regarded as an icon of Post-modernist design. The substantially sized unit is covered with brightly coloured plastic laminate.

Specifications

Country: Italy Material: Plastic laminate Height: 196cm (77½in)

Twelve-drawer sideboard 1950s

This sideboard is an example of American designer Florence Knoll's work from her most influential period, after World War II. Utilizing new techniques and structures, pieces of furniture such as this classically austere twelve-drawer sideboard were widely imitated. It was manufactured by Knoll Associates, a design group founded by Florence and husband Hans in 1938.

Specifications

Country: US Materials: Steel, wood, and marble Height: 62cm (24½in)

Settimanale 1985

This steel cabinet is the work of Matteo Thun, a founding member of Memphis. Its industrial appearance is typical of "micro architecture", a style characterized by its references to architectural concepts. The diamond-shaped holes are punched out in a geometric pattern.

Specifications

Country: Italy Material: Pressed steel Height: 160cm (63in)

Made of Waste shelving 1994

British designer Jane Atfield set up the Made of Waste partnership in 1992. She uses recycled plastic bottles to produce furniture in a wild mixture of colours.

Specifications

Country: UK Material: Plastic Height: 184cm (72½in)

"MOBILE INFINITO"

Studio Alchimia was founded in Milan in 1976 by Alessandro Mendini and Ettore Sottsass, among others. This wardrobe is part of a major project known as "Mobile Infinito", in which over 30 artists collaborated in the creation of individual pieces of furniture. Mendini's wardrobe has feet designed by Denis

Santachiara (1950–), handles by Ugo la Pietra (1938–), and flags by Kazuko Sato. The decoration, which can be placed

anywhere on the magnetic body, was designed by several artists, including Sandro Chia and Francesco Clemente.

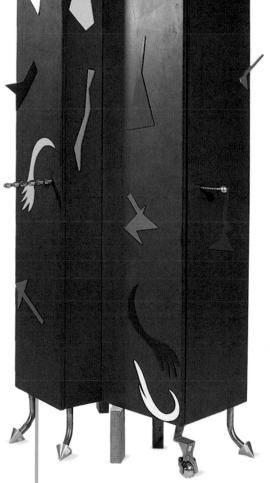

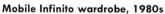

PROGRESSIVE STYLE

The Czech designer Bořek Šípek created this unique "wardrobe" for Vitra. A playful combination of colours and materials, it is capped with halogen lighting. Šípek has said of design: "Tradition is the law of progressiveness; progressive design does not destroy that which was, but rather places it in another dimension".

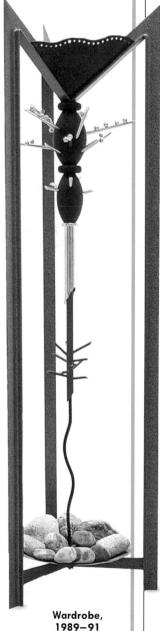

Skeleton c.1900

The hugely successful Skeleton model was first produced in the late 19th century by L.M. Ericsson. This elegant telephone was often finished in high-quality black lacquer and decorated with gold transfers. The ingenious design utilizes the four curved legs to form the magnets of the generator. The working parts are exposed, as are the bells.

Specifications

Country: Sweden Material: Brass/ aluminium

> This Candlestick telephone is unusual in that it has two receivers

Candlestick c.1910

The familiar, classic shape of the Candlestick telephone derives from the practical necessity of keeping the transmitter upright. However, the apparent simplicity of the design is misleading, for the telephone requires a separate bellset - containing induction coil, capacitor, and ringer - in order to operate.

Specifications

Country: US Material: Enamelled brass

TELEPHONES

THE TELEPHONE, INVENTED by Alexander Graham Bell in 1876, is now a common feature in households around the world. Early models were often designed to be wall-mounted, and tended to be cumbersome and over-sensitive. The candlestick was the first successful compact desk telephone, but it was not until the Ericofon of the 1940s that all the components were unified in a single-element instrument. Since then, the use of plastics has given us cheap, lightweight telephones – including the pocketsized cordless models of the 1990s - in a range of vivid colours.

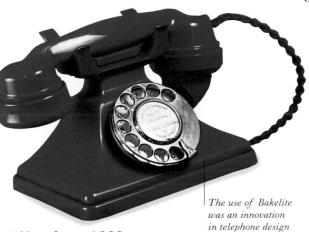

Neophone 1929

Siemens' Neophone, originally made of black Bakelite, was the first completely moulded plastic telephone ever produced. Until its introduction, it was still common for telephones to be made from wood or metal.

Specifications

Country: UK Material: Bakelite

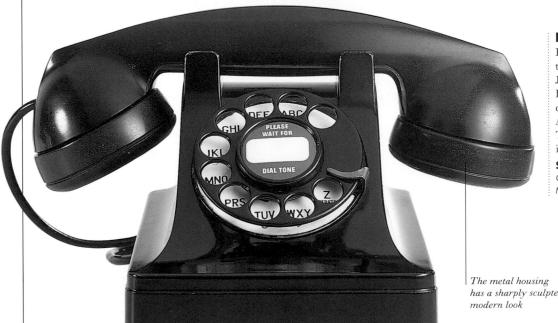

Desk telephone 1937

Inspired by the modern plastic telephone designed by painter Jean Heiberg in 1930, Henry Dreyfuss created this selfcontained metal model for American Telephone and Telegraph. It was later produced in Bakelite or similar plastic.

Specifications

Country: US Material: Die-cast metal

has a sharply sculpted,

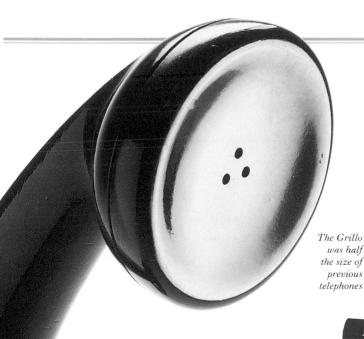

Single-element telephone 1950s

The first single-element (one-piece) telephone was the Ericofon, designed by Ralf Lysell and Hugo Blomberg in the 1940s. The design of this single element model combines sensuality of form with the function of technology: the earpiece and transmitter are contained in a unified plastic body, and the dial is on the base.

Specifications

Country: Sweden Materials: Plastic. rubber, and nylon

> The dial and circuitry are at the bottom of the phone

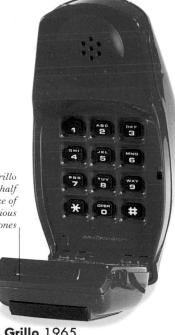

Grillo 1965

The smart, modern-looking Grillo telephone was designed by Richard Sapper and Marco Zanuso in the 1960s; this model dates from the 1980s. It is made from brightly coloured plastic, with either push-button keys or a traditional dial. The mouthpiece and main body are hinged so that the unit can be folded away when not in use.

Specifications

Country: Italy Material: Plastic

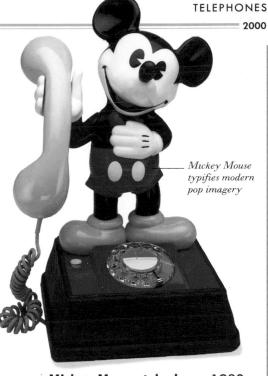

Mickey Mouse telephone 1980

The 1970s and '80s witnessed a departure from the restrictive conventions of the past, and a variety of inexpensive plastic telephones were produced. This Mickey Mouse telephone by the British company Plessey, is lighthearted and fun, and as an item of modern technology, it functions perfectly well.

Specifications

Country: UK Material: Plastic

Swatch Twinphone 1994

This telephone, which can be used by two people at the same time, has a simple shape, but decoration is provided in the form of the internal wiring and electronics.

Specifications

Country: Switzerland Materials: Plastic

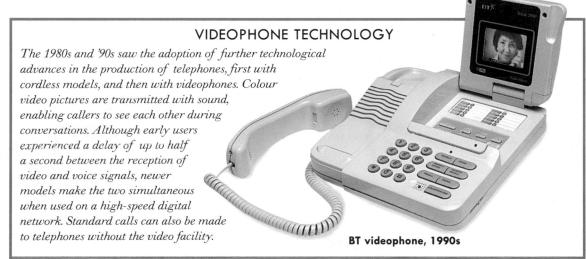

CLOCKS

Grandfather clock 1900

Serrurier-Bovy was one of Belgium's leading Art Nouveau designers. Inspired in youth by William Morris, in later years his work showed a German influence. Key hallmarks evident in this partially restored piece include architectural form, geometric decoration, and subtle use of brass fittings.

Specifications

Country: Belgium Height: 233cm (91¾in) ALTHOUGH A FORM of electric clock had been invented by 1900, the majority of clocks were mechanical, generally encased in wood or metal. Electric models of increased accuracy became popular in the 1920s, but it was not until 1928, with the design of the first quartz clock, that near-total accuracy was possible — the maximum error being one second every ten years. Smaller movements, together with the development of plastic housings, have since given designers greater freedom for innovation.

bells are linked by a slim, curved handle

The two ear-like

Strongly vertical designs were favoured in the 1920s

Cartier clock c.1920

French jewellers Cartier also produced a vast array of clocks. One of the most famous is the Art Deco mantel clock, renowned for its invisible movement. This tiny, exquisite clock is decorated with stripes of gold and white enamel, and has diamond-studded hands.

Specifications

Country: France Height: 8cm (3½in)

Double bell alarm clock 1920s

This modern version of the traditional double bell alarm clock, with ear-like bells, luminous hands, and slender legs, has a common type mechanism. It offers the user the option of waking up to a single ring or a repeat ring every few seconds. Many models also feature a small seconds dial.

Specifications

Country: US Height: 15cm (6in)

Zephyr c.1930

Kem Weber was a proponent of the streamline aesthetic, which characterized much American design during the 1930s. He has applied that principle in the design of this elegant digital clock for Lawson Time Inc. "Zephyr" is both the Greek god of the west wind and the name of the streamlined trains that appeared in 1934.

Specifications

Country: US Length: 20.6cm (8in)

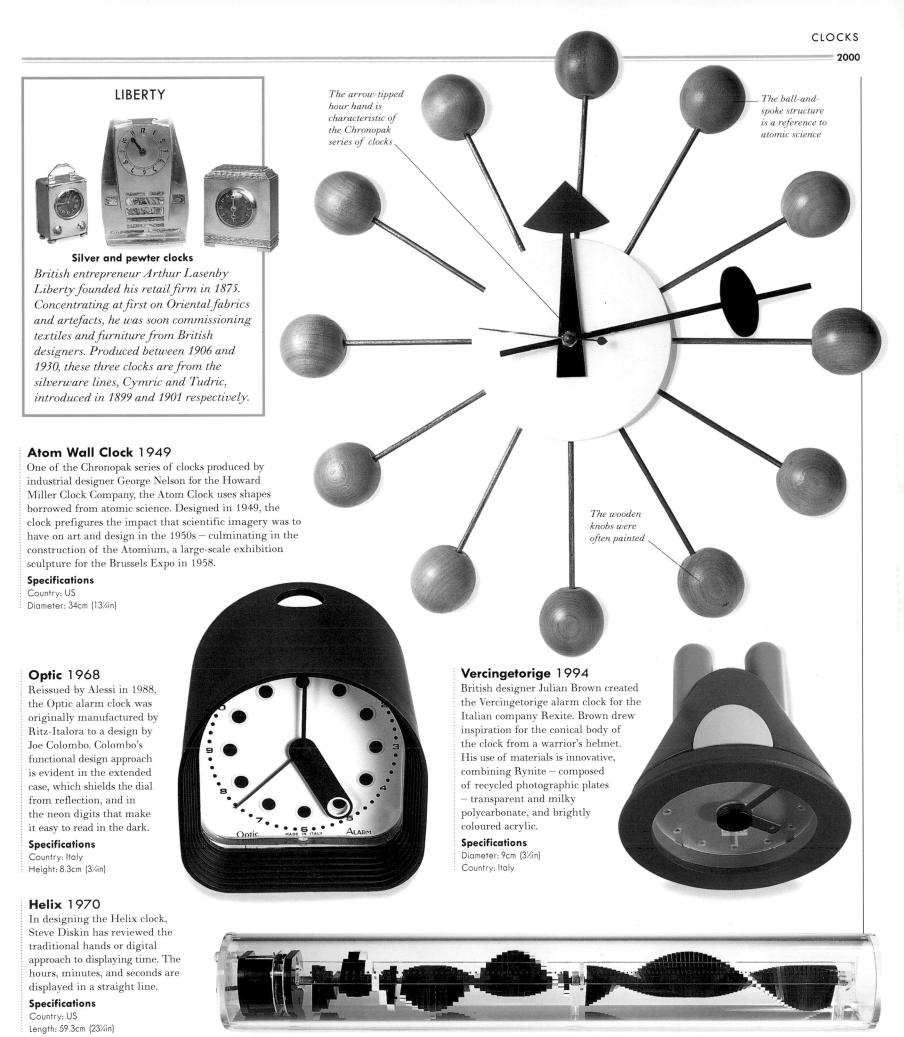

Baby Daisy c.1908

One of many introduced in the 1900s, the Baby Daisy was a hand-operated bellows vacuum cleaner. Although it was cumbersome and difficult to use — one hand pumped the bellows while the other guided the hose — it was an improvement on sweeping. Within a decade, hand-operated machines were replaced by power-driven vacuum pumps.

Nº4

Specifications

Country: UK Height: 100cm (39in)

Baby Daisy was easier

pumped the bellows

to operate if an assistant

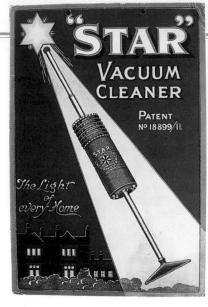

Advertising the Star

The relatively expensive Star cleaner was designed to be lightweight and easy to use: "The Light of Every Home", proclaimed the advertising.

Hoover **700** 1920

In 1916, the American Hoover Suction Sweeper Company introduced an upright vacuum cleaner that became the standard for the next two decades. The cleaner has a canvas bag housing a disposable paper sack in which the dust was collected. Rotating brushes loosened the dust as the cleaner sucked. The angle of the handle to the head could be adjusted; it was connected on swing hinges.

Specifications

Country: US Height: 120cm (47in)

> , The bellows produced sufficient suction to draw up the dust

Although easier to use than the unwieldy Baby Daisy, the Star had to be hand-pumped and was without rotating brushes. Its utilitarian design — no attempt has been made to hide the wing-nuts or rivets — suggests that it was to be kept out of sight when not in use.

Specifications

Country: UK Height: 130cm (51in)

THE BEGINNING OF THE CENTURY saw the demise of the domestic servant, and many middle-class families were responsible for the first time for their own cleaning. This coincided with growing paranoia about the dangers of inhaling the germs in household dust — in 1907, one French doctor wrote: "Dry sweeping and dusting are homicidal practices." Soon, the hand- or foot-operated bellows vacuum cleaners that had been available since the 1890s became essential household items. These were rapidly replaced by electric-powered suction cleaners, developed in 1908 by the American Murray Spangler and financed by William Hoover. For many years, Hoover has dominated the market. Only recently have traditional cleaners been challenged by new technology.

Dyson Dual Cyclone 1986

Not since the introduction of the original Hoover has there been so revolutionary a development in upright cleaner design as the Cyclone. The dust bag has been eliminated; instead, dirt is collected, using G-force technology, in the cylindrical body. Dyson claims 100 per cent suction, even when the cleaner is almost full, because centrifugal spin keeps the airstream clear.

Specifications

Country: UK Height: 107cm (42in)

Vacuum cleaner

This illustration shows a futuristic vacuum cleaner design from 1948, as envisaged by Sixten Sason. He produced a whole series of designs for Electrolux, all of them in the newly popular streamlined style, as championed by Raymond Loewy in the US.

The sleek, cylindrical body gives the cleaner a high-tech, futuristic uppearance

HAND-HELD CLEANERS

Hoover Dustette

The Hoover Dustette is one of many hand-held cleaners designed specifically to dispose of crumbs or pet hairs. Light, portable, and cordless, these appliances are far more convenient than full-size vacuum cleaners for small-scale, precise work. Hand-held vacuum cleaners first gained popularity in the 1960s and '70s as a convenient way to clean car interiors. Many could be powered by the car's battery via the cigarette lighter socket.

Electrolux 1920

Despite the prevalence of the upright vacuum cleaner, the cylinder type continues to challenge it in popularity. Manufactured by Electrolux, the original revolutionary design of 1915 had a horizontal cylinder with cleaning brushes attached to a flexible hose. This enabled the user to clean curtains, upholstery, and fabrics at any height.

Specifications

Country: Sweden Height: Not known

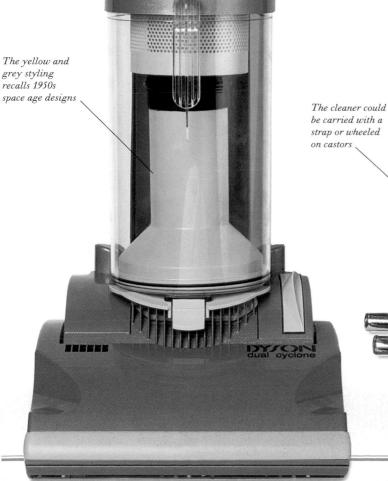

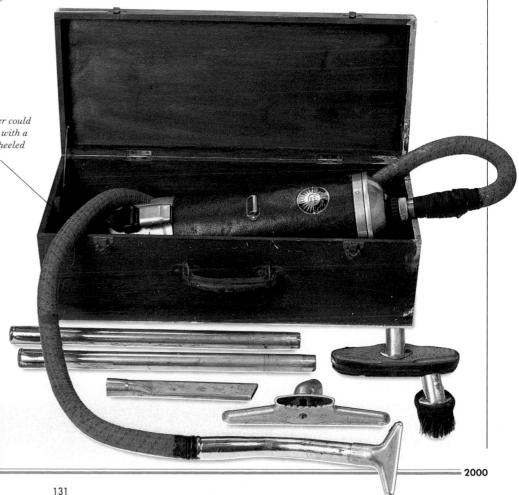

CLOTHING & • ACCESSORIES •

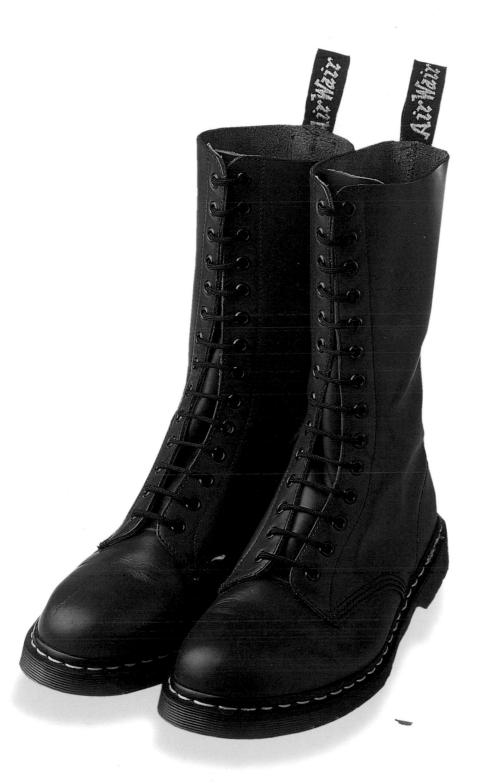

Childrenswear

Women's daywear

Men's daywear

Haute couture

Shoes

Hats

Watches

Fountain pens

Make-up

Jewellery

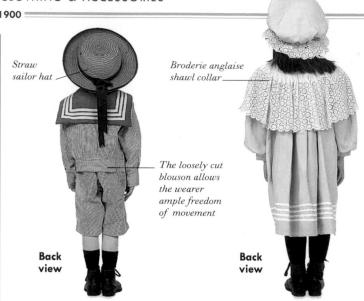

CHILDRENSWEAR

ALTHOUGH THE CLOTHING REFORMS of the late-19th century prompted a relaxation in public attitudes towards children's dress, it was World War I that witnessed the first significant upheavals. Children were taken out of their heavy, formal outfits - invariably scaled-down versions of their parents' and dressed in lighter, plainer, less restrictive garments. When, in the 1950s, an array of new man-made fibres, easycare fabrics, and simpler fasteners emerged, the industry was galvanized anew. The revolution was finally complete with the advent of mass production, when traditional hand-tailored clothes were universally replaced by ready-to-wear outfits.

> The linen suit is trimmed with blue smocking

Straw Panama

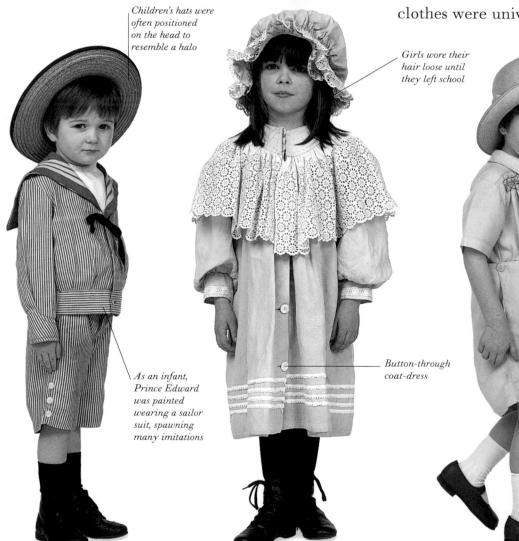

Boys' and girls' daywear 1920s

It was after World War I that children's clothes changed most dramatically and universally. This transformation echoed the radical changes taking place in adult fashion. Lighter, less elaborate garments, including soft collars, jerseys, and socks instead of stockings, were adopted, in contrast to the formal styles of the first decades of the century. Girls wore simple dresses with dropped waists and boys wore updated versions of the skeleton suit - brief shorts buttoned onto a shirt top.

Ankle-strap shoes were worn with ankle socks

Boys' and girls' daywear c.1900

Although children's sailor suits had been available for decades, they came into their own at the turn of the century, when changes in education meant that clothing had to be suitable for the recently introduced gymnastics and outdoor games that formed part of the revised school curriculum. Looser clothing for girls, like this linen coat-dress, began to gain popularity. Even so, it was still customary to wear heavy, lace-up boots and black cashmere stockings.

Shirley Temple

CHILD STAR

In the 1930s, film played a major role in influencing fashion. Nobody had more impact on children's clothes than Shirley Temple. After her debut at the age of three, she was for a decade one of the biggest stars in the US. She acted in films such as Dimples and Curly Top, and the dresses she wore with puffed sleeves and Peter Pan collars - became very popular.

Outdoor clothing 1930s

Matching coat and leggings outfits were popular outdoor wear for young children throughout the 1930s and '40s. They were immensely practical because the leggings were loose enough for dresses to be tucked into them, and they could be zipped or buttoned tightly over the shoes for extra warmth.

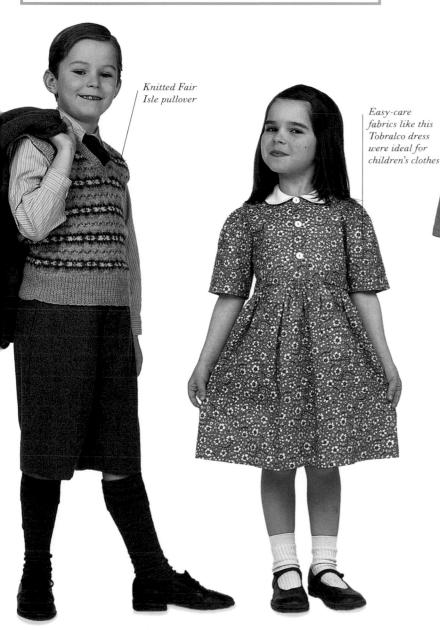

Boys' and girls' daywear 1940s

With the outbreak of World War II children's clothing took on a more practical aspect than previously. Clothes were designed to be comfortable and hard-wearing. Outfits like this doublebreasted suit, worn with a knitted sweater, were common. American styles – including snow suits, knee breeches, and checked shirts – which were to flourish in the postwar years, began to filter into Europe with the parcels of clothes sent from the US to aid war-stricken countries.

The postwar baby boom emphasized the potential market for children's clothing. Outfits for very young children were influenced by adult styles, but subtle changes did start to appear, and slowly their dress began to follow teenage rather than adult fashions. Teenagers were an important market force in the 1950s. They used their new-found income to show off their independence, purchasing the clothes, records, and accessories associated with the new pop culture.

Sandals were popular for both boys and girls

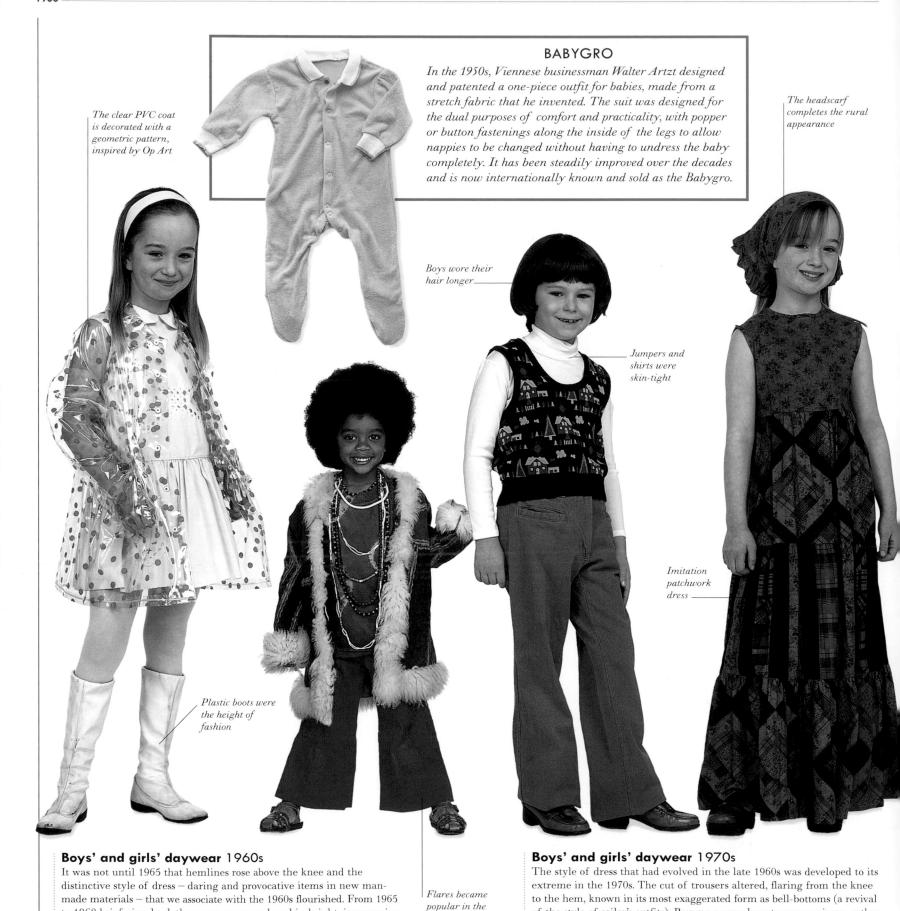

1900 =

to 1968 brief, simple clothes were mass produced in bright, inexpensive

styles, which were ideally suited to the children's market. In the late 1960s, the hippie movement emerged. Developing the experimental

clothing, long robes in natural materials, exotic beads, and long hair.

nature of the decade, hippies encouraged the adoption of ethnic

late 1960s

of the style of sailor's outfits). Boys now wore long trousers or jeans, rather

than shorts, from an early age. There was a revival of interest in crafts,

such as patchwork, which led to the production of patchwork-printed

textiles. Following adult fashions, girls' skirts became longer, and were often worn with frilly blouses inspired by historical or ethnic costume.

LADYBIRD

The history of the Pasold family and its transformation from domestic weavers in the remote village of Fleissen, Bohemia, to mass producers and brand leaders of children's clothing spans 300 years. Two important landmarks in this history were the acquisition of its British plant in 1932, when the company began to shift production from ladies' to children's garments; and the purchase of the Ladybird trademark in 1938. Today, Ladybird clothes are sold throughout the world—its name is used everywhere except in the US and Spain, but the "bug" motif—is universal and instantly recognizable.

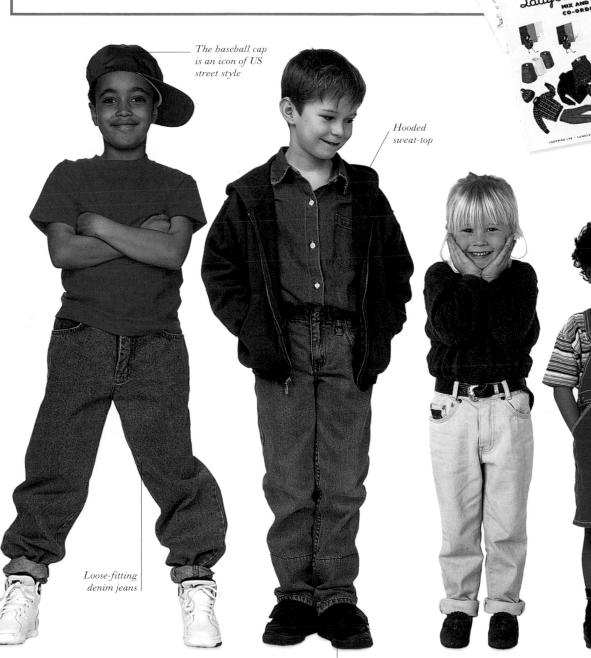

There is no one style that definitively characterizes the 1990s. The number of manufacturers designing especially for children has multiplied and the number of looks available is vast. Many styles or materials have endured or been rediscovered with regular 1950s', '60s', and even '70s' revivals. One children's fashion item that has made a dramatic impact is the training shoe, which has become a billion-dollar industry as companies such as Nike and Adidas (see pp.162–63) vie to persuade the young that their product is coolest.

The sturdy, practical shoe design is enlivened by the decorative trim

Primary colours are perennially popular for childrenswear

Boys' daywear 1980s

The influence of television and video on childrenswear intensified throughout the 1980s. One effect of this was the spread of American styles to Europe; baseball caps and trainers becoming enormously popular. Denim jeans, standard casual wear for the young since the 1960s, returned to a straight-legged shape after the demise of flares.

Quick-release Velcro fastenings are ideal for children's shoes

WOMEN'S DAYWEAR

THE CHANGING VALUES AND ATTITUDES of the century are clearly reflected in the way women dress: the role of women, the permissive society, and the growth of the youth market have all had an impact. In daywear, restrictive full-length dresses, with a multitude of petticoats, have been replaced by clothing better suited to the lifestyles of modern women. New looks are created through a combination of aesthetic judgment, new materials, and the challenging of past conventions.

NYLON

First produced by the Du Pont laboratories in 1938, nylon was named after the cities where it was hoped it would sell, New York and London. This fine, strong, elastic, synthetic fibre was an ideal substitute for rayon or silk. Research was led by Wallace H. Carothers; after his death the patent was awarded to Du Pont.

Carothers testing nylon

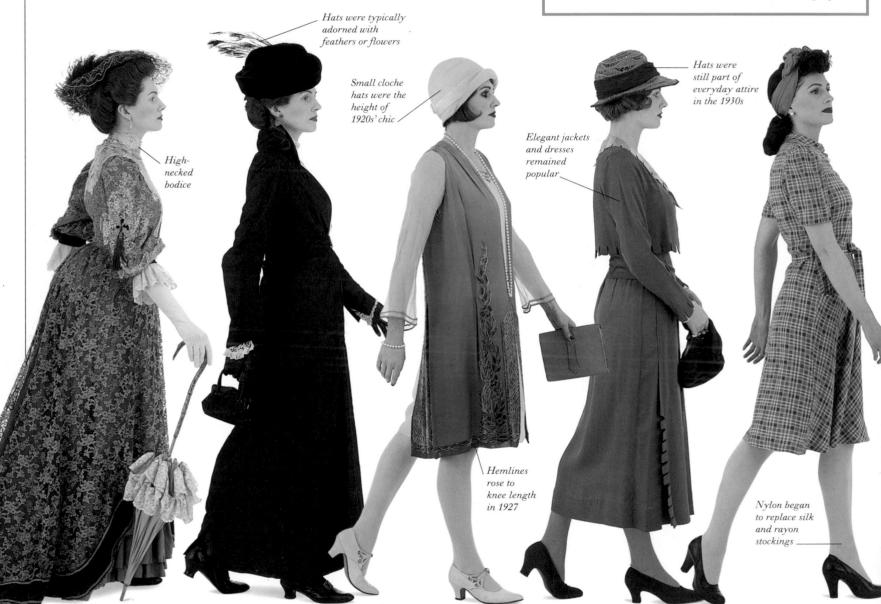

Daywear c.1900

Although less restrictive than the multilayered late-19th-century style, women's dress at the turn of the century, was still uncomfortable. The "S"-shaped silhouette was moulded by a corset, pushing the bust forward and the hips back.

Daywear 1910s

In 1914, Mary Phelps Jacobs designed the brassière — two handkerchiefs with ribbon straps, intended to flatten the bust. World War I brought more women into the workplace, increasing the demand for less restrictive clothing.

Daywear 1920s

In the decade of the tubular silhouette, dresses were shorter, light, and elegant, in silk or crêpe-de-chine, often revealing the arms and back. Beige stockings were worn to suggest bare legs, and rayon provided an affordable alternative to silk.

Daywear 1930s

The Depression influenced fashion in the 1950s. Women's clothes became more sober and the hemline dropped once again. The overall silhouette was more curvaceous. Elegant suits in soft fabrics were popular, often worn with fox fur.

Daywear 1940s

Cloth became scarce during World War II and clothes were plainer and used less fabric than previously. A Utility Scheme was set up in Britain to ration clothes. Nylons were introduced in America in 1940, but were very difficult to obtain in Europe.

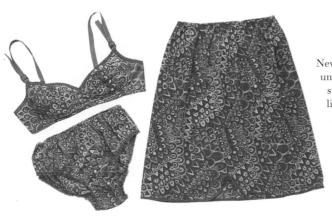

Underwear

New, easy-to-care-for underwear perfectly suited the carefree lifestyles of women during the 1960s. Matching sets of nylon bra, briefs, and half-slips appeared in bold, bright prints.

UNISEX CLOTHING

Although practical, masculine styles had previously been seen in women's sports and casual clothing, it was not until the 1960s and '70s that the gender conventions of traditional dress codes were truly challenged, and unisex clothing gained popularity. Women wore men's trousers, often with braces, waistcoats, and dinner jackets, and adopted jeans and collarless shirts. Meanwhile, men took to colourful, floral patterns and flamboyant styling.

Fashion plate, 1930s

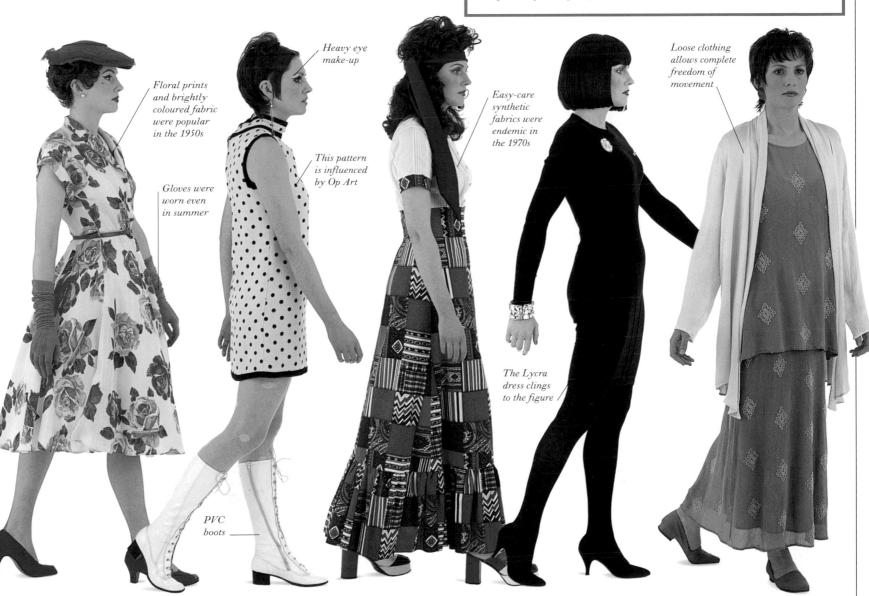

Daywear 1950s

Christian Dior's "New Look" (see p.142), introduced in 1947, had a huge impact on everyday fashion. The tight-fitting bodice, narrow waist, and full skirt gave a curving silhouette. The brassière was padded and wired to enhance the bust.

Daywear 1960s

Although the decade witnessed a multitude of styles, the 1960s will be forever associated with the miniskirt. It was no longer possible to wear stockings and suspenders, so designers experimented with fine-quality coloured and patterned tights.

Daywear 1970s

In the 1970s, fashion designers drew inspiration from a variety of sources: feminism, the hippie movement, and civil rights. Continuing trends set in the 1960s, easy-care synthetic fibres and psychedelic and patchwork patterns were popular.

Daywear 1980s

Clothes in the 1980s were a mix of glamour, body consciousness, and the casual, multilayered look. Lycra, invented in 1958 in the US and previously used only for underwear, gave rise to the body-hugging designs that went with the 1980s' fitness craze.

Daywear 1990s

Unlike previous decades, the 1990s are not epitomized by any single "look"; individualism is the key. There has been a shift in emphasis away from the high achievement that influenced the look of the 1980s and towards a more casual, comfortable style.

MEN'S DAYWEAR

COMPARED TO THE RADICAL changes in women's dress during the 20th century, menswear has appeared more constant in character. The lounge suit, worn at the turn of the century, has undergone changes in material and cut, but remains similar in form to its modern derivative. However, the fashionable male silhouette, like its female counterpart, has been moulded to suit changing social

values and advances in technology. Heavy Edwardian suits and starched collars have given way to separates in lightweight and synthetic fabrics; waistcoats and hats, once essential components of daywear, are now optional extras. The biggest change in men's dress occurred in the 1960s, when young men adopted colourful, casual clothes that challenged strict gender definitions.

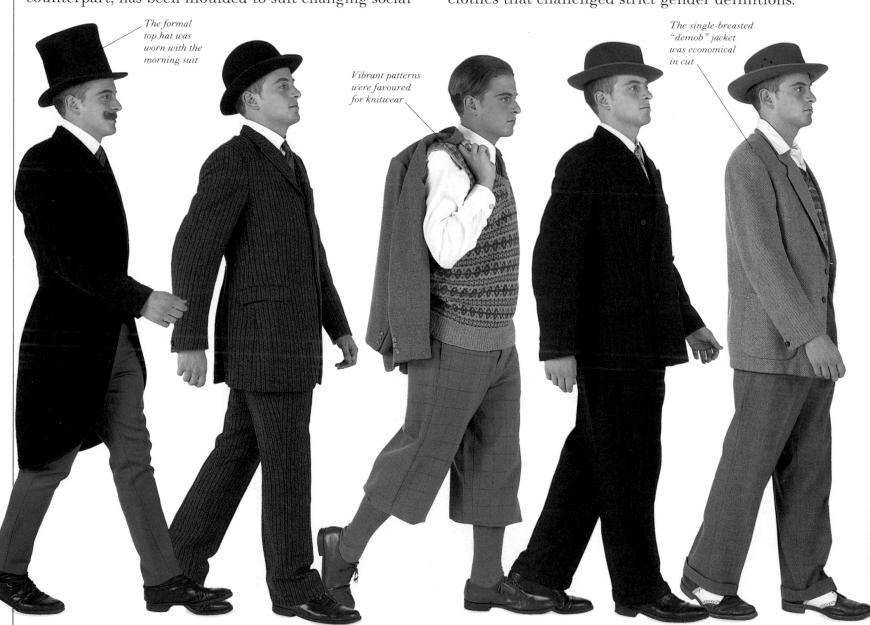

Daywear c.1900

Men's dress did not change instantly with the new century. In the first decade the emphasis was on formality; a frock coat or morning suit was correct daywear, worn with a starched shirt collar that averaged 10cm (4in) high.

Daywear 1910s

By 1910, the three-piece lounge suit (waistcoat, trousers, and jacket), intended as casual dress, was popular daywear for city dwellers. The jacket had small lapels and buttoned high on the chest. It was worn with narrow trousers and a bowler hat.

Daywear 1920s

Equally acceptable on the golf course or as informal daywear, plus-fours became extremely popular in the 1920s. The wide trousers, deriving their name from the fact that they fall four inches (10cm) below the knee, were usually made from tweed.

Daywear 1930s

The ideal male silhouette in the 1950s had broad shoulders and narrow hips. These features were accentuated in the cut of the double-breasted suit, which had padded shoulders and wide lapels. Trouser legs were cut wide with turn-ups at the hem.

Daywear 1940s

It is difficult to identify any definitive style during the postwar period because the lack of raw materials and, in some countries, rationing meant that many clothes were recycled, a concept unheard of before the war.

THE T-SHIRT

In 1942, the US Navy introduced a knitted cotton undershirt with short sleeves and a round collar. It was known as the T-Type because it formed a "T" shape when laid flat. Worn initially by soldiers and marines, it was later popularized by James Dean, who wore one in Rebel Without a Cause, 1955.

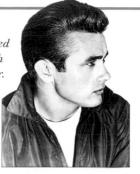

James Dean, 1955

POP CULTURE INFLUENCE

Owing to the immense popularity that followed their first hit records in the early 1960s, the Beatles had an enormous impact on menswear. The collarless jacket shown here, designed by Pierre Cardin (see p.144), was particularly associated with the group. As Beutlemania swept across the world, fans began to mimic the group's style. Although it seems unremarkable now, the "mop-top" haircut, with its thick fringe was considered shocking at the time.

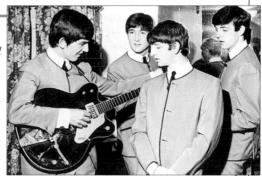

The Beatles, early-1960s

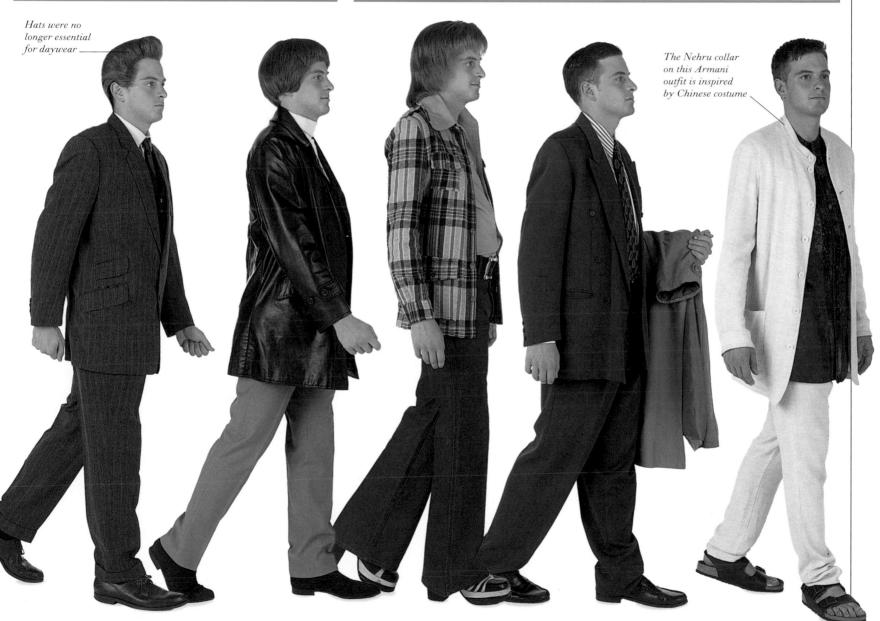

Daywear 1950s

The 1950s saw a steady paring down of the male silhouette. A narrower cut was adopted for suits, with slimmer trousers and a long single-breasted jacket. Known as the drape suit, it was worn in an extreme form by the Teddy boys in Britain.

Daywear 1960s

The male wardrobe underwent a radical transformation in the 1960s. Cheap, colourful clothes were produced for young men and sold in the new boutiques. "Swinging" London, particularly Carnaby Street, was the centre of an emerging pop culture.

Daywear 1970s

The traditional suit was, by the early 1970s, an occasional item of dress for most men. In men's fashion, the decade was typified by casualwear and separates. Hipster jeans were popular, cut tight over the hips and thighs and flaring from the knee.

Daywear 1980s

Menswear took a new direction in the 1980s when, for the first time, high-street chain stores began to specialize in clothing for men. The economic boom led to the creation of a new type of young city gent with a distinctly corporate image.

Daywear 1990s

The mood has swung again in the 1990s, with a rejection of the professional look that characterized the 1980s. Soft, natural fabrics, such as linen and silk, are favoured. Shirts are often worn untucked in a loose, layered style.

HAUTE COUTURE

FRENCH FOR "HIGH SEWING", haute couture was originally clothing for the upper classes — high prices prohibiting all but the wealthy from enjoying its luxury. The growth of ready-to-wear clothing since the 1950s has led to a democratization of fashion: couturiers' designs are revealed on the catwalk and then toned down and cheaply reproduced for the mass market. Now involved in the more lucrative markets of perfume and make-up, the most successful couturiers still produce "one-off" pieces.

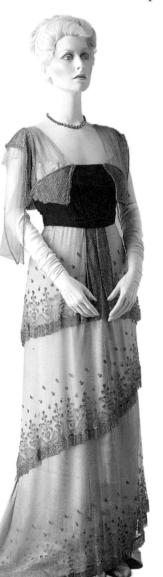

Worth 1910-11

Created by the house of Worth for its 1910–11 collection, this velvet and silk evening gown reflects changing fashion trends. The high waistline and narrow skirt represent a move away from the tightly corseted "S"-bend silhouette of the previous decade.

The tiny waist is the wasp

Christian Dior 1947

The "New Look", presented in Paris in 1947, was Christian Dior's first collection, and it brought him instant fame. After the austere styles of the war years, this elegant, feminine look was a hit with women hungry for something new and glamorous. A narrow waist, tight bodice, and padded hips were features of the "New Look".

The tiny, nipped-in waist is shaped by the waspie corset __

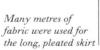

Fortuny 1912

Mariano Fortuny y Madrazo was an inventor, as well as an artist and couturier. The fine pleats of this silk evening gown were created by his own patented process. This dress shows the influence of classical Greece and its timeless design would not look out of place today.

Poiret 1912

Paul Poiret is credited with liberating women from the constraints of the corset. This outfit demonstrates several of his signature features — the kimono-style tunic with wired hem, the raised waistline, the turban, the fur trim, and the richly coloured and embroidered silks.

The high heels and full skirt emphasize the slenderness of the lower leg and ankle /

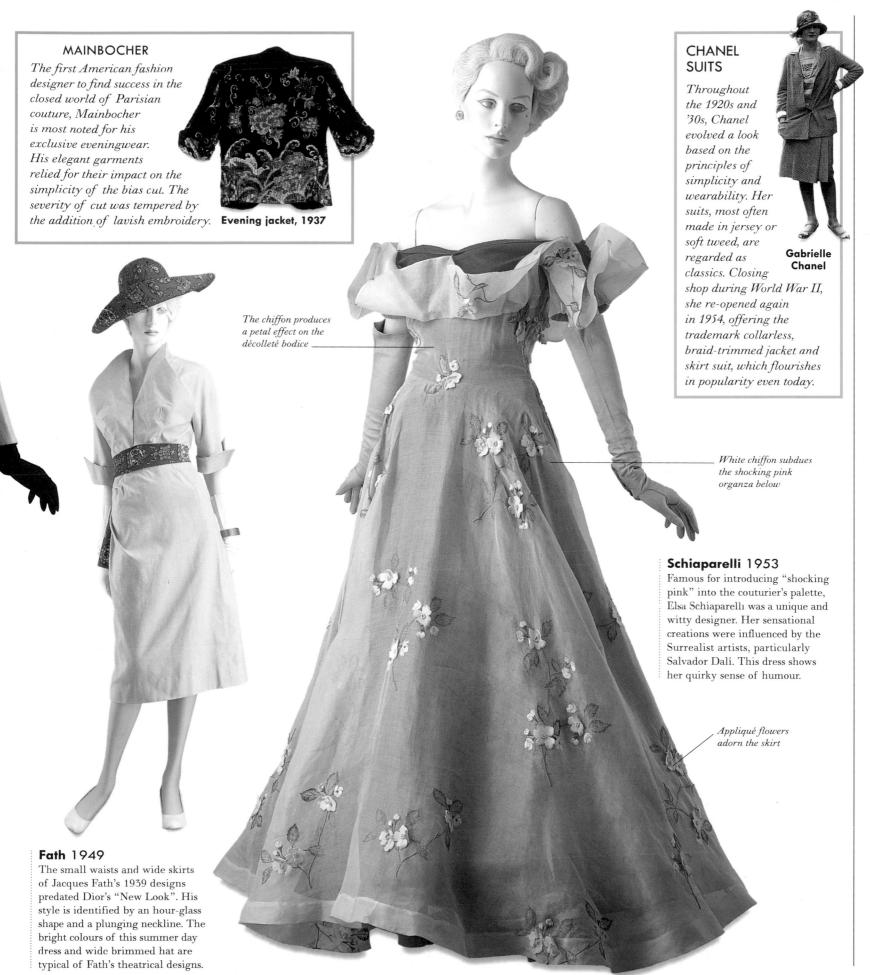

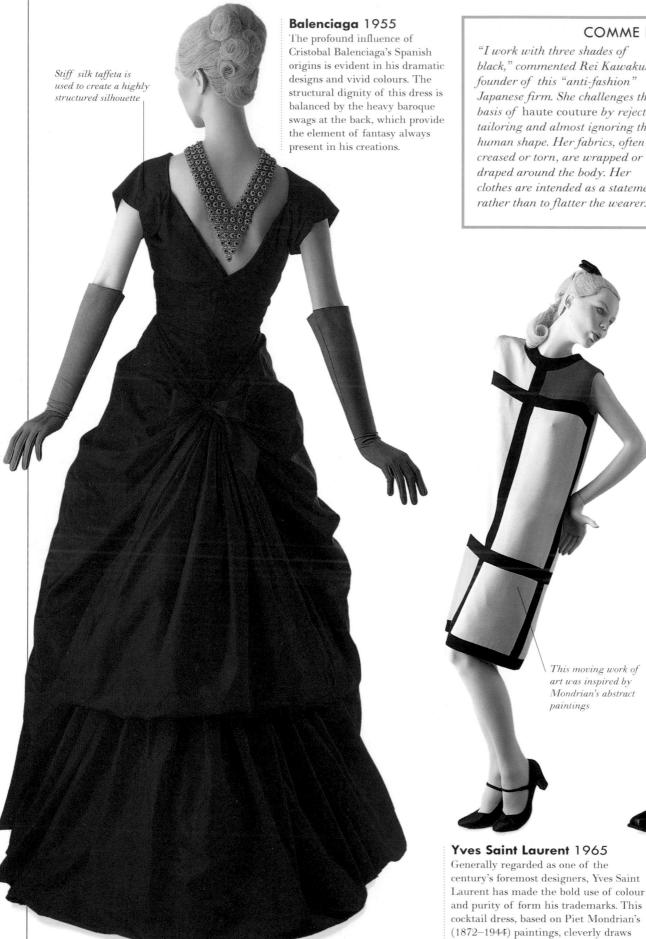

COMME DES GARCONS

black," commented Rei Kawakubo, founder of this "anti-fashion" Japanese firm. She challenges the basis of haute couture by rejecting tailoring and almost ignoring the human shape. Her fabrics, often creased or torn, are wrapped or clothes are intended as a statement rather than to flatter the wearer.

This moving work of Mondrian's abstract

Cardin 1967

Along with Courrèges, the avant-garde Pierre Cardin was labelled a "Space Age" designer for his 1964 show. He was one of the first couturiers to consider men's fashion and to experiment with unisex styles. This outfit uses zips as a design feature, repeated on the boots.

together art and fashion.

Vivienne Westwood 1981

Consistently outrageous but nevertheless influential, Westwood has always looked to the street for inspiration. Her subversive designs including ripped T-shirts, necklines cut under the arm, and dangerously high shoes - do not attempt to approach the traditional concepts of comfort and fit. The Pirate collection of 1981 brought her recognition on the international fashion circuit. This extravagant, multilayered look, dubbed "New Romantic" in Britain, was a maturation of the creative spirit of Punk.

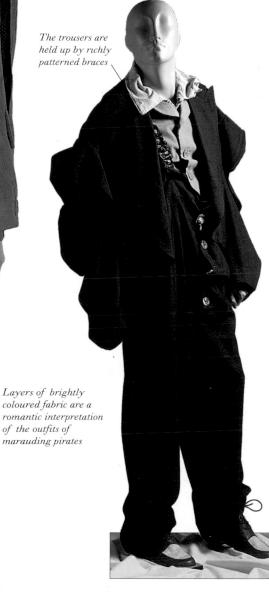

Galliano 1985

John Galliano achieved instant fame with his 1984 college graduation collection. Like Westwood, he takes ideas from diverse sources and reworks them in new and unusual ways. His avant-garde designs are often difficult to understand - with complex fastenings and multiple layers - but his brilliance of cut has won him a lasting reputation.

JAPANESE DESIGNS

designers such as Poiret at the turn of the century, Japan has played a significant role in Western fashion design. The new generation of Japanese designers is undoubtedly the most important influence on haute couture in recent decades. Designers like Issey Miyake are often concerned with concealing, wrapping up, and disguising body shape rather than enhancing it. Garments are designed to show off the beauty of the fabrics, concentrating on texture rather than form. Japanese design has given us greater flexibility in clothing, allowing a freedom of movement often lacking in Western designs.

Ever since the kimono inspired

Kenzo ensemble

MIYAKE AND KENZO Although he received his grounding in the Parisian couture tradition, the success of Hiroshima-born Issey Miyake has been in combining traditional Japanese and African costume to create a loosely wrapped "anti-status" look. He cites the 1968 student revolution in Paris as a formative influence, the event urging him to abandon the restraints of established Parisian couture culture and create less restrictive ensembles for active, modern women. Miyake's compatriot and contemporary, the Kyoto-born Kenzo Takada, has also created an ethnic look, which concentrates on the flow and drape of the fabric. However, he is most

famous for revitalizing knitwear design.

Bead shoes c.1900

These ornate shoes from early in the century combine a high upper with the slightly waisted heel of a court shoe. The pattern cut into the leather is enhanced by an intricate arrangement of tiny steel beads.

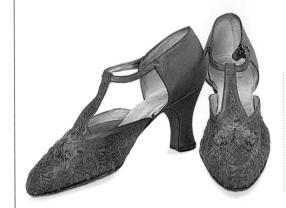

T-bar shoes 1920s

These elegant, highheeled shoes are made from embroidered purple fabric. The bar shoe is the definitive women's style of the 1920s, the T-bar shown here being a variant of the style below.

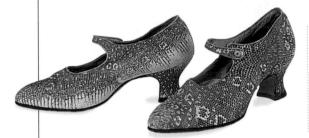

Skin shoes 1920s

Reptile skin has been exceptionally popular in women's shoe design for much of the century. Recently, synthetic copies have developed in response to concerns for wildlife.

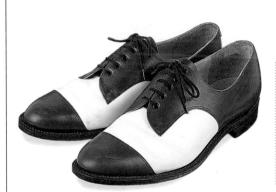

Correspondent shoes 1920s

The two-tone correspondent, or spectator, shoe flourished in popularity during the Jazz era. Primarily a fashion for men, these black or brown and white shoes enjoyed a revival in the 1940s.

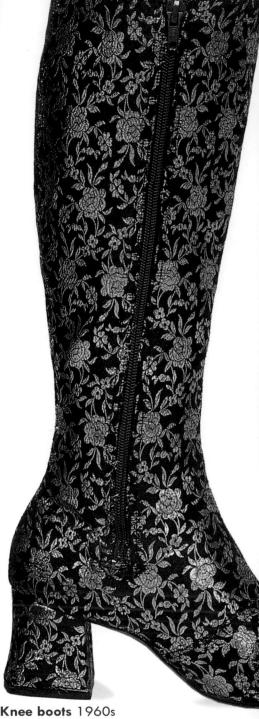

Although boots were originally made to protect the ankles and calves, by the 1960s they had become more of a fashion statement. Produced in leather or synthetic material, they varied in length from ankle to thigh.

SHOES

REFLECTING AND COMPLEMENTING new styles of clothing, shoe design has always been an important branch of the fashion industry. Italian designer Salvatore Ferragamo was one of the first to put new synthetic materials to use, combining cork platform soles with plastic uppers in the 1930s. Another notable Italian innovation, the stiletto, appeared in the 1950s, and has played a controversial role in women's fashion ever since. Elsewhere in footwear, the distinction between men's and women's styles has lessened noticeably towards the end of the century.

SALVATORE FERRAGAMO

The work of the greatest Italian shoe designer of the century, this "invisible shoe" with nylon toe straps was launched in 1947. It followed the legendary cork wedge heel, patented in 1936 and imitated worldwide. The full Ferragamo collection is celebrated in a

museum in Florence.

Invisible shoe, 1947

Crepe sole shoe 1950s

Emerging with the cult of the teenager, crepe soles became popular in the 1950s. These shoes were colloquially known as "brothel creepers", because of their thick, rubbery soles and soft suede uppers.

The stiletto 1950s

Since it was introduced in Italy in 1953, the stiletto has varied significantly in shape. Although originally 5cm (2in) thick and gently tapered, the heel has changed over time to become increasingly tall and pointed.

Winklepickers 1960s

Introduced in the late-1950s, the winklepickers' extreme pointed toes show design influences from as long ago as the 14th century. The name refers to the sharp pin used to pick winkles out of their shells.

RED OR DEAD

Silver boots 1990s

These calf-length silver boots have a central seam running to a pointed toe. The inside zip is a practical fastening that creates a slimline silhouette, emphasized by the stiletto heels.

Chunky platform soles have become icons of 1970s' street style

Silver has risen in popularity as a colour for 1990s' fashions

Ladies' platform shoes 1970s

The celebrated platform soles of the 1970s are a radical version of the 1940s' wedge. Revived as a fashionable, slightly offbeat shoe, they were made from an affordable combination of leather and plastic.

Men's platform shoes 1970

In the 1970s, platform shoes were worn by both men and women. Some soles, as with these men's lace-ups, reached such heights that they posed the danger of broken ankles.

Dr. V air-cu comfe

Women's shoes, 1996

in 1982 by Wayne and Gerardine Hemingway. It began as a market stall in London, growing into a chain of international shops. The label's innovative

Red or Dead was founded

fashions often demonstrate a futuristic, space-age influence.

Dr. Martens 1960-90

Dr. Maertens and Dr. Funck pioneered air-cushioned soles in 1945, as a comfortable solution to shodding Maertens' injured foot. They were an instant success. The 1960s' "1460" shown here was the first Dr. Martens boot, and has remained a favourite.

Top hat 1900s

Introduced in the early years of the 19th century, top hats have varied greatly in height; there has even been the collapsible black silk version designed to fit under one's seat at the opera. Although this cumbersome formal headgear continued to be widely worn until World War I, it had already passed its heyday by the turn of the century.

Velvet hat 1910

This black velvet hat, decorated with feathers and appliqué flowers, is discreet and practical compared to some of the richly ornamented, wide-brimmed hats of the period. It was rare at this time to find a formal ladies' hat without embellishment – ribbons, bows, plumes, flowers, and fruit were all used. Gloves and parasol would be worn to complete the look.

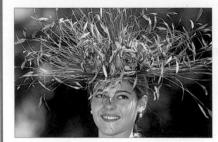

Ascot headwear, 1990s

The annual Royal Ascot horse-racing meeting in Berkshire, England, is a showground for milliners to display their skill and ingenuity. Wildly eccentric creations, which appear to take little account of the wearer's comfort, are paraded for press and public.

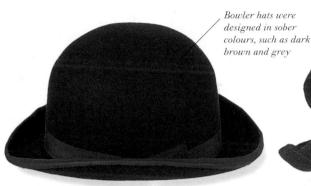

Bowler hat 1910

Originally worn as protective headgear, this hard felt hat with a rounded crown and narrow curved brim was designed by London hatter John Bowler in the 1850s. In the US and Canada, it became known as the derby, after Lord Derby. It gradually replaced the top hat and was still worn by some businessmen until the 1960s.

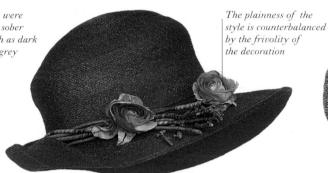

Straw hat 1918

This simple straw hat, with its elegant silhouette, is a typical example of the gradual transition in style from the wide brims and excessively elaborate trimmings of hats in the early 1900s to the close-fitting helmet-shaped cloche hats of the 1920s. It is made of glossy red straw, with the hatband eschewed in favour of a decorative ring of pale pink roses.

Cloth cap 1920

Over the years, the cloth cap has been produced in countless variations, including the Sherlock Holmes deerstalker look and the pioneering motorist style. The brimless peaked cap shown here would have originally been worn by workmen, but enjoyed a revival in the 1960s, when it was designed in a range of brightly coloured PVC and leather styles.

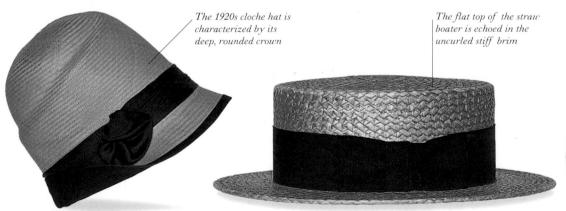

Cloche hat 1920s

This snug-fitting ladies' hat was designed to be pulled low over the forehead and neck. Narrow-brimmed, or even brimless, its shape resembles a bell (*cloche* is the French word for "bell"), which particularly suited the bobbed hairstyles and short permanent waves that were *de rigueur* from 1915 to the mid-1930s. Both cloche and hairstyle were updated in the 1960s and early '70s, led by Mary Quant and Biba.

Straw boater 1920s

The wide-brimmed, flat-crowned straw boater, complete with broad hatband, was originally worn by men for leisure activities such as boating and seaside excursions. Invariably, it topped an outfit of flannel trousers and striped blazer. The traditional masculine style has long since been adopted by women to accessorize casual summer fashions, as well as by girls' schools as part of summer uniform.

Baseball cap 1920s

With its close-fitting crown and deep peak, the baseball cap is instantly identifiable as one of the century's most enduring headwear styles. Caps with stiffened visors first appeared for sport in the late-19th century, popularized and renamed in the US through the game of baseball. Today, the cap is produced in an array of colours and logo-intensive designs, often featuring mesh panels for ventilation.

HATS

THIS CENTURY HAS SEEN SWEEPING CHANGES in both hat styles and in the regularity with which they have been worn. While, at the turn of the century, no self-respecting adult would have ventured outdoors without the appropriate headgear, today formal hats are far less frequently seen. Worn by the majority only at social events, they remain otherwise the domain of the fashion individualist. Nevertheless, all the classics of the century — the men's top hat and bowler and the ladies' cloche and pillbox among them — have been revived and reinterpreted by modern milliners. As far as more casual street style is concerned, the common hat of choice is the baseball cap.

PRINCESS DIANA

John Boyd hat, 1981

The Princess of Wales's style has always been closely scrutinized by the world's media. This John Boyd bowler-inspired hat, complete with oversized feather, was highly influential, spawning countless copies. The hat was designed to suit the hairstyle of the wearer, the brim seeming to flow with the line of Diana's sweeping fringe.

Homburg 1940s

In its smartest form, the ubiquitous men's soft felt hat was known as a Homburg, after the German town where it was first made and worn. It has a narrow, curved brim, high, creased crown, dark band, and braid trim around the brim. Its popularity was largely thanks to the Prince of Wales (later Edward VII), who introduced the Homburg to Britain and beyond.

Black straw hat 1940s

The 1940s saw a move to higher crowns and the emergence of the chic pillbox shape (later to be epitomized by Halston's creation for Jackie Kennedy). Although far less flamboyant than earlier styles, this hat has an unusual curved shape and would have been worn tilted to the front of the liead to display the decoration of pressed flowers.

Berry hat 1950s

This delightful summer piece could be described as all trimming and no hat. It is little more than a skullcap strewn with silk leaves and glass beads for berries. Purely decorative, it would have served no purpose as a shield from sun, wind, or rain. Instead, from an era of unfussy headgear in practical fabrics, it represents a welcome exercise in frivolity.

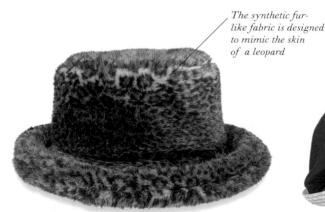

Fake fur hat 1990

While formal millinery plays only a limited role in modern dress, more casual hat styles continue to be worn for warmth and protection. In keeping with the 1990s' concerns for animal rights, this hat is made from fake fur. The silk-lined crown is spacious and deep, with the thick brim designed to be pulled down low over the forehead and ears to keep the wearer warm in cold weather.

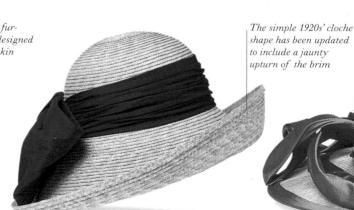

Belgravia hat c.1989

This natural straw and silk hat is made by the Wiltshire-based British milliner Pamela Bromley. Its streamlined shape echoes the cloche hat of the 1920s, with braids of straw stitched together to create a deep, flared helmet. The colourful ruche is of raw, woven Indian silk. Designed to be worn at outdoor summer social events, the Belgravia is also available in other fabrics and colours.

Leonora hat 1995

Also the work of Pamela Bromley, the basic structure of this fanciful creation has been crafted of a woven material made from coconut fibre. The shocking pink and orange decoration is in shot-spun silk, the exuberant loops around the brim stiffened with wire. Intended for appearances at weddings or race meetings, the Leonora harks back to the glamorous wide-brimmed concoctions of the early-1900s.

WATCHES

THE FIRST WRISTWATCHES were manufactured in the 1890s and closely resembled the traditional pocket watch. The idea of strapping a watch to the wrist was not initially favoured, and considered more suitable for women than men. When World War I officers found them more efficient than fumbling in their pockets, this feminine image was dispelled. In the 1960s, electronic advances resulted in the digital watch, with its easy-to-read display and highly accurate time-keeping.

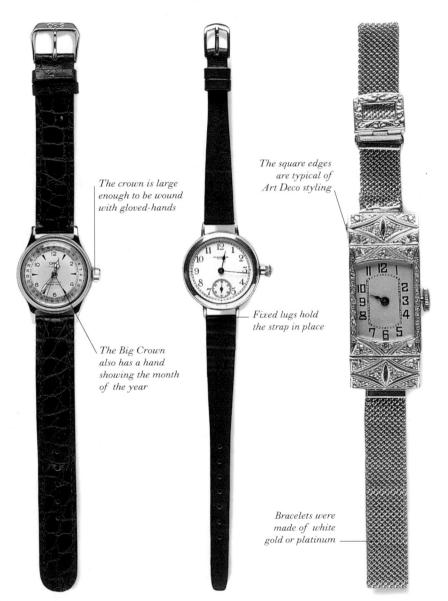

Oris Big Crown 1910s

Named for its oversized winder, the Big Crown was designed to allow World War I aviators to wind it without removing their gloves. It is still produced today.

Specifications

Country: Switzerland Materials: Stainless steel and leather

Waltham 1920s

The bulbous case design of this early lady's wristwatch is little removed from the pocket fob. The miniaturization of movements for small women's watches added to their expense.

Specifications

Country: US Materials: White gold and leather

Cocktail watch 1930s

Ornate cocktail watches were prestigious accessories for evening wear during the 1930s. This Art Deco example houses a Swiss movement in a diamond-encrusted case.

Specifications

Country: Switzerland Materials: Platinum and diamonds

Mickey watch 1930s

This children's Mickey Mouse pocket fob is an early example of a novelty watch. Decades later, the idea of decorated faces was taken to extremes in designs for adults by Swatch.

Specifications

Country: US Material: Stainless steel

Women's Oyster 1930

Pioneered by Rolex in 1926, the Oyster was the first waterproof watch to be produced. Its case was carved from a solid piece of gold.

Specifications

Country: Switzerland Material: Gold

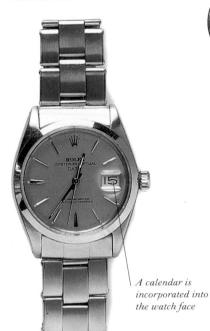

Oyster Perpetual 1965

A twin-lock system seals the winding crown of the Rolex Oyster against water and dust. The Perpetual model winds automatically, working on the movement of the wrist.

Specifications

Country: Switzerland Material: Stainless steel

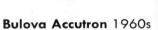

Engineered by Max Hetzel, the Accutron Spaceview was the first electronic watch. Its timebase is controlled by a tuning fork, which was the precursor of the quartz watch.

Specifications

Country: Switzerland Materials: Stainless steel and leather

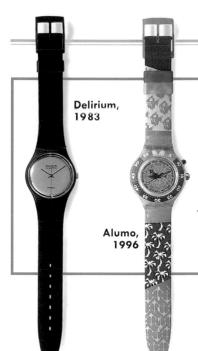

SWATCH

Developed by Ernst Thonke, Jacques Müller, and Elmer Mock in 1983, the Swatch was the first integrated watch, in which the action was not a separate component from the case. The introductory Swatch model, marketed in 1983, was the Delirium, a modest example compared to the 1990s' Alumo, with its brightly patterned strap and face. Swatch has frequently employed artists to create exclusive watches, such as photographer Annie Leibovitz (who made a contribution to mark the 1996 Atlanta Olympic Games) and Vivienne Westwood (see p. 145).

Vivienne Westwood

The digital face includes alarm, calendar, and stop-watch,

At just 1.2cm (/sin) wide, the watch face is a discreet element of the design

2:\$S3:4

DIVER'S WATCHES

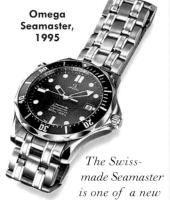

breed of professional diver's watches, and was the chosen timepiece of James Bond in the 1995 film Goldeneye. The self-winding chronometer utilizes the movement of the wearer's wrist, making it unnecessary to wind manually. This stainless steel watch is waterproof to a depth of 300m (1,000ft).

This ring turns to indicate the depths reached by divers

Speedmaster 1969

Devised by Claude Baillodin, the Speedmaster is the only watch to have been worn on the Moon. Rigorously tested by NASA, it can withstand temperatures up to 95°C (199°F).

Specifications

Country: Switzerland Material: Stainless steel

Lasser digital 1970s

Forerunner to the electronic digital, this mechanical version was more common for some time. Its space-age references epitomize the 1970s' vogue for futuristic styling.

Specifications

Country: Switzerland Material: Stainless steel

Gold watch 1970s

From the most affordable to the most exclusive examples, women's watches in the 1970s commonly resembled jewellery. This wide bracelet and small watch-face are typical.

Specifications

Country: Not known Material: Gold

Casio digital 1990s

The combination of quartz powering and liquid crystal display faces revolutionized digital watch manufacturing. Low production costs mean they can be sold inexpensively.

Specifications

Country: Japan Material: Stainless steel

Seiko Kinetic 1990s

An improvement of the Automatic Generating System, introduced in 1988, the Kinetic is one of the most reliable self-winding watches. The need for batteries is eliminated.

Specifications

Country: Japan Materials: Stainless steel and gold

FOUNTAIN PENS

THROUGHOUT THE 19TH CENTURY, designers experimented with ways to improve dip-pens, until then the standard writing instruments. By 1900, the main principles for a successful fountain pen had been established: a reservoir for ink; a filling system; and a method of supplying ink to the nib. Finding the most successful combination has provided a constant challenge, with three American companies -Parker, Waterman, and Sheaffer – dominating the market. The design of the fountain pen has not relied solely on the demands of engineering, for aesthetics have also played an important role. The look of a pen, its size, weight, colour, and the materials used in its construction all contribute to its success. Despite the ascendency of the cartridge pen and ball-point pen, the nostalgic tastes of the late 20th century ensure the continued desirability of the fountain pen both as collectible item and functional tool.

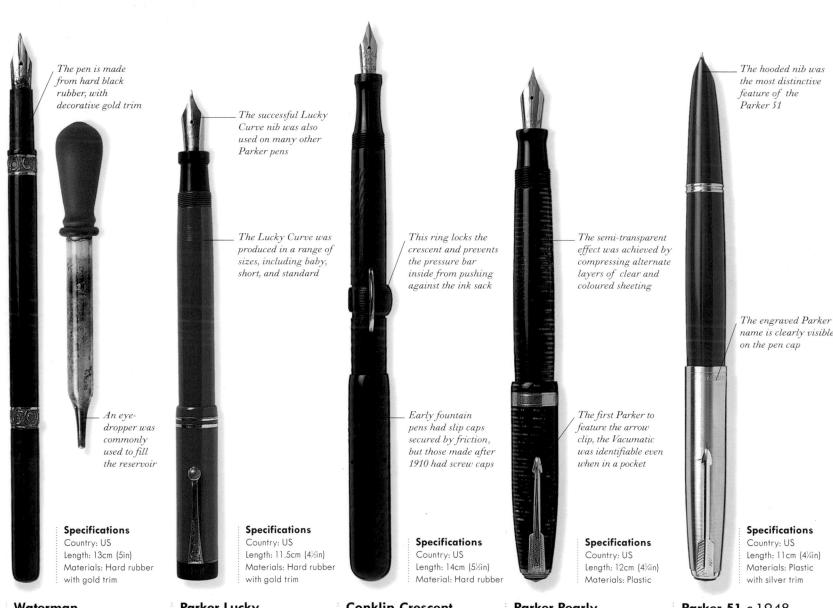

Waterman Eye-dropper c.1903

Fountain pen pioneer Lewis E. Waterman began his successful company by patenting an improved feed design involving fine grooves under the nib. This was incorporated in this early Eye-dropper pen.

Parker Lucky Curve c.1916-23

To prevent fountain pens blobbing ink onto the paper if left lying horizontally for some time, Parker developed a feed that channelled the ink back into the reservoir. This was used for pens such as the Lucky Curve.

Conklin Crescent Filler c.1923

Conklin's crescent filler system, patented in 1901, was copied by all the major pen manufacturers in the world. Air is expelled when the crescent is pressed, and ink drawn into the sack when it is released.

Parker Pearly Vacumatic c.1935

As famous for its fine appearance as its technological innovation, Parker's Vacumatic design introduced a rubber diaphragm to replace the traditional sack, as well as new mechanisms to suck up the ink.

Parker 51 c.1948

Marking the 51st anniversary of the company's foundation, the Parker 51 inspired a fashion for slim, elegant pens with hooded nibs. None emulated the commercial success of this original, which was still in production in the 1960s.

SNORKEL FILLING SYSTEM

One of a succession of filling systems developed this century, Sheaffer's snorkel method uses a thin tube, which emerges from the underside of the hooded nib when the user turns the knob at the end of the barrel. The tube is then dipped into the ink and, by extending and contracting the plunger, ink is drawn into the rubber sack. The nib remains Sheaffer dry throughout the process. Snorkel pen

PARKER PEN COMPANY

Born in the US in 1863, George S. Parker worked as a school teacher, selling fountain pens to his students to supplement his income. As the school pen repairman, he mastered the inner workings of the pens and decided to put his knowledge to commercial use. His first major success arrived in 1892, when he designed the Lucky Curve pen. Subsequent coups have included the massproduced Vacumatics. As the century draws to a close, there is a growing nostalgia for old-fashioned writing tools, and pre-1920s' Parkers are among the most valuable of collectible fountain pens.

George S. Parker

The pen can be filled without the need to submerge the nib in the ink The Pen for Men was designed with a wide, supposedly masculine-shaped barrel **Specifications**

Sheaffer Pen for Men 1960

Walter A. Sheaffer's 1907 lever filler - widely used for the next 40 years - established him as a leading figure in pen design. The Pen for Men uses the Snorkel system (see above), introduced in the 1940s.

Country: US

Length: 11cm (41/4in)

Material: Plastic

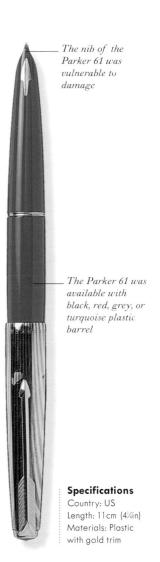

Parker 61 1956

Although similar in appearance to the Parker 51, the 61 model incorporates an unusual filling system using a new ink called Super Quink. The ink cell, not the nib, is immersed in ink, which is drawn into the cell by capillary attraction.

The white star represents the snow-topped mountain Mont Blanc Long at 13.25cm (51/4in) and wide-barreled, the Montblanc is a solid. weighty pen **Specifications** Country: Germany Length: 13.25cm (51/4in) Materials: Plastic with gold trim

Montblanc 149 Masterpiece c.1970

The Masterpiece pen dates from 1924, with this 149 model introduced in the 1970s. The figure 4,810 engraved on the nib refers to the mountain's height and symbolizes the company's high standards of craftsmanship.

Parker 180 c.1980

This pen is called the 180 because, by turning it 180 degrees, the user can achieve a fine line with one side of the nib, and a thicker one with the other. The pen originally had a 14k gold nib and often a lacquercoated barrel with gold trim.

The twin-headed

nib produces both

With its diamond

pattern etched into

barrel, the pen was

designed to appeal

Specifications

Length: 11cm (41/4in)

Country: US

stainless steel

the gold-plated

to women

thick and thin lines This Duofold from 1929 features the early pocket clip The glossy red colour recalls the lacquered colour of the original Duofold Specifications Country: US Length: 14cm (5½in) Materials: Gold-plated Material: Rippled rubber/acrylic

Parker Duofold 1929; 1994

In keeping with 1990s' tastes for retrospective styling, Parker has relaunched its 1920s' Duofold. The original could be converted from pocket pen to desk pen by replacing the blind end cap with an extension to the barrel.

MAKE-UP

"AT TIMES THE URGE to improve one's appearance, even if only temporary, becomes too strong to resist" (Vogue). Through the ages, both men and women have searched for ways to enhance their appearance using artificial aids. The first decade of the 20th century, when the use of cosmetics became widely accepted, is

regarded as the heyday of the beauty palour. A further democratization of the cosmetics industry occurred after World War I, as women's looks attained a more classless appearance. Before long, new looks were created as women studiously copied the hair and make-up styles of glamorous film stars. The 1950s heralded a new era for the cosmetics industry, which turned its attention to a younger clientele, seducing them with novel packaging and seasonal ranges.

Eye make-up c.1930

The dramatic eye make-up used by actresses and film stars had a profound influence on everyday make-up in the early decades of this century. Diaghilev's Ballets Russes, which arrived in Paris in 1909, had a lasting effect on cosmetics. The dancers' exotic eye make-up created a vogue for coloured and gilded eyeshadows, and heavy use of mascara.

Pastel compact by Bourjois 1928

A growing demand for novelty in cosmetics encouraged manufacturers to introduce new beauty products to the market. Bourjois offered compacts with complementary rouges and lip colours. Vivid lip dyes, applied with a brush, gained in popularity after World War I.

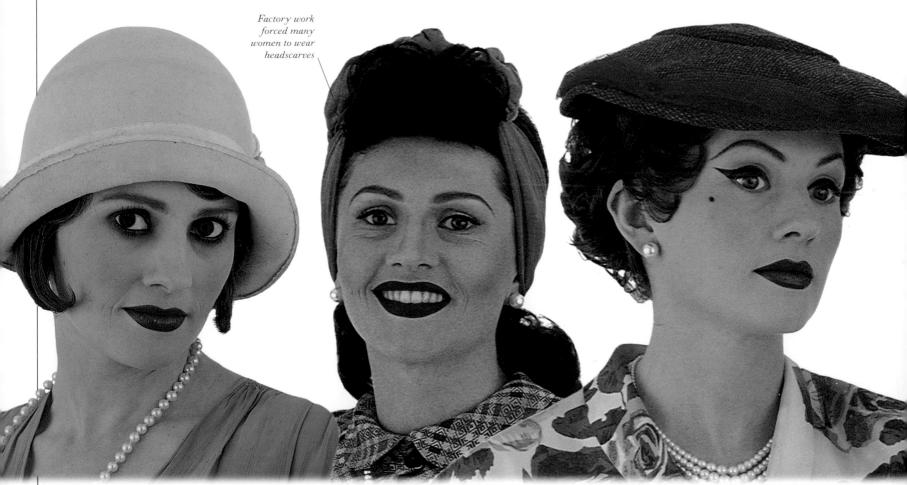

The Jazz Age 1920s

Lipstick made its debut in the 1920s. The lips were painted to resemble a cupid's bow, in vivid shades designed to shock. The look to aim for was radically cropped, smooth, bobbed hair; kohl around the eyes; severely plucked and pencilled eyebrows; and a white complexion. Beauty spots were also pencilled in.

Wartime cosmetics 1940s

During World War II, make-up was in short supply, for the petroleum and alcohol used in its manufacture were required for war purposes. Cosmetics were good for feminine morale and many women improvised with homemade substitutes. Deep red lipstick, available on the black market, was worn with matching nail varnish.

Hollywood glamour 1950s

There was a return to a more feminine look after World War II. The eyes were emphasized by shorter hairstyles and by the exaggerated use of black eyeliner on the upper lids. Liquid eyeliner, which was applied with a brush, replaced the pencil, and a variety of new products aimed at a younger market was launched.

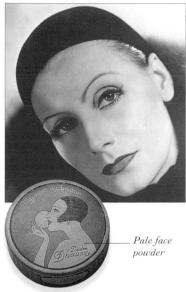

Greta Garbo 1930s

The sophisticated look of film star Greta Garbo was widely emulated by women in the 1930s. Garbo wore a very pale face powder with no rouge, and accentuated her eyebrows and eyelids with pencil, rather than using tinted eyeshadow.

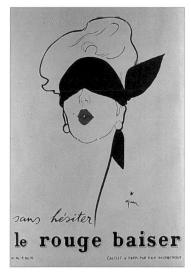

Red Lips 1949

This provocative poster, by René Gruau reads "the red kiss". Colour is confined to the lips, which when contrasted with the monochrome illustration has a stunning impact.

Audrey Hepburn 1956

The gamine charm of Audrey Hepburn captured the imagination of cinema audiences worldwide when she made her film debut in 1953. Her short hairstyle accentuated her fine features and her large, dark eyes, which were painted with black cycliner. She wore pale lipstick, presaging the fashion of the 1960s, and her eyebrows were left unplucked.

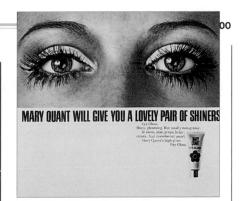

Mary Quant 1970

To complement her fashion collection, in 1966 Mary Quant launched a range of cosmetics. The products were strikingly packaged in black and silver, with the famous daisy logo. The lipsticks shown here date from the 1990s, indicating the enduring popularity of Quant's products.

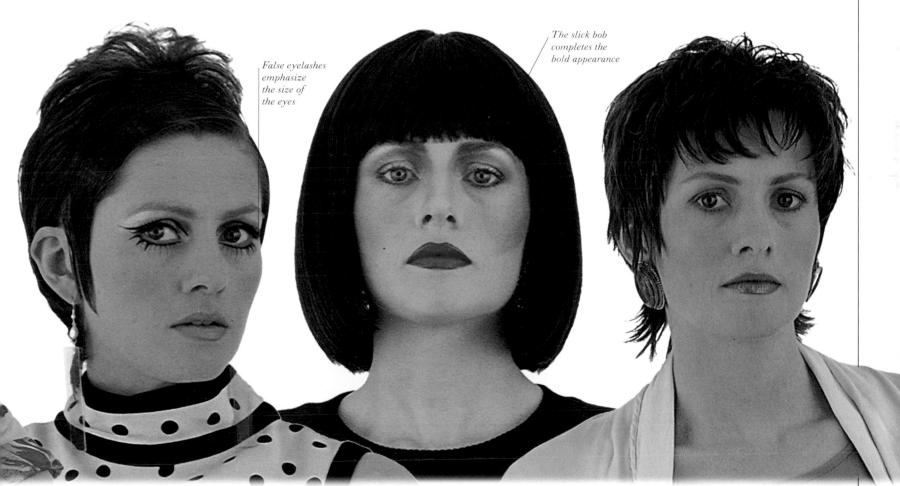

The cult of youth 1960s

During the 1960s, cosmetics manufacturers increasingly concentrated on the teenage consumer. Inspired by the Continental look, girls used pale pink or white lipstick and heavy eye make-up. Cosmetics that were quick and easy to use, such as powder compacts and mascara in tube rather than block form, were favoured.

Career woman 1980s

A new type of young, urban careerist emerged during the economic boom of the 1980s. This was reflected in cosmetic fashion by a more assertive look, with bold definition of facial features. Manufacturers stressed the longevity of their cosmetics to appeal to women too busy to reapply make-up throughout the day.

The natural look 1990s

Subtlety is the key to applying make-up in the 1990s. Artful application of cosmetics may give the impression of not actually wearing make-up at all. The names of cosmetics hint at the clinically tested ingredients and indicate a move away from the glamour of the early-20th century towards a purer aesthetic.

Buckle 1904

The Danish silversmith Georg Jensen was well-known for the quality of his craftsmanship, and his impeccable standards are evident in this fine buckle. It is centred on a large piece of agate, which is surrounded by smaller, symmetrically positioned amber and peridot stones.

Specifications

Specifications

Country: The Netherlands

Country: Denmark Materials: Silver, green agate, amber, and peridot

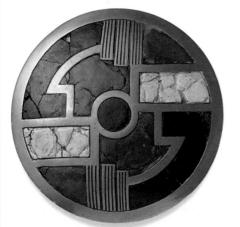

Art Deco brooch c.1925

This enamelled piece demonstrates a key hallmark of Art Deco jewellery: geometric combinations of circular and angular blocks of solid colour. The influences of Cubism and Fauvism are evident in the bold

Art Deco necklace c.1930

The success of this stunning Art Deco necklace lies in the subtle colour combination of dulled silver and pale blue moonstones. Marcasite and semi-precious stones are used to create an inexpensive piece that would have been highly popular in the 1930s.

Specifications

Country: Germany Materials: Silver, moonstones, and marcasite

Bakelite necklace 1936

Lightweight, mass-produced jewellery flourished in the 1930s and designers began to exploit the decorative qualities of Bakelite. The subject matter for such costume jewellery was often inspired by topical events. This necklace was made to commemorate the coronation of King George VI of England.

Country: UK Materials: Bakelite and metal

Specifications

JEWELLERY

JEWELLERY CAN BE DIVIDED into three basic groups: classic pieces in high-value metals or stones; paste and metal imitations, orginally produced for security reasons and later known as costume jewellery; and Art Jewellery, a category in which innovation takes precedence over value. The first two are as popular today as they have ever been, with designers using their skills to create subtly modern variations on classic themes. As attitudes to women's fashions have relaxed, so limitations on jewellery design have been discarded, to the point where a necklace of beaten nails may be as celebrated as a string of pearls.

Martha Graham in a production of Salem Shore

Dancer brooch 1947

Ed Wiener modelled this brooch on a photograph of Martha Graham taken in 1941. She was a champion of the modern dance movement and viewed dance as an organic structure - a philosophy reflected in Wiener's design. A biomorphic shape cut from sheet silver defines the body, dress, and right arm; one wire suggests the dancer's head and left arm; and another the skirt frill.

Specifications

Country: US Material: Silver

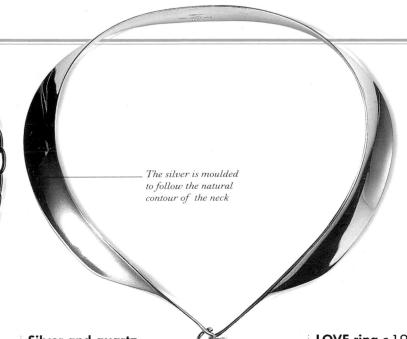

COSTUME JEWELLERY

Advertisement, 1990s

Coco Chanel is largely responsible for the development of costume jewellery as an art form in its own right, rather than as mere imitation. She scoffed at those who desired gems merely for monetary value, and designed "blatantly fake" jewellery of her own. In the 1920s and '30s, the outrageous and witty "jewels" designed and sported by Chanel and fellow couturier Elsa Schiaparelli helped popularize costume jewellery and pave the way for future designers.

Silver and quartz neckring 1959

Designed by Vivianna Torun Bülow-Hübe in 1959 and made in 1967, this neckring typifies the simplicity of the Scandinavian approach to jewellery design. Its attraction lies in its unfussiness: an undecorated silver band that supports a large quartz droplet.

Specifications

necklace by Oslo-born Tone Vigeland

actually made of hammered steel nails.

The nails have been used in such a way

that their simplicity is retained whilst

seems to be made of feathers; it is

completely disguising their form.

Country: Denmark Materials: Silver and quartz

LOVE ring c.1966

The Pop artist Robert Indiana's ring is about as close as you can get to summing up the 1960s' "Love and Peace" movement in one artefact. Indiana's LOVE motif, first shown in his one-man exhibition in 1962, was also used in a best-selling poster, and has appeared on 400 million US postage stamps.

Specifications

Country: US Material: Gilded metal

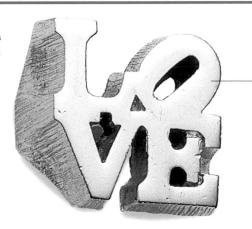

The "O" is positioned quirkily awry

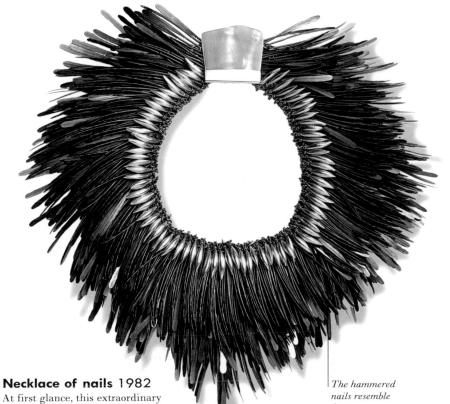

nails resemble feathers

Country: Norway Materials: Steel, silver, gold, and mother-of-pearl

Specifications

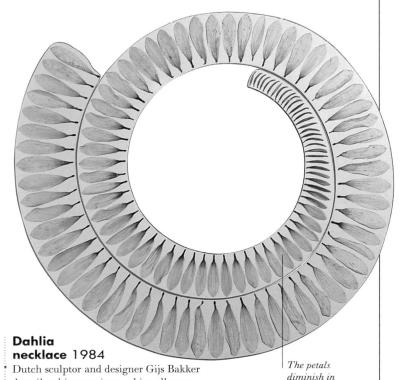

describes his experimental jewellery as

preserved dahlia petals in a flat ring of

laminated plastic. His use of ephemeral

materials represents a new approach to

jewellery design - exploiting nature's

intrinsic aesthetic qualities.

"wearable art". In this piece he has

Specifications

Country: The Netherlands Materials: Plastic and flower petals

size as they

spiral inwards

LEISURE

Wurlfizer

Swimwear

Sports equipment

Cameras

Guitars

Jukeboxes

SWIMWEAR

EARLY BATHING COSTUMES were highly proper garments, with women's ensembles not dissimilar to regular daywear. However, the adoption of elasticated and synthetic fabrics led to a succession of modifications, and swimsuits became progressively less restrictive – and more revealing. For men, the original one-piece suit was soon abbreviated to shorts. For women, the key innovation was the two-piece, launched in the 1940s as a result of US fabric

Bathing suit, 1902

FABRICS

Early in the century, impractical fabrics, such as serge, worsted, and flannel, were still used for bathing costumes. This loose-fitting cotton suit, for example, would have become heavy and uncomfortable when wet. Progress arrived in the form of a light, knitted jersey, which was superseded, in turn, by a new generation of elasticated and synthetic fabrics.

Oakley Jackets

Giorgio Armani

Swatch Snowbuck

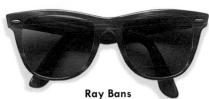

SUNGLASSES

Although they appeared as early as 1885, sunglasses were widely worn for the first time in the 1930s. Popularized by film and pop stars, their status as fashion accessories has become as great a consideration as the degree of protection they offer from the sun. The 1950s in particular witnessed an explosion in the number of frame designs available. The frames shown here are from the 1990s, a health-conscious decade that has seen the refinement of lens quality, with improved filters for ultraviolet light. With eyewear now a highly lucrative area of the fashion industry, many of the world's top designers, including Armani, Valentino, and Gaultier, have ascribed their name to sunglasses.

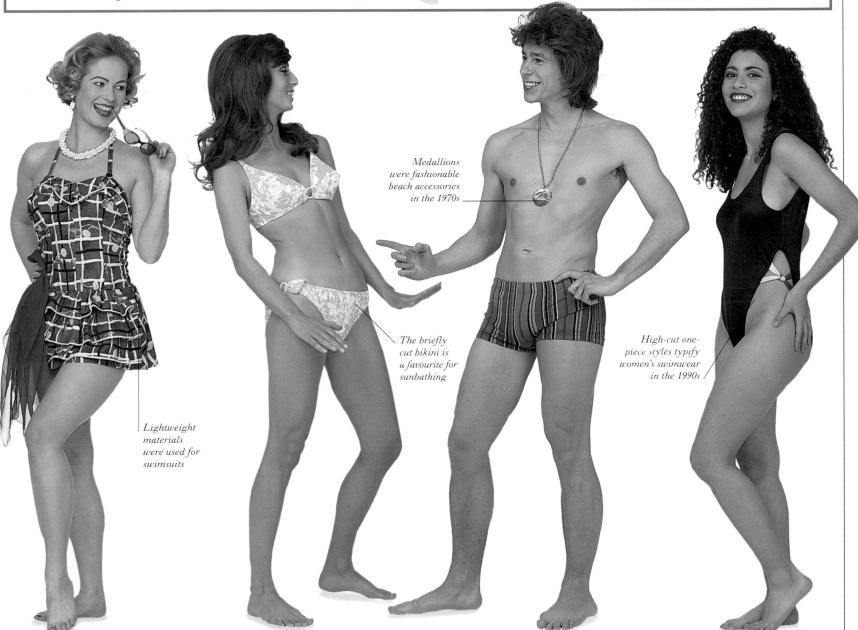

Women's one-piece 1950s

With its boned bodice, this suit enhances the wearer's silhouette, emphasizing the bust and reducing the waist. A departure from the tubular style, the influence of Dior's "New Look" is unmistakable (see p.142).

Bikini 1960s

Pioneered by French couturiers Jacques Heim and Louis Reard in 1946, the bikini was named after the Bikini Atoll, where the Americans were conducting atomic tests. It reached its peak in popularity in the 1960s.

Trunks 1970s

Introduced in the 1930s, swimming trunks allowed men to bathe with a bare torso. By the 1970s, tight-fitting, square-legged trunks such as these showcased new, brightly coloured, drip-dry synthetic fabrics.

Women's one-piece 1990s

Lycra has made a valuable contribution to the revival of the onepiece swimsuit in the 1990s. Closely sculpted to the shape of the body, modern costumes are able to retain their shape perfectly even when wet.

SPORTS EQUIPMENT

THE MAJORITY OF THE SPORTS that we enjoy today have existed for centuries. "Real" tennis and soccer date from the Middle Ages, and American Football was first played in the 19th century. The chief contribution to sport in the 20th century has been professionalism, which has brought with it a demand for lighter, stronger, and more flexible sports equipment. Today's breed of professional sportsman is now afforded greater precision, control, and protection from injury than ever before, with the combination of sophisticated materials and advanced engineering

resulting in masterpieces of sports technology.

In the early years of the century, with lawn tennis established as a popular sport, tennis racket frames less resembled the looselystrung, pear-shaped Real Tennis racket and now had a symmetrical head. To improve the grip, handles were grooved. Fishtail ends such as this were highly fashionable.

Early metal racket 1920

Although most racket frames were made from a solid piece of ash, experiments began in the 1920s with aluminium racket heads that were strung with piano wire. This long-handled grip is made of bare wood, but others at this time were bound in leather to improve the grip.

Classic wooden racket 1950

By the 1950s, the wooden racket had reached a design peak, remaining largely unchanged for the next 20 years. The lightweight frame had reinforced shoulders and was laminated in various woods for extra durability. It was not until the 1970s that wood was seriously challenged by metal.

Graphite racket 1980

The lightweight metal rackets widely favoured by professionals in the 1970s were soon rendered extinct by moulded frames made from a combination of materials that included carbon graphite and fibreglass.

Early in the century, the "toe-poke" technique of kicking the ball with the toe of the boot was favoured by players. As a result, their leather ankle boots had steel toe-caps to protect the feet.

Football boots 1950

By the 1950s, soccer boots were lighter at 500g (1lb) each and were more streamlined in style, with decorative stitching on the leather uppers. Shin pads were now worn inside rather than outside the socks.

Football boots 1970

These vivid blue and yellow boots, designed by Adidas for the 1970 World Cup in Mexico, are

streamlined, supple, and light. They were the first football boots with injected nylon soles, and feature removable screw-in studs.

Athletes running in the ancient

he broad wooden

frame is heavy by

modern standards

ool-covered

tennis halls wore

out quickly on the piano wire

strings

Greek games 4,000 years ago would have raced barefoot. Today, sprinters

practically do run barefoot, so light, supple, and sculpted are modern track shoes, with their optimum cushioning and spiked

Adidas track shoe, 1949

soles for maximum grip. The Adidas shoe shown here, produced by the giant German sports manufacturer in 1949, was used to make the design application for the three-stripe trim, now instantly associated with the company's footwear and clothing.

AMERICAN FOOTBALL

The enormous amount of protective padding worn headto-toe by American footballers is essential in this most physical of sports. In 1905, before the introduction of stringent clothing rules, 18 college footballers were killed

playing with inadequate protection. Those early boiled

leather helmets have now been replaced by helmets

of the toughest plastic, with built-in shock absorbers.

Shoulder pads

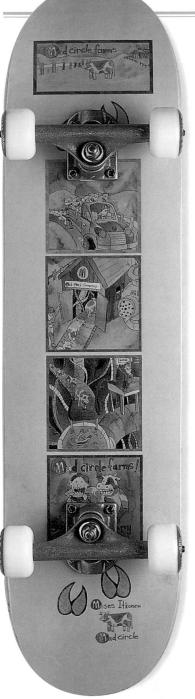

Goofy Foot skateboard 1950

Although skateboarding became hugely popular in the 1970s, the activity was invented in California in the 1950s as a kind of "street surfing". Then, it was a much gentler pastime, with clay-wheeled, flat wooden boards, like this one by Nash Manufacturing Inc., ridden similarly to scooters.

Mad Circle skateboard 1995

Modern skateboards curve upwards at either end and feature coarse plastic grips on the upper surface to aid the spectacular leaps and stunts performed by many devotees. Made from Canadian maple, with polyurethane wheels,

Football 1930s

Early leather balls were heavier and less waterproof than their modern counterparts. Simple stitching techniques meant that the final seam had to be laced up.

Football 1990

Stiff, strong, and durable, modern footballs are made from 18 panels of waterproof leather. The average weight is 400–450g (14–160z).

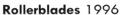

Those who have trundled leisurely around the park on heavy, leatherstrapped metal roller skates would barely relate the high-tech modern in line skates to those traditional "quads". In-line skates, like these by the US manufacturer Rollerblade, are closer in design to ice skates than roller skates. Rollerblades have excellent ankle support, shock-absorbing heel brakes, and "micro-closure" straps to ensure a snug fit. The outer boot and frame are moulded from highquality, lightweight polyurethane.

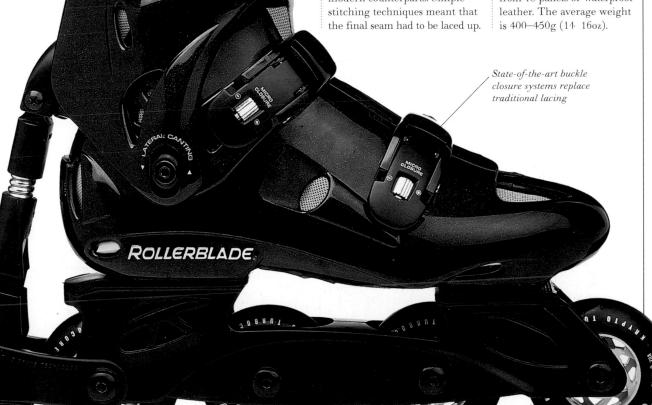

CAMERAS

THE EASTMAN KODAK box camera of 1888, with its ready-loaded roll film and widely advertised developing and printing service, opened up photography to the amateur. "You press the button, we do the rest" stated the advertisement. Various designs for small, hand cameras existed from the early days of photography, but the Leica, introduced by Leitz optical works in Germany in 1924, had an enormous and lasting impact on camera design and 35mm photographic technique. The 35mm single lens reflex (SLR) camera was developed throughout the 1940s and '50s, attaining true popularity with the Nikon F in 1959. Modern cameras have integral light meters, auto-focus, and use highly sensitive film — making the Kodak adage seem truer than ever.

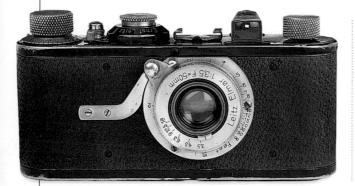

Leica 1A 1929

The Leica, designed by Oskar Barnack in 1915, was the first commercially successful 35mm camera. The Leica 1A, based on the earlier model, was put into production in the mid-1920s. The camera format has become the industry standard.

Specifications

Country: Germany Width: 13.4cm (51/4in)

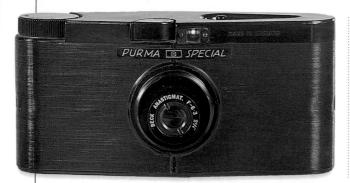

Purma Special 1937

Designed by Raymond Loewy and produced by R.F. Hunter Ltd, the Purma Special was made from black Bakelite and had a unique perspex lens. This was cheaper than the usual glass lens so the camera could be retailed at a lower cost.

Specifications

Country: UK Width: 15.5cm (6in)

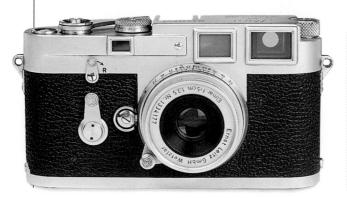

Leica M3 1954

First of a new generation of rangefinder cameras, the Leica M3 had a bayonet lens mount, which facilitated a faster lens change. Although production of this model ceased in 1966, a phenomenal 250,000 cameras had been made since 1954.

Specifications

Country: Germany Width: 14cm (5½in)

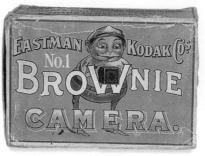

The Brownie 1900

In an attempt to sell more film, Eastman Kodak commissioned Frank Brownell to design a truly low-cost camera. The result was the hugely successful Brownie, a box camera made from the cheapest materials — cardboard and wood.

Specifications

Country: US Width: 8.2cm (31/4in)

No. 2 Beau Brownie 1930

In 1926, Walter Dorwin Teague set up an industrial design consultancy. For Eastman Kodak, his first major client, he redesigned the Brownie, transforming it from a simple box into a sophisticated camera. He restyled the camera exterior with themes associated with Art Deco.

Specifications

Country: US Width: 10.5cm (4in)

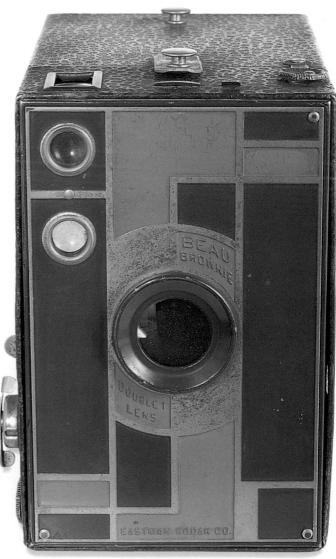

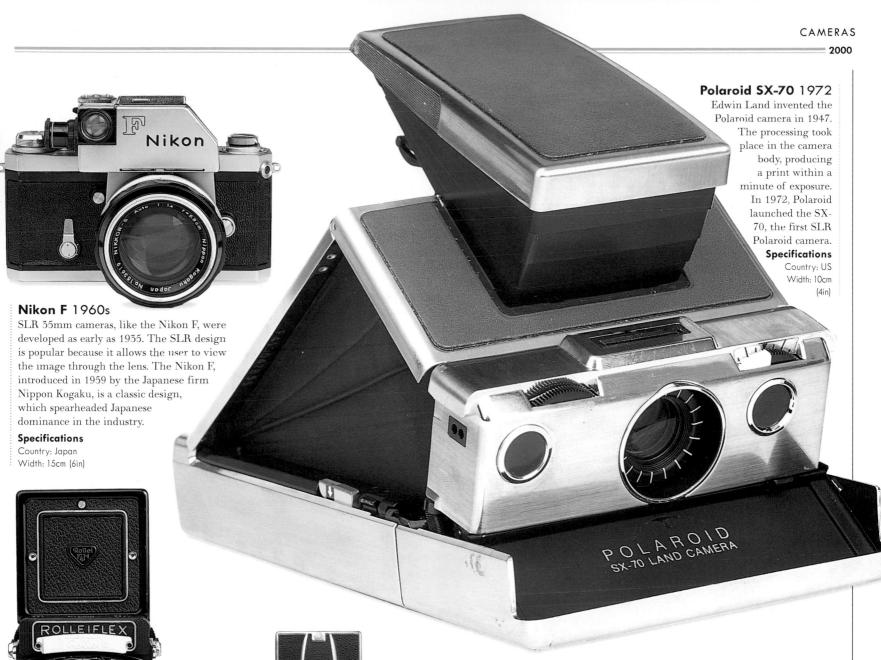

The twin-lens Rolleiflex is a bulky camera, with a mirror housing and viewing panel mounted above a roll-film box camera. It was favoured by professionals because it could take medium-format film, which facilitates high-quality results.

Specifications

Country: Germany Width: 11.5cm (4½in)

Hasselblad 500 1972

This roll-film SLR camera was produced by a firm set up by Victor Hasselblad in 1941 to make aerial cameras. Based on an earlier model, designed by Sixten Sason, it is a celebrated professional camera.

Specifications

Country: Sweden Width: 10.5cm (4in)

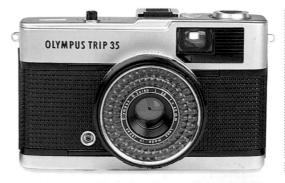

Olympus Trip 35 1968

Grandfather of the compact instamatic, the Olympus Trip 35 is a small, user-friendly camera. It was the first notable departure from the bulky forms of earlier 35mm SLR cameras.

Specifications

Country: Japan Width: 11.8cm (4¾in)

Designed to slip into a jacket pocket, the stylish $\mu[mju:]$ has won many awards. When the sliding lens is closed, the camera is fully protected by its ultra-compact body.

Specifications

Country: Japan Width: 12cm (4¾in)

OLYMPUS

GUITARS

ALTHOUGH THE CLASSIC ACOUSTIC VERSION is still widely strummed, it is the electric guitar that has stolen the limelight this century, and determined the evolution of the instrument's shape and sound. Introduced in the 1930s, the first electric guitars merely electrically amplified the acoustic guitar sound, but, by the 1940s, solid-bodied guitars with a bright new sound were being designed. In 1950, the pioneering Leo Fender released the first mass-produced solid-body — the Broadcaster, following up its success with the legendary Stratocaster. Today, guitars are produced in innovative shapes and constructed of new materials, though rarely do these improve the sound.

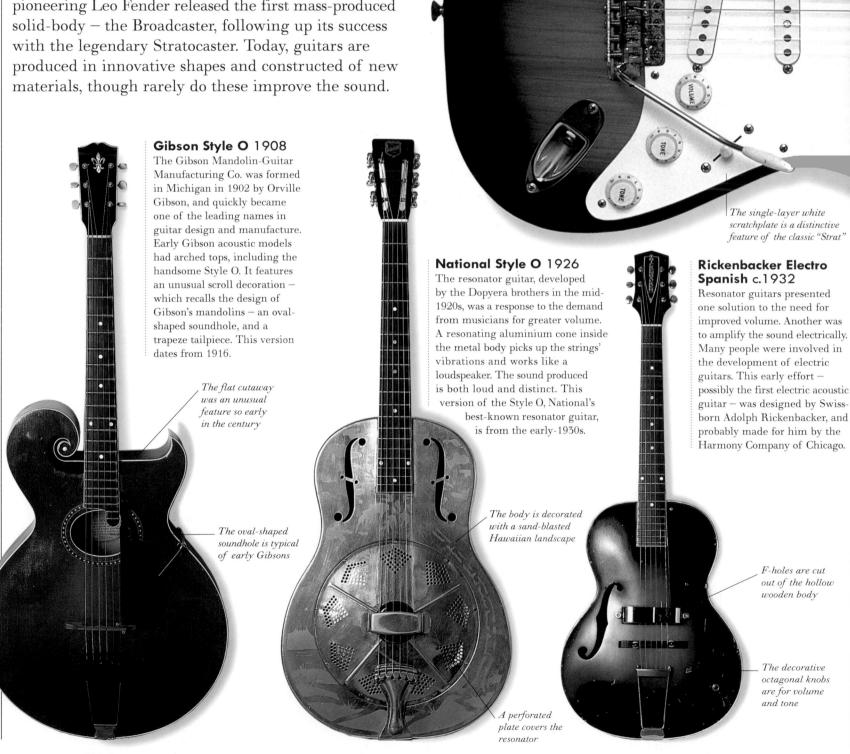

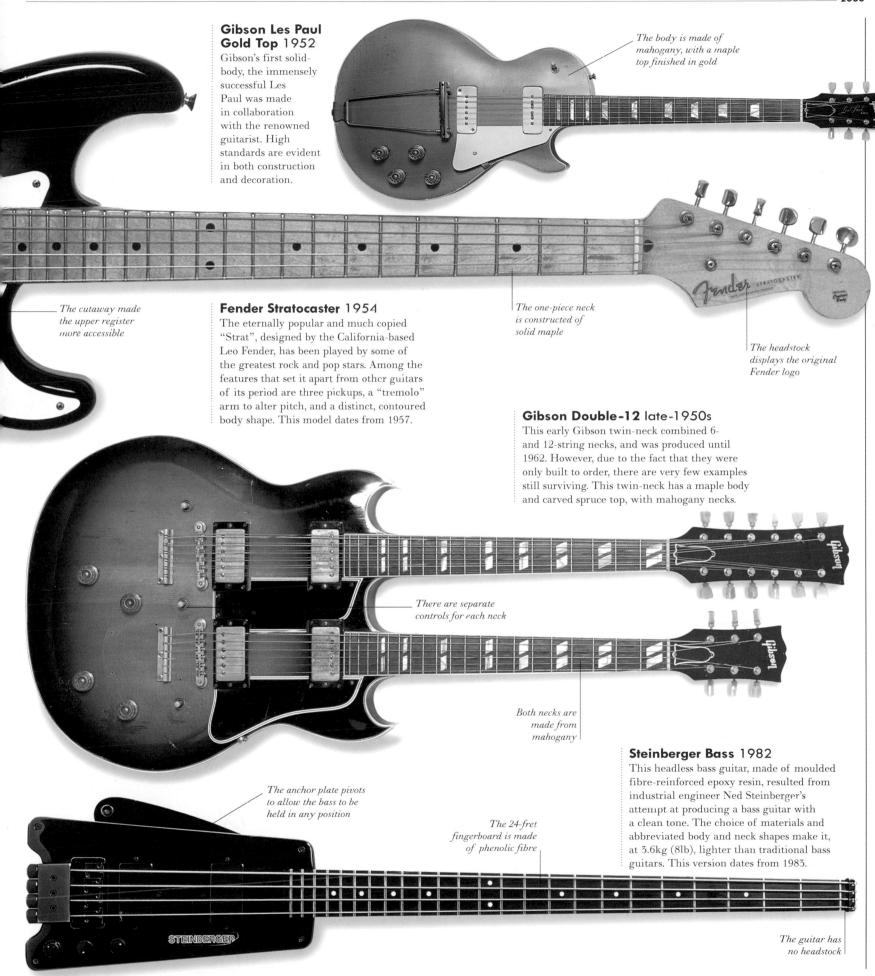

JUKEBOXES

COIN-IN-THE-SLOT MUSIC MACHINES were already well established by the time the Golden Age of the jukebox dawned in the 1940s. While designers of this era, such as Paul Fuller, are particularly revered, design aficionados are beginning to pay closer attention to the two decades that followed. The machines of the rock 'n' roll era — with which the jukebox has

become synonymous – scream teenage rebellion with their blatant use of flashy automobile looks. The bold, bright colours of these classics are probably the first thing to cross most people's minds on hearing the word "jukebox".

Polyphon c.1900

This wooden, turn-of-the-century coin-in-the-slot machine does not play records — because they did not exist — but plays large metal discs with "pins" on. The pins pluck the tuned teeth of a comblike metal plate, as in a music box. This clockwork machine must be fully wound before it will play.

Specifications

Country: Germany Height: 130cm (51in) Number of selections: 1

Wurlitzer 1100 1948

Paul Fuller is generally considered to be the "genius" of jukebox design, and the incredible Wurlitzer 1100 was his last jukebox model. It plays from a selection of 78rpm records – seven-inch 45s were still two years away – although the revolving selection display shows only eight at any one time.

Specifications

Country: US Height: 145cm (57in) Number of selections: 24

Wurlitzer 1800 1955

At first glance, the design of this jukebox may seem rather muted. However, the colours, the lights, and the generous use of chrome combine to make this machine aesthetically pleasing. In addition, the user has a far greater choice of music than before.

Specifications

Country: US Height: 135cm (53in) Number of selections: 104

Seeburg KD200 1957

One quirk of Seeburg jukeboxes is that they play records vertically; this requires only one motor instead of three. The distinctive fins on the front are based on the tail fins and lights of 1950s' American cars. The KD200 plays seven-inch vinyl records.

Specifications

Country: US Height: 147cm (58in) Number of selections: 200

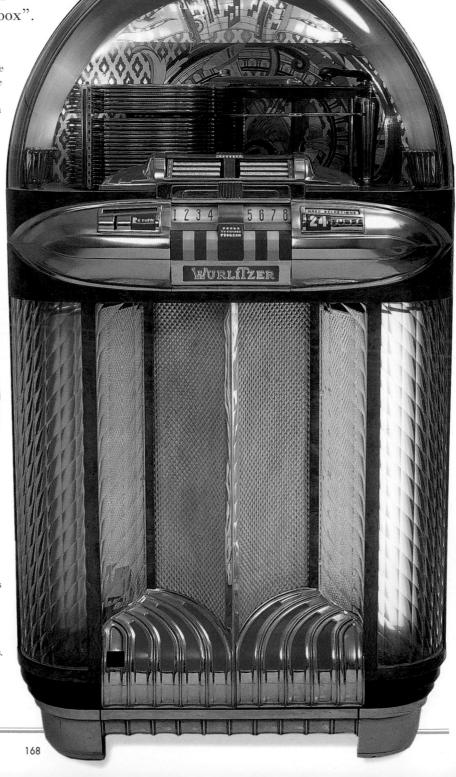

AMi Continental 2 1961

This 200-selection stereo machine by AMi (Automatic Musical Instruments) is of particular interest because of its domed glass top. AMi was one of only two jukebox manufacturers ever to do this – the other was UK-based Chantal – because it was very expensive to produce. The design also makes extensive use of the word "stereo". Sharpeyed viewers of the 1990 Patrick Swayze movie Ghost may recognize this machine.

Specifications

Country: US Height: 162cm (64in) Number of selections: 200

> This stereo machine's curved display represents its "all-around" sound

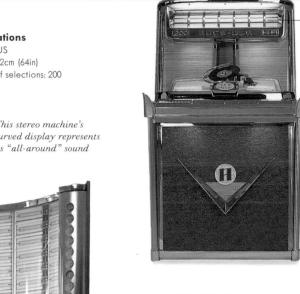

Revolving-drum selection display

Rock-Ola Tempo 1475 1959

Many jukeboxes of this era were based on the back-ends of US cars and the very rare Rock-Ola Tempo is no exception. Tailfins make another appearance, though far more subtly than in the case of the Seeburg KD200, and the V-shaped logo on the front of the machine is similar in essence to many automobile badges. Note the revolving-drum selection display at the top of the machine.

Specifications

Country: US Height: 150cm (59in) Number of selections: 200

All 200 possible selections are visible at the same time

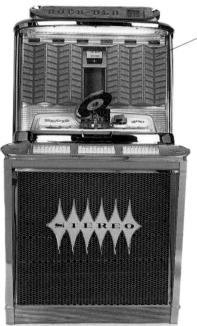

Rock-Ola Regis 1495 1961

Stereo jukeboxes first appeared in 1959 and one of the most instantly striking design features about the Rock-Ola Regis is the rather bold emblazoning of the word "stereo" across its front, ensuring that everyone is well aware of this fact. Another point of interest is the use of pastel colours in its pink andblue colour scheme.

Specifications

Country: US Height: 150cm (59in) Number of selections: 200

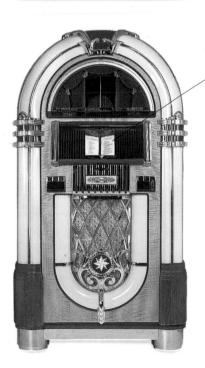

Just one-fiftieth of this jukebox's contents can be viewed at a time

NSM Nostalgia Gold 1995

This machine's design is based on Paul Fuller's 1946 Wurlitzer 1015, the most popular jukebox ever: during 1946 and 1947 Wurlitzer built 56,000 of them. The original would have held twelve 78rpm records but this replica can accommodate up to 100 compact discs. It would actually be possible to listen to this jukebox for more than five days and nights. without hearing the same track twice.

Specifications

Country: Germany Height: 155cm (61in) Number of selections: Up to 2,500 (approx.)

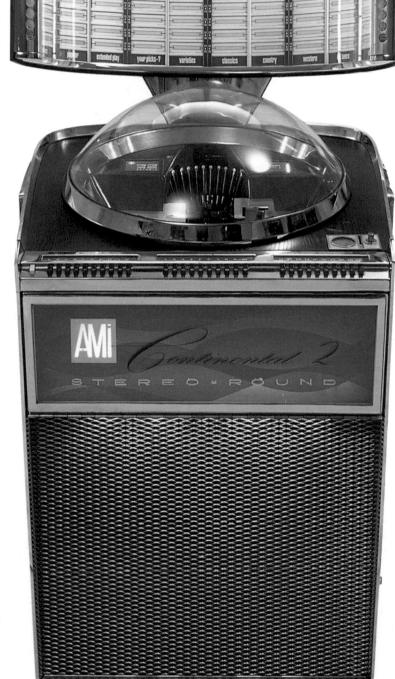

TRANSPORT

Bicycles

Scooters

Motorcycles

Cars

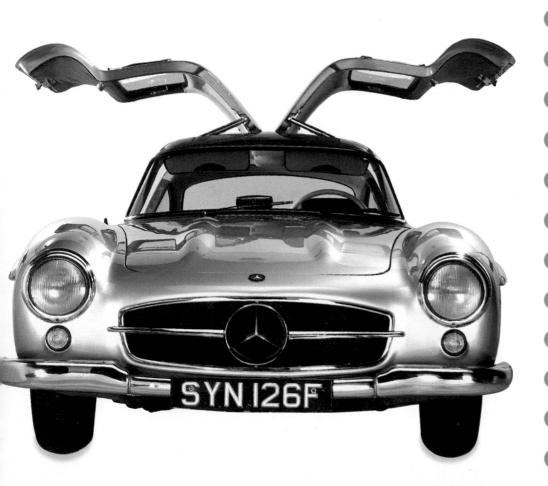

BICYCLES

SINCE THE APPEARANCE of the first safety bicycles in the 1870s, a remarkable – and enormously popular – form of transport has emerged. The modern machine is not only lightweight, strong, and fast, but also easy to ride, comfortable, and safe. Various models have been designed to meet specific market demands: for instance, in the 1900s, versions without high cross-bars were introduced to suit women riders, and increasingly aerodynamic models have been developed for the highly competitive sport of cycle racing. At the end of the century, lighter, more durable materials, such as titanium and carbon fibre, are frequently favoured over traditional materials like steel.

Ladles' Humber 1905

By the time the Ladies' Humber was introduced, the key features of the modern bicycle were well established. Instead of the diamond-shaped frame of men's bicycles, the ladies' had an open frame. This catered for the long dresses worn at the time, as illustrated in this poster.

Specifications

Country: UK Wheel diameter: 71cm (28in) Material: High-tensile steel

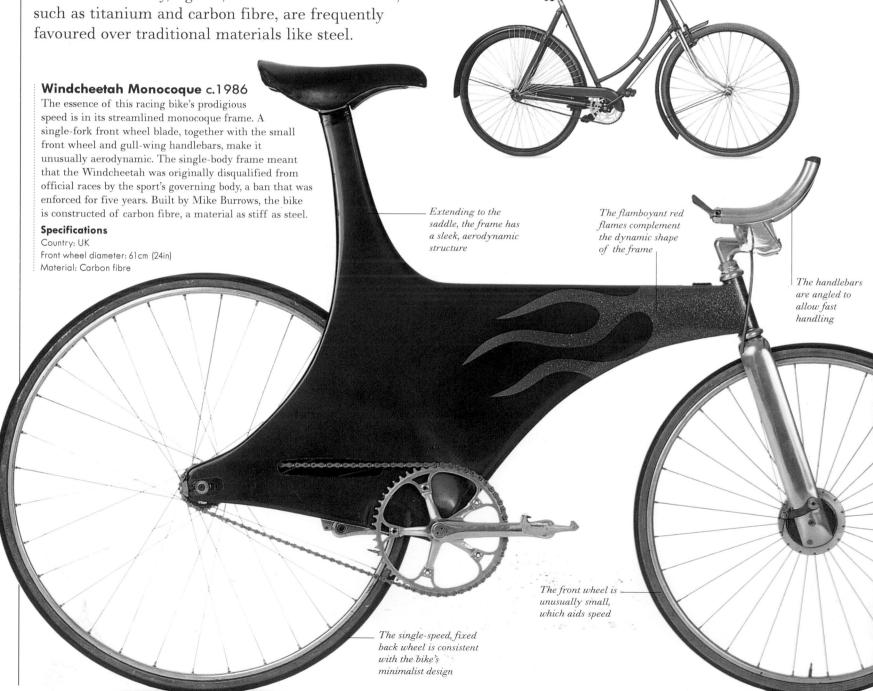

COLLAPSIBLE BICYCLES

For their portability and ease of storage, foldaway bicycles are often favoured. Alex Moulton, who worked on the suspension of the Mini in the 1950s (see p.185), went on to design this compact, collapsible bicycle. The innovative rubber suspension on both front and back wheels made the bike easy to handle and comfortable to ride.

Battaglin 1980s

The development of racing bikes, such as this Italian model by Battaglin, saw the introduction of drop handlebars, which reduced body-created wind resistance. The "aero-tuck" body position was further exaggerated by the high placing of the saddle, which is favoured by racers.

Specifications

Country: Italy Wheel diameter: Not known Material: High-tensile steel

lightweight bicycle frames. In the 1970s, versatile, lightweight alloy steels were developed, followed by aluminium tubing in the 1980s.

Country: France

Specifications

Wheel diameter: 66cm (26in) Material: Carbon fibre

Sociable Tandem 1992

Specifications Country: Switzerland Front wheel diameter: 51cm (20in) Materials: Fibre glass and aluminium

This motor-assisted, three-wheeled recumbent bicycle can accommodate two riders. Using pedals alone, it can reach up to 19mph (30km/h), but, with assistance from the electric motor, can travel over twice as fast.

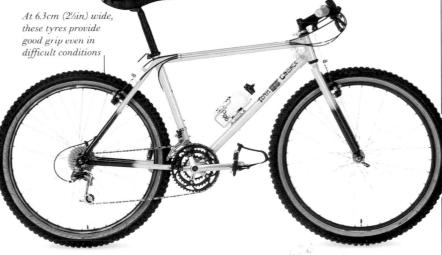

Fat Chance "Yo Eddy" off-road racer 1989

Developed in California by Charlie Kelly and Gary Fisher during the 1970s, mountain bikes have opened up a new experience for cyclists. This model has been refined from the early prototypes, which weighed less than 12kg (26lb).

Specifications

Country: US Wheel diameter: 66cm (26in) Material: High-tensile steel

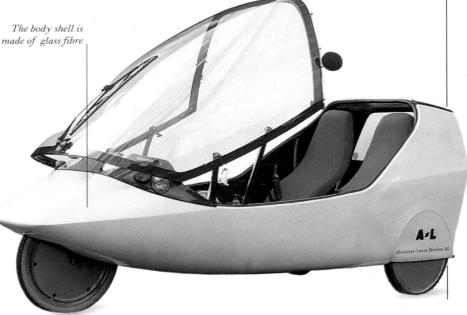

SCOOTERS

YOUNG ITALIANS DODGING TRAFFIC through the backstreets of Rome; 1960s' "Mods" driving in gangs to British coastal resorts: scooters are synonymous with street style and youth culture. The machines traditionally favoured by both groups are the Italian classics Vespa and Lambretta. These elegant, streamlined machines are notable for their rounded body panels, as opposed to the largely angular bodywork of non-European scooters, such as those built by the American company Cushman. Scooters have been popular since the 1920s, when they bore little difference to a child's push-along toy vehicle. Since then, there have been a bewildering array of these cheap, lightweight, easy-to-ride motorcycles, the two common factors being

the small wheels and step-through frame.

Lambretta LD150 1957

Lambretta was the main challenger to Vespa in the 1950s and '60s, and the Lambretta LD150 sold in enormous quantities. It had easily removable engine and gearbox covers, two separate seats, and carried a spare wheel. Like the Vespa, it was rounded in styling, compared with its angular American cousins. The first Lambrettas were built in 1947, and production stopped in Italy in the 1970s.

Specifications

Country: Italy Top speed: 50mph (80.5km/h)

The pressed-steel body panels were mounted on a tubular-spine frame

Autoped 1915

Built in the US from 1915 to 1921, the Autoped's key assets were its size and portability. Starkly utilitarian, it was designed to be ridden standing up, with a pressed-steel foot-plate. The long column for the handlebars can be folded down flat for storage.

Specifications

Country: US

Top speed: 20mph (32km/h) (estimated)

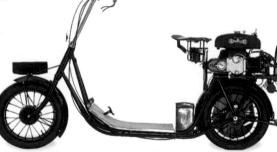

ABC Skootamota 1919

Much in demand after World War I, the Britishdesigned ABC Skootamota had one great advantage over the Autoped: a seat. Designed by Granville Bradshaw, the machine featured the step-through frame that has defined the look of the scooter ever since.

Specifications

Country: UK Top speed: 25mph (40km/h)

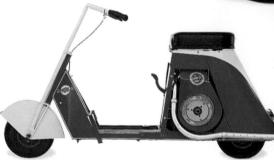

Cushman Auto-Glide 1937

Cushman produced a remarkable range of outlandish scooters in the middle decades of the century. While its European counterparts were characterized by their curves, Cushman favoured angularity. The Auto-Glide is the epitome of simplicity in vehicle design.

Specifications

Country: US

Top speed: 30mph (48km/h) (estimated)

SCOOTERS AND STREET STYLE

Although originally popularized as a cheap and convenient form of transport in the postwar era, by the 1960s, the scooter had been adopted by young people as a fashion accessory. Members of the British "Mod" cult rode en masse on customized Vespas or Lambrettas to coastal resorts, where they invariably clashed with rival "Rocker" gangs.

The rider-friendly build of the GS included a leather dual seat designed for maximum comfort

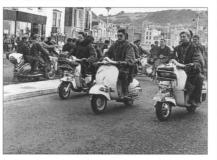

"Mods" at Hastings, England

Vespa Grand Sport 160 1963

The Vespa (Italian for "wasp" and so-named for its buzzing exhaust note) is the most famous of all scooters. It was designed in 1946 by Corradino d'Ascanio, whose previous involvement in aircraft design is clearly evident. It has a waisted rear and a rounded pressed-steel monocoque chassis. One of the most attractive scooters built was the Vespa Grand Sport (GS) 160 Mark 1, considered by many aficionados to be the best Vespa ever designed.

Specifications

Country: Italy
Top speed: 62mph (100km/h)

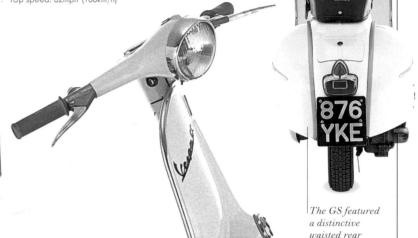

The streamlined body was constructed from moulded and stretched steel

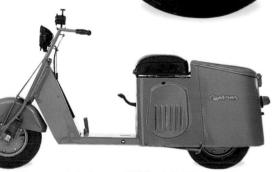

Cushman 32 Auto-Glide 1945

This 32 model first appeared in 1945. Unlike its predecessor, it had lights, "Floating Drive" suspension, and an automatic clutch and transmission system. Designed with convenience in mind, it had a large storage compartment behind the seat for baggage.

Specifications

Country: US
Top speed: Not known

Indian Papoose 1948

The famous American motorbike manufacturer Indian gave its name to a small British scooter originally designed as a folding bike for paratroopers in World War II. The Papoose included a retracting saddle column, which enabled the handlebars to be folded down flat.

Specifications

Country: US

Top speed: 35mph (56km/h) (estimated)

Simplex Scooter 1958

Although it never challenged market leader Cushman, Simplex took advantage of the 1950s' scooter boom by introducing this version of its Servi-Cycle. The characteristic clean, straight lines of the American scooter are typified by the simple, tubular-steel frame.

Specifications

Country: US

Top speed: 45mph (72km/h)

MOTORCYCLES

THE FIRST MOTORCYCLES were introduced towards the end of the 19th century. With chassis based on the newly developed safety bicycles (see pp.172–73), they lacked power, were difficult to ride, and had inadequate lights and brakes. It was not until the Werner brothers produced their motorcycle of 1901, with its advanced braking system and electronic ignition, that practical motorcycling became possible. Thirty-five years later, Harley-Davidson produced the 61E, a motorcycle that demonstrates just

how rapidly technology, performance, and style have evolved.

Throughout the century, there has been a remarkable array of weird and wonderful designs. Designers continue to exploit the latest materials and technology to enhance performance and provide a safe ride.

A MOTORCYCLE FOR THREE

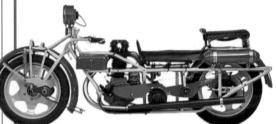

Böhmerland, 1925

The red-and-yellow colour scheme and enormously long wheelbase combine to make the Czechoslovakian Böhmerland one of the most bizarre motorcycles ever built. It was created by Albin Liebisch in 1925 (this model is from 1927), and remained in production until 1939, the design changing little over the years.

Werner 1901

In 1897, the French brothers Werner made the first motorbike to be sold in significant numbers. The 1901 Werner was one of the first bikes to move from a "bicycle-plus-engine" design to a more integrated look: in some ways, the first "real" motorcycle.

Specifications

Country: France Top speed: 20mph (32km/h) Weight: Not known

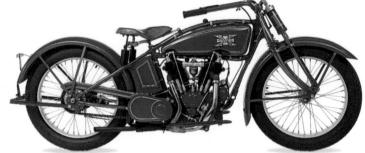

Excelsior 20R 1912

Until it collapsed in 1931, Excelsior was one of the big three American manufacturers with Harley-Davidson and Indian. The first bike to break the 100mph (161km/h) barrier, the 20R had a 61 cubic inch engine (1,000cc). It featured the long, upright handlebars that were prevalent in the US until the 1920s.

Specifications

Country: US
Top speed: 100mph
(161km/h)
Weight: 500lb (227kg)

BMW R32 1923

The radical styling is typified by the rounded

oil tank wrapped

around the battery

Created by aircraft designer Max Friz, the first BMW was an astonishing leap forward in motorbike design: its 500cc engine was fitted into the frame so that the cylinders were cooled by the air.

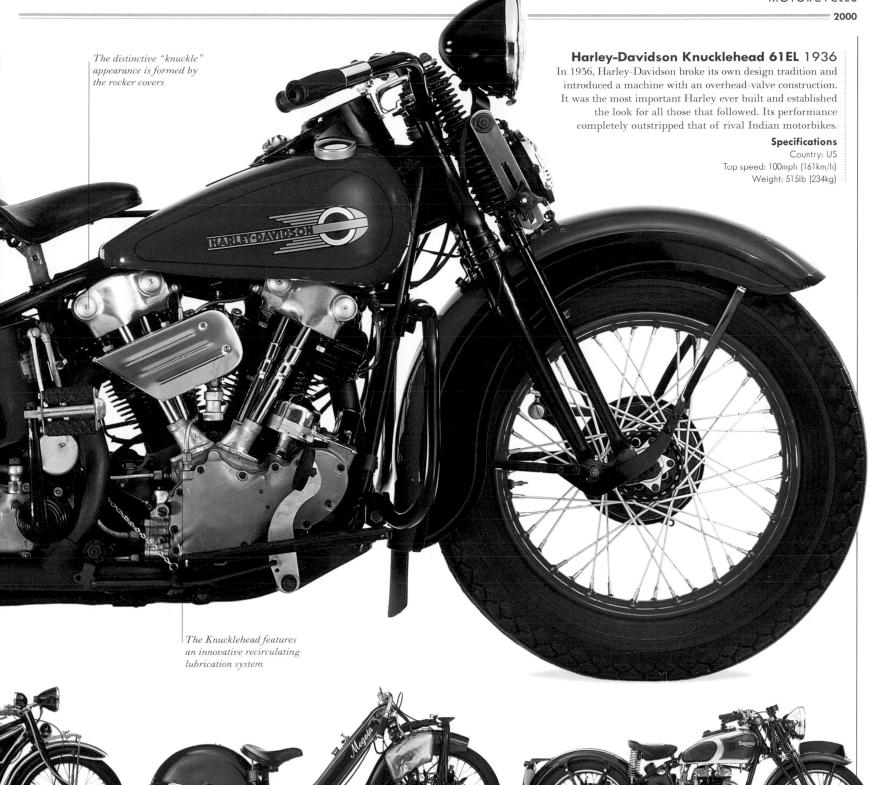

Specifications

Country: Germany Top speed: 53mph (85km/h) Weight: 269lb (122kg)

Megola Racing Model 1923

The Megola rivals the Böhmerland as one of the most unconventional motorbike designs ever. Designer Fritz Cockerell's five-cylinder side-valve radial engine was mounted within the front wheel; as the wheel turned forward once, the engine turned six times in the opposite direction.

Specifications

Country: Germany Top speed: Not known Weight: Not known

Triumph Speed Twin 1939

Designed by Edward Turner with speed in mind, the Speed Twin's lines are elegant from any angle. The model formed the basis of Triumph's big bike range for the next 40 years. Turner was also responsible for adapting Triumphs for the American market in the 1950s.

Specifications

Country: UK Top speed: 93mph (150km/h) Weight: 378lb (171kg)

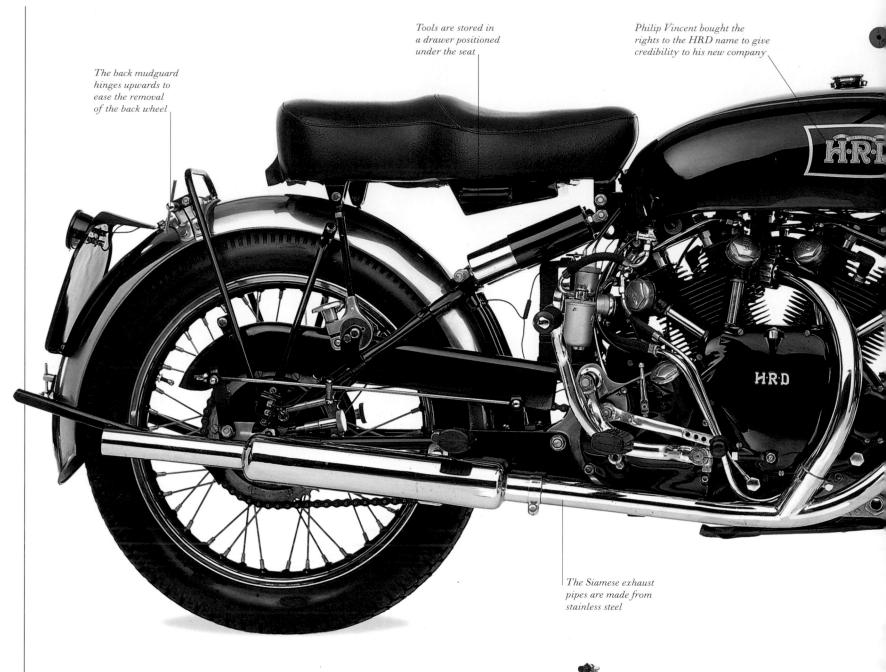

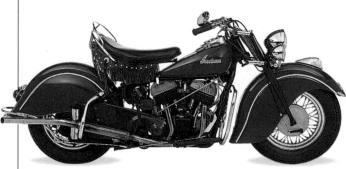

Indian Chief 1947

Built for comfort not speed, the Chiefs were stylish machines that reached their peak with this 1947 design. Valanced mudguards and elegant girder forks combined with the sprung leather saddle and chrome-plated details to give an air of streamlined luxury.

Specifications

Country: US Top speed: 85mph (137km/h) Weight: 550lb (249kg)

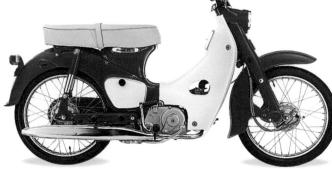

Honda 50 Super Cub 1958

Originally designed as a basic, cheap form of transport, the ubiquitous Cub is the most successful bike ever made, with sales in excess of 21 million. It was among the first machines to make extensive use of plastic, in the form of the front mudguard, the side panels, and the leg shields.

Specifications

Country: Japan Top speed: 43mph (70km/h) Weight: 143lb (65kg)

Honda CB750 1969

The CB750 launched the era of the Superbike, combining in one powerful machine disc brake, five-speed gearbox, electric starter, four-cylinder engine, and 124mph (200km/h) performance.

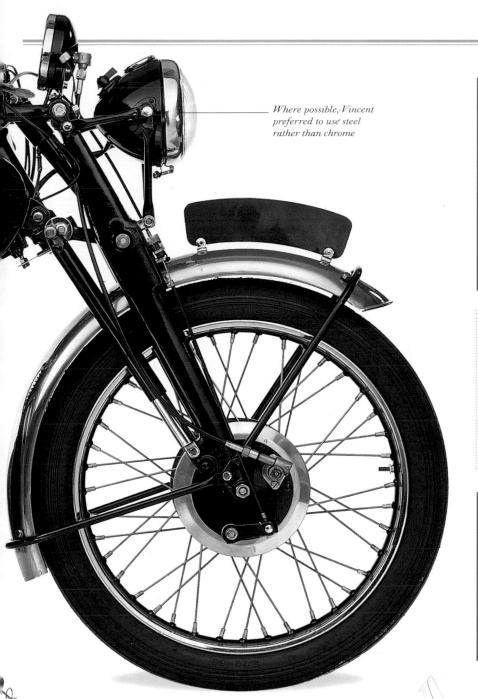

STARCK STYLE

When Aprilia invited Philippe Starck to design the Moto 6.5, the designer's distinctive touch was not compromised at all. His style is evident in both the overall form of the bike and in the details, such as the graphics and paint scheme.

The top speed is 100mph (161km/h).

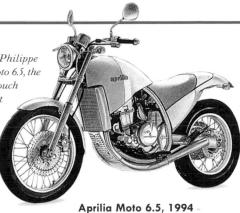

Vincent Black Shadow Series C 1949

In 1949, when the first Vincent C-series Black Shadow was introduced, it was the fastest and the classiest bike in the world. The black bodywork continued in the baked-on black 998cc engine, and the mudguards were made in stainless steel, with stainless steel and chrome engine details and exhaust pipes. The Shadow had an oversized speedometer, emphasizing its impressive top speed of 125mph (201km/h).

Specifications

Country: UK Top speed: 125mph (201km/h) Weight: 458lb (208kg)

MOTOCROSS

Light, strong bikes
with good suspension
are required for the
gruelling sport of
motocross, which began
as "scrambling" in
1920s' Britain. The
knobbly tyres increase
grip in muddy conditions.

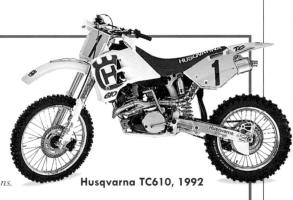

Specifications

Top speed: 124mph

Weight: 485lb (220kg)

Country: Japan

(200km/h)

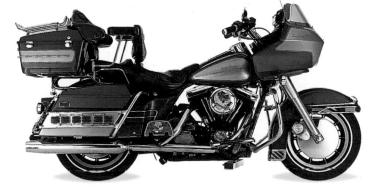

Harley-Davidson Evolution FLTC Tour Glide Classic 1989

In direct competition with Honda's massive Goldwing, the Tour Glide rejected the retro styling of previous Glides. Comfort was the prime design objective, with footboards for the rider and armrests and backrests for the passenger.

Specifications

Country: US
Top speed: 110mph
(177km/h) (estimated)
Weight: 732lb (332kg)

Kawasaki ZZ-R1100 1990

Everything about the ZZ-R is big, from its top speed of 175mph (282km/h) to its enormous twin front brake discs. Aerodynamic styling (the tank is sculpted to fit the rider's legs snugly) and superb power delivery made the ZZ-R the fastest bike of its day. This model is from 1994.

Specifications

Country: Japan Top speed: 175mph (282km/h) Weight: 513lb (233kg)

2000

CARS

FEW THINGS MAP the development of design in this century better than the car. In 1900, cars were just beginning to shed their "horseless cart" look, yet by 1915, all of the basic design features of the modern car were already in place. All that remained was for cars to get bigger, smaller, safer, more beautiful, more bizarre, and, of course, faster. At the end of the century, there are nearly one billion cars on the road, including some lovingly restored early models.

But overtaking these vintage vehicles are a vast array of cars: sports cars such as Jaguar's E-type (see p.186); family vehicles, like Renault's Espace (see p.189); city cars, such as the Fiat 500 (see p.184); outlandish cars such as the 1959 Cadillac (see pp.184–85); and supercars

like the Lamborghini Miura (see p.186).

1920s' RACING MACHINE

Widely regarded as one of the most beautiful motoring creations of the century, this superb racing car by Ettore Bugatti tapers elegantly at both front and back, the widest point being the two-seat cockpit. Distinctive features include the criss-crossed piano-wire cast that braces the car's body and the alloy wheels with integral brake drums. The car has a powerful eight-cylinder engine, which, combined

with the four-speed gear box, took the car up to speeds of 120mph (193km/h).

Bugatti Type 35, 1924

Rolls Rovce 40/50 1907

In 1907, when Rolls Royce launched the 40/50, or "Silver Ghost" as it became known, it described the model as "the best car in the world". Emphasis was placed on mechanical precision and

craftsmanship rather than innovation. The winged figurehead, known as the "spirit of ecstasy", was modelled by Charles Sykes

Specifications

Top speed: 55mph (88km/h)

Country: UK

and first graced the top of a Rolls-Royce radiator in 1911.

The Ghost has a lowslung "slipper" body

De Dion-Bouton Model Q 1903

The key to the Model Q's success was its powerful 846cc petrol engine. De Dion's revolutionary engine design was used in over 100 makes of car from 1898 to 1908, and helped launch companies such as Renault.

Specifications

Country: France
Top speed: Not known

Model T Ford 1908

This was the first car to be mass produced, with over 15 million made. The car's minimal design, the use of standardized parts, and new production techniques kept costs down. By the 1920s, every second car on the world's roads was a Model T Ford.

Specifications

Country: US Top speed: 42mph (68km/h)

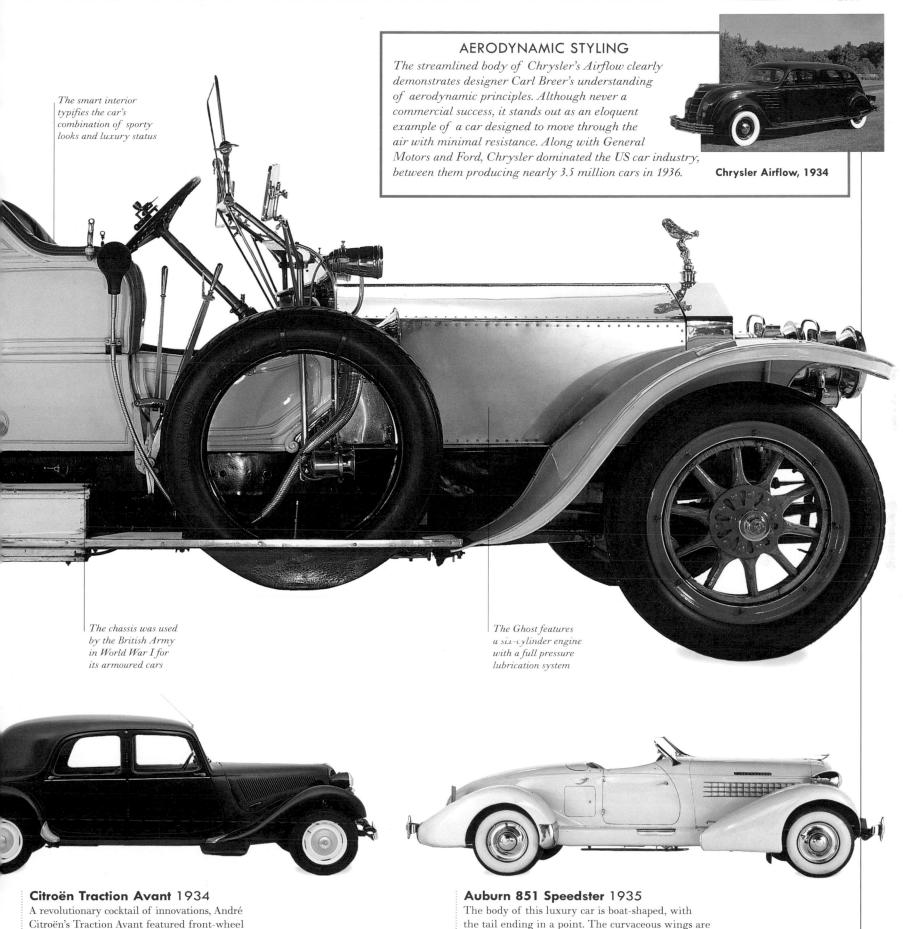

Specifications

Top speed: 103mph (166km/h)

Country: US

Specifications

Country: France

Top speed: 70mph (113km/h)

drawn back, echoing the body shape. Details such as

the "V"-shaped radiator and the headlights help

give the car a feeling of forward movement.

drive, monocoque construction, overhead-

valve engine, hydraulic brakes, and long

wheel base, allowing more passenger space.

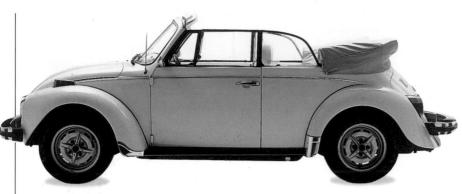

Volkswagen Beetle 1939

In 1973, the Beetle became the best-selling car ever produced. The work of Ferdinand Porsche, it originated in Germany and attracted the attention of Adolf Hitler, who gave the project his personal support. Since the Beetle went into full production in 1945, there have been over 78,000 design modifications – all of them minor. The Karmann Cabriolet, shown here, is one of the most sought-after models.

Specifications

Country: Germany Top speed: 82mph (132km/h)

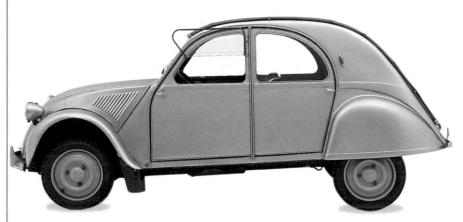

Citroën 2CV 1948

Flaminio Bertone is responsible for the appearance of some of Citroën's most successful cars: the Traction Avant (see p.181), the DS (see p.185), and the 2CV or *Deux Chevaux* ("Two Horses"). Built in part as a response to the Volkswagen Beetle, the 2CV uses a simple construction and simple manufacturing techniques to fulfil a practical need – a cheap and reliable means of transporting people and goods.

Specifications

Country: France Top speed: 115mph (185km/h)

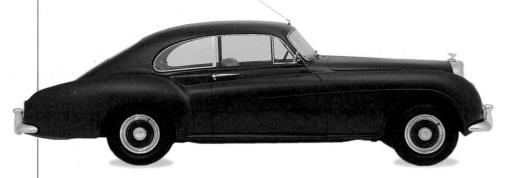

Bentley R-type Continental 1952

Launched in 1952, Bentley's R-type Continental was the fastest production car in the world. Only 208 were made – possibly because it was so expensive – but it was worth every penny to the many who revered it as the greatest car of all time. Described as "a modern magic carpet", the wind-tunnel inspired lightweight aluminium housing enabled the car to reach 60mph (97km/h) in 14 seconds.

Specifications

Country: UK Top speed: 115mph (185km/h)

THE JEEP

When it entered production in 1941, the legendary Jeep was made in the US by both Willy's and Ford. Described as "a divine instrument of military locomotion", it was the US Army's "General Purpose" vehicle ("GP"

US Army jeep, 1944 Purpose" vehicle ("GP" soon became shortened to "Jeep"). Although it was designed for battlefield reconnaissance duties, it

soon became clear that the Jeep had more uses. It was light enough to be carried in a glider and tough enough to be dropped by parachute.

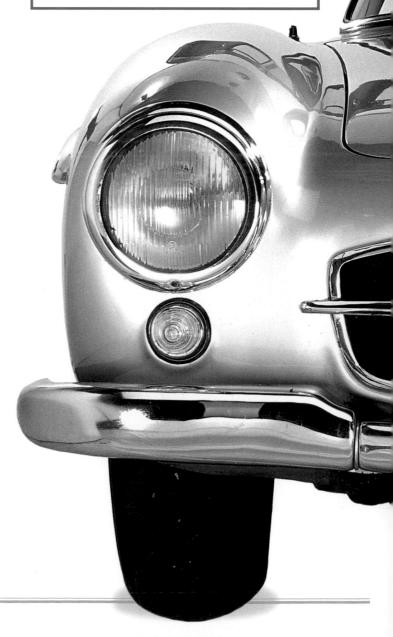

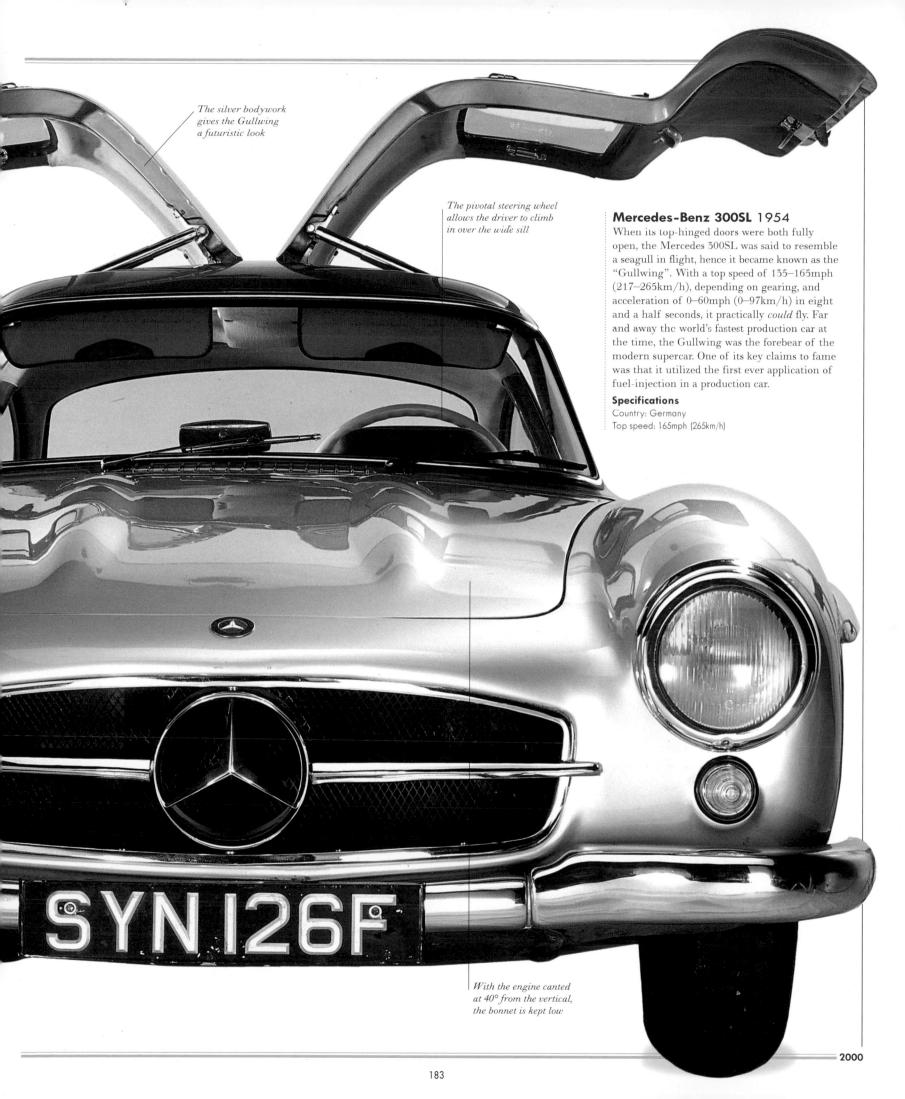

1900 =

Cadil Nothing than the flamber cars, the of coar influer the Lo a source the share expering of cars fascinar research these of for mo The tail fins rise over a metre (39in) above the ground The tail fins rise over a metre (39in) above the ground Cadil Nothing than the flamber cars, the of coar influer the Lo a source the share expering of cars fascinar research these of for mo

Cadillac Eldorado Convertible 1959

Nothing sums up the optimism of the 1950s better than the 1959 Cadillac Convertible. The most flamboyant and extravagant of mass-produced cars, this beautiful, brash machine was the creation of coach builder and stylist Harley Earl. He was influenced by Clarence Johnson, the designer of the Lockheed P38 aeroplane, which was certainly a source of inspiration. Earl used clay to model the shape of his cars, giving him the freedom to experiment with form. The outcome was a series of cars that owe as much to science fiction and a fascination with space flight as they do to empirical research. For America in the 1950s, the style of these cars represented more than just an enthusiasm for modernity, they embodied a dream.

Specifications

Country: US Top speed: 112mph (180km/h)

At 6.1m (20ft) in length and two tonnes in weight, the Cadillac was unchallenged in size and power

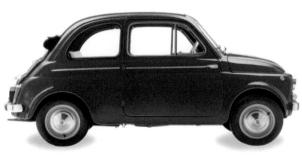

Fiat 500 1957

You could practically fit the Fiat 500 into the trunk of the Cadillac, so opposite are the two cars in philosophy. This charming car's gently rounded body is moulded into shape by the unitary construction. It appeared two years before the British Mini and was 8cm (3½in) shorter. The Fiat 500, along with the Vespa scooter (see p.175), have come to symbolize Italy's postwar *ricostruzione*.

Specifications

Country: Italy Top speed: 59mph (95km/h)

Buick Roadmaster 1957

The massive Buick Roadmaster was all about power. At 5.5m (18ft) long and 1.8m (6ft) wide, it needed its V8 engine to propel its mighty bulk to 60mph (96km/h) from standing in just 10.5 seconds. The giant chrome bumpers were just one statement of the car's might. In the 1950s, aircraft design was a major influence on car design, evident here in the wraparound windscreens and the tail fins.

Specifications

Country: US Top speed: 112mph (180km/h)

Morris Mini Minor 1959

Alec Issigonis' legendary Mini Minor is a fine example of the economic use of space. As this advertisement demonstrates, the tiny boot fits behind the rear passenger seat.

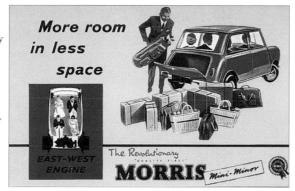

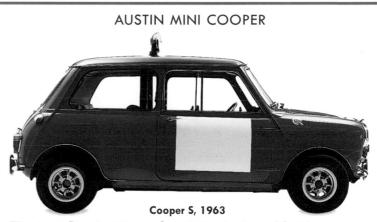

The classic British rally car of the 1960s, the Austin Mini Cooper was a high performance version of Alec Issigonis' 1959 Morris Mini Minor. These box-shaped vehicles set the standard for small cars and, along with the miniskirt (see p. 139), became British icons of modernity in the 1960s. The rubber suspension was designed by Alex Moulton, who went on to create an innovative collapsible bicycle (see p.173).

Chevrolet Impala 1960

In 1959, Bill Mitchell succeeded Harley Earl as Director of Styling at General Motors, but Earl's obsession with all things space age clearly rubbed off on his protegé: there was even a badge of a speeding rocket on the rear door of his Chevrolet Impala. Everything about the Impala expresses speed: for, example, the aeriel appears to bend in the wind even when the car is stationary.

Specifications

Country: US Top speed: 112mph (180km/h)

Nicknamed "The Shark", the technically and stylistically daring Citroën DS was an immediate success on its launch in 1960: 80,000 were sold in the first week. The impressive and aerodynamic body shape, the wide area of glass, the spacious interior, and the space-age instrument panel all set this car apart from all others.

Specifications

Country: France Top speed: 116mph (187km/h)

When tractor magnate Ferrucio Lamborghini had problems with his Ferrari, he went straight to the top with his complaints. Enzo Ferrari refused him an audience and Lamborghini vowed to build a better car carrying his own name – and so the Lamborghini

Lamborghini Miura, 1966

legend was born. The Miura was capable of

that was matched by its racy
looks – all futuristic, low
lines and swooping curves.
When it was launched at the
1966 Geneva Motor Show, it created
the motoring sensation of the decade.

The steeply raked windscreen typifies the 911's aerodynamic styling

The bodywork is constructed of thinguage steel panels

E-Type Jaguar 1961

At its launch in 1961, the E-type caused a sensation. This beautiful sports car's looks, with its distinctive elongated bonnet, were only part of the attraction, for it was capable of 150mph (241km/h) and cost half the price of its main competitors. Designer Malcolm Sayer (1916—) claimed that the E-type was the first car to be "mathematically" designed.

car's matt black and

polished red styling

Specifications

Country: UK Top speed: 150mph (241km/h)

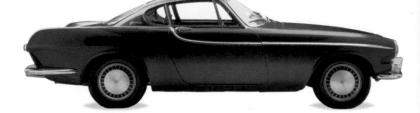

Volvo P1800 1961

From a manufacturer renowned for safe, strong, reliable cars, the stunningly styled P1800 seems a one-off. But closer inspection reveals a car as robust as any other Volvo, mechanically based on the Amazon Saloon and therefore not especially fast. It will forever be known as the car driven by Roger Moore in the hit TV series *The Saint*.

Specifications

Country: Sweden Top speed: 105mph (169km/h)

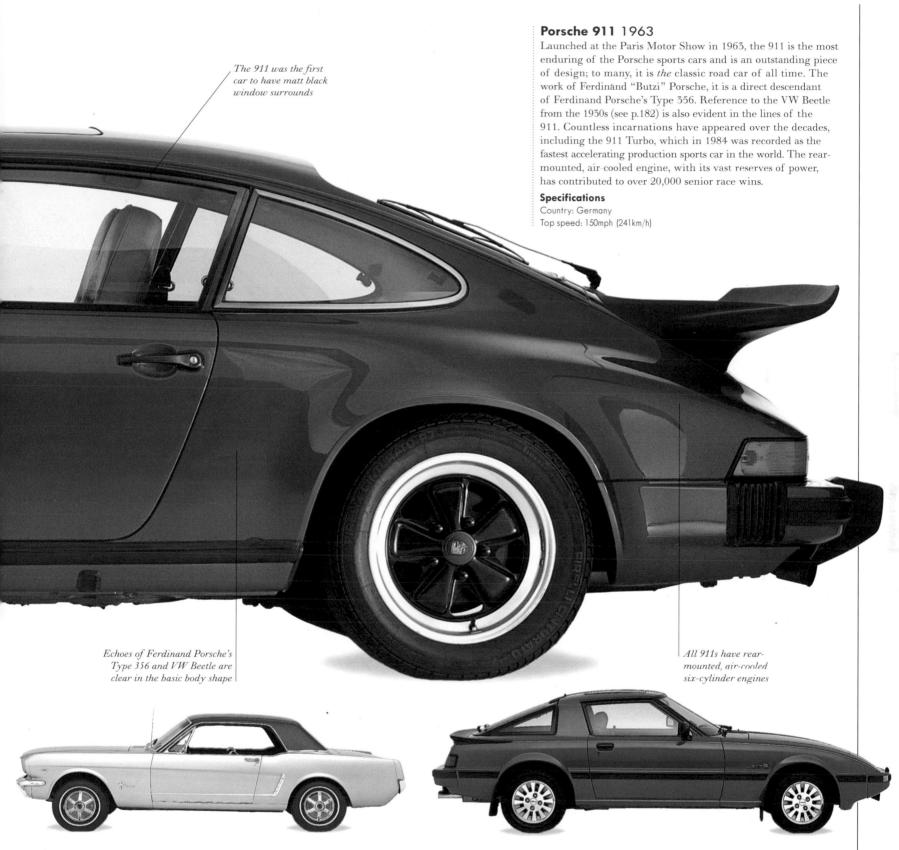

Ford Mustang 1964

To most Europeans, the Ford Mustang is a big American car. In fact, when the Mustang was introduced, it was a mould-breaking "compact", conceived as a sports car for the masses. After the excesses of the 1950s, its low-key styling was something of a relief. However, a vast range of options were offered, and, in 1965, the average buyer spent \$1,000 on options, almost half the car's price.

Specifications

Country: US Top speed: 117mph (188km/h)

Mazda RX7 1978

Almost half a million RX7s were sold in seven years of production -75 per cent in the US - making it the most successful rotary-engined car of all time. Pop-up headlights added glamour and reduced wind resistance. Indeed, the car was styled to slice through the air; its shape was so well conceived that in seven years only minor changes were made to its design.

Specifications

Country: Japan Top speed: 125mph (201km/h)

Pontiac GTO 1964

Taking a step back in time towards the big American cars of the 1950s, the immovative division of General Motors, Pontiac, put the biggest possible engine into a medium-sized body and came up with the GTO. Designed by John DeLorean (1925—), it was a powerful car, with an agility that earned it the nickname "The Goat". The first full-sized car to offer sports car performance and handling, it found an eager audience in the US, particularly among younger drivers. After various modifications, the car was relaunched in 1970 with an all-new design.

Specifications

Country: US Top speed: 135mph (217km/h)

A GLIMPSE OF THE FUTURE

Despite £65 million of British government backing and a starring role in the Hollywood film Back to the Future, the DeLorean DMC12 was a spectacular failure. With its stainless steel body and gull-wing doors, the Giorgio Giugiaro design was intended to be a glimpse of the future. In reality, it was dated before it even reached production.

The vertical twin headlights on this 1966 model were later repositioned side-by-side

Ferrari Dino 246GT 1969

The beautiful, sweeping lines of the Ferrari Dino are unmistakable: it is the archetypal Italian sports car. Invariably red in colour (this metallic brown model was rare), it was aimed at the Porsche 911 market and made an immediate impact. The Dino was named after Enzo Ferrari's son, Alfredino, who died at 24 of kidney disease.

Specifications

Country: Italy Top speed: 148mph (238km/h)

five-seat coupé, hard

top, or convertible

Volkswagen Golf GTi 1976

The car that launched a thousand imitations, the Golf was single-handedly responsible for the craze for hatchbacks that swept the world in the 1970s and '80s. It boasts an appealing combination of good performance and handling, practical design, and great reliability: the engine was easily capable of 150,000 miles (241,400km).

Specifications

Country: Germany Top speed: 111mph (179km/h)

Ford Sierra, 1982

The Ford Cortina, launched in the 1960s, was extremely successful in Europe, thanks to its combination of American styling with the smaller scale and high efficiency expected by its target market. However, by the 1980s, drivers had more exacting demands, particularly with regard to safety and economy. Ford's solution was the Sierra, a collaboration led by Uwe Bahnsen between the company's design studios in Cologne, Germany, and Essex, England. The car was launched in 1982, spearheading new, higher standards for the popular end of car production. Its aerodynamic appearance and highly sophisticated engineering placed it indisputably at the cutting edge of technological development. It was also impressively fast: the top-of-the-range Cosworth, which appeared in 1986, was capable of reaching speeds of about 150mph (242km/h).

Audi Episodi

Audi Quattro Sport 1983

The first four-wheel drive road car with impressive all-round performance, Audi's most expensive car, the Quattro Sport, can travel fast in mixed conditions. In looks, it is boxy, with an unremarkable interior. However, the excellent handling and safety-conscious design ensure that it appeals to a wide range of users, from families to long distance drivers.

Specifications

Country: Germany Top speed: 155mph (250km/h)

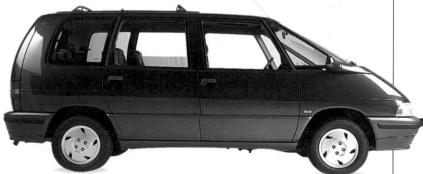

Renault Espace 1984

When it first appeared, the Renault Espace sparked a brand new philosophy in car design. Its so-called "one-box" construction offers maximum interior versatility, with space for seating and storage utilized according to the number of travellers and the type of trip. It is possible, for instance, to swivel seats or convert seating into a table top.

Specifications

Country: France Top speed: 118mph (190km/h)

THE OFFICE :

z≘lco M

Desks & chairs

Office equipment

Desk accessories

Typewriters

Computers

Photocopiers & fax machines

Adding machines

DESKS & CHAIRS

AT THE BEGINNING OF THE CENTURY, desks and chairs were considerable pieces of furniture: they were made of wood, made by hand, and made to last. However, the development of new materials and the introduction of computers made them chief targets for innovation. The traditional solid desk, with its high back and numerous drawers, has gradually been transformed into a simple work surface. Chairs, the items of office furniture most vital to workers' comfort and efficiency, now include unexpectedly comfortable high-tech structures and ergonomic masterpieces. An office planner's choice of both desk and chair is fundamental to the establishment of the company's image, and is often an indication within the office of company hierarchy.

Mahogany bureau 1920s

This solid mahogany bureau by Charles Rennie Mackintosh is one of the designer's numerous furniture designs for the study. The formality of the elongated lines is enlivened by a decorative panel.

Specifications

Country: UK Material: Mahogany

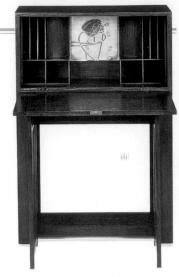

Synthesis 45 office chair 1972

Ettore Sottsass's chunky secretary chair for Olivetti shows a marked Pop Art influence. Its back and supports are made of bright plastic, and even the spring cover has been styled with great exaggeration.

Specifications

Country: Italy Materials: Lacquered castaluminium, plastic, and fabric upholstery

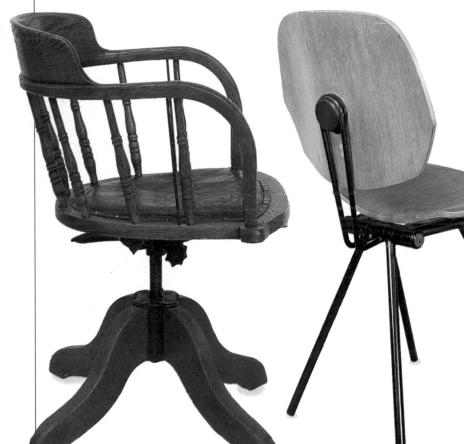

Swivel chair 1930s

This carved and bentwood swivel chair is an attractive combination of sturdiness and elegance, with its solid oak base and slender turned spindles. Originally developed to suit the movements of the user, the chair's height is adjustable. The leather seat covers a web of crisscrossed canvas that provides surprising comfort.

Specifications

Country: UK

Materials: Oak and leather upholstery

Folding chair 1958

This slim-legged, collapsible chair was designed in 1958 by Osvaldo Borsani for his company, Tecno, founded in 1954 with his twin brother Fulgenzio. Leaders in 1950s' furniture technology, Tecno designers placed technical research as the top priority, with styling a close second.

Specifications

Country: Italy

Materials: Wood and metal

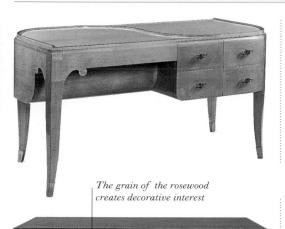

Partners' desk 1930

Made of sycamore, in the style of André Goult, this Art Deco desk was designed with two low, round-backed armchairs so that two "partners" could work opposite each other.

Specifications

Country: France Materials: Sycamore, goatskin, gilt bronze, and glass

The work of Danish designer Nanna Ditzel, this is a classically elegant rosewood desk. The simple design features four identical drawers along the full length of the work surface.

Specifications

Country: Denmark Material: Rosewood

Pippa folding desk and chair 1985

Rena Dumas and Peter Coles, designers of the impeccably finished Pippa furniture collection for Hermès, claimed that the complexity of the designs demanded "perfect materials".

Specifications

Country: France Materials: Pearwood, leather, and brass

Robot desk, 1989

Designed by Fred Baier in 1989, it is clear how the Roll-Top Drop Leaf Transformer Robot desk earned its name. The birch plywood and steel desk is fully adjustable to suit most office needs.

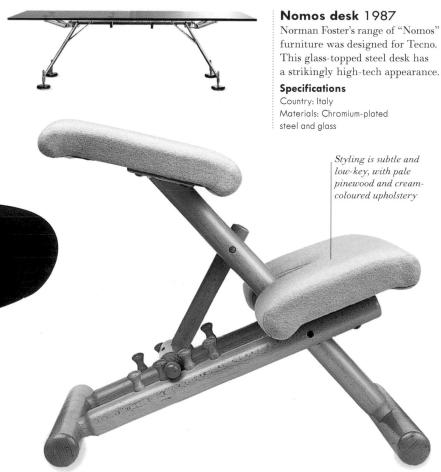

Balans chair 1990s

A product of the Norwegian firm Stokke, the Balans chair represents a complete rethink of the structure of the office chair. The aim is to reduce stress on the sitter's spine caused by working all day at a desk. This was achieved by redistributing the upper body weight: the typist perches on the sloping seat, with his or her knees bearing much of the weight as they rest on a cushioned "knee seat".

Specifications

Country: Norway Materials: Pine and fabric upholstery

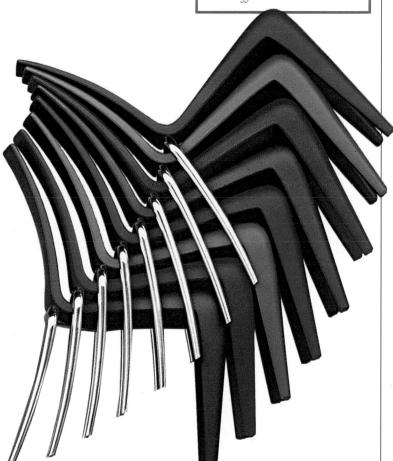

Louis 20 chair 1995

The back, seat, and front legs of Philippe Starck's Louis 20 chair are made from a single piece of moulded plastic, with the rear legs formed by a bridge of tubular aluminium. These are screwed rather than glued to the body for ease of separating and recycling the different pieces. The chair is available with or without armrests, also constructed of tubular aluminium, and several can be stacked together.

Specifications

Country: France

Materials: Polypropylene and aluminium

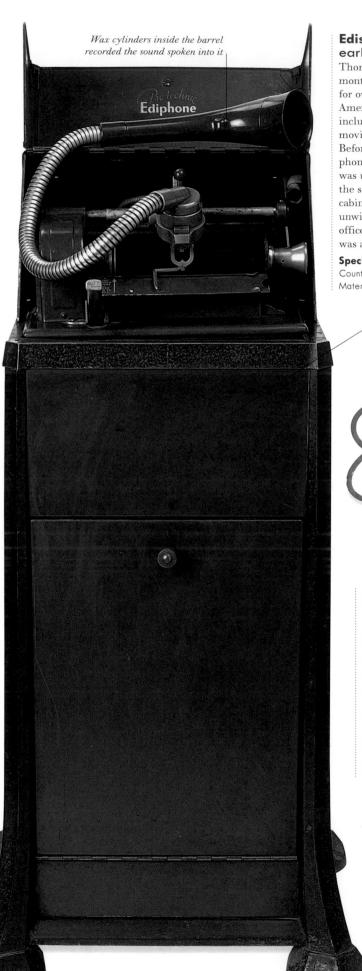

Edison Protechnic Ediphone early-20th century

Thomas Alva Edison, with only three months of formal education, was responsible for over 1,200 patents and was one of America's greatest inventors. His inventions included the light bulb, the origins of moving pictures, and the phonograph. Before Edison saw the potential of the phonograph for home entertainment, it was used in business to record dictation, the sound recorded in a wax cylinder. The cabinets of this large early machine were unwieldy, but were one of the few aspects of office furniture design where consideration was actually given to aesthetics.

Specifications

Country: UK Material: Metal

> The cabinet doors have the smooth finish of an item of furniture

OFFICE LIFE 1903

Early stenographer

Although dictaphones increased efficiency, they tended to depersonalize the office environment. Before their widespread adoption, documents would be dictated to a stenographer – one of the few interpersonal elements of office life.

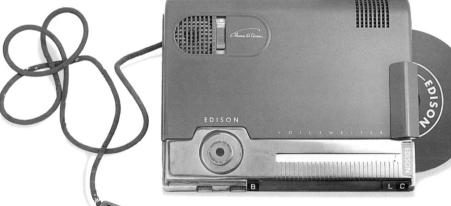

Edison Voicewriter 1953

Manufactured by the Ediphone Division of Thomas A. Edison Inc., this compact magnetic tape recorder was produced 22 years after Edison's death, but his influential name appears four times on the machine. Designed by Carl Otto, the Voicewriter was revolutionary for its portability.

Specifications

Country: US Material: Metal

The Pocket Memo is just 14cm (5½in) in length

Pocket Memo 1993

The development of cassette tapes, and now microcassettes, has meant that dictaphones have become smaller and more sleekly styled over the years. The diminutive Pocket Memo Executive 396 dictaphone, manufactured by Philips Dictation Systems, was designed by Austrian Konrad Ellermeier.

Specifications

Country: Austria Material: Plastic

The fabric blades exemplify the safety

conscious design of

the fan

OFFICE EQUIPMENT

BEFORE WORLD WAR II, the office was a distinctly impersonal place, with the stark, industrial appearance of a factory environment. Office equipment was purely functional; machines such as typewriters and photocopiers had their inner workings exposed (see pp.198–199; 202–203), and the use of dictation machines, commonplace by the 1930s, depersonalized office life

further. Decades passed before any link was acknowledged between productivity and environment. It was only as recently as the 1950s that designers began to place the aesthetics of office equipment

on a par with technical performance.

The bars of the guard resemble ribbons fluttering in a breeze

AEG fan 1911

Peter Behrens was as concerned as any designer of his time with the function of the machinery he designed, but his refined sensibilities meant that his designs stole a march on those of his rivals. This pioneering electric desk fan for AEG is a fine example of Behrens tailoring the design of the item to emphasize its function.

Specifications

Country: Germany Material: Cast iron and brass

PORTABLE STORAGE

The ingenious Boby trolley was designed by Joe Colombo for the Italian company Kartell in 1970, and is now produced by Bieffeplast. Made of ABS plastic, its structure is an excellent example of how designers mastered the storage potential of plastics in the 1960s and '70s. The trolley has swing-out drawers and a number of storage compartments. One of its main advantages is that it is so light it can be moved around an office on its large castors.

Boby trolley, 1970

Bandolero desk fan 1930s

The streamlined Bakelite Bandolero fan was produced by Diehl, the electrical division of Singer, for the American mail order company Sears. The design dispenses with metal blades, using in their place safer cross-hatched fabric blades, which were replaceable. This removed the need for a protective cage and contributed to the fan's sharp, modern image. The fabric blades were later replaced with rubber versions.

Specifications

Country: US Materials: Bakelite and fabric

DESK ACCESSORIES

MOST OFFICE DESKS are littered with items that are, in their way, design classics. The humble paperclip, invented in 1899 by Norwegian Johann Vaaler, has hardly changed, and the pencil sharpener, developed in Germany in 1908 by the TPX Bias company, remains an essential office item. The Rolodex, which first appeared in 1950, has survived the age of electronically stored information as a simple and efficient means of storing addresses. Even the disposable ball-point has a fascinating history.

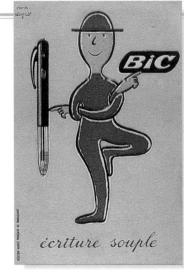

Blotting paper c.1955

In the 1950s, collecting printed blotting paper was popular in many European countries and in the US. The widespread introduction of the Bic biro killed off the fad in the 1960s. This advertisement was designed by French illustrator Savignac.

Specifications

Country: France Material: Paper

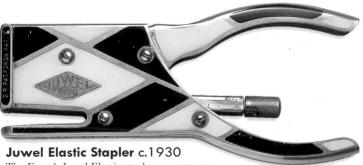

The French Juwel Elastic stapler operates, as its name suggests, by means of an elastic band rather than the spring used in modern staplers. The beautiful, Deco-inspired geometric enamelling in black and white ensures that the Juwel lives up to its name.

Specifications

Country: France Materials: Metal and enamel

Stapler 1960s

The design of the stapler has changed very little this century. When they first appeared, patented by C.H. Gould in 1896, they were used to fasten together the soles and uppers of shoes. The first paper staplers appeared in the late-1890s.

Specifications

Materials: Metal and plastic

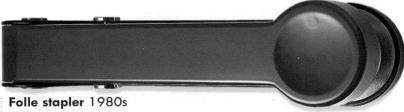

Resigned to the fact that little can be done to improve the stapler's function, designers toy with its looks. This round-headed model is available in a range of bright colours. It was designed by Henning Andreasen for Folle APS of Denmark.

Specifications

Country: Denmark Material: Steel

Rolodex 1952

Arnold Neudstadter's 1952 design of the Rolodex card file was so successful that the company claimed that "there's a Rolodex file on almost every desk in America". The Rolodex is deceptively simple; made of heavy steel, it rotates "Tuff Fiber" index cards and will stop in any position, thanks to an ingenious ballbearing clutch mechanism known as the "Rolomatic".

Specifications

Country- US Materials: Metal, plastic, and paper

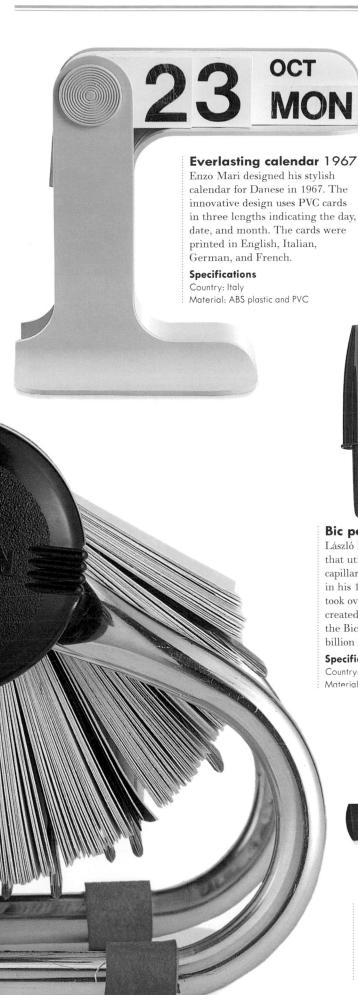

23 MON

Enzo Mari designed his stylish calendar for Danese in 1967. The innovative design uses PVC cards in three lengths indicating the day, date, and month. The cards were

Bic pens 1938

László Biró first developed a pen that utilized quick-drying ink, capillary action, and a ball-point in his 1938 "Biro". Marcel Bich took over the patent in 1958 and created a disposable version, the Bic. In the 1990s, three billion Bics are sold each year.

Specifications

Country: France Material: Plastic

Fibre-tip pens 1963

Ball Dentel Fine Point R50

Pentel Extra Fine

One of the few advances on the ball-point, the first fibre-tipped pens, developed in Japan in 1963 by Pentel, used a bamboo inner barrel. This was superseded by a fibre tube that fed ink to the nib by capillary action. This system is still used.

Specifications

Country: Japan Material: Plastic

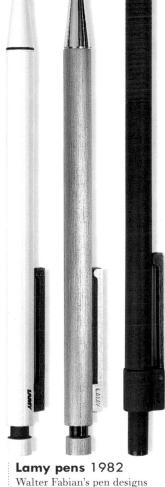

for the German company Lamy were an enormous success, elevating them to "classic" status immediately. The pens were popular for their styling rather than for any new technical advances.

Specifications

Country: Germany Material: Plastic

Factory F2 desk tool 1986

Developed by brothers, Yoshihisa and Kohji Imaizumi for Plus Coporation, this compact desk accessory is in the style of a Swiss Army knife. It has a stapler, magnifying glass, tape measure, hole punch, staple remover, pin case, scissors, and tape dispenser.

Specifications

Country: Japan Materials: Plastic and metal

TYPEWRITERS

THE FIRST TYPEWRITERS, made in 1873, had a QWERTY layout, from the word spelled by the first six letters of the top row of keys. This system is based on the positioning of the most-often-used keys and is still used today. Early typewriters had an industrial appearance unsuitable for the home market, but by the 1930s, portables had been introduced and electric machines developed. By 1961, when IBM launched the "Golfball", electric models had largely replaced manuals. The advent of personal computers in the 1990s delivered the final death blow to the traditional typewriter.

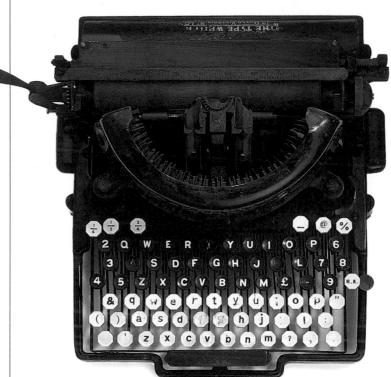

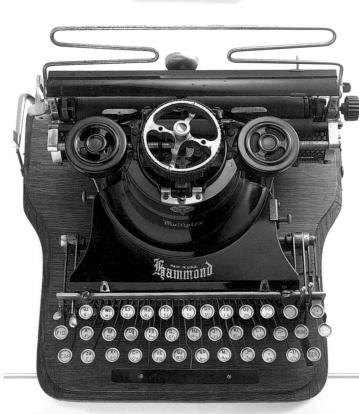

Royal Bar-Lock c.1910

This typewriter has a double keyboard. Without a shift key, which had been developed by Remington in 1878, it was necessary to have two keyboards, one for the upper case and one for the lower. The position of the typebars would have made it very difficult for the typist to see what was being printed. The open body gives the typewriter an industrial look, which would not have appealed to the domestic market.

Specifications

Country: US Width: 40cm (15¾in)

Advertisement for the Royal Bar-Lock

Multiplex 1919

Hammond produced many innovative typewriters. The Multiplex had a system of interchangeable type shuttles that carried different fonts. The typewriter bears the legend "For All Nations and Tongues", which implies that the various fonts might be used for foreign languages. Most shuttles carried the fonts in three rows, but for specialized shuttles that had four, a second shift key was required.

Specifications

Country: US

Dimensions: h 58.42cm (23in), w 104.14cm (41in)

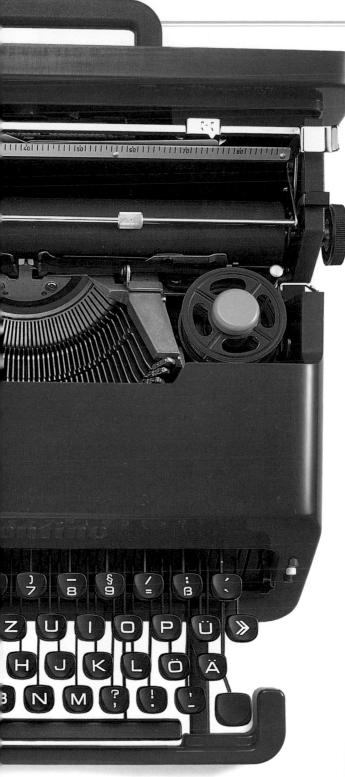

THE "GOLFBALL"

Eliot Noyes designed the innovative Selectric or "Golfball" typewriter for IBM in 1961. It was a revolutionary design because the typebars were replaced by a small spherical typing head shaped like a golfball. This head carried the usual 88 characters, but it moved while the carriage remained stationary. Heads were interchangeable, allowing for a greater selection of typefaces. The Selectric was part of Noyes' programme to create a corporate identity for IBM, and its style owes a great deal to Marcello Nizzoli, who was so instrumental in reshaping Olivetti's post-1945 product range.

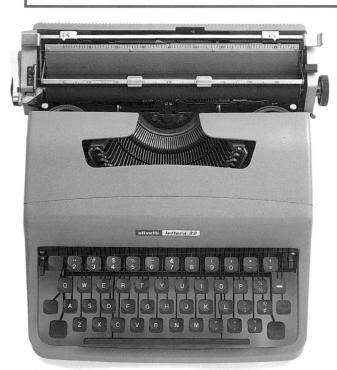

Lettera 32 c.1960

IBM Selectric, 1961

Marcello Nizzoli was Olivetti's first and most influential product designer. In the 1940s and '50s, he created office appliances, including adding machines (see p.205) and typewriters, which have achieved classic status. The Lettera 32 is based on his portable typewriter of 1950, the Lettera 22. The hallmark of Nizzoli's designs was his keen attention to form and applied graphics.

Specifications

Country: Italy Dimensions: h 8cm (3in), w 31cm (12in)

Valentine 1969

The Valentine is the ultimate portable typewriter, comprising two simple elements. The machine and handle form one element and the matching carrying case the other. It was designed for Olivetti by Ettore Sottsass and Perry A. King, who wanted to create a typewriter that would be light enough to carry anywhere and that would not be associated with the work environment. It is made from bright orange-red moulded plastic, with yellow caps on the ribbon spools "like the two eyes of a robot", as Sottsass himself described them. It represents a radical departure from traditional office equipment.

Specifications

Country: Italy

Dimensions: h 10.3cm (4in), w 33cm (13in)

Samsung SQ-3000 1990s

This Samsung is an example of a crossbreed of typewriter that combined a compact electronic machine with a memory facility. The small screen allowed the user to view a line of text before it was printed. Such models were popular from the mid-1980s, until the development of the personal computer rendered their features obsolete.

Specifications

Country: South Korea Dimensions: h 11.3cm (4½in), w 39cm (15½in)

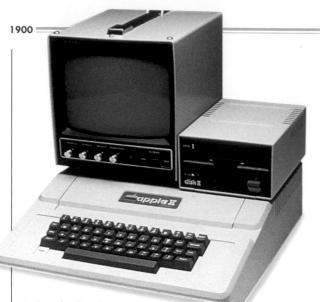

EARLY COMPUTERS

The first electronic computer contained 19,000 electronic tubes, which enabled it to compute 5,000 additions per second, and about 300 multiplications. At the time this must have seemed very quick, but it was child's play compared to the capabilities of modern computers such as Cray Y-MP (1988), which can achieve more than two billion computations per second.

Apple II 1977

The success of the Apple II, shown here with the Disk II disk drive introduced in 1978, lay in its userfriendliness. Developed by Steve Jobs and Steve Wozniak, it was the first commercial personal computer.

Specifications

Country: US Dimensions: Not known

AMSTRAD

IBM PC XT 1981

The most popular and influential personal computer ever produced, the IBM PC sold over 800,000 units within two years of its launch in August 1981. It was designed by a young team of computer scientists, headed by Philip Estridge. Despite its meagre specification, it spawned a whole new industry, setting higher standards in personal computing.

Specifications

Country: US Dimensions: h 43cm (17in), w 51cm (20in)

Clean, pale colours, such as beige, have long been favoured by the designers and users of computers

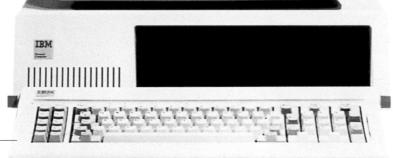

THE APPLE MAC

The Macintosh, designed by frogdesign for Apple Computer and unveiled in 1984, was by far the most original personal

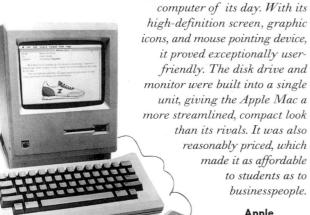

Apple Macintosh, 1984

COMPUTERS

THE BOOK THAT YOU ARE READING was written on a computer small enough to fit in a briefcase, and designed and edited on versatile desktop computers. Yet the first electronic computer, the ENIAC (Electronic Numerical Integrator And Calculator), developed as recently as 1946, weighed 30 tonnes and occupied a surface area of 160m^2 (1722ft²). The invention of the transistor in 1947, and its successor, the integrated circuit in 1959, facilitated the reduced size and greater power that characterize computers today. As more schoolchildren are taught to use computers, they are becoming as commonplace in the home as televisions, and with the advent of CD-ROM, just as entertaining.

CD-ROM

Invented by Philips, and promoted internationally in collaboration with Sony, the CD-ROM is a laser-read disc that can be used to produce images on a computer screen. It can hold a large amount of information, which is displayed either in the form of text and images, or as narrated animated sequences. Until the 1990s the main market for CD-ROMs was professional, but they are now increasingly available to the home audience.

DESKTOP

456+ Ht 1 2 3 -8 . X =

Sony CD-ROM player, 1985

SERIES 3 PSION ystem Data Word Agenda Time World Calc Progre 📶 Q W E R T Y U I O P 💳 🔤 ASDFGHUKL!

Amstrad PC1512 1986

The British company Amstrad, established by entrepreneur Alan Sugar, launched the hugely successful PC1512 in 1986. Compatible with IBM's PC, it was, however, easier to use, twice as fast, and substantially lower in price. It made IBM standard computing, previously restricted to the US market, accessible to the European home-user for the first time.

Specifications

Country: UK Dimensions: Not known

Psion Series 3 1992

The miniaturization made possible by the microchip is epitomized in this palmtop computer, which incorporates a personal organizer and word-processor. It has more power than the computers aboard the Apollo spacecraft.

Specifications

Country: UK Dimensions: h 5cm (2in) open, w 16.5cm (6½in)

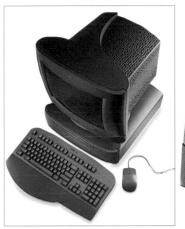

Acer Aspire 1996

In the marketing of computers the emphasis has generally been on function rather than form. Previously, computer use was largely restricted to offices, but the 1990s have seen the emergence of the home office. Companies, like Acer, have recognized this change in the market, and are offering something more attractive than the ubiquitous beige box. With its decorative surface, sculpted shape, and ultra-modern appearance, the Aspire is an attractive item of home furniture, as well as a powerful computer.

Specifications

Country: Taiwan Dimensions: h 49cm (19½in), w 39.5cm (15½in)

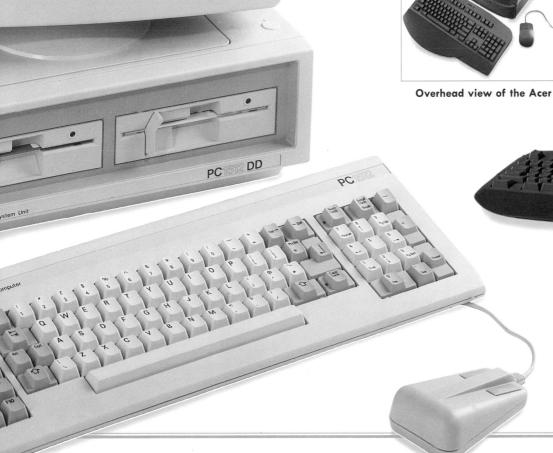

PC-CM

PHOTOCOPIERS & FAX MACHINES

THE PRINCIPLES FOR duplicating and transmitting documents have existed since the beginning of the century. However, it is only with the development of an integrated telephone system and advances in electronics that photocopiers and facsimile machines have come to play such crucial roles in the office. Originally forbidding-looking, the first copiers were transformed as early as the 1930s, thanks to Raymond Loewy's "face-lift" of a Gestetner duplicating machine. Fax machines were developed much later, emerging in Japan and the US simultaneously in 1968, when it took six minutes to transmit a single-page document. Today, communication by fax is an instantaneous and indispensable process.

Gestetner duplicating machine 1920s

There is no applied ornamentation on this early duplicator by the British manufacturer Gestetner. Instead, the mechanism has been left exposed, giving the machine an unmistakably industrial and uninviting appearance.

Specifications

Country: UK
Materials: Wood and metal
Dimensions: Not known

Gestetner duplicating machine 1929

Gestetner commissioned Raymond Loewy to restyle the exterior of its duplicating machine in the late 1920s. In contrast to the overtly utilitarian appearance of the original machine, Loewy's simplified version is sleek and refined, with the mechanism concealed in a casing. He used a full-scale clay model to achieve the desired sculptural qualities — a working method that was subsequently adopted by designers in the car industry.

Specifications

Country: UK Materials: Wood and metal Dimensions: Not known

THE FIRST COMMERCIAL COPIER

Xerox 914, 1959

The word "Xerography" was coined by American Chester Carlson in 1937 to describe his invented method for reproducing images. It is derived from the Greek Xeros, meaning "dry", and Graphein, meaning "to write". The process, which is still used in modern photocopiers, involves the use of a powerful lamp, dry powder (toner), static electricity, and heat. After years of struggle, Carlson teamed up with Haloid, which later became Rank Xerox, and the Xerox 914 automatic copier was introduced in 1959. It was the first commercially available photocopier, capable of making seven copies per minute. Today, led by the Japanese, manufacturers produce machines that make as many as 100 copies per minute.

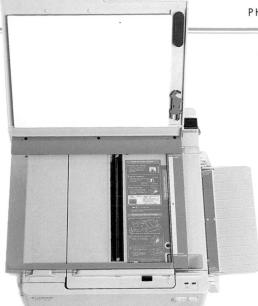

Canon PC-3 portable copier 1993

This personal desktop portable copier by Canon was designed to meet the growing need for a photocopier suitable for infrequent use. It works in the same way as a conventional office photocopier, but is restricted to the most basic operations. It is unable to enlarge or reduce documents, and is without a paper stack.

Specifications

Country: Japan Material: Plastic Dimensions: h 14.6cm (5%in), w 38.4cm (15in)

QuadMark PassPort portable copier 1993

When Xerox company QuadMark introduced this portable copier in 1993, it was the world's smallest plain paper copier. Battery-operated and cordless, it weighs just 1.8kg (4lb) and is diminutive enough to be stored in a briefcase or desk drawer. Despite its modest size, the reproduction quality is high, with copies printed at 400 dots per inch resolution.

Specifications

Country: US Material: Plastic Dimensions: h 7cm (2¾in), w 30cm (11¾in)

By the 1970s, fax machines were starting to become a familiar feature in modern office environments. By offering companies the very latest technology in a new, compact form, the Qwip 1200 series revolutionized the market. The machine was designed in two sections: the main sender/receiver and the acoustic housing for the telephone headset. It required special paper to receive documents, but otherwise it was simple to use, taking about four minutes to transmit or receive a document.

The headset of a standard telephone is housed in this acoustic shell

Specifications

Country: US Material: Plastic Dimensions: h 16cm (6¼in), w 56cm (22in)

Canon Faxphone 8 1988

Compact and unobtrusive, this integrated telephone/fax machine could serve either in the office or the home. The light grey plastic housing conceals all the working apparatus. It has push-button keys and a memory facility. Its great advantage is that it can print onto ordinary paper and can transmit and receive documents in a matter of seconds.

Specifications

Country: Japan Material: Plastic Dimensions: h 12.5cm (5in), w 31cm (12¼in) ADDING MACHINES

WE NOW TAKE FOR GRANTED the use of sophisticated, inexpensive electronic calculators. However, early calculating machines were heavy, slow, and had no stored memory. Computers with this capacity became available for commercial use in the 1950s; they could be programmed to solve complex problems, but their size made them impractical for home use. It was the introduction of the microchip in the 1970s that facilitated massive reductions in the size, weight, and cost of calculators, while transforming their power beyond compare. Today, designers' increased sensitivity to the needs of the operator is reflected in the form of the machine, its graphics, and the grouping of keys.

Victor adding machine c.1935

This mechanical calculator has a two-tone, typewriter-style keyboard, which allows the fast and efficient entry of numbers. Designed by W.A. Knapp for

the Victor Adding Machine
Co., of Chicago, it is housed
in a lightweight Bakelite
case. Relatively inexpensive
and easy to mould into a
modern shape, Bakelite was
made popular in the 1930s by
the likes of Raymond Loewy,
Wells Coates, and Jean Heiberg.

Specifications

Country: US Materials: Bakelite and metal Dimensions: h 18cm (7in), w 18.5cm (7½in), d 31cm (12½in)

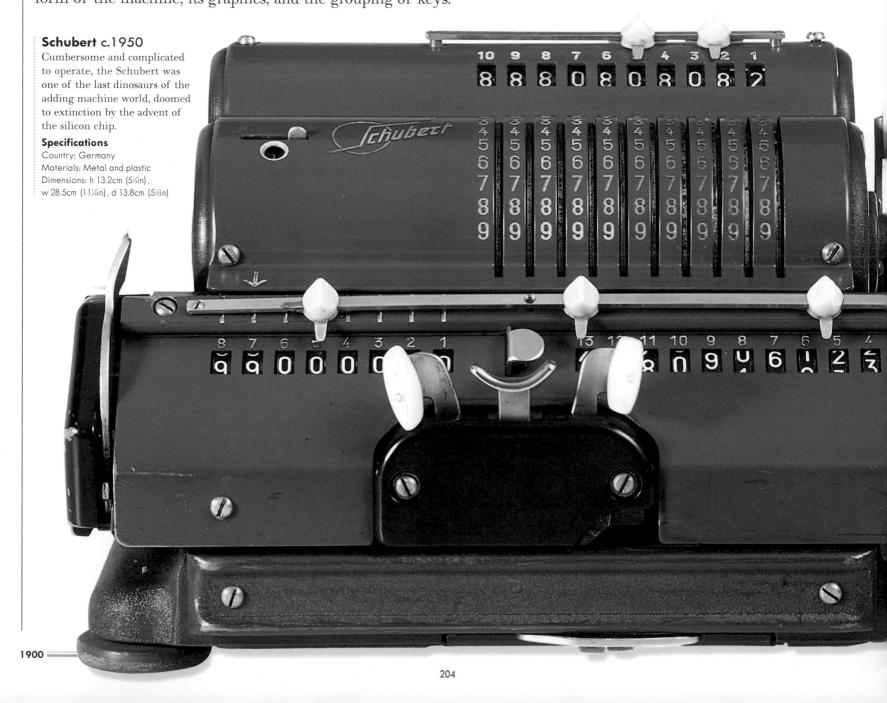

The calculating

process relied on

mechanical operation

Olivetti **Divisumma 24** 1956

This calculator is the work of one of Olivetti's most celebrated designers, Marcello Nizzoli. Always mindful of those who will use and maintain his products, Nizzoli has considered the positioning of the keys, the colouring, and the graphics layout to make the machine easier to use. To ease servicing, the two-part plastic casing is removable, allowing maximum access to the mechanism.

Specifications

Country: Italy Materials: Plastic and metal Dimensions: h 24cm (9½in), w 24.4cm (9½in), d 43cm (17in)

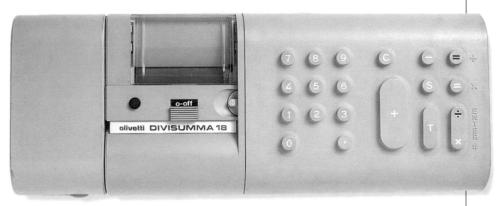

Olivetti Divisumma 18 1973

Like Marcello Nizzoli, Olivetti designer Mario Bellini responds to human requirements in his designs. Although he studies ergonomics, he stresses that they can be merely a starting point, as man is much more complex than a set of measurements. Divisumma 18 will be remembered as much for its feel as its appearance. Manufactured in brightly coloured plastic and covered with a thin sheath of rubber, its soft, tactile keys and the rounded forms make it a pleasure to handle.

Specifications

Country: Italy Materials: Plastic and rubber Dimensions: h 4.6cm (13/4in), w 30.9cm (12¾in), d 12cm (4¾in)

Because of the ergonomic design, there are separate versions for right- and left-handed users

Zelco "Double Plus" calculator 1986

Designed by Donald Booty Jr. for Zelco Industries, this calculator is shaped to be gripped. The name "Double Plus" derives from the unusual feature of having two plus keys, which allows for a brisker addition function than usual. These, and the other keys, are positioned, shaped, and coloured to maximize efficiency.

Specifications

Country: US Materials: Plastic and acrylic Dimensions: h 14.4cm (5½in), w 6.6cm (2½in), d 1.3cm (½in)

POCKET CALCULATORS

This pocket calculator by Casio is typical of the millions now inexpensively available to all, and in constant use in homes, offices, and schools across the world. It demonstrates the possibilities

afforded by modern technology: in addition to its memory storage facility and multitude of mathematical functions, it is powered by a solar cell, and so requires no batteries. The first pocket calculator was introduced in 1972 by Clive Sinclair.

Casio pocket calculator, 1990s

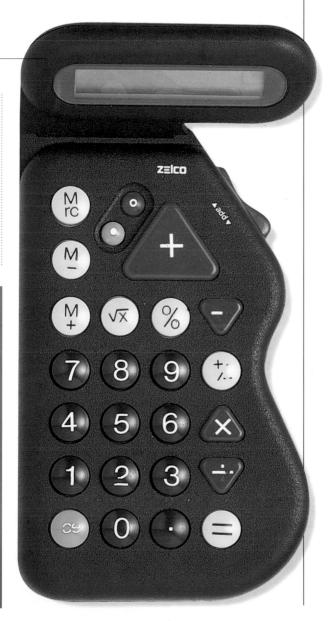

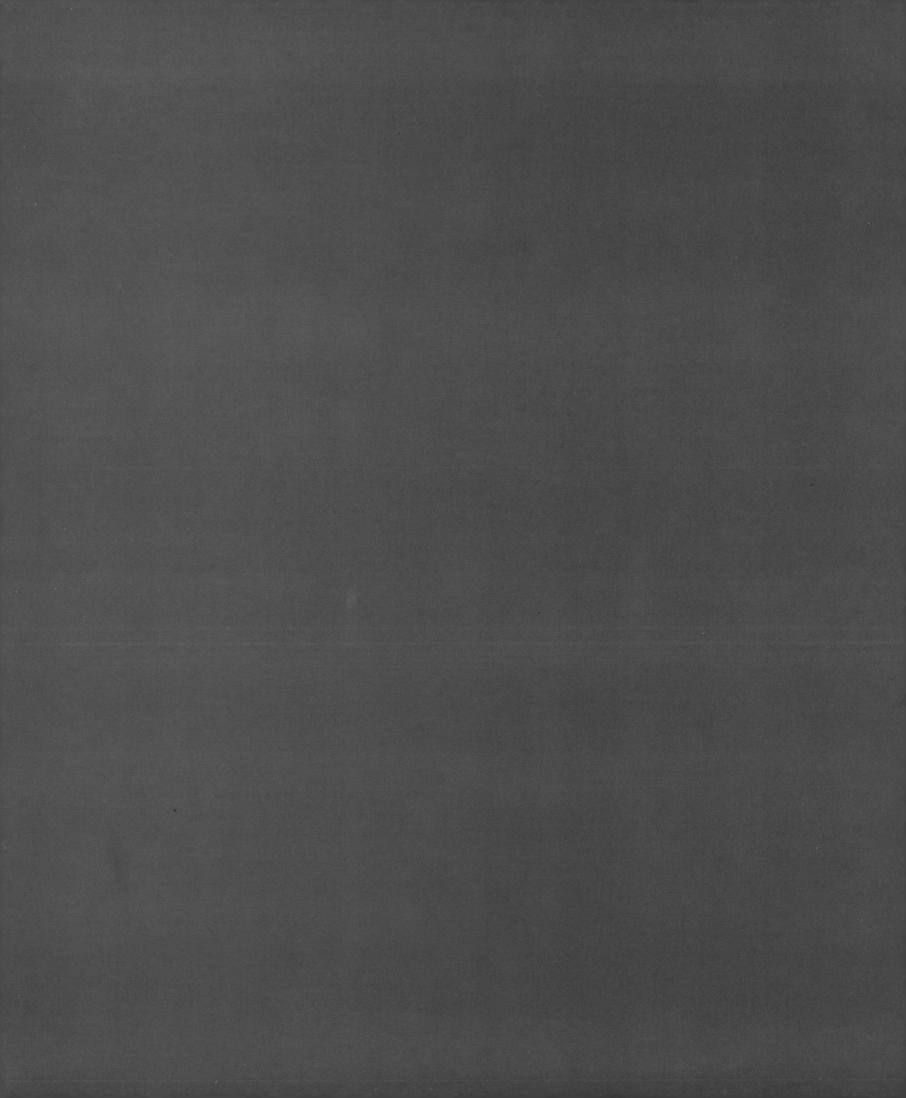

GRAPHICS, ADVERTISING, & PACKAGING

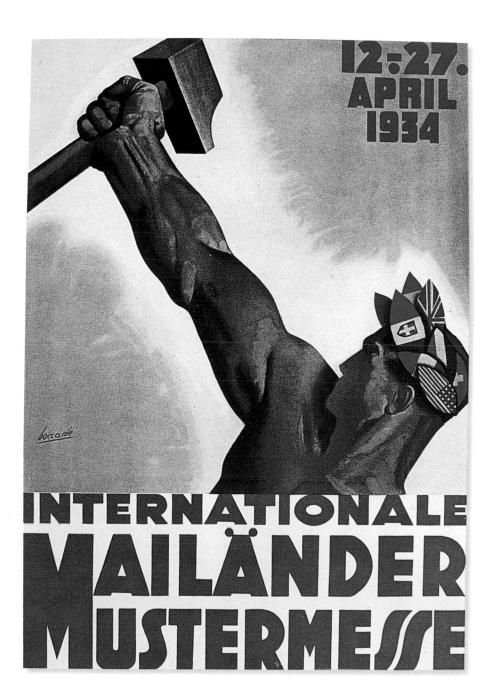

Typefaces

Corporate ID

Magazine covers

Record covers

Posters 1900—19

Posters 1920—39

Posters 1940-59

Posters 1960–79

Posters 1980—90s

Packaging 1900-09

Packaging 1910—19

Packaging 1920—29

Packaging 1930—39

Packaging 1940-49

Packaging 1950-59

Packaging 1960-69

Packaging 1970—79

Packaging 1980-89

Packaging 1990s

Eckmann Schmuck 1900

this Jugendstil typeface, designed

Eckmann. The curvilinear strokes of each letter taper and swell, as

if with the movement of an italic

pen nib. Devised for the Rudhard Foundry, it was also adopted by

Klingpor, with which it is most

commonly associated.

by German typographer Otto

Organic and calligraphic influences are clearly evident in

Marchael Mar

Die Meilterlinger von Nürnberg Gudrun NIBELUNGEN Egmont

Rudhard'iche Gießerei in Offenbach am Main

Fette Eckmann Busitellung in Dülleldorf Kunit RHEINGAU Ideal
Schule von Brabant Lied RUBENS Poet
Roland Samlet

Roland Samler
5 DON SUAN 7

Frankenthal

Frankenthal 4 GUBEN 2

Rudhard'sche Gießerei in Offenbach am Main

The launch pack for Futura shows a decorative variation of the basic typeface

TYPEFACES

Even the verticals of Eckmann Schmuck curve organically

COUNTLESS PRODUCTS from the 20th century are instantly associated with a particular style of lettering, be it a cereal box, a newspaper, or a public transport map. In fact, so powerful is the impact of many typefaces that words are often given expression even before the literal meaning becomes apparent. There are two basic divisions of typefaces: serif faces (those with terminal strokes) and sans serifs (those without terminal strokes), and a multitude of variations exist. Functional and geometric, sans serif letterforms were pioneered by Bauhaus designers in the 1930s, and labelled "new typography".

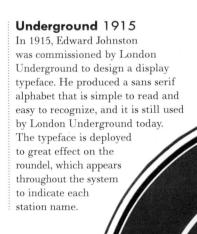

The roundel
originally had
a solid red disc
with a blue bar

Each stroke is
of an identical
thickness

abcdefghi jklmnopqr stuvwxyz

Beispiel eines Zeichens In größerem Maßstab

sturm blond

Abb. 2. Anwendung

Universal 1925

During his time as head of the print department at the Bauhaus, Austrian Herbert Bayer produced this alphabet. An advocate of modernism, Bayer defended the sans serif typeface as an expression of its time. He denounced serifs as a hangover from handwriting, incompatible with modern typography and printing. His simple, geometric Universal alphabet also suspended the use of capital letters. It was employed in the Bauhaus publication Offset, but

never released as a typeface.

The letter forms are hard on elevical.

The letter forms are hard on elevical.

based on classical Roman proportions

1900

ΩΩ

DER OFFSET-VERLAGIGM B.H.LEMZ

BI

FUTURA fett

8408 8 Punkte a. 4,25 kg 30 A 106 a

DANN BLIEBE NEBEN DEM TECHNISCHEN STIL JA NOCH PLATZ FÜR einen reichen handwerklichen! Man hat das wiederholt behauptet, aber 1st es wirklich so? Könnte die Maschine nicht ebensgut auch reiche, kompligierte Formen massanuste herstell von die Alefa-

DIE DRUCKTYPE IST DER MASCHINELLE ABDRUCK maschinell hergestellter Metall-Lettern, die mehr Lesezeichen sind als Schrift. Die Druckschrift ist Punkle A700 keine Ausdrucksbewegung wie die Handschrift.

DIE MASCHINE HAT DAS DOCH SCHON OFT BEWIESEN. Aber der Stilwille unserer Zeit will es anders; er ist einheitlich und wurzelt tiefer. Nun erst war die Zeit reif,
30 kp 24 A 84 a auch die Maschine zu verstehen und sie zu bemeistern.

DIE GROTESKSCHRIFTEN SIND DIE NATUR,

BAUERSCHE GIESSEREI

FUTURA

FRANKFURT AM MAIN

FUTURA fett

MEISTERKURSUS 8436 30 Printe Handwerkskunft

MANUSKRIPT 844 48 Profes Schriftproben

INDUSTRIE Neuheiten

BARMEN Reklame

SCHULE Malerei Malerei

Futura 1927-30

The design of the Futura typeface owes more to precision engineering than to the calligrapher's pen. Taking inspiration from Bayer's Universal face, German typographer Paul Renner was one of the first to utilize the revolutionary approach of a completely even stroke throughout the alphabet. Futura is notably more rigid in its geometry than its corresponding British typeface, Gill Sans. As with Universal, the letterforms are based on squares and circles, but, interestingly, the crossbar of the "E" and "F" is positioned above centre. The typeface is still used today in a number of variations.

> The form of the lowercase "i" is reduced to a

Gill Sans type is used in this page from the typographic journal The Fleuron

TANNUAL MEETING

FEDERATION

OF

MASTER PRINTERS

THE LANSTON MONOTYPE CORPORATION LIMITED, LONDON PRESENT

AN INTERIM PROOF OF THEIR

SANS-SERIF TITLING

DESIGNED BY ERIC GILL

CONGRESS

SELLING

AND

PUBLICITY

MAY 31 COLLECT FOR THE FEAST OF S. ANGELA MERICI

DEUS, QUI NOVUM PER BEATAM ANGELAM SACRARUM VIRGINUM COLLEGIUM IN ECCLESIA TUA FLOR-ESCERE VOLUISTI: DA NOBIS, EIUS INTERCESSIONE, ANGELICIS MORIBUS VIVERE; UT, TERRENIS OMNIBUS ABDICATIS, GAUDIIS PERFRUI MERE-AMUR AETERNIS - PER DOMINUM NOSTRUM

IESUM CHRISTUM FILIUM TUUM QUI TECUM VIVIT ET REGNAT IN UNITATE SPIRITUS SANCTI DEUS PER OMNIA SAECULA SAECULORUM

ABCDEFGHIJJKLMN OPQQRRSTUV WXY7

■ 1.2.3:4:5-6!7?8§9*¶()[■■■]

Gill Sans 1928

British designer Eric Gill was a highly respected type-designer, sculptor, and letter-cutter, whose Gill Sans typeface is firmly identified with Modernism. Gill studied under Edward Johnston, whose guidance can be detected in the forms of this sans serif alphabet. The application of subtle stroke variation gives the face greater fluidity, making it easy to read as continuous text. Gill Sans was created for the Monotype Company (renamed the Monotype Corporation in 1931), whose adviser for typography, Stanley Morison, had earlier supported Gill in the development of his typeface Perpetua. Gill Sans was adopted by London and North Eastern Railways in 1929, and has remained prevalent in the printing of forms.

BLACKPOOL

Times New Roman 1931

As well as advising Monotype (see p.209), Stanley Morison was typographic consultant to The Times, London, for three decades, and he created this typeface for the newspaper. It was used exclusively for one year, replacing a Gothic type that had been favoured for over 120 years. Simplifications to the formation of each letter meant that text could be condensed and remain legible, at the same time saving space.

THE TIMES NEW ROMAN

It may be claimed that *The Times*, with its new titling, its new device, and its new text types, possesses, from the headline on the front page to the tail imprint on the back, a visual unity. But this is no more than the beginning of typographical wisdom, for visual harmony, whatever its

It may be claimed that The Times, with its new titling, its new device, and its new text types, possesses, from the headline on the front page to the tail imprint on the back, a visual unity. But this is no more than the beginning of typographical wisdom, for visual harmony, whatever its significance for the artist, has little value for the general reader unless and until it accompanies the

It may be claimed that The Times, with its new tilding, its new device, and its new text types, possesses, from the headline on the front page to the tail imprint on the back, a visual unity. But this is no more than the beginning of typographical wisdom, for visual harmony, whatever its significance for the artist, has little value for the general reader unless and until it accompanies the basic factors of textual legibility. The reader needs a definite

It may be claimed that *The Times*, with its new titling, its new device, and its new text types, possesses, from the headline on the front page to the tail imprint on the back, a visual unity. But this is an more than the beginning of typographical wisdom, for visual harmony, whatever its significant with the artist, said the value for the general factor of the artist, and the tail the significant with the artist, and the property of the artist, and the significant with the property of th

It may be claimed that The Timer, with its new titling, its new device, and its new test types, possesses, from the headline on the front page to the tail imprint on the back, a visual unity. But this is no more than the beginning of a visual unity. But this is no more than the result of the significance for the artist, has little value for the general reader unless and until it accompanies the basic factors of textual legibility. The reader needs as definite plainness and claims of impression: and that adjustment of the spacing, first, to the single letters, next to their combination in words, lines, paragraphs, columns, and pages which

It may be claimed that The Then, with its new thirty, it were device, and its new test types, possesses, from the healthing in its first one to the control of the control

MOVABLE TYPE

Printing with metal type has its origins in the invention of movable type by the 15th-century German goldsmith Johannes Gutenberg. Each block has a single letter that can be set, inked, and the relief surface then impressed onto paper. The method was an improvement on woodblock printing, not least because one mistake no longer meant the replacement of an entire printing block. Here, a "forme" is made up of the inked type, wedges,

Inked forme

Univers 65

DANS LA PREMIÈRE SÉRIE Les efforts que l'homere fait

POUR BERVIR D'INTRO Les efforts que l'horome misus comprendre et p connaître assocplisses

er je savnjevi bjih 90ge prv budi covingsa aktoribijavac soo sa er je savnjevi bjih 90ge prv budi er je savnjevi bjih 90ge problev bjih 90ge pro

UNE IMPRESSION RECONFORTANTE SE DEGA Les efforts que l'homme fait pour mieux connaître pour mieux comprendre assouplissont son esprit rendent plus apte aux progrès du landemein. C'est

LE MERVEILLEUX ESSOR DE LA PHYSIQUI Les efforts de l'homme pour mioux connaître et pour mieux comprondre assouplissent sor esprit et le rendent plus apte aux progrès du

UN SUJET ASSEZ DIFFICILE A TRAITER
Les efforts que l'homme fait pour mieux
connaître et pour mieux comprendre
assouplissent son esprit et le rendent plus

LES DISCIPLINES DE LA SCIENCE Les efforts que l'homme fait pour mieux comprendre et pour mieux connaître assouplissent son esprit

UN MOUVEMENT RAPIDE la réflexion de la lumière sur les miroirs et la propagation RÉSUMONS UN PEU maintenant que nous devons cesser pour un

BANQUEROUTE une reproduction authentique de la

PERSUASION le mouvement qui était prévu

FRANCHE instruction

as unive

univers univers

21 variations sur un thèr

ABCDEFGHIJK LMNOPQRSTUVW XYZ ÄÖÜ MN abcdefghijklmnopq rstuvwxyz äöü

ne Optima ist lieferbar in den Graden 6, 8, 9, 9/10, 10, 12, 14, 16, 20, 24, 28, 36 und 48 p., ne Sahniti sip pria get est un den gesetzlich geschwitzes Original Ereugnis der D. Siempel AG, ignatur - Hauptstynstaur, 6-12 p in allen Gominiuren Sondersiynotur 3, 6-12 p Holbstoler Optima ondersupatur 3 5, Gleich Hormanz Zapit Mellor haben die Brotschnitigrade in die Gominiuren

AUSZEICHNUNGSMÖGLICHKEITEN

Nebon der stehenden Optima laufen die Kursiv und die Holbfette her, Dia Grode der Kursiv und der Halbfetten belinden sich in Vorbereitung. Kontraste der Werk- und Akzidenzschriften der Optima

ILGESCHICHTLICHES

Die Optima von Hermann Zapf erschien nach jahrelangen Vararbeiten zur Drupa 1958. Sie gehört

ÆŒÇ ÉÊÈË ÅØ åø æœç chckfffifftijß £ 1234567890 \$.,-:;!?'(),," »« &-[]§†* áâà éêèë í î i ï ó ô ò ú û ù

Univers 1957

Swiss designer Adrian Frutiger earned his considerable reputation through the creation of this versatile typeface. Univers 65, shown here, is just one of 21 variations contributing to this universal lettering system, which permits a multitude of combinations and effects. Designed for the purpose of filmsetting, Univers is particularly compatible with printing in condensed spaces, and has frequently been the preferred choice for timetables. In expanded, bolder format, it has been used for large-scale, public signage systems. The typestyle is sans serif, with the weight stress balanced on both vertical and diagonal strokes. Univers was taken up by the Monotype Corporation soon after it was launched.

Optima 1958

German type designer Hermann Zapf created this sans serif typeface, the Roman proportions of which have a hand-written quality. Elegant, flowing, and easy to read when reduced in size, the letters terminate in shallow cups. Initially, Optima was badly received by critics and designers, but soon became a highly popular choice for page text. Zapf is internationally recognized for his considerable contribution to the printmaking industry, his celebrated designs including Palatino in 1949, Melior in 1952, Zapf Book in 1976, and Zapf International in 1979. More recently, he has been involved in the developmental design of digital type.

Z

OPTIMA

GURENVERZEICHNIS DER

developmental design of digital type.

Una nuova l'amiglia di stile lineare che sarà pienamente rispondente, nella sua futura gamma di oltre 20 gradazioni diverse, a tutte le esigenze tipografiche moderne

Serie corsiva nera stretta in corso di lavorazione

Provatevi a respirare artificialmente e a fare pensatamente qualcuno di quei moltissimi atti che si fanno per natura: non potrete, se non a grande stento e men bene. La troppa arte nuoce a noi, e in quello che

L'AVARO PROVA INSIEMÉ TUTTE LE PREOCCUPAZIONI DEL RICCO E TUTTI I TORMENTI DEL POVERO

Alessandro Manzoni nelle Odi

Concorso grafico DIPLOMATICO

Inciso nei cor; 6, 8, 10, 12, 14, 16, 2 24, 28, 3

SOCIETÀ NEBIOLO TORINO

Recta 1958

This typeface was designed by Italian graphic artist Aldo Novarese, director of its production type foundry, the Società Nebiolo, in Turin. Linear and sans serif in design, the alphabet comprises a series of 21 variations, designed to be compatible with the technical requirements of modern printing. This presentation document has been created to accentuate the geometric propensity of Novarese's typeface.

Sabon 1964-66

Jan Tshichold began his career as a Modernist, advocating simplicity and symmetrical composition. His first book, *Die Neue Typographie*, published in 1928, had a significant impact on members of the Bauhaus. In the 1930s, Tshichold returned to a more traditional style of typography. His Sabon face (see mauve alphabet below) was the first typeface to be designed for linotype, monotype, and hand composition. It is a modernized version of the well-established Garamond.

WATERGATE—WATSON ### WATERGATE—### WATER

| Wathins Age | 1.13 S | 1.15

Bell Centennial 1978

Devised by British designer Matthew Carter, this typeface was commissioned for use in US telephone directories and was launched during Bell Directories' centennial year. Its key advantage was its capability of standing up to compression; unlike Bell Gothic or Helvetica, Bell Centennial can be reduced without blotting or anamorphic distortion.

Sabon Antiqua

ABCDEFGHIJKLMNOPQ RSTUVWXYZÄÖÜ abcdefghijklmnopqrstuvwxyz ßchckfffiflfl&äöü 1234567890 1234567890 .,;;-!?·()[]*†>:»«""/£\$

Sabon Kursiv

too much form to first of the second of the

Typeface Six 1986

Post-modernist designer Neville Brody made his name while art editor of British music and style magazine The Face (see p.219). He is one of a number of designers who have taken advantage of technological developments in printing to produce typefaces and layouts that break the rules of traditional printsetting. Frequently aided by computergenerated manipulations, Brody uses letterforms as graphic devices, designing unconventional alphabets that make a dramatic impact. Words, such as "Duran" shown here, take on an expressive quality of their own. His work extends to books, advertisements, and record covers.

STUVWXYZ

CORPORATE ID

PETER BEHRENS was the original "corporate designer", the first to consider the complete look of a company and the image that it projects to the public. Since his revolutionary programme at AEG, most major corporations have paid vast sums to designers to create for them a memorable visual identity. Ironically, one of the world's most successful works of corporate identity, the Coca-Cola script, was designed by the company's book-keeper.

THE SHELL PECTEN AND LOGOTYPE	1900	1904	1909	1930
1948	SHELL)	SHELL 1961	Shell 1971	Shell 1995

Shell 1900-71

Although primarily a petroleum company, Shell has many other commercial interests, and more than 90 per cent of its businesses around the world use the time-honoured logo. The picture of the shell has been altered several times over the years, but has been modified very little since 1971, when the name was repositioned below the stylized image.

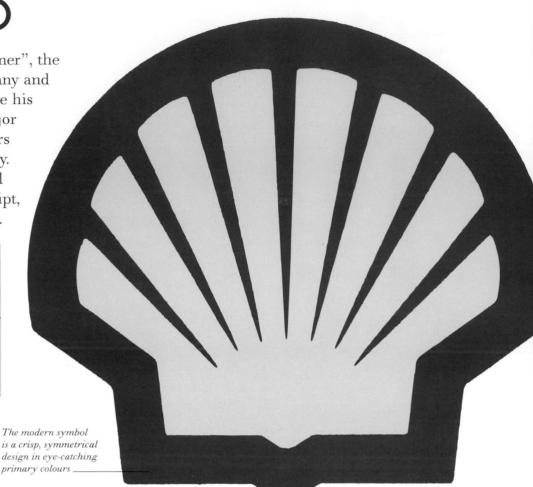

MICHELIN MAN

Early-20th-century advertisement

Monsieur Bibendum. the Michelin Man, has been the chief symbol of the French tyre company since he was created in 1898. Legend has it that the designer, Mr. O'Galop, was inspired by the sight of a pile of rubber tyres. In his earliest incarnations, Monsieur Bibendum had many more thinner rolls, as Michelin made bicycle tyres at the beginning of the century; but as

the company moved into the production of car tyres, his shape changed accordingly. Always depicted as an active, friendly figure, Monsieur Bibendum has achieved lasting success, being both highly memorable and evocative of the product he represents.

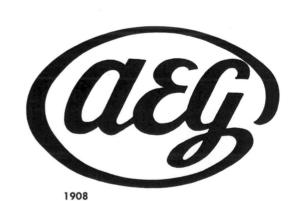

EG

AEG

AEG

1914

The bold, authoritative style of lettering evokes the might of the company

AEG 1908-60

When, in 1907, Peter Behrens was appointed Artistic Director of the giant German industrial combine AEG (Allgemeine Elektricitäts-Gesellschaft), one of his first challenges was to redesign the company logo. This he did by dramatically simplifying it to just three letters in a rectangle. The strong, unfussy lettering remains the basis of the logo used today.

1960

COCA-COLA

The Coca-Cola script was designed by an amateur, Frank Robinson, the fledgling company's book-keeper. He devised both the Spencerian script and the brilliantly concise words beneath: "Delicious and Refreshing". The bottle is also among the most recognizable icons in the world, a design that has come to symbolize the youthful exuberance of America. Countless variations have been released over the decades, but the enduring classic is the curved vessel designed by the Root Glass Company of Terre Haute, Indiana, and introduced in 1915. A Coca-Cola dispenser was later designed by Raymond Loewy.

Early poster

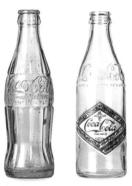

1980

1950

1983

Selection of Coca-Cola bottles and can

The shield symbolizes

1980s

Bayerische Motoren Werke was founded in 1916 in Munich, the capital of Bavaria, but it was not until 1929 that the Dixi became the first vehicle to carry the famous BMW badge. The symbol is remarkably simple: silver lettering on a circular black band that encases four segments of solid blue and white - the colours of Bavaria. The image has its origins in World War I, when the Bavarian Luftwaffe flew planes painted in Bayern blue and white, affording the pilot a view through his propeller of blue and white segments. This inspired the stylized design we now recognize on vehicle badges, such as the one pictured here, and on other BMW products. It has been updated to project an identity that is smart, clean-cut, sporty – and image-conscious.

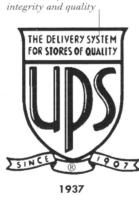

CND 1958

When Gerald Holtom designed what has become the symbol for the British Campaign for Nuclear Disarmament, he was told that it would never catch on. It has since been adopted as the universal image of peace. Designed originally for the Direct Action Committee Against Nuclear War, it works on two levels: it is semaphore for "N" and "D", and it is a self-portrait. Holtom explained: "I drew myself, the representative of an individual in despair, with hands palm outstretched outwards and downwards in the manner of Goya's peasant before the firing squad."

United Parcel Service developed its first shield logo in the 1920s, using the bold image of an eagle carrying a package labelled "Safe, Swift, Sure". This was simplified in 1937 to a shield outline containing the company initials, with a new message to appeal to the retail trade. In 1961, the current logo was born, the work of Paul Rand. He abbreviated the shield, added a rectangular package, and clarified the lettering. The key to good design, he explained, was "taking the essence of something that is already there and enhancing its meaning by putting it into a form everyone can identify with."

2000

SONTY

Sony 1973

The visual simplicity of the Sony logo is pivotal to its design. Easy to understand and pronounce, the name is readable in any language and immediately recognizable. The name derives from the Latin *sonus*, meaning "sound", and also recalls the English word "sonny", a term of endearment for a small boy. The design of the logo has been modified only minimally since 1957, when the strokes of the letters were lighter and more expanded. The version shown here is from 1973, since when it has remained the same.

The thick letters of the Sony logotype always appear in a single colour

The McDonald's Golden Arches logo was introduced in 1962. It was created by Jim Schindler to resemble new arch-shaped signs on the sides of the restaurants. He merged the two golden arches together to form the famous "M" now recognized throughout the world. Schindler's work was a development of the stylized "v" logo sketched by Fred Turner, which was conceived as a more stylish corporate symbol than the Speedee chef character that had previously been used. The McDonald's name was added

to the logo in 1968.

McDONALD'S

McDonald's restaurant, Leicester, England

SNCF 1970

Since it was established in 1958, the French railway SNCF (Société Nationale des Chemins de Fer) has made two significant redesigns of its corporate image. The example shown here dates from 1970, before which the interwoven letters "SNF" were framed by the "C". Updated by Roger Tallon in 1985, a lighter, more fluid-looking logo emerged, based on the italicized outline of its letters.

There is no accompanying image or framing line with the simply composed lower-case letters

Olivetti 1970

Like Sony, Olivetti eschews a corporate symbol, instead using the letters of its name to suggest a product of quality and style. Devised by Walter Ballmer, this latest logo, with its rounded, lower-case letters, has evolved from three earlier designs, dating back to a 1934 version by X. Schawinsky.

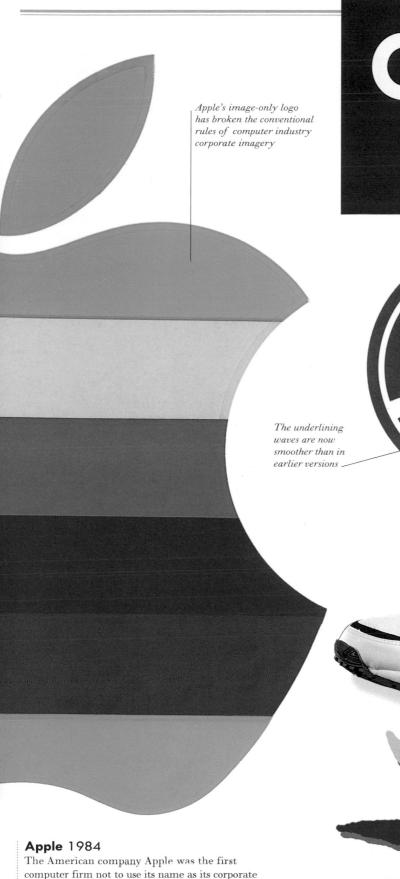

Q8 1986

In a bid to expand its retail petroleum business into the international market, Kuwait Petroleum took the radical step of completely changing the name of its subsidiary company, Gulf Oil. Gulf became Q8 in 1986, based on the English pronunciation of Kuwait. Its symbol of twin sails refers to traditional Kuwaiti trading ships, and the bright colour combination is intended to improve the visibility of the petrol stations in the dark. The new identity was created by Wolff Olins.

ICI 1987

When, in 1926, Nobel and three other large British chemical companies merged to form Imperial Chemical Industries, the existing black and orange Nobel roundel was adopted by the new company. It has been updated several times since, most notably in 1987, when the corporate identity design group Wolff Olins introduced the clean, modern combination of white letters against a blue background. The full name is now used only occasionally; instead, the company is universally identifiable by its initials.

Nike 1989

The Nike logo is a classic case of a company gradually simplifying its corporate identity as its fame increases. The company's first logo appeared in 1971, when the word "Nike", the Greek Goddess of Victory, was printed in orange over the outline of a tick, the mark of positivity. Used as a motif on sports shoes since the 1970s, this tick is now so recognizable that the company name itself has became a superfluous addition. The solid, orange tick was registered as a trademark in 1995.

The American company Apple was the first computer firm not to use its name as its corporate identity. The idea of selling a computer under the name and image of a fruit was conceived by Californian Steve Jobs and his colleagues (even "Macintosh" is the name of an American apple variety). The motif of a multicoloured apple with a bite taken out of it is a reference to the Bible story of Adam and Eve, in which the apple represents the fruit of the Tree of Knowledge.

Barcelona Olympic Games 1992

In 1988, José M. Trías, Professor of Design, and Director of Quod Design Company, won a competition that was launched to select the symbol and logotype for the 1992 Olympic Games in Barcelona. The apparently abstract image above the words "Barcelona '92" is based on the stylized form of a leaping human figure. It faces the right, following the flow of the text, and expresses dynamism, victory, and joy. A shadow has been included to give a sense of height. The five interlocking Olympic rings were designed in 1913 by Pierre de Coubertin, each ring representing one of the five competing continents.

MOVITIE & PRICE'S OATCAKES

Magazines 1900-10

Figaro Illustré is a fine example of Art Nouveau design. It features the abstract floral motifs and organic forms typical of the French style. Elements of this style were adopted by Edward Penfield, who illustrated this edition of Colliers. Penfield was an influential figure in the evolution of the American art poster a new genre of advertising that was typified by bold, flat colours and unfussy design. The Young Man, counterpart to the popular Victorian publication The Young Woman, shows elements of the Arts and Crafts style, the predecessor to European Art Nouveau.

> Abstract floral patterns were popular in French Art Nouveau graphics .

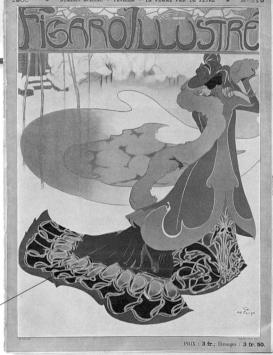

The classic Roman alphabet contrasts with the florid Art Nouveau typefaces

MAGAZINE COVERS

BEFORE THE 1930s, THE MAJORITY of magazines featured art illustrations rather than photographs on their covers, but, during World War II, designers began to realize fully the power of the photographic image. Often used for political manipulation, pictures such as those showcased by the photojournalism magazine *Picture Post* had enormous impact. After the war, there was a boom in the market for women's journals; this was largely fashion led and started a trend, which continues today, for glossy, colour cover shots of glamorous models. The advent of desktop publishing in the 1980s has enabled designers to create pages on screen and to experiment with unusual typefaces. In some cases, the creative presentation of type and the frank content of the text make the cover lines as eye-catching as the image itself.

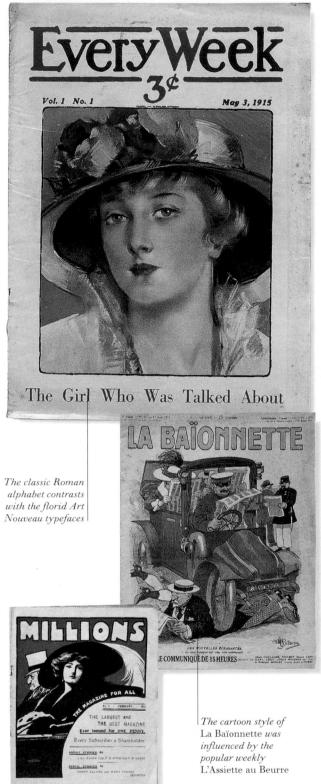

Magazines 1910s

There are several subjects that, when featured on the cover of a magazine, are guaranteed to attract a readership. Amongst these are political satire and lifestyles of the fashionable. The French publication La Baïonnette is a prime example of the first, while Millions and Every Week, with their cover images of chic women, demonstrate the second. In early magazines, it was the illustration rather than the words that conveyed the title's content. It was not really until the 1980s that cover lines became equally as influential.

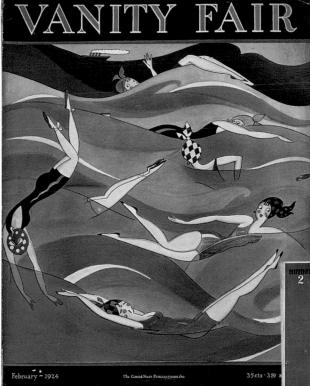

Magazines 1920s

The Art Deco style takes its name from the seminal Paris Exposition Internationale des Arts Décoratifs et Industriels Modernes, held in 1925. The style was quickly adopted worldwide and to such an extent that national origin is often difficult to identify. All of the magazines shown here demonstrate the combination of Cubist and Modernist elements with a bold use of colour and stylized forms, which were hallmarks of the Art Deco style in the graphic arts. The images promote the glamorous high-living of the 1920s.

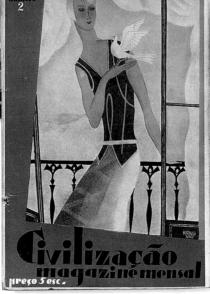

Magazines 1930s

The Spanish Civil War turned Spain into a battleground of rival ideologies. Great political art grew from the conflict, in the form of literature, posters, and magazines. The propagandist cover of *Blanco y Negro* celebrates women's wartime role in industry. Germany continued to be a centre for design excellence, exemplified by the assimilation of the Bauhaus school, and by the stream of great designers such as Herbert Bayer (see p.208), who was responsible for this beautiful cover of *die neue linie*.

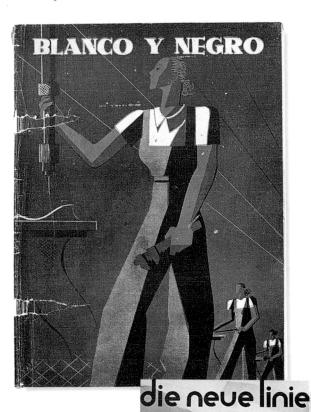

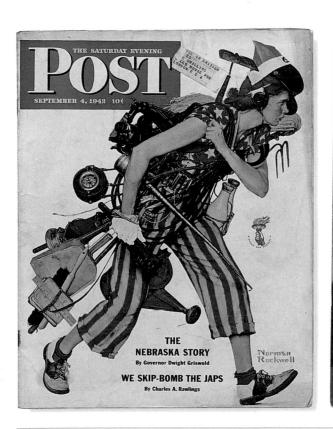

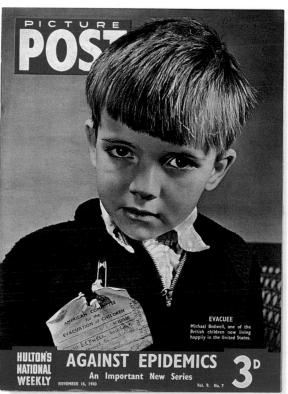

Magazines 1940s

World War II dominated design in the 1940s, and is the subject of both the covers shown here. Like *Blanco y Negro*, the witty cover of *Saturday Evening Post*, created by Norman Rockwell, pays tribute to women war workers. Both women hold a monkey wrench; but Rockwell's woman, dressed in the American flag, struggles with the tools of many trades, from milk delivery to nursing. *Picture Post* was one of the first magazines to feature photography – inside and out.

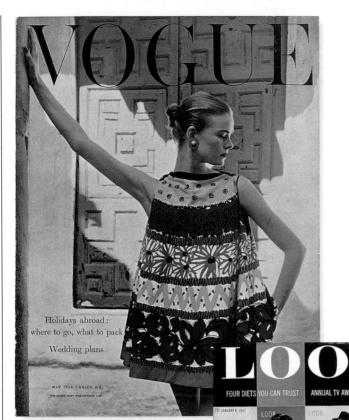

WOMAN BEAUTY

THE 20 MOST EXCITING YEARS OF YOUR LIFE

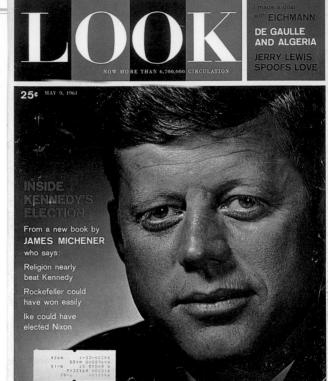

Magazines 1960s

Among the many underground publications that appeared in the 1960s was OZ magazine. Along with contemporaries such as Milton Glaser (see p.22), OZ's designer Martin Sharp was instrumental in setting new standards in graphic design. Their experiments with typography even rubbed off on more conventional magazines like Woman and Beauty. Whilst photographs were favoured by news magazines like Look, Time, and Paris Match, the satirical journal Punch continued to use illustrations.

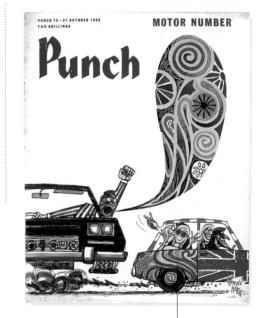

Women's magazine covers typically bear bold, confident images of femininity The psychedelic style was a bold adaption of Art Nouveau motifs

Magazines 1970s

By the 1970s, as more magazines appeared on the news-stands, sales became heavily reliant on an arresting cover image. The grainy, tinted photograph used on this edition of *Vanity Fair* demonstrates a technique favoured by designers in the 1970s, which was intended to give a sense of realism. The provocative choice of cover image has since come to characterize *Vanity Fair*. *Cosmopolitan*, launched in its present form in the US in 1965, is now an internationally successful title. Shown here, the first British issue prefigures the style of women's magazine covers of the 1980s – strong, vivid, and unmistakably confident.

Magazines 1950s

American Vogue was established in the early 1890s, followed by the British and French versions in 1916 and 1920 respectively. The early covers showed a commitment to contemporary art movements but, from the 1950s, colour photographs of the latest haute couture fashions were increasingly popular. This copy of the photojournalism title Look shows a grid of famous faces that repeats the squares of the masthead.

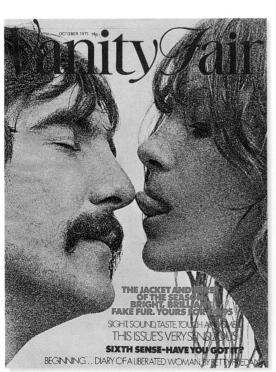

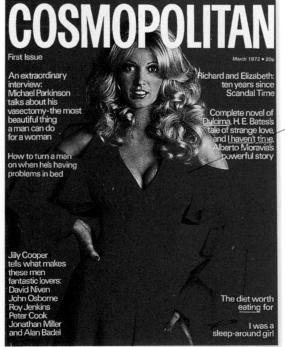

NOUVELLE SÉRIE No 8 - JUILLET-AOÛT-SEPTEMBRE 1995 - 22 FF - 7 FS - 180 FB - 7 SCAN - 600 PTS

vibrations LE MAGAZINE WORLD JAZZ RAP

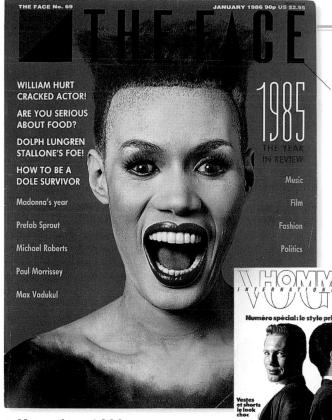

The geometric typeface was generated on a computer

ISAAC HAYES

MENELIK

JOSHUA

REDMAN DIONNE

FARRIS

KIP HANRAHAN

JAZZMATAZZ II MO'WAX

Magazines 1980s

From 1981 to 1986, graphic designer Neville Brody (see p.211) was responsible for the ground-breaking British style and music magazine *The Face*. Like Peter Saville (see p.221), Brody was influenced by the chaotic typography of Punk. He manipulated new and existing typefaces to create a unique visual language that challenged the editorial content of the text. Although *The Face* had a mixed readership, it was aimed more at men than women. *Vogue* took advantage of a gap in the market for a fashion-led men's magazine and launched *Hommes*, presaging the 1990s' craze for men's magazines.

Magazines 1990s

Over the past decade, Terry Jones' i-D magazine and others, such as Raygun, have challenged the most basic concepts of magazine design, eschewing the grid (on which designers lay images and text), in favour of a seemingly random, anarchic approach to layout. Desktop publishing has meant that the typesetter's skills have been learned by designers, who now create the pages on screen, and can make immediate changes to typography, rather than sending corrections to the typesetter to be input manually. The ability to manipulate and overlay type directly has resulted in the image almost taking second place to the text in magazines.

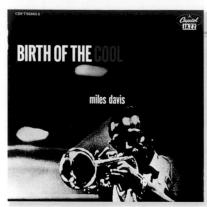

Birth of the Cool 1956

Amran Avakian created the atmospheric image on this record sleeve for *Birth of the Cool* by Miles Davis, released by Capitol Records. The black and white photograph is the perfect vehicle for cultivating the ultracool persona of this 1950s' jazz giant.

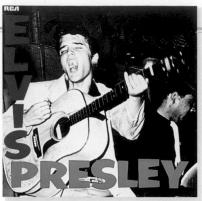

Elvis Presley 1956

The sleeve of Elvis Presley's eponymous first album, produced by RCA, captures the young "King of Rock 'n' Roll" during a live performance. The red and green lettering that spells out his name was echoed two decades later on *London Calling* by The Clash (see opposite).

True Blue 1960

Blue Note Records is responsible for some of the greatest album cover concepts ever devised. This sleeve for Tina Brooks' album is a witty example by Reid Miles. Each song contains the word "blue" in its title, and each is represented by a rectangle in a different shade of blue.

Sgt. Pepper's Lonely Hearts Club Band 1967

Designed by Pop artists Peter Blake and Jann Haworth, this celebrated sleeve for the Beatles' seminal album, released by Parlophone, is probably the most famous ever created. The host of stars includes Marilyn Monroe and W.C. Fields.

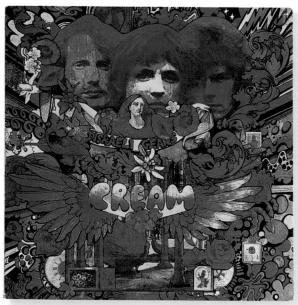

Disraeli Gears 1967

Psychedelic illustration was favoured for record sleeves in the 1960s. Martin Sharp's design for Cream's album combines peacocks, flowers, and clocks — all surrealist icons of drug-induced hallucination — in red and acidic yellows. In their midst float the band members' heads, photographed by Bob Whitaker. The album was released by Polydor.

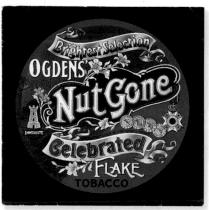

Ogdens' Nut Gone Flake 1968

The British band The Small Faces released this album for the company Immediate Records. Created by P. Brown, the illustration on the sleeve resembles a circular tin of tobacco. Developing this theme, the compact disc version of Ogdens' Nut Gone Flake was later released in a tin. This typifies the boom in novelty packaging since the advent of the more manageably sized CD in 1985.

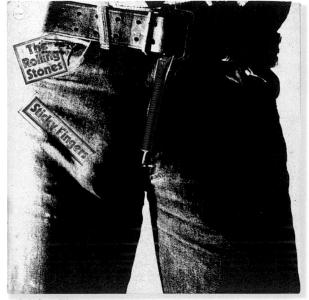

Sticky Fingers 1971

Early editions of this sexually suggestive album cover for the Rolling Stones' *Sticky Fingers* incorporate a real, functioning zip, while the back of the sleeve shows the rear view of the same denim-clad figure. The concept and photography is by Andy Warhol, whose name appears on the band of the Y-fronts on the inner sleeve.

RECORD COVERS

ALTHOUGH POPULAR MUSIC has been available on record since the beginning of the century, only since the 1950s has the design of record sleeves emerged as an art form. The American record company Blue Note was one of the first to develop an apparent design brand, an idea taken to austere lengths in the 1980s by the British label Factory Records. In the 1990s, the significance of covers to the potential purchaser is recognized by all major record companies, who employ teams of designers to create competitive packaging for releases on vinyl, tape cassette, and compact disc.

Tales from Topographic Oceans 1972

This fantasy landscape for the triple-fold cover of the album by supergroup Yes, is by British artist Roger Dean, a prolific designer of record sleeves and typography during the 1970s. Using illustrations of famous English rocks, including those at both Stonehenge and Land's End, Dean has created a space-age, dreamlike plane with an infinite background. The album was released by Atlantic Records.

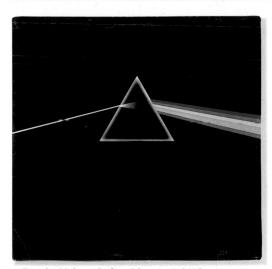

Dark Side of the Moon 1973

Released by EMI Records, this Pink Floyd album was one of the most successful of the 1970s. Its cover is a product of the influential British design group Hipgnosis; George Hardie produced the slick, enigmatic image of a light beam splitting into seven colours as it passes through a prism.

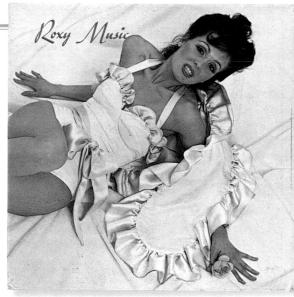

Roxy Music 1972

The term "Art Rock" was coined for Roxy Music, famed for the arty, image-conscious sophistication of their music and personal style. Released by Island Records, this was the first album to contain credits for art (Nicholas deVille), clothes, make-up, and hair (Anthony Price), as well as photography (Karl Stoecker), and "cover concept" (Bryan Ferry).

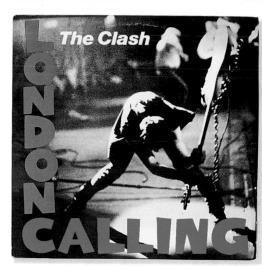

London Calling 1979

Designer Ray Lowry makes overt typographic and photographic references to Elvis Presley's album of 1956 (see opposite) in his sleeve design for the punk rock band The Clash. The powerful photograph by Penny Smith immortalizes vocalist/guitarist Joe Strummer in the act of smashing his guitar.

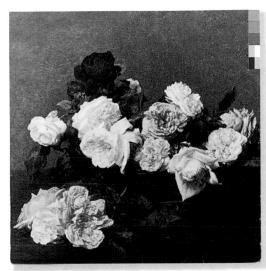

Power Corruption and Lies 1983

Inspired by the painting *Roses* by Henri Fantin-Latour (1836–1904), Peter Saville composed the cover for New Order's album *Power Corruption and Lies* for Manchester's Factory Records. The only alteration to the 19th-century French artist's work is the placing of a colour bar in the top right corner. A folded poster is included with the CD version.

House Tornado 1988

Graphic artist Vaughan Oliver is renowned for his ability to reflect the style of music in the design of its accompanying record sleeve. He established the design studio 23 Envelope, known as v23 after 1988, to create packaging for the British record company 4AD. He designed this album sleeve for the group Throwing Muses, showing painterly influences.

Blue Lines 1991

Designed by Michael Nash Associates, this CD insert features the flame logo that has come to identify Massive Attack albums. The title *Blue Lines* appears in such tiny lettering it looks almost like a copyright mark.

Screamadelica 1991

This CD by Primal Scream was released by Creation Records. The insert design by Paul Connell does not include any text, simply an image typical of the 1990s' "rave" scene.

Post 1995

The cover of Björk's album, released on One Little Indian, features the singer against an electronically enhanced background. The pages of the CD insert feature repeated images of a lotus flower.

POSTERS 1900-19

THE DEVELOPMENT OF LITHOGRAPHIC PRINTING in the second half of the 19th century heralded the start of modern poster art. Work by Frenchmen Jules Chéret (1836–1932) and Henri de Toulouse-Lautrec (1864–1901) formed the background to the new art form. By the turn of the century, the most important movement in poster design was Art Nouveau, but William Morris and the Arts and Crafts Movement also had a marked impact on the two main centres of design – Glasgow, home to the Glasgow School, and Vienna, birthplace of the Vienna Secession.

Flirt c.1895

The Czech artist Alphonse
Mucha is the most famous
and flamboyant exponent of
the Art Nouveau poster design.
His posters featured beautiful
women, often with long
flowing hair, framed by floral
decoration and organic lines.
Mucha's break came in Paris
in 1894 when he designed a
hugely successful life-size
poster for Sarah Bernhardt.
This example is one of many
advertising posters he produced.

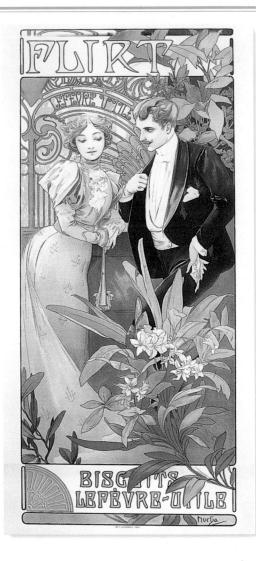

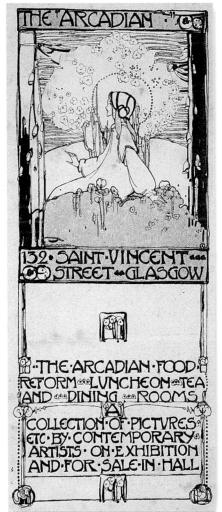

The Arcadian c.1906

During the 1890s and 1900s, the so-called Glasgow School was centred around Charles Rennie Mackintosh, and included Jessie M. King, who designed this poster for the Arcadian Tea Rooms. The Glasgow School took recognizable Art Nouveau elements and added rigid geometry and compositional decoration.

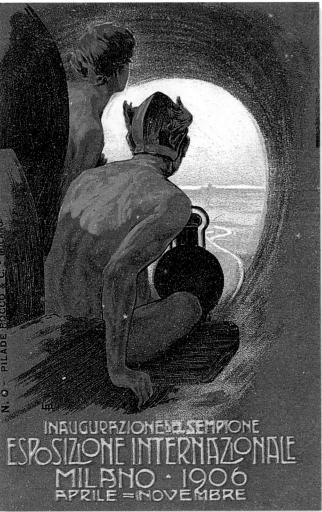

Inauguration of the Simplon Tunnel 1906

Italian designer Leopoldo Metlicovitz (1868–1944) created this poster to mark the opening of the Simplon Tunnel at the Milan International Exhibition. The winged-helmeted figure of Mercury, the god of Speed, sits at the front of the train as it is about to leave the tunnel. The poster's message is that "even Mercury finds it faster to take the train!" It typifies Metlicovitz's work, with the painterly figure of a muscular athletic young man, the allegorical subject matter, and subdued brown tones.

Liberty poster 1907

In Italy, the Art Nouveau movement was known as Stile Liberty (or Stile Floreale), the name making direct reference to the influential store on London's Regent Street. Founded in 1875 by Arthur Lasenby Liberty, the establishment had commercial links with Italy. This leather panel was produced for the Venice International Exhibition in 1907 by Serruccio Pizzanelli.

Vienna Secession poster stamp 1908

The Vienna Secession came into being in 1897 when a number of young artists rebelled over the art establishment's refusal to exhibit foreign work. The Secessionists included Gustav Klimt, Koloman Moser, Josef Hoffman, and J.M. Olbrich. Vienna became the creative design capital of Europe. Berthold Löffler (1874–1960) designed the 1908 Secessionist Exhibition poster. He was also responsible for this poster stamp announcing a procession to mark the Austrian Emperor Francis-Joseph I's 60th Jubilee.

Odeon Casino 1911

The German designer Walter Schnackenberg (1880–1961) produced a series of posters advertising the Odeon Casino. They all featured beautiful, sophisticated women and most of them also showed handsome men. The bestubbled, ingratiating fellow in this example is presumably a waiter! The poster is striking for its use of bold colour. As well as posters, during his long, successful career Schnackenberg contributed to the German magazines Jugend (from which the German form of Art Nouveau, Jugendstil, was named) and Das Plakat.

Skegness is so Bracing 1909

The growth of the British railways at the start of the century is responsible for some quality posters commissioned by London Transport, various railway companies, and tourist resorts served by the railways. This famous poster by prolific graphic designer John Hassall (1868-1948) extols the virtues of the seaside resort of Skegness. Like many other seaside destinations, off-season was harder to sell so Hassall resorts to the invigorating effect of the cold fresh sea air. His comic image is of a portly gentleman skipping along the beach in Wellington boots, scarf, and hat. The poster was so successful that Hassall produced different versions of it. It is, in effect, a translation into English design of the French entertainment posters of the 1890s, typified by the work of Toulouse-Lautrec.

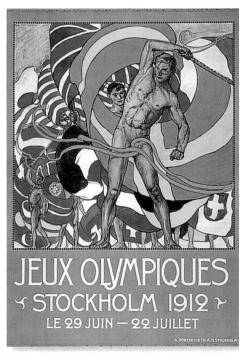

Stockholm Olympic Games 1912

Throughout the century, the Olympic Games has given both athletes and poster designers the opportunity to prove their prowess. In this version, A. Börtzells places centre stage a young naked man (his dignity preserved by a well-positioned streamer) swirling the Swedish flag above his head. He is followed by a host of naked men with undulating national flags.

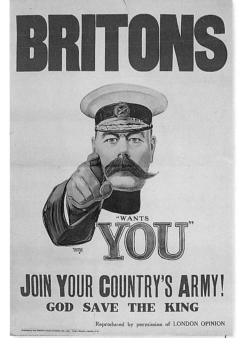

Your Country Needs You 1914

During World War I, many governments made use of posters to aid the war effort. This one, designed by Alfred Leete (1882–1933), gave rise to many imitations, including a recruitment poster for the US Army by J.M. Flagg (1877–1960). Leete's poster features the inescapable gaze of Lord Kitchener, the Secretary of War.

Odeon-Casino 1911

POSTERS 1920-39

THERE ARE AS MANY SCHOOLS and movements in poster design as there are in painting, and from 1920 to 1939 they abounded: Bauhaus, De Stijl, Futurism, Cubism, to name but four. Yet we should be wary of categorizing designers by movement. Certainly, the designer E. McKnight Kauffer, author of *The Art of the Poster* (1924), complained that the public placed "Cubist" or "Futurist" tags on anything modern. The majority of the posters produced during these two decades were designed to promote commercial products or cultural events, but propaganda pieces, including the El Lissitsky poster shown here, continued to appear in Russia and elsewhere to support particular causes such as the Spanish Civil War.

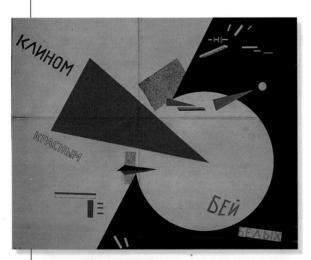

Beat the Whites with the Red Wedge c.1920

El Lissitsky's famous Soviet propaganda poster for the Red Army is an icon of Constructivist design. The poster is typical of Lissitsky's style: simple elements; sharp, dynamic diagonals contrasting with circles; and a bold use of limited colour, in this case red, white, and black.

Futurist poster stamp 1931

Through their experiments in typography, the Futurists had a direct influence on poster design. Their approach has been called "painterly typography": a visual onomatopoeia, where words look like their meaning. So *Speed* might be in italics, and **Shout** in bold type. Stamp-sized posters, allowing advertising though the mail, were popular in the 1920s.

Hagen-Pathé 1920s

German designer, painter, theatre set designer, and illustrator, Walter Schnackenberg (see p.225) produced a number of high-quality posters, of which this atmospheric theatre poster is typical.

Palmolive early-1920s

This poster exemplifies the technique of selling a product with a slogan. American designer Clarence Underwood (1871–) was commissioned by J.B. Watson, head of the giant Walter Thompson agency, to produce a series of posters around the same slogan: "Keep that Schoolgirl Complexion". Watson had done extensive research into finding slogans that triggered the "buy impulse".

Jyldis c.1925

Josef Binder (1898–1972) was an Austrian designer who was described in his day as "the biggest talent and the greatest hope of Austrian graphic arts". His highly individual, aggressively modern style was hugely successful. He soon turned to theory though, lecturing regularly in the States. The basis of his theory was "everything moves faster today; we need the same speed to transmit the message effectively".

LIDO DI CAMAIORE MARINA DI PIETRASANTA FORTE DEI MARMI

Forte dei Marmi 1930s

One of Italy's lesser-known poster artists, Gino Bocasile designed both the Internationale Mailänder Mustermesse poster (see p.207) and this travel one for the resort of Viareggio. The latter is an early example of using sexual imagery to sell.

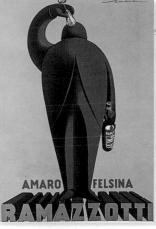

Ramazzotti 1930s

Federico Seneca (1891–1976), one of the most sought-after poster designers of his day, often featured stylized, Decostyle cartoon characters like this creation. Important clients included Buitoni pasta and Perugina chocolates.

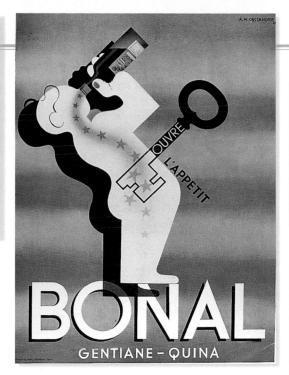

Bonal 1935

A.M. Cassandre believed that the poster was primarily important as the conveyor of the message. Drawing on Cubist and Constructivist ideas, Cassandre's powerful posters dominated French advertising between world wars. He was particularly interested in lettering, believing it to be an integral, but often neglected, part of poster design. Even his hand-drawn letters are indistinguishable from type.

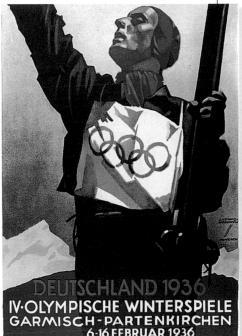

I udwig Hohlwein is the greatest German poster designer of the century and his work prior to World War I has hardly been equalled. Hohlwein's style remained unchanged — usually one or two figures set against large areas of colour, and the lettering confined to a rectangle. Sadly, it is for his last works, celebrating the idealized Aryan race, that he is commonly remembered.

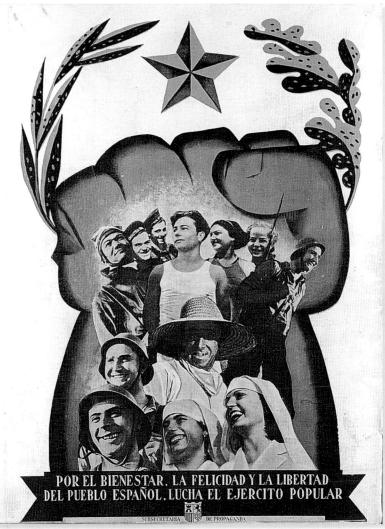

Spanish Civil War 1936-37

The Spanish Civil War attracted the attention of artists and intellectuals the world over, and saw groups of designers collaborating in Madrid and Barcelona on the design of posters in support of the Republican cause. Many of them made use of photography rather than illustrations. This poster shows Constructivist influences with the powerful fist grasping a laurel wreath and sheltering the people in the foreground.

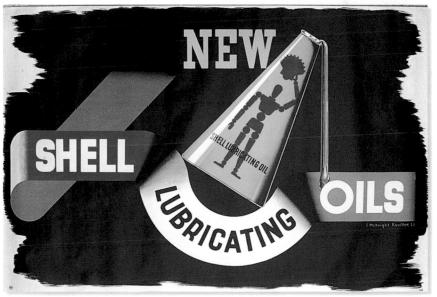

Shell 1937

E. McKnight Kauffer was one of several designers commissioned to produce posters for the Shell oil company in the 1930s. The poster shown is a good example of Kauffer's work, with Modernist imagery, bold graphics, stark colour contrast, and reductivist typography. The images suggest smooth movement and oil pouring from a can. Kauffer devised the figure that was used throughout the campaign.

POSTERS 1940-59

DURING WORLD WAR II, there was a move away from posters advertising products to those that helped to further the war effort, be they recruitment appeals or vehicles for issuing information. The governments that commissioned these posters urgently wanted direct, effective messages, and so took the risk of employing and giving free reign to young Modernist designers. The results were often controversial, but from this period comes some of the most creative poster designs. The gates were also opened for more inventive commercial advertising after the war was over.

Kill the Fascist Reptile c.1940

Propaganda posters often lacked subtlety. This Soviet example shows the mighty arm of the red soldier smashing the enemy, here depicted as a swastika-shaped reptile. Symbols such as the hammer and sickle make the message easily identifiable.

Budapest Gasworks 1940

This commercial poster makes effective use of colour. Its focal point is the flame that forms the engineer's hand, and which illuminates the lettering above. It was designed by leading Hungarian graphic artist Georg Konecsni (1908–).

7up family c.1945

This advertising poster portrays an archetypal American family enjoying the great outdoors. The fresh-faced beauty, wide smiles, relaxed attitude (the father is holding a fishing rod), and clear imagery present the drink as a healthy, refreshing product.

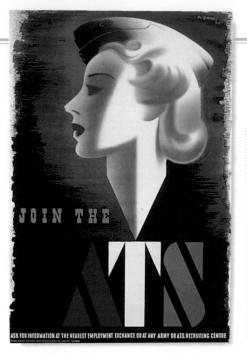

Join the ATS 1941

In his role as Official War Poster Designer for Britain, Abram Games produced nearly 100 posters. This one is a good illustration of his personal maxim "maximum meaning, minimum means". It depicts a stylized profile of a glamorous woman soldier, with the simple message plastered across the bottom. The serifs that descend from the crossbar of the white letter "T" form the continuation of the woman's collar, and the post of the "T" suggests a tie.

Perrier 1949

The Frenchman Jean Carlu was an important and prolific poster artist. Initially trained as an architect, Carlu turned to graphic design after he lost his right arm in an accident. His early work showed a strong Cubist influence, but, from the mid-1930s, he increasingly championed Surrealist design. Having produced some important political posters during the war, Carlu returned to product advertising for French and American clients. Here, a cartoon-like figure with an outsized ear listens to the fizz emanating from a glass of Perrier mineral water.

Ofen Lüdin 1949

One of Switzerland's most successful poster artists, Herbert Leupin (1916–) first gained fame for his realistic commercial advertising posters. However, after setting up his own studio in 1959, he developed a distinct style of illustration that earned him commissions from both European and American clients. Many of his posters were humorous, like this penguin warming himself with a Lüdin company heater.

Champagne 1949

During the 1940s, René Gruau's sophisticated women graced numerous French fashion and cosmetic illustrations and advertisements (see p.155). His work often made striking use of a limited number of colours with black and white.

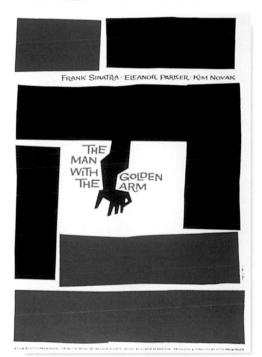

The Man with the Golden Arm 1955

Saul Bass's poster for Otto Preminger's film about a drug addict marked a radical departure in movie advertising. Instead of depicting the storyline, the jagged arm and stark imagery is used to capture the film's essence.

Astral Email 1955

Raymond Savignac was the master of the visual gag. His numerous posters, produced for clients around the world, are all characterized by their direct, simple, witty, and effective designs.

Tokyo International Trade Fair 1956

Takashi Kono (1906—), who designed this poster, is one of the pioneers of modern Japanese graphic design. The simplified blocks of colour incorporating the Japanese flag are reminiscent of 1950s' textile design.

Kobe Workers' Music Council 1961

Tadanori Yokoo was one of the many innovative graphic artists to emerge from training at the Nippon Design Centre, which was founded in 1959. His cultural and commercial posters of the 1960s and '70s drew on both traditional Japanese and Western imagery. Yokoo experimented with different printing techniques, photomontage, and collage.

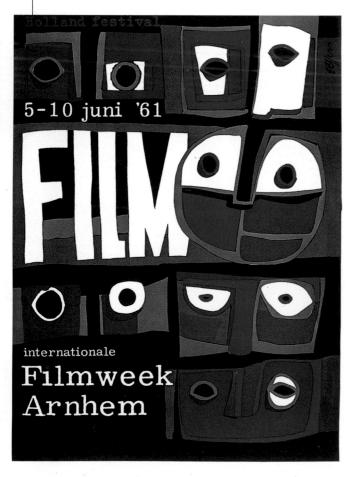

POSTERS 1960-79

THE PSYCHEDELIC ERA was one of the briefest, but most memorable, movements of this period. Its posters were designed for an exclusive audience with almost illegible lettering carrying the implied message "If you can't read it, it isn't for you". Psychedelia began on the West coast of America but spread to Europe with the hippie movement. Elsewhere, Japanese designers were growing in international importance, being more willing than most to embrace new technology. In the 1970s, this gave designers far greater freedom through increased control of typesetting and image reproduction.

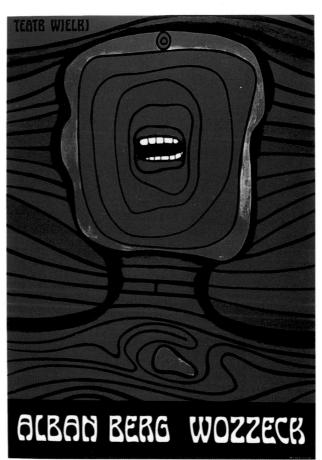

Arnhem Internationale Filmweek 1961

This was one of several screenprinted posters created by Dutchman Dick Elffers (1910—) to promote the Holland Festival of 1961. They featured abstract masked faces rendered with blocks of solid colour. This particular example, advertising the Arnhem film week, displays a mixture of crude typography including some handrendered lettering. In addition to his work as a graphic artist and painter, Elffers taught at the Rotterdam Academy, was architect of the interior of the Rijksmuseum in Amsterdam, and set designer for other cultural projects.

Wozzeck 1964

Jan Lenica's famed poster for the opera, Wozzeck, makes direct reference to the 1893 painting The Scream by the Norwegian Expressionist artist Edvard Munch (1863-1944). In both works, the focal point of the image is a screaming mouth, surrounded by resonating lines. Lenica, a prodigiously inventive Polish designer, uses heavy flowing lines that divide the space into solid bands of colour: in this instance the whole poster is designed in vibrant shades of red, split by varying thicknesses of black line.

Paper Dress Show 1967

Designed by Hirokatsu Hijikata, this poster advertises a Japanese fashion show presenting dresses made of paper. It combines a photographic image (the woman's face) with artwork. The design makes striking use of bold graduated colours to evoke the woman's dress and cape.

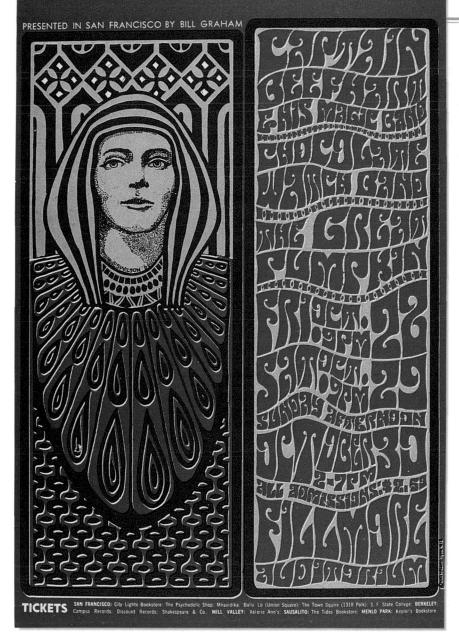

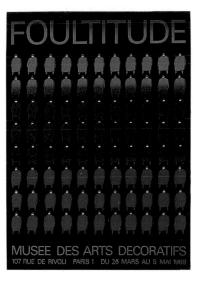

Foultitude 1969

During the 1960s, posters were increasingly viewed and sold as works of art to be framed and hung on the wall. In the US and Europe, museums and art galleries commissioned, published, and marketed posters featuring the work of many major artists, including Andy Warhol, Robert Rauschenberg (1925-), René Magritte (1898-1967), and Roy Lichtenstein (1923-). The Belgian cartoonist and artist Jean-Michel Folon was commissioned to create a poster to advertise an exhibition at the Musée des Arts Décoratifs in Paris. In it, ranks of anonymous men are differentiated only by bands of colour.

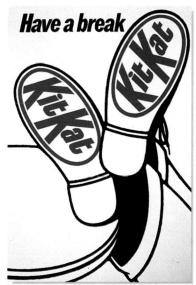

KitKat 1970s

The success of this commercial poster for a well-known chocolate bar relies on the power of the brand-name. Many things are suggested but not shown in the design. The slogan "Have a Break, Have a KitKat" is not completed; it is left to the viewer to finish. Likewise, the owner of the feet is not shown, the viewer must imagine him. The product itself does not appear, although the typography and colour on the sole of the shoe is the same as the packaging on the bar of chocolate. This kind of suggestive advertising has gained great popularity in Britain, particularly with cigarette manufacturers (see p.230).

Captain Beefhart at the Fillmore 1966

The psychedelic artist Wes Wilson borrowed ideas from a variety of sources and fused them together into a style of his own. Using images and lettering from the Vienna Seccession (including the flowing hair), Art Nouveau ornamentation, and druginspired colouring, he created a language that was aimed at an exclusive "underground" audience. The swirling, multicoloured lettering is barely legible.

Chicago 1968

John Rieben's (1935—) poster is clearly influenced by the Swiss magazine Neue Grafik ("New Graphic Design"), which was launched in 1958 by Josef Müller-Brockmann and others. Its designers championed compositions based on grid systems, lower-case sans serif typography, and unornamented images.

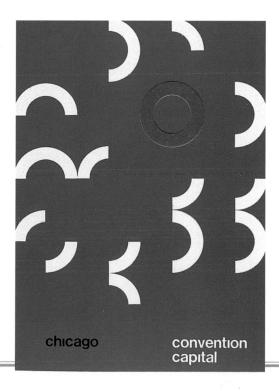

Echos de Grande Bretagne 1970s

Reginald Mount was one of a number of graphic artists who made his name with work commissioned by the British Ministry of Information during World War II. After the war, he produced many commercial and public service posters, including some for the "Keep Britain Tidy" campaign. Humorous, cartoon-like images, sometimes with Surrealist elements, are typical of his style. This quirky menu pokes fun at the English etiquette of eating peas with the back of the fork.

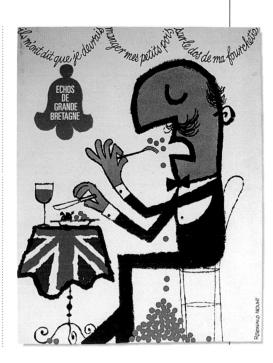

POSTERS 1980-90s

DESPITE THE VAST SUMS OF MONEY that are spent on television advertising campaigns, commercial companies and government agencies have by no means abandoned the poster as a direct and effective means of communication. The computer continues to play an increasingly important role in poster design, and new programmes allow image manipulation to a degree that was not dreamed of even a decade ago. The resulting work may mix any combination of photography, illustration, and typography.

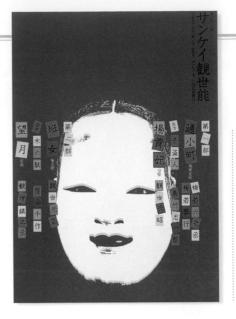

Noh 1981

Ikko Tanaka's posters are renowned for their subtle use of colour, and, while they are distinctly Japanese, they do indicate an understanding of modern western design thought. This performance poster is one of many he produced for the Kanze Noh drama. At either side of the actor's masked head calligraphic boxes suggest bunched hair.

Exhibition poster for Musée de l'Affiche 1981

This striking poster by the French design collective Grapus combines elements of three political philosophies: capitalism — the central image is of Mickey Mouse, and one eye is made up of the US colours; fascism, suggested by the Hitler moustache and flick of fringe; and communism, represented by the hammer and sickle forming the left eye. Grapus was founded in 1970 by Pierre Bernard (1942—), Gérard-Paris Clavel (1943—), and Francois Miehe (1942—) to produce "social, political, and cultural images". The collage effect, crude drawing, scribbles, and splashes are typical of its acclaimed work.

De Stijl exhibition at the Walker Art Center, Minneapolis 1982

By photographing a created "scene", Gert Dumbar broke all the conventions of museum poster design. It advertises an exhibition of the Dutch art movement De Stijl. The movement's originator, Theo van Doesburg, appears, and there are references to De Stijl's ideas, including placing the text at the same angle as the lines in the painting.

MIDDLE TAR As defined by H.M. Government

DANGER: Government Health WARNING: CIGARETTES CAN SERIOUSLY DAMAGE YOUR HEALTH

Benson and Hedges Shaved Pack 1985

The influential advertising campaign for Benson and Hedges cigarettes has featured a series of increasingly cryptic posters, of which this one, designed by Nigel Rose for the Collett Dickenson Pearce agency, is particularly successful. Although it is impossible to read the product's name (the letters have been shaved off the pack), the gold suggests it.

Rambow at the Bibliothèque Nationale 1987

This poster for an exhibition of Gunter Rambow's work was designed by the artist himself, and features a cut-up photograph of a book, rearranged to create a wedge shape that seems to split the book itself in half. Rambow, who typically employs photography and photomontage, is best known for his powerful political and social posters.

Bicentennial Exhibition for "The Human and The Citizens' Rights" 1989

Peret, born Pere Torrent, is a Spanish
Post-modernist designer. His work
often consists of bold, simple graphics
in strong colours. He has worked for
many humanist organizations,
including the Spanish Red Cross and
Amnesty International. This simple,
yet effective, poster plays on a
mathematical equation, putting a
human pictogram in a bracket,
multiplied to the power of "n",
meaning humanity is all-important.

Benetton advertisement 1991-92

Oliviero Toscani has produced some of the most controversial posters of the century for the Italian clothing company Benetton. Under the slogan "The United Colours of Benetton", he has often depicted shocking and violent images, including a Christ-like man dying of AIDS, a burning car, and a woman giving birth. The one thing they all have in common is arresting imagery, and though some have questioned their relevance to the product, they have attracted great attention. This brightly coloured example works more obviously with the slogan.

Bowling for Rhinos 1991

The 1980s and '90s have seen the rise of posters supporting a variety of environmental and coological campaigns. The American graphic designer Sonia Greteman produced this poster for Sedgwick County Zoo to raise funds for black rhino conservation. Its central image of a rhino is framed by a collage of newspaper clippings about the plight of the species, including one discussing the demand for powdered rhino horn as an aphrodisiac. At the bottom of the poster are the shadowy silhouettes of the hunters who are driving the rhino into extinction.

PACKAGING 1900-09

UNLIKE MOST OTHER AREAS OF DESIGN, packaging can rarely be associated with individual designers. Rather, designs evolve with each new era: by 1900, shopping for groceries was changing from a traditional reliance on a grocer to advise on and wrap items, to manufacturers' designs influencing choice. Many pack designs still reflected late-19th-century tastes, although toiletries and new brands were the exception, taking advantage of the flowing, organic style of the moment, Art Nouveau, to attract customers with a "modern" look.

Turnwrights toffees

This tin of English toffees was an attempt to compete with chocolates by presenting them in a gift-style box. Fashionable Art Nouveau graphics decorate the edges.

SOAP Procter & Gamble, Cincinnati

Ivory soap

The name "ivory" was first used by its American manufacturer Procter and Gamble in 1879. The traditional appearance of this packaging remained quite similar until a redesign was commissioned in 1940 (see p.241).

L'Auréole soap

From a box of three individually wrapped French toilet soaps, this label also draws heavily on the Art Nouveau style. The rather extravagant design was intended to appeal directly to ladies as a luxury product.

Indische Blumen-Seife

The bright, eye-catching picture on this box of German Indian Flower soap illustrates the product quite literally. The luxuriantly detailed exotic flowers still reflect popular tastes of the late-19th century.

Lübecker marzipan

Sombre colours and a picture of an industrial factory lend this box a heavy sense of the past. Two crests appear to give credence to the product.

Soft pack cigarettes

At about this time, collectible pictorial cards became popular with competing cigarette companies. As well as providing free promotional opportunities, the stiff cards helped to protect the cigarettes as the packs themselves were flimsy.

Le Furet corset

The beautiful woman reclining in this idyllic scene is clearly intended to persuade the customer that no other garment could enhance her life so dramatically! The stylish Art Nouveau graphics at either end create a strong sense of refined elegance.

Heinz soup's 19th-century "keystone" logo is still familiar in the 20th century

This packaging by a small manufacturer is comparatively crude

The stylish Lefevre-Utile packs were often illustrated by famous artists such as the Art Nouveau painter Alphonse Mucha (see p.222)

Quality products

The arrival of individual pre-wrapped branded goods meant that for the first time the customer had to rely on the look of the manufacturer's packaging to suggest the freshness and quality of a product. Designs that appeared to change little were often meant to give the impression that a product was of a consistently good quality.

Recurring images

Over the course of the 20th century, certain styles or images have often recurred. Examples include the sunrise motif, such as the Robin starch pack (top right), or intricate graphic patterns as on the Lefèvre-Utile biscuits (centre right). Women have also become a much stronger selling point, either depicted as strong individuals attractive to men and or as role models for other women.

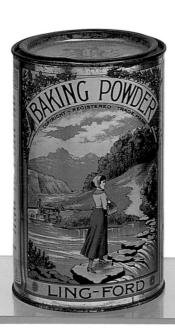

This American pharmaceutical product is quite traditional with its information displayed against a white background on the outside of the packet.

Jawnicholsonal
Finest
DRY GIN
LONDON
ENGLAND

This scene of a woman driving a car reflects the new attraction of automobiles, but it also portrays an independent woman, perhaps to attract more female drinkers

PACKAGING 1910-19

WORLD WAR I ACCELERATED THE TREND towards individual packaging, for it was much easier to distribute and supply rations to the troops in small packets. The world was jolted into a new era by the war and packaging reflected this. Many 19th-century brand labels were updated and more importantly, better packaging techniques improved the possibilities of dispensing or resealing products. Art Nouveau was still popular until about 1915, its characteristic swirls and typography appearing on coffee labels and confectionery boxes.

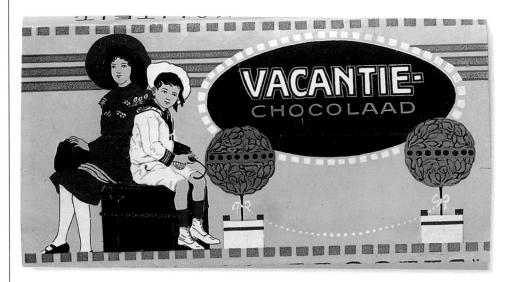

Chocolate wrappers

Commercially sold chocolate bars tasted so similar that the packaging had to attract the eye: the Vacantie wrapper (above), for instance, uses simple colours and looks elegant. By contrast, this German chocolate (right), which was distributed to troops during World War I, shows a patriotic image on a functional wrapper.

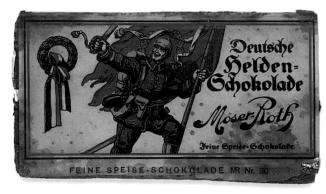

BIWHEBAR KIEBCKAR MAMBKA IM MIEPIAJЪ BODOUH, SABODA C. WAIPIAPCKIЙ BЪТИФЛИСБ.

Cherry Kiev drink

This Russian drinks label, possibly for a schnapps drink, was manufactured by S. Shagriarskiy in Tbilisi. The simple pattern around the border has a strong Art Nouveau style and shows how much the popular style influenced all types of packaging internationally during this decade.

Crème Eclipse

Advertising came into its own as manufacturers jostled for the customer's attention. This tin of string for tying parcels would sit on the shop counter, its sides covered with adverts, such as the one for Crème Eclipse boot polish shown here.

Colgate's ribbon dental cream

This toothpaste packet informs the user about the innovative and efficient nature of the product. Previously, tooth powder had been sold in a glazed pot or tin; here, a cream is dispensed from a soft metal tube in a flat ribbon, making it more economical and preventing the toothpaste falling off the brush. Graphic illustrations and simple instructions on the sides of every cardboard packet show the user how to fold the tube up as the cream is used and how to squeeze the lower sides of the tube to create a vacuum, drawing back any cream still oozing after use.

Savon Tatiana

Images from nature were popular with exponents of Art Nouveau, as the snaking golden tendrils and buds on this French soap packet reveal. The embossed gold work and rich blue colours make this unusual gift packaging extravagantly beautiful.

Camembert cheese

French Camembert cheese box labels traditionally depicted rural scenes or country maids but instead this label reflects the world's new fascination with machinery and flight. The aeroplane skimming across this label is an exciting modern contrast to the image of a smiling dairy maid.

The side of this Horniman's cocoa packet illustrates the plantation where the product was grown

An elegant Art Nouveau design turns this packet of crystalized chestnuts into a sophisticated gift

Exotic influences

Some brands, such as the talcum powder (far right), Horniman's cocoa (above left), and dates (below) accentuated the setting of the product's origin or the mystique of the Far East to set the brand apart from others and sell it.

Sprinkler tops were one of the new advances made in dispensing products

The flattened oval shape of powder tins appeared after 1909

Extraordinary claims

New household products for cleaning and washing made some extraordinary claims on their packaging: for instance, Armour's Cleanser (below) "lightens housework", while Borolic Soap (top) is "The good health soap". The images are also ordered and controlled, with simple, straightforward colours and uncomplicated pictures.

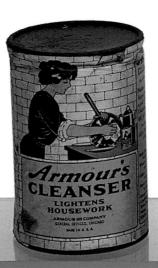

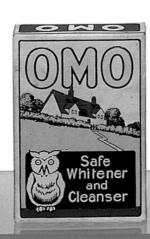

This generic brand is typical of the off-the-shelf design packaging of the period

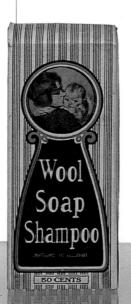

Packaging developments

By 1910, both the US and UK were producing aluminium foil; in 1908, a Swiss chemist had invented Cellophane film. These new materials would revolutionize the way products could be sealed to retain their freshness, but it took time for them to become commonplace. More immediate were the advances made in resealing packages and dispensing the product, such as the sprinkler tops for talcum powder.

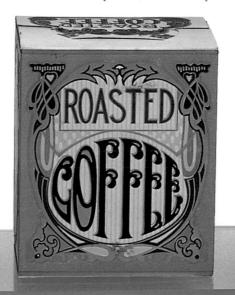

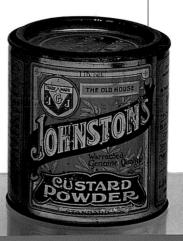

PACKAGING 1920-29

THE YEARS OF CHANGE after World War I continued into the 1920s as the number of servants in the home declined and the family unit reduced, so encouraging a trend towards smaller pack sizes. Leisure time also increased and with it came a new breed of snacks and "instant" packaged foods that saved time, such as shelled peas. A different style in packaging gradually emerged through the 1920s, with cleaner, fresher designs influenced by the popular vivid colours and angular lines of the Art Deco movement.

Confectionery wrappers

This 1927 Stolwerck wrapper (left) and Sprengel label (below) are typical of the highly decorative nature of items intended as luxury products. Their extravagant graphics and strong colours contrast distinctively with the American Hershey bar (below left), its embossed monochrome packaging giving a mass market appeal.

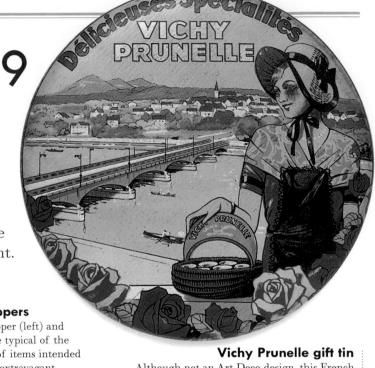

Although not an Art Deco design, this French gift tin has adopted Art Deco colours to give it fresh appeal. This packaging is one version of a traditional design that is gradually adapting to the changing times.

Boyhood fruit crate label

A flourishing fruit trade existed in California, by the 1900s and in order to identify different orchards, pictorial labels were pasted on to each wooden crate of fruit. This label, with its dynamic, rather stylized image, is quite upbeat, the outsize grapefruit on the cart and the jolly colours creating a bold, attractive impression.

Women's cigarettes

With the increasing emancipation of women in the 1920s came a new breed of products targeted at their leisure time. Aimed at the female smoker, these cigarette packs are stylishly elegant or exotic and use, in the case of the du Maurier pack, an impressive Art Deco design.

The carnation flower on this American evaporated milk tin has been used to suggest freshness and sweetness

Strong, geometric shapes and intense colours defined Art Deco

This American household cleaning product has been continually updated through the century (see p.242)

Appetizing images

Realistic illustrations printed on the front of packets were becoming commonplace, giving a better impression of what the product actually contained. The sumptuous display of fruit on the Rowntree's pastilles (below) and the juicy marrowfat peas on the Thorn's packet (right) make the brands seem far more enticing.

This crisp pack design, which came out in 1920, lasted until the '50s

Instant snacks

Synonymous with the concept of increased leisure time and convenience food were a new wave of packaged snacks. The popularity of snacks such as potato crisps and Pretz Sticks (below) in the US caught on in the 1920s and spread to Britain (see Smith's crisps, above right) and around the world.

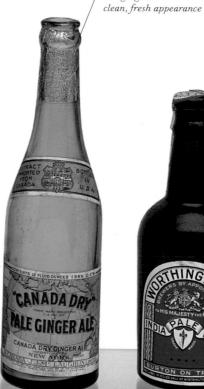

Launched in the US in 1923,

this ginger ale bottle has a

PACKAGING 1930-39

THE 1930s WAS NOT ONLY A DECADE when Art Deco influenced packaging, but also a point when graphics became noticeably bolder and simpler, catching the eye more immediately; this was a time of rationalization with clear, uncomplicated styles. Packing technology was also improving: Cellophane was a more hygienic overwrap for packed products, keeping them fresher, and plastic and aluminium, although still expensive, were new, lightweight replacements for heavy glass containers.

Gargantua sweet bag

Although a cheap piece of packaging, this waxed paper bag is fun and vital with its simple illustration. Waxy paper cartons were also used for milk and waxed cardboard cartons for cream, honey, ice cream, and glacé cherries in the 1950s.

Rowntree's Dairy Box

The chocolates illustrated on this box clearly explain its contents; labels to identify each chocolate are even printed alongside. This realistic format appears to prefigure the photographic packaging of the 1960s and beyond.

Petits Fours assortment

A classic example of two popular concepts in packaging at the time, this tin of Petits Fours depicts a sunburst motif in the late Art Deco style using a range of limited, yet striking colours.

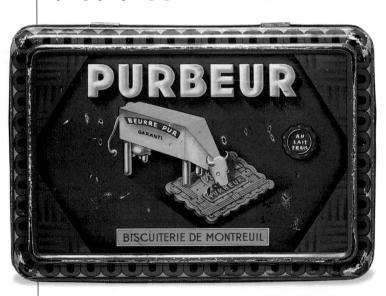

カフェー大線町一大線町一丁目

Purbeur butter biscuits

Images of animals were often linked with certain products, such as cows with dairy goods. This stylized illustration makes the cow licking a Purbeur look like a pat of butter.

Japanese matchboxes

The stylish clothes and Art Deco colours on these elegant-looking matchbox covers illustrate the international influence of both western fashions and Art Deco.

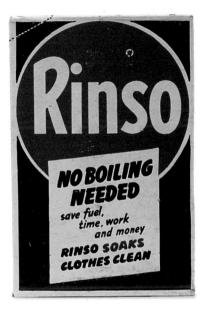

Rinso

A washing powder, Rinso was first launched in 1910 by the American Lever Company to compete directly with Persil (right). This basic design was adapted slightly with each decade (see p.241 and p.245).

Sacco Bonito Asalmonado

All canned tuna fish tasted much the same, so it was the brand label that had to influence the customer's choice. This label is made more attractive by the realistic illustrations of tuna fish leaping through a stylized sea.

Cigarette packs

By the 1930s, cigarettes and tobacco were packed in aluminium containers, as well as round tins and cardboard boxes. Pack designs also changed: this 1930 Gitanes design by Max Ponty has become a classic.

VOOR ALLE WAS

schitterend wit
(Zie gebruiksaamwijzing)
ZONDER CHLOOR

Black Magic's Art Deco chocolate pack remained constant for years

This fun light bulb pack substitutes a light bulb for the body of a butterfly

Sunrise motif

Throughout the history of packaging, the sunrise motif has featured repeatedly as an immediately identifiable symbol. Here it manifests itself in the Gold Tint shortening (above left), Petits Fours (opposite page), and Synergy light bulb pack (left).

Bold graphics

The influence of late Art Deco can be seen clearly in the 1930s, especially in the way that many packs – Black Magic chocolates (top), Lifebuoy soap (top), and Giant soap flakes (right) – use such bold blocks of colour, angular lines, and large, clear lettering.

This washing powder pack design, with its bold, unadorned lettering, gives immediate visual impact

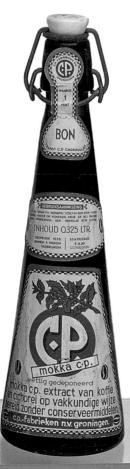

PACKAGING 1940-49

IN THE 1940s, LIFE WAS DOMINATED, once more, by a world war that affected every aspect of society. Packaging had to be adapted in some countries, because the availability of printing ink and packing materials was in short supply. Labels were reduced in size, notably in Britain, in order to save paper and the concept of packaging became more of a functional one. Limited natural resources and food shortages persisted in Europe after World War II ended in 1945, so relatively unaffected countries such as the US and Canada continued to export canned or dried produce overseas.

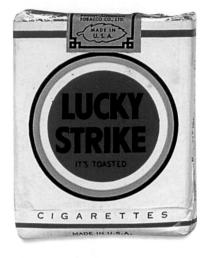

Lucky Strike cigarettes

Lucky Strike cigarettes were introduced to the US in 1917, using the trademark red bull's eye from the familiar Lucky Strike tobacco. The pack remained the same until 1942, when Raymond Loewy replaced the green background with a white one. Such minor changes made this a best-selling product: the whiteness of the pack made it look clean, fresh, and smart.

Marathon

The image of this athlete on a Dutch soft drinks label is an epic and heroic one.

Matchbox

Friction matches first became available in 1827 and initally the labels tended to be plain. This Eastern bloc label is just one example of the wide variety of designs that were subsequently produced.

Górnik cigarettes

The stark design on this pack has a strong utilitarian feel that is reminiscent of posters of the period.

Omo

The austerity of the 1940s affected even printing ink: the amount of ink printed on some brand packets reduced until only the brand-name and instructions were in colour (see Rinso, right).

Velim paper wrapper

As a result of paper shortages in the 1940s, some items were sold without any wrappings. Chocolate bars, when they were available, were packaged without silver foil and for a time even the paper wrappers were replaced by thin transparent ones.

Suiker Tabletten

As the source of raw materials dried up through the decade, the quality of cardboard and paper deteriorated considerably. This packet of sugar cubes Simple designs and strong colour contrasts were effective substitutes.

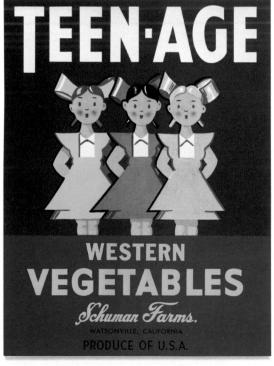

Teen-age Western Vegetables label

The airbrush technique and graphics of this label are typically 1940s. As with other American food crate labels of the period, this is attractive and colourful (see also the Boyhood fruit crate label, p.236).

Aceto di Vino

The image on this wine vinegar label shows the consumer exactly how to use the product.

Silver Lake USA tomatoes

Part of the war effort, this can is minimalist in terms of its two-colour printing.

 $A\ typically\ British$ utilitarian 1940s' pack design

Utilitarian design

Economic restrictions and limited natural resources in Europe and forced designers in the 1940s to adopt a utilitarian style for packaging. The products shown here clearly reflect the war years.

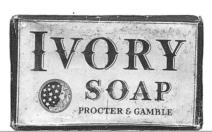

Heinz's shrunken keystone label (see p.233)

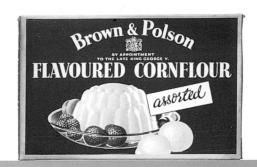

Special wartime instructions for using Rinso are printed on the back of this packet

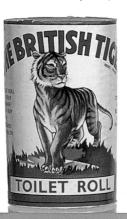

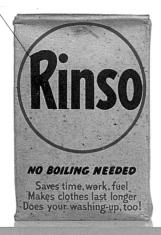

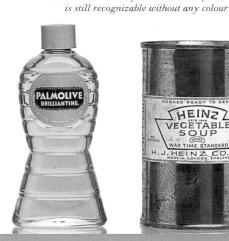

This dried product states clearly that it is wrapped in a "temporary pack"

Wartime label reductions

Rationing in Europe extended to paper for a time. This led to the introduction of smaller labels on products, which were packed in poor-quality cardboard packages.

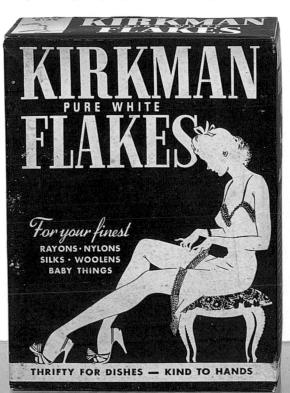

This pack of cleaning powder illustrates well the measures of wartime paper rationing

This Australian wheat flakes pack has the feel of the wartime effort

PACKAGING 1950-59

BIGGER, BOLDER, BRIGHTER — by the end of the 1950s, packaging could not have looked more different to that of the '40s. This new incentive for packaging to be more competitive was due to the rise of the supermarket store: by 1950, the vast majority of goods sold were prepacked and as self-service stores gradually overwhelmed small grocers' shops, the need for instantly recognizable products to sell themselves on a supermarket shelf became imperative. Packaging was becoming a proper marketing tool, evoking a set of values in the consumer's mind through the images.

Sharpe's toffee tin

This bright, space-age gift tin lid is redolent of the 1950s' fascination with science fiction and popular children's comics. Interestingly, gift tins rarely had the manufacturer's name printed on their lids.

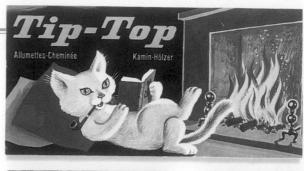

Cigarette packs and Tip-Top matchbox

The manufacturers of products such as these capitalized on the 1950s' trend in graphics towards simpler, bolder images or cartoon characters to identify them. The painting palettes and bird are literal visual references to the products' brand-names.

Sport chocolate

This Danish design relies on a clever visual association with the brand-name to make a memorable image in the consumer's mind.

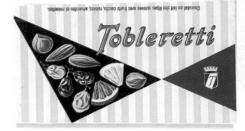

Tobleretti chocolate

Visually arresting, this wrapper has an "active" feel, relying on a combination of geometric shapes and detailed illustrations.

Sneeuwwit

Some well-known household products still had traditional packaging compared to the new wave of soaps and detergents emerging (see Tide, far right).

Bon Ami

The chick motif of the Bon Ami household cleaner, designed in 1901 by Louis H. Soule, was updated in the 1950s (compare with p.237).

Connoisseur coffee

There is little to identify visually exactly what this product is, but the simple, bold graphics make a strong impact. Designed by Ruth Gill, it was retained for many years.

Peek Freans Playbox biscuits

The photo-type realism of this illustration, displaying the contents of a biscuit tin, was typical of the early-1950s. By the end of the decade, photographs were replacing drawn images (see Birds Eye peas, top right), as they were a cheaper means of producing an image. This American soap pack has a strong, bold design

Like cartoon or comic characters, sales pitches using popular personalities proved successful

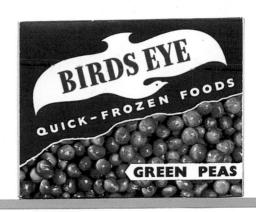

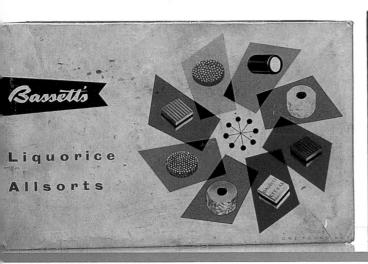

This design attempts a modern feel with its

This Australian pack of Rinso makes good use of simple silhouetted figures for a contemporary feel

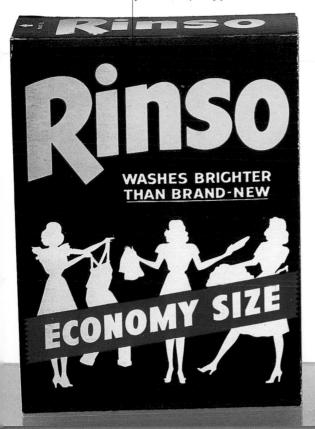

Tide and Surf (Suno)
were part of a new type
of soapless detergent, which
were packaged in active,
or busy, bright designs

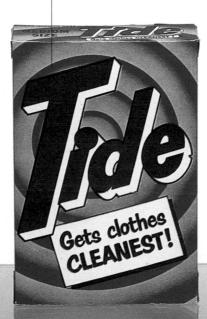

Consumerism in the 1950s

The advertising commercials that first appeared on television in the 1950s were part of a new phase of consumerism. The range of frozen foods available expanded, as did the selection of products on the shelves. As the choice became wider, so there was more competition and products had to compete for the "impulse buy". Graphics freshened up, becoming simpler and more recognizable with an emphatic logo or motif.

This French hot chocolate pack uses "modern" colours to liven up a traditional image

PACKAGING 1960-69

THE 1960s WERE TRULY AN AGE of modernity. Fast food, refrigerators, freezers, convenience food, slimming products — all these were becoming commonplace, influencing the eating habits and lifestyles of consumers throughout the world. Soft drinks were sold in "throwaway cans" with ring pulls, a dramatic departure from the traditional glass bottle and cork stopper. Cellophane, aluminium, and plastic now sealed up the freshness of a whole variety of products. Packaging designers were preoccupied with conveying a message to buy, while photography and promotional incentives proliferated.

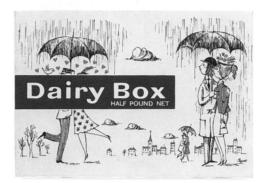

Dairy Box chocolates

The simple, rounded characters on the label of this box are modern and eye-catching. Designed by the artist Raymond Peynet (1908–), the quirky picture would have been used only briefly as this box was aimed at the gifts market.

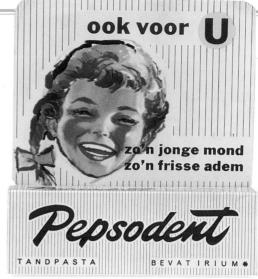

Pepsodent tandpasta

This toothpaste product competes for more shelf space, and therefore more customer awareness, by adding a tall cardboard back to the packet. The typography has been updated and the fresh-faced child added to give the product a sense of vitality.

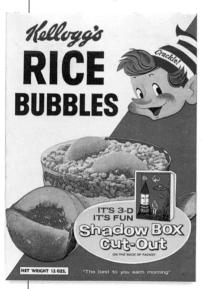

Cigarette pack

The design on this pack of cigarettes is full of dramatic visual impact. A stylized image of a spacecraft, this design was influenced by the contemporary space race between the then Soviet Union and the US.

An updated Australian pack (see p.239), this is a modern yet familiar version of Kellogg's designs. The healthy photographic image aims to convince the parent of its nutritious value, while the fun cartoon character and free promotion appeal directly to the child.

Radion washing powder

In order to stand out from other products on the supermarket shelf, this pack has strong complementary colours and bold, raised letters that appear to jump out from the twodimensional design.

Siks slimming biscuits

The new fashions in clothes meant that women were more conscious of their figures. Slimming packs used fashionable images of women and up-to-date designs to attract the consumer.

Liaa rusks

Household packs increasingly used vibrant designs and active images to capture the attention of customers. This pack was designed to appeal to women who wanted their children to look as healthy as this one.

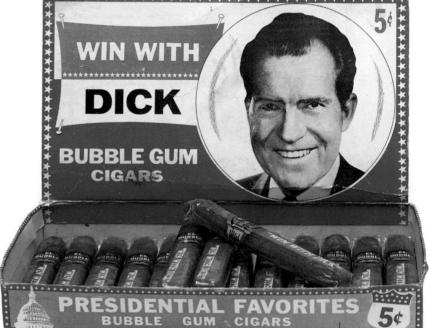

Presidential Favourites bubble gum cigars

Individually packed in Cellophane, these bubble gum cigars are sold through another personality sales pitch, promoting Richard Nixon as a candidate for the American presidential elections in 1969. Presumably they were aimed at politically aware adults buying treats for their children.

This cardboard counter box is a traditional selling technique

A free rattle is included in the lid of this tin of talcum powder

ROBINSON'S

orange, egg &
honey cereal
INSTANT FOOD FOR BABY

This pack of own-brand supermarket peas is stylistically typical of the 1960s

The fun packaging represents a bird's head and beak with its cap and direction pointer

Typography now had little to do with the past unless it was part of an established logo

(oca:Cola

Coca:Cola

Although displayed on a tin can, this design depicts a bottle cap from previous packaging

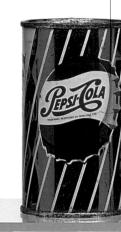

Stylish alternatives

Interestingly, some of the more successful designs of the decade were supermarket "own brand" packs, such as Sainsbury's garden peas pack (above), which were more experimental, despite being sold as cheap alternatives.

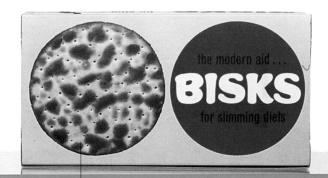

Disposable drinks cans

The 1960s was very much the era of the throwaway drinks can. Coca-Cola (above, left) was the first drink to be canned in 1960 and, after the ring-pull opener was developed in the US in 1967, the canned drinks market burgeoned.

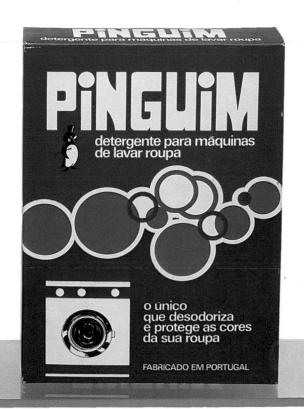

PACKAGING 1970-79

PACKAGING DESIGN REACHED A CROSSROADS in the 1970s, with a tremendous variety of different styles; the stark new style of some products and supermarket "own brands" provided yet another alternative. Packing technology continued to improve, however, with the arrival of the "Tetrapak" to hold milk, soft drinks, and juices, and moulded plastic containers that were all lighter and cheaper to transport than heavy, breakable glass bottles. Consumer tastes were changing as people took more holidays abroad and tasted foreign food, while instant "TV dinners" proved popular alternatives to family meals around the table.

Floral Nature beauty soap

Toiletries continued to represent the latest fashions and popular styles on their packaging, as this line illustration on a pack of beauty soap shows. The white background is used to imply that this is a pure, natural product.

Café Tofa

The modern typography of this stylish Portuguese coffee pack has a clever motif of a full coffee cup, seen from above, incorporated into it.

Brooke Bond Girl Brand Ceylon tea

This simply illustrated pack of Syrian tea uses a traditional image to create a sense of symbolism and enduring permanence.

Euro Coop hazelnut biscuits

Packaging was generally becoming lightweight, while retaining a pack's freshness. Biscuits were often now only packed in tins as gifts.

Antelope Brand mosquito coil incense

This conspicuous Indonesian pack design encapsulates the modern approach to selling a product: using bold graphics and colours to catch the eye.

Crocodillo sparkling wine

Developed in 1979, this strangely shaped bottle prefigures some of the gimmicky containers that have appeared in the 1980s and '90s. Shaped like the top part of a glass bottle, it looks as though the rest of the body is missing.

Fruyio yoghurt

The Greeks started to package their yoghurt in plastic containers in about 1970. Moulded plastic containers could literally be produced in any size or shape as this square-bottomed, round-topped yoghurt pot shows.

Mir washing powder

The coloured silhouettes on this pack of French washing powder are displayed as examples of the free gifts available in every packet.

Presto washing powder

The age of computer technology took off in the 1970s. These animated enzymes devouring dirt are similar to a popular computer game concept.

Fruit yoghurts were part of a flourishing range of healthy dairy products

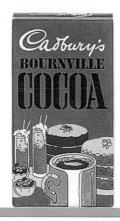

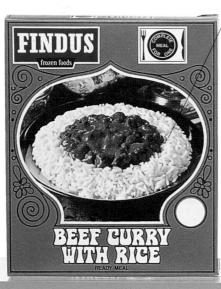

Minimalist design

The bewildering array of styles that appeared in the 1970s were capped by the "own brand" packs in supermarkets. The tea pack (above) takes the theme of a single colour on a white ground to an extreme compared with the Welch's and Dannon brands. This box of chocolate liqueurs uses retrostyled artwork more synonymous with the 1950s

Psychedelic colours

Many of the packages on these pages make use of orange and brown, both strong fashion shades at the time. The garish plastic Aqua Manda container (below) is dyed orange to accentuate the orange-scented talcum powder inside. It is wrapped in a yellow cardboard box purely to create a greater sense of value.

This design by Dick Bruna was intended to appeal to both the mothers buying the product and the children eating it

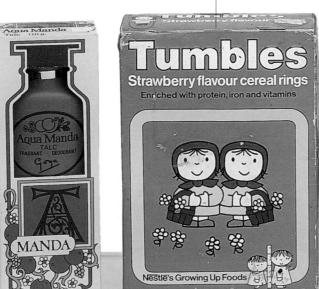

This British cereal pack -

with sunrise motif and earthy

colours - captures the essence

of California, US, in the 1970s

Another example of personality sales, this orange drink is promoted by comic-book hero Superman

PACKAGING 1980-89

IN THE 1980s, PACKAGING became a stronger selling vehicle for products. Designers realised that packaging could be integrated as part of a brand concept, conveying a total message to the consumer. The technology for cutting and folding materials and moulding plastics became cheaper, leading to more innovative packaging ideas. While upbeat, contemporary graphics targeted a younger generation, nostalgia also came back into fashion to stress the wholesomeness and consistent quality of some products.

Rowntree Christmas selection pack

A piece of novelty packaging aimed at the youth market, the dynamic graphics and vibrant colours make this moulded plastic chocolate gift box an unusual and exciting one.

food

Prepacked ready-made

meals such as these

reflect a growing

trend in the 1980s

finding less time to shop for and cook basic ingredients. The growing popularity of microwaves has meant that these packs really can provide instant cooked food.

and '90s of consumers

Le Sueur tinned peas

This ultimately functional yet stylish American design is one way of incorporating the packaging material as part of a product. The reflective silver label imitating a tin can - would have stood out on the supermarket shelves, which is surely the purpose of good packaging.

Terry's Le Box

One of the more complicated packaging devices of the 1980s, this origami-inspired box for chocolates looked impressive as a concept on the drawing board but proved too impractical and expensive in reality.

Hawaiian punch

This startling container is shaped as a character, so creating a product identity through its very form.

Pepsodent toothpaste

Gone are the pink candy stripes of previous decades (see p.244); this "new" Portuguese version of the American product has a different, very clinical and precise graphic design, with strong, clean white typography.

Pink orangeade

This small cartooncharacter label allows the bright contents to show through.

Created by radical furniture

designer Gaetano Pesce,

this prototype bottle is

shaped like a waterfall.

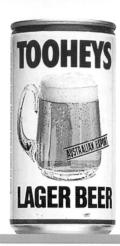

Recreating identities

Manufacturers have used different strategies to recreate fresh identities for their products. The Coca-Cola can (above) has a 1980s' fashion-led design that, although collectible, was intended to have a short shelf-life. The traditional look of the gravy granules (top right) gives a nostalgic feel, harking back to a previous era, but it also helps the product to stand out on a supermarket shelf. The classic Black Magic chocolates (below) have been updated using a deep red rose (compare with p.239).

Developed in 1988, the bold, stylized image and bright colours help give this hair bleach a summery look

A bold version of

carton of milk

the sunburst motif

reappears on a tetrapak

Announcement flashes of the latest changes and improvements, as well as special offers and competitions, have begun to cover much packaging

An embossed basket on the innovative new label makes this modern-looking liqueur

Glass bottles

Ironically, after disposable aluminium cans had almost universally dominated the soft-drink market for years, glass bottles (below) began to make a comeback with certain soft drinks. The hope is that the product will be imbued with a greater sense of quality and value.

PACKAGING 1990s

CONSUMERISM IN THE 1990s has created a curious juxtaposition. On the one hand, excessive choice has meant that product designs are taken to extremes to attract attention, creating a whole series of novel or gimmicky images. On the other hand, increasing worldwide concern about environmental and ecological issues has put pressure on manufacturers to supply their products in recyclable, biodegradable packaging. There is more variety, with more flavours, bigger sizes, and an "international consumerism" that rejects any regional product varieties – and yet, at the same time, there is a trend towards minimalist packaging with cleaner, purer products that stress a particularly independent and authentic identity.

Arm & Hammer baking soda

The nature of the contents seem completely irrelevant to this American packaging design, which has an engaging character to encourage sales.

Crik Crok Woody crisps

Printing methods are now so advanced that bright, fluorescent colours can be printed most effectively on packing materials. This Italian crisp packet, with its fun colours and cartoon characters, also contains a novelty toy inside to boost sales.

Body Shop toiletries

The identity and beliefs of this health and beauty company are embodied in its minimalist packaging. This is unusual in the cosmetics world, which is known as primarily a packaging industry. The majority of its packaging is also recyclable, enabling customers to return with their empty bottles for refills.

Choko-Ufos

Having none of the sophisticated style of adult gift boxes, this pack of German children's chocolates uses every incentive to buy, including a free toy. As is the case with many products on these pages, children are targeted specifically.

Harvey Nichols tea and pasta

Although these black and white photographs appear to have no direct relevance to the produce inside, they do give the utilitarian packaging a sophisticated, alternative image.

This is an ultimate example of state-of-the-art plastics technology used in the packaging industry. Aimed entirely at children, the container is moulded in the shape of a popular film character, which can also be used as a toy once empty.

This Japanese energy drink has a quirky, stylized image of a Samurai warrior on the label

This disc top plastic dispenser allows the product to be opened and resealed easily with just one finger

User-friendly

Even mundane household items now have complete packaging concepts. The friendly eyes on this cat food tin (below), for instance, are meant to draw the customer's attention to it.

International consumerism

As a packaging material, plastic has been instrumental in transforming our society: plastic packaging, with its robust, durable nature and excellent barrier qualities that prevent contamination, has made it possible to preserve, pack, and transport products from across the world for consumption or use elsewhere, so inviting an international consumerism into our lives.

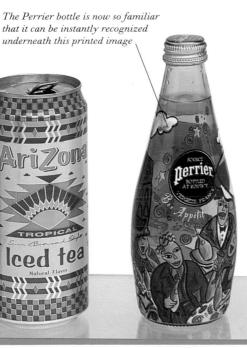

The use of transparent plastic suggests that the water is clean and pur

A-Z OF DESIGNERS •

The use of this symbol and a cross-reference indicates the page(s) on which work by the particular designer appears in another part of the book.

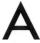

AALTO, Aino

1894-1949 Finnish

Ø p.48

Aino Marsio was an architect and designer best-known for her glassware and interior designs. She was the wife of Alvar Aalto (see below), with whom she often collaborated.

AALTO, Alvar

1898-1976 Finnish

Ø p.34, 48 One of Finland's most important designers, Aalto designed avant-garde buildings that reflected the close relationship of architecture with nature. During the 1920s, he experimented with wood, especially plywood, and in 1935 founded Artek to produce his furniture and lighting. The company still produces many of his original designs. His work includes the Paimio Tuberculosis Sanatorium, Finland (1929-32), the Viipuri Library (1927–35), the Paimio chair (1930), and the Savoy vase (1936).

1932 - Finnish

Ø p.37

Aarnio studied industrial design before opening his own design studio. He is wellknown for his chair design and use of synthetic materials. His early and late works make use of traditional materials, although during the 1980s he used computer-aided design and manufacture. His pieces include the Ball, or Globe, fibreglass chair with built-in speakers or telephone (Asko, 1963), the Gyro fibreglass chair (Asko, 1968), and the Viking dining table and chairs (Polardesign, 1983).

AICHER, Otl

1922-91 German A corporate identity specialist, Aicher studied sculpture before establishing a graphics studio. He was the consultant designer for the corporate identity of the 1972 Munich Olympic Games (see right), and produced many corporate identity and visual information systems, working for Braun, Lufthansa, and Frankfurt airport, among others. In the 1970s, he designed a new identity for the German town of

ALISON, Filippo 1930 - Italian

Ø p.73

ALBERS, Anni

1899-1981 German

Textile and industrial designer

studied at the Bauhaus under

Gunta Stölzl (see p.273). In

1933, she emigrated to the

US with her husband, Josef

Albers (see below). There,

she taught, experimented

textiles for industry.

1888-1976 German

Albers was a painter,

ALBERS, Josef

with weaving, and designed

designer, and colour theorist,

who taught at the Bauhaus

from 1923. After its closure

several universities

in the US. A series

of abstract paintings

the Square epitomize

entitled Homage to

his colour theories.

in 1933, he lectured at

Albers (née Fleischmann)

Alison is an architect with a special interest in interior design. Among his industrial designs is the Filumena 2 coffeepot (Sabattini, 1984).

Aicher's 1972 **Olympic Games** pictograms

AMBASZ, Emilio

1943 - Argentinian In 1972, while Curator of Design at New York's Museum of Modern

Art, Ambasz organized an exhibition proposing that good design depended on many objects functioning together as an environment. He designed the Vertebra

1951 - Israeli/British

The design company One-Off was founded in 1981 by Ron Arad. Many of his furniture designs were made of metal, such as his stainless steel Big Easy Volume II armchair and

sofa. Possibly his most famous design is the Rover Chair (1985; see left), consisting of

ARMANI, Giorgio 1935- Italian

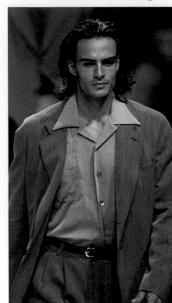

An Emporio Armani design, 1996 Armani stores.

One of the most highly acclaimed fashion designers to emerge from Milan, Armani pioneered a loosely tailored look of casual elegance in the 1980s. After working as a window dresser, he began designing for menswear company Nino Cerruti in 1961. Armani founded his own clothing firm in 1974. As well as his exclusive mens- and womenswear ranges, he also mass produces clothing for Emporio

a salvaged seat from a Rover car fitted into a tubular-steel frame. His later work includes hi-fi systems made of concrete (1985) and the interior design of the Tel Aviv Opera House (1990).

ARAI, Junichi

1932 - Japanese

A textile designer and manufacturer, Arai gained fame for his experiments with unusual combinations of materials, including celluloid and metallic fibres. His highly complex patterns for weaving using computer punch cards have influenced other textile designers. He now works for his Tokyobased retail company, Nuno.

ARMANI, Giorgio See panel above

Ø p.141

d'ASCANIO, Corradino

1891-1981 Italian

Ø p.175

In the 1920s, d'Ascanio worked at an aeroplane factory as technical director. He soon started his own firm and designed a successful helicopter. In 1934, he began working for the engineering company Piaggio, designing aircraft components and helicopters. But it is a 1946 design for which he is bestknown - the eternally popular Vespa scooter (see right).

ASHBEE, Charles Robert

1863-1942 British

Ashbee was one of the leading figures in the English Arts and Crafts movement. He set up the Guild and School of Handicraft in 1888 and designed many pieces of jewellery, silverware, and furniture for it. His style was linked to Art Nouveau.

ASHLEY, Laura

See panel right Ø p.121

ASPLUND, Gunnar

1885-1940 **Swedish** Although usually remembered for his contribution towards Scandinavian Modernist architecture and for his interior designs, Asplund also designed furniture. Reproductions of some pieces, such as his Senna chair (1925), are currently manufactured by Cassina.

BAHNSEN, Uwe

1930 - German

Ø p.189

Automobile designer Bahnsen has been head of car design at Ford Europe since 1976. He has overseen the design of the Fiesta, Granada, and Escort, but the most radical and admired of his cars is the Ford Sierra, launched in 1982.

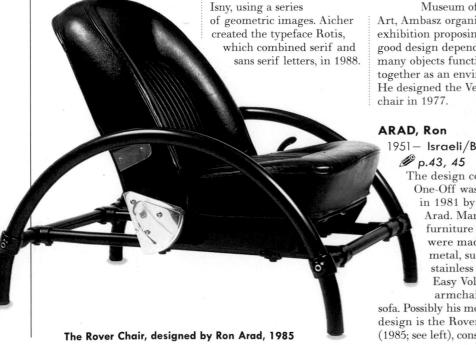

BAIER, Fred

1949 - British

Ø p.193

The work of furniture designer and maker Baier is complex, often colourful, and always unconventional. For example, his Roll Top Drop Leaf Transforming Robot Desk (1989) owes as much to science-fiction imagery as traditional furniture design.

BAKKER, Gijs

1942- **Dutch**

Ø p.157

Together with his late wife, Emmy van Leersum, Bakker created a new look for contemporary jewellery. In the 1960s, they made aluminium collars and bracelets. Later, they moved into performance and sculpture, using the body as a part of jewellery design. Bakker has also designed items of furniture, including the Strip chair (1974) and

1935- Canadian Canada's most successful industrial designer, Ball is best-known for the Race office system (Sunar Hauserman, 1978). He has also designed wheelchairs.

BALMAIN, Pierre

1914-82 French

Balmain began his fashion career supplying drawings for the couturier Piguet. After a five-year stint for Molyneux, he worked for Lelong alongside Christian Dior (see p.259). Balmain founded his own house in 1945. His designs found favour with rich, older women and many celebrities. The house diversified into ready-to-wear, sportswear, and perfumes, while Balmain himself designed air hostess uniforms and numerous stage and film costumes.

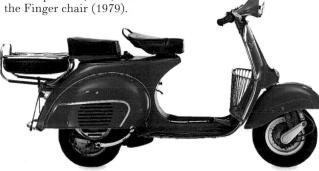

Corradino d'Ascanio's Vespa scooter, 1946

BALENCIAGA, Cristobal

1895-1972 Spanish

Ø p.144

Balenciaga is thought by many to be the century's greatest couturier. At the age of 18, he opened his own shop in San Sebastián and began work as a couturier under the name Eisa. In the late 1930s, he opened a couture house in Paris, and produced his first collection, consisting of full-skirted crinoline dresses. Like much of his later work, the designs were influenced by his Spanish background and featured brocades, ruffles, black lace, and embroidery. His dramatic evening clothes were strongly coloured. In 1957, he produced the "sack" dress, a radical departure from Dior's close-fitting "New Look". He retired in 1968.

BARNACK, Oskar

1879-1936 German

Ø p.164

Barnack was the inventor of the Leica camera, the first successful 35mm camera.

BASS, Saul

1920-96 **American**

p.227
Design pioneer Bass established his graphic design company, Saul Bass Associates, in Los Angeles. In movie advertising and credit sequences, he produced groundbreaking work, most notably for Otto Preminger's film The Man with the Golden Arm (1955). In addition to his film work, Bass' company has developed many corporate identities including AT&T, Minolta, Quaker Oats, United Airlines, and Warner Communications.

BAYER, Herbert

1900 – 85 Austrian/American @ p.208, 217

The graphic designer most associated with the Bauhaus, Bayer designed and produced all its typography between 1925 and 1928. These lowercase, sans-serif typefaces became identified as the Bauhaus graphic style. Bayer left the school in 1928. In the years that followed, he art directed the German Vogue, designed typefaces, and introduced surrealism to the advertising style of the 1930s. In 1938, Bayer emigrated to the US, where he designed graphics and buildings.

BECK, Henry C.

1903-74 British

Ø p.17

In 1931, Beck designed a diagrammatic route map for London Underground. Its geographically distorted and simplified lines were easier to follow than previous maps. Beck developed it until 1959.

BEDINE, Martine

1957 - French Bedine moved to Florence, Italy, in 1978. There, she worked for the Super-studio group before joining Ettore Sottsass at Alchimia, then Memphis. Her designs include the Super table or floor lamp (1981) and Charlotte sideboard (1987) for Memphis, and luggage for Louis Vuitton. In 1992, she co-founded La Manufacture Familiale to produce mainly wooden furniture.

BEHRENS, Peter

1868-1940 **German**

\$\mu\$ p.74, 106, 194, 212 Industrial designer and architect associated with the electrical company AEG, Behrens epitomized the growing relationship between art and industry during the early-20th century. His early paintings and graphic work were influenced by Jugendstil. After joining the Munich Secession, and then the artists' colony in Darmstadt, Behrens worked for AEG between 1903 and 1914. He was responsible for its publicity, packaging, and later

Ø p.91

After working as a theatre designer and window dresser, Bel Geddes began designing industrial objects in 1927. These included cars, radios, and aeroplane interiors. Due to the futuristic nature of his designs, few went into production. However, his book Horizons helped popularize streamlining and he was the first industrial designer to gain public notice.

BELLINI, Mario

1935 - Italian

p.62, 87, 99, 205 One of Italy's leading industrial designers, Bellini studied architecture in Milan. Since 1963, he has been consultant to Olivetti, for

BENNETT, Ward

1917- American

Artist, sculptor, and designer in many other capacities, Ward has also worked as an interior designer. He is now best-known for his furniture, textiles, and jewellery.

BERTOIA, Harry

1915-78 Italian/American

Ø p.36

Italian-born Bertoia moved to the US in 1930. After teaching metalwork, he worked with Charles Eames (see p.260) on plywood and wire chairs. In 1950, he set up a studio with help from Knoll International, for which he produced the Diamond Chair (1952).

ASHLEY, Laura 1926-85 British

From an inauspicious start as a cottage industry, Laura Ashley's company has become a worldwide commercial success. Aside from the trademark floral dresses and womenswear, the shops sell domestic interior furnishings, all marketing a nostalgic English "country" look.

A 1960s' Laura Ashley design

BERTONE, Flaminio

1903 - Italian

Ø p.181, 182, 185 The man behind the idiosyncratic shape and styling of the Citroën 2CV (1939), Bertone also styled the company's Traction Avant (1934) and DS (1960).

BERTONE, Giuseppe

1914- Italian

Ø p.186

"Nuccio" Bertone joined his father's car body shop in 1934 and went on to change it into a successful and influential auto design studio. He was responsible for the design of the Alfa Romeo Giulietta Sprint (1954), Lamborghini Miura (1966), Ferrari Dino 308 (1973), and the Citroën BX (1982), among others.

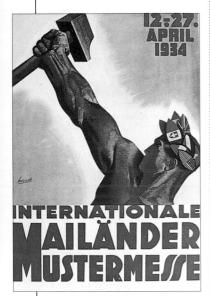

Bocasile's poster for a trade fair in Milan, 1934

BLACK, Misha

1910-77 British Russian-born Black moved to the UK as a child. During the 1930s, he designed radios and televisions for Ekco, using new plastics. Much of his career was devoted to exhibition design, and he was responsible for part of the Festival of Britain (1951). Between 1959 and 1975, he taught industrial design.

BLAHNIK, Manolo

1940 - Spanish

Known as the creator of original and extravagant shoes, Blahnik has produced footwear collections for many important fashion houses, including Calvin Klein and Yves Saint Laurent.

BLAKE, Peter

1932 - British

Ø p.220

Pioneer of the British Pop Art Movement, Blake's most famous design is the LP cover for the Beatles' Sgt Pepper's Lonely Hearts Club Band (1967). He is associate artist at the National Gallery, London.

BLOMBERG, Hugo

1897 - Swedish

Ø p.127

As chief engineer and head of design at the Swedish telecommunications company Ericsson, Blomberg designed the Ericofon one-piece telephone with Ralph Lysell in the 1940s (see p.266).

BOCASILE, Gino

active 1930s Italian

Ø p.225

One of Italy's leading poster designers during the 1930s, Bocasile produced many advertising and tourism posters (see left).

BOERI, Cini

1924- Italian After graduating in architecture, Boeri worked in the studio of Marco Zanuso (see p.275) until 1963, when she became a freelance designer. Although best-known for her furniture designs, including the Bobo (1967) and Strips (1972) seating sytems, she has designed showrooms for Knoll International (1976) and a series of prefabricated houses in Japan (1983).

BONETTO, Rodolfo

1929 - Italian

A furniture and industrial designer, Bonetto first worked in the Pininfarina car design studio. Since setting up his own studio in 1958, he has designed products for Brionvega, Olivetti, Gaggia, Driade, Veglia Borletti, and FIAT. His original use of single-piece plastic moulding in the interior of the FIAT 132 Bellini (1980) earned him much acclaim.

BOOTY Jr, Donald

1956 - American

Ø p.205

Before founding Booty Design Associates in 1988, Donald Booty Jr had studied industrial design in Chicago. The company designs not only for other manufacturers, but also for its own production company, Phorm.

BORSANI, Osvaldo

1911 - 85 Italian

Ø p.40

Borsani worked as both an architect and furniture designer. In 1954, with his twin brother Fulgenzio Borsani, he founded the furniture company Tecno. In the early years, Tecno produced Borsani's designs only, but later offered the work of other designers, such as Norman Foster (see p.261). Borsani's most famous pieces are the P40 chaise longue (1954) and D70 reclining sofa (1955).

BOTTA, Mario

1943 - **Swiss**

Ø p.92

Botta studied architecture at the University of Venice, and his training included a stint in the Paris studio of Le Corbusier (see p.266). In 1969, Botta returned to Lugano and began work on various public and private buildings that would earn him recognition as an organic, rationalist architect. A recent commision was the San Francisco Museum of Modern Art (1995). Since 1982, Botta has designed a number of pieces of metal furniture for the Italian company Alias. These include the Prima chair (1982), Quarta chair (see right), and Tesi table (1986).

BOUE, Michel

1936-71 French

Automobile designer Boué's career was cut short when he died of cancer at the age of 35. However, he had already produced one major design, the Renault 5 (known in the US as Le Car). The car, which appeared in 1972, was the first of the Superminis, and became the best-selling French car ever.

Quarta chair, designed by Mario Botta for Alias, 1984

BOULANGER, Pierre

1886-1950 French

Ø p.181, 182, 185 Boulanger, an engineer, worked for the French tyre company, Michelin, until 1935, when it took over the car manufacturer Citroën. Boulanger became chief of the car company and was responsible for the concept of the Traction Avant (1934), 2CV (1939), and DS (1960), all of which were styled by

BRANDT, Marianne

Flaminio Bertone (see left).

1893-1983 German Painter, designer, and metalworker, Brandt studied painting and sculpture in Weimar. She joined the Bauhaus in 1923 and, under the influence of László Moholy-Nagy (see p.267), became one of its bestknown metalwork students. She evolved from an Arts and Crafts worker to an industrial designer employing geometric principles. In 1925, she began designing metal lamps at the Bauhaus, and is particularly remembered for the Kandem bedside light (Körting and Matthiesen,

1928). Between 1928 and 1929, Brandt briefly worked for Walter Gropius's office (see p.263) in Berlin, and after World War II she taught first in Dresden, then in Berlin.

BRANZI, Andrea

1938 - Italian

An architect and designer, Branzi was an influential member of the Florencebased design group Archizoom (founded in 1966). He moved to Milan in 1979 and worked with Studio Alchimia, then Memphis. His designs for Memphis include the Century couch (1982), Labrador sauceboat (1982), and Magnolia bookcase (1985). In 1982, Branzi became educational director of the Domus Academy, a postgraduate design school.

BRAUN, Artur

1921-71 **German**

Ø p.57

Artur Braun took over the Frankfurt-based radio and record-player company, Braun, on the death of his father in 1951, and turned it into the electronics giant it is today. He hired Fritz Eichler (see p.260) as design director. Together they designed the SK 25 radio in 1955 (see below). Eichler employed Otl Aicher (see p.254), Dieter Rams (see p.271), and Hans

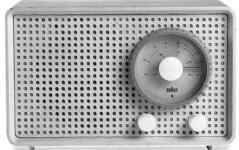

Artur Braun and Fritz Eichler's SK 25 radio, 1955

Gugelot (see p.263), designers with whom he had worked at the Ulm Hochshule für Gestaltung (Ulm College of Design). The Braun products they created displayed a strong company look, epitomized by an unadorned, industrialized style and geometric simplicity.

BREER, Carl

1883−1970 **American P** p.181

In the 1930s, Breer was chief engineer at the US car manufacturer Chrysler. He was responsible for the unconventional looking Airflow (1934), which although a commercial failure, was widely commentated on at the time and influenced the design of many other automobiles. Breer retired in 1951.

BREUER, Marcel

1902 - 81

Hungarian

Ø p.33, 124 After studying at the Bauhaus, Breuer opened an architect's office in Berlin in 1928. His most significant contribution to design this century is his revolutionary tubular-steel furniture (see right). Inspired by the strength and lightness of his bicycle, he first made use of tubular steel for the Wassily chair (1925). The Cantilever chair that followed (1928) was made with an unbroken length of tubing, and became a prototype for countless similar chairs. After a short time working for Isokon in England (for whom he produced a bent plywood chair), Breuer moved to the US, where he built his own house and produced experi-mental furniture. His major architectural works include the UNESCO headquarters in Paris (1953) and the Whitney Museum of American Art in New York (1966).

BROADHEAD, Caroline

1950 - British

A prominent figure in European jewellery design, Broadhead first worked with ivory. In 1977, she produced bound-thread necklaces and, in 1978, innovative bracelets. She was one of the first designers to reject precious materials in favour of everyday materials such as cloth, rubber, and paper. In the 1980s, she created wearable pieces that combined jewellery, clothing, and sculpture.

BRODOVITCH, Alexey

1898—1971 American Born in Russia, Brodovitch worked in Paris during the 1920s, where he designed books, posters, furnishings, and advertising. He moved to the US in 1930, where he was art director of *Harper's Bazaar* for 25 years.

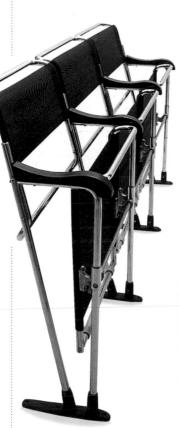

Bauhaus tubular-steel cinema chairs, designed by Marcel Breuer, 1929

Brodovitch revolutionized American magazine design by introducing cropped photographs, spare layouts with ample white space, and illusory effects.

BRODY, Neville

1957 – British

p.211, 219

A graphic designer who rose to fame in the 1980s, Brody studied fine art and graphic design at the London College of Printing. He began his career by designing record covers. In 1981, he was appointed art director of the magazine *The Face*, and experimented with unconventional typefaces, logos, and symbols. He continues to run his own design studio in London.

BÜLOW-HÜBE, Vivianna Torun

1927 – Swedish p.157

From 1951 to 1956, Bülow-Hübe worked in her own studio concentrating on wooden and silver jewellery. From 1967, she produced various jewellery and watch prototypes for Georg Jensen Sølvesmedie. She later turned her hand to glassware, porcelain, and ceramics, and went on to design kitchen

BURYLIN, Sergei Petrovich

utensils, lamps, baskets,

and office equipment.

See panel right

CAMPBELL, Sarah

CAMPBELL, Saran

1946 – British p.123, 258

Textile designer Campbell works with her sister, Susan Collier (see p.258), with whom she founded Collier Campbell.

CAPUCCI, Roberto

1929 - Italian

Capucci studied at the Accademia delle Belle Arti in Rome, and in 1950 opened a fashion house there. In 1962, he went to Paris, returning to Rome after seven years. He produced many experimental and daring fashion items, using bright colours and sculptural forms, including plastic garments filled with coloured water. Capucci was renowned for the skillful cut of his garments.

CARDER, Frederick

1863-1963 British

In 1903, Carder moved to the US, where he co-founded the Steuben Glassworks in New York. Starting out by making iridescent glass, Aurene, in an

Art Nouveau style, Steuben soon became a major player in the glass world. In 1918, the company was taken over by the Corning Glass Works. During the 30 years that Carder was art director there, he designed many of the most successful pieces himself.

CARDIN, Pierre

1922 - French p.144

Born in Italy to French parents, Cardin studied architecture in Paris after World War II, and then trained at the fashion houses of Paquin, Schiaparelli, and Dior. In 1950, he opened his own house, showing his first collection in 1953. During the 1960s, he moved into menswear, and came to be considered one of France's most adventurous couturiers. His unconventional designs used bright and patterned materials, some influenced by the space age, and had exaggerated features. Many of his designs were suitable for men or women, and he is said to have invented unisex clothing. Cardin's name is now also associated with cars, furniture, luggage, and wigs.

CARLU, Jean

1900 - French

Ø p.227

One of France's leading poster designers of the 1920s and '30s, Carlu was clearly influenced by Cubism. Between 1940 and 1953, he lived in the US, and there produced the first US defence poster in 1941.

CARTER, Matthew

1937 - British

Ø p.211

Today considered to be a master of typography and its technology, Carter designed the Bell Centennial type for the US AT&T telephone directories in 1978. In 1981, he co-founded Bitstream Inc. to produce fonts for computers.

CARTIER, Louis

1875-1942 French

Ø p.128

Grandson of the founder of the jewellers Cartier, Louis Cartier became its most important and innovative designer, improving the types of materials used in jewellery design. From around 1900, he utilized platinum, a suitably flexible metal for his lace-like diamond-set jewellery.

BURYLIN, Sergei Petrovich 1876-1942 Russian

Tractor fabric, 1930

A textile designer, Burylin was active at various textile mills in Ivanovo-Vosnesensk. His most widely known fabric, the Tractor cotton print, is typical of his strong, semi-abstract, Constructivist style.

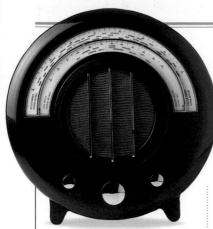

Wells Coates' AD 65 radio, 1932-34

CARWARDINE, George

1887-1948 British

Ø p.54

As an automobile engineer, Carwardine was a suspension system specialist; as a lighting designer, he is famous for his 1934 Anglepoise lamp. The springs and hinges of the lamp were designed to replicate the muscles and movement of a human arm. Over 60 years later, the design is still in production and remains virtually unchanged.

CASSANDRE, A.M.

1901-68 **French**

@ p.225

A.M. Cassandre was the pseudonym of graphic artist Adolphe Jean-Marie Mouron. Between 1923 and 1936, he designed a series of highly successful and influential advertising posters using his idiosyncratic style of bold, geometric abstraction and broad planes of restricted colour to integrate images and words. He also created three new typefaces: Bifur (1929), Acier Noir (1930), and Peignot (1936). His Dubonnet poster (1934) and Etoile du Nord poster (1927) have become classics.

CASTIGLIONI, Achille

1918- Italian Ø p.37

Innovative industrial designer Castiglioni joined the studio of brothers Livio (1911-79) and Pier Giacomo (1913-68) in 1944, after graduating in architecture from Milan Polytechnic. His work includes lighting but he is best-known for his exploratory furniture design: the 1957 tractor-seatstool Mezzadro, and the 1970 kneeling stool Primate.

CHANEL, Gabrielle (Coco)

1883-1971 French

Pp.104, 143, 157 From humble origins, Chanel had no formal fashion training, yet she is one of the most enduring fashion success stories. In 1914, she opened her first dress shop; during the 1920s, she responded to women's work and leisure fashion needs with practical but stylish wool jersey and corduroy clothing in neutral shades or red. Hers was a relaxed, unfussy style. Her eveningwear was luxurious, with beading, embroidery, and fur. The look for which she is best-known is the jersey or soft tweed collarless suit, with braid trim and many pearls or gold chains. After her death, the House of Chanel remained open and was taken over by Karl Lagerfeld in 1983 (see p.266).

CHASHNIK, Ilia Grigorevich

1902-1929 **Russian**

Ø p.15, 83

Chashnik collaborated with fellow Suprematist painter Kazimir Malevich while working at the Lomonosov State Porcelain Factory design studios between 1922 and 1924. Chashnik designed the enamelled decoration for Malevich's witty 1923 porcelain Half Cup.

CHERMAYEFF, IVAN

1932-1996 American A designer, illustrator, and painter, Chermayeff's major work was in partnership with Thomas Geismar (see p.262). The design group Chermayeff and Geismar Inc. became known for its bold, graphic work in corporate identity. He won many awards, both jointly and individually.

CLIFF, Clarice

1899-1972 British

Ø p.83

Cliff is one of the foremost British ceramic designers of this century. She began as a lithographer in 1916 at A.J. Wilkinson Ltd, the Royal Staffordshire pottery with which she was associated for the rest of her working life. Her best-known design was the Bizarre range, produced from 1927, which was typified by brightly coloured, stylized designs against a creamy background, giving a strong Art Deco feel. Despite their unconventional look, Cliff's designs were sold in shops such as Harrods. Her work is enjoying renewed popularity.

COATES, Nigel

1949 - British

An architect and furniture designer, Coates has achieved notoriety for his extravagant and unconventional designs

for a series of Japanese bar and club interiors. He has also designed fashion shops in London for Jasper Conran and Katherine Hamnett (see p.263). He launched his Metropole and Jazz furniture collections in 1987 and his Noah collection in 1988.

COATES, Wells

1895-1958 **Canadian**

Ø p.56

Born in Tokyo and educated in Canada, Coates settled in the UK in 1929. He is most commonly associated with the Modern Movement in England during the 1930s. His interest in new technologies and materials led him to form the Isokon company with Jack Pritchard in 1931 to design and build modern housing and furnishings. Most of Coates' industrial design work in the 1930s was for Ekco and he is particularly remembered for his series of Bakelite radios, including the AD 65 (see left).

COLANI, Luigi

1928 - **German**

Ø p.85

Colani's designs are largely influenced by aerodynamic styling, ranging in subject matter from transportation to fashion accessories. Most of his transport designs have never progressed beyond prototypes, although they have inspired other designers. Among his best-known designs are his 1970 Drop porcelain service for Rosenthal and his cameras for Canon.

COLLIER, Susan

See panel, left Ø p.123

COLOMBO, Joe

1930-71 **Italian**

₽ p.66, 92, 129 A painter, sculptor, and designer, Colombo was a leading figure of post-World War II Italian design. He set up his own studio in Milan in 1962 and his works show

a concern for the technical

problems of design using new materials and techniques. His 1965 Chair 4860, made by Kartell, was one of the first one-piece injection moulded chairs in ABS plastics. His interest in economy and scale led him to design a complete mobile kitchen in 1972. His other clients have included Bernini, Italora, O'Luce, Bieffeplast, and Zanotta.

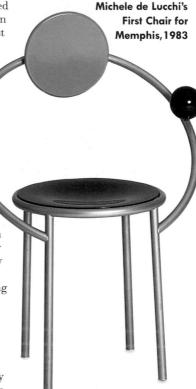

CONRAN, Terence

1931 - British

Conran has greatly increased Britain's design awareness, bringing "good design" to the masses at affordable prices, largely through the Habitat stores, he established in 1964. His early work was inspired by Italian and Scandinavian designs. In 1989, the Conran Foundation funded a Design Museum in London devoted to mass-produced goods.

COOPER, Susie

1902 - British

An enduring name in British ceramics, Cooper set up her own firm in 1929, producing popular tea and coffee services and decorative items. Her designs feature patterns inspired by nature and strong shapes with clean lines and modern colours.

COLLIER, Susan 1942- British

Bauhaus furnishing fabric, 1972

Collier worked as the design and colour consultant to Liberty of London Prints, before founding her own textile company in 1979 with her sister, Sarah Campbell. Collier Campbell's philosophy was to grow away from the formal, organized graphic designs of the 1950s and produce painterly fabrics with strong colours and abstract patterns. Its concept of "design for now" is still apparent in its fashion, bedding, and furniture fabrics.

DEAN, Roger 1942- British

Close to the Edge record sleeve, 1972

Dean has designed stage sets, Teddy Bear Chairs, and seating for a jazz club, as well as illustrating album covers. His work is characterized by fusing natural images with fantastical, unworldly creations. In 1979, he co-founded his own design company, Magnetic Storm, to specialize in product research and development, theatrical construction, architectural design, illustration, and film.

CORDERO, Toni

active 1980s & '90s Italian

p.109

Designer of the dramatic Sospir bed, Cordero also built the Alpine Stadium (1985) and the Automobile Museum (1987) both in Turin, Italy. He designs for Artemide, Driade, and Sawaya & Moroni.

COURREGES, André

1923 - French

Trained by Balenciaga, Courrèges received groat acclaim for his futuristic clothes. The 1964 Space Age collection was followed by his 1965 miniskirts and white and pastel trousers, which were copied worldwide.

D

DAY, Lucienne

1917- British

Day created her famous Calyx fabric design in 1951: its thin black lines, precise graphics, and autumnal colours expressed a new approach to textile design. She has created many elegant screenprinted furnishing fabrics.

DAY, Robin

1915- British

Husband of Lucienne (see above), with whom he formed a design studio, Day won a low-cost furniture competition in 1948 at the Museum of Modern Art in New York. He subsequently designed one of the most successful post-World War II chairs for the non-domestic market, the Polyprop stacking chair, in 1963.

DEAN, Roger

See panel, above p.220

DELAUNAY, Sonia

1885-1979 French

Delaunay's painter husband, Robert, influenced much of Sonia's work: with him she explored dynamism, rhythm, and movement through colour.

Dreyfuss' Thermos carafe, 1930s

Her work incorporated fabrics, interior design, and theatre, designing ballet costumes for Diaghilev's *Aida* and *Cleopatra* productions. By 1925, her bold, decorative clothing designs had become fashionable.

DE BRETTEVILLE, Sheila Levant

1940 – American A typographer, graphic designer, and educator, de Bretteville is known for combining social and political attitudes with design. Her early inspiration came from feminist issues and much of her work promotes women's creative expression.

DE LUCCHI, Michele

1952- Italian

p.24, 25, 43, 45 De Lucchi was closely linked with the radical international design group, Memphis, from its initiation in 1981; he worked previously for Studio Alchimia. Like many Memphis designers, de Lucchi used bright, garish colours and asymmetry in his Postmodernist work. His bestknown piece for Memphis was the 1983 First Chair (see left). He set up his own studio in 1984 and went on to design plastic tableware for Bodum. He has also been a consultant to the office supplies manufacturer, Olivetti, and designed more than 50 Fiorucci shops.

DE PAS, D'URBINO, LOMAZZI

established 1966 – Italian Originally established as an architectural practice, the firm of Jonathan de Pas (1932–1991), Donato d'Urbino (1935 –), and Paolo Lomazzi (1936 –) turned to furniture design, producing one of the most memorable pieces of Pop-inspired design, a PVC inflatable Blow chair, in 1967.

DEGANELLO, Paolo

1940- Italian

After studying architecture, in 1966 Deganello became a co-founder of the radical design group Archizoom in Florence. He has also designed furniture for the Cassina and Driade companies: his 1982

Torso armchair, sofa, and bed for Cassina are particularly important pieces.

DESKEY, Donald

1894-1989 American

Ø p.44

An industrial and interior designer, Deskey was a pioneer design consultant and an important exponent of Art Deco in the 1930s. He began in advertising but was later commissioned to design items such as washing machines and printing presses. He was greatly interested in the new materials aluminium, cork, and linoleum. From 1927 to 1931, he worked in partnership with Phillip Vollmer and his work expanded to include interiors, wallpapers, and fabrics. In 1932, he won a competition to design the interior of the Radio City Music Hall in the Rockefeller Centre, New York, which is acknowledged as a piece of classic American Art Deco.

DIOR, Christian

1905-57 French

Ø p.18, 142

At his first collection in 1947, Dior launched a totally new look that transformed fashions worldwide. His rise to fame was meteoric: he taught himself to draw, selling his ideas to couturiers and magazines, and then trained formally at the Piguet and LeLong fashion houses. His 1947 "New Look" captured the postwar mood; his famous A-line collection appeared in 1956. After Dior's death, Yves Saint Laurent (see p.272) became head of design for a brief period.

DORN, Marion Victoria

1899–1964 American After experimenting with resist-dyed fabrics in the US, Dorn moved to the UK in the early-1920s, making original batiks for interiors. During the 1930s, she became a leading Modernist designer, achieving acclaim for her textiles and tufted carpets.

Natalie du Pasquier's Bordeaux Lamp for Memphis, 1986

DREYFUSS, Henry

1903-72 **American**

Ø p.107, 126 Industrial designer Drevfuss' interest in the relationship between man and society led him to incorporate ergonomic features in his work, an approach that influenced later designers. Apprenticed to Norman Bel Geddes (see p.255), he then established his name in the 1930s with the Bell Telephone Company, designing its classic Bell 300 in 1933. He also designed for companies such as American Airlines, Lockheed, Thermos (see left), and Hoover. His autobiography, Designing For People, was published in 1955.

DU PASQUIER, Natalie

1957 - French

Ø p.123

A leading Post-modern textile designer, du Pasquier worked first for Rainbow Studio and then Memphis from 1981 to 1988. She is known for her vivid printed patterns. In 1982, she joined the creative staff of Fiorucci. She has also designed furniture, lamps (see below), clocks, and ceramics.

DUFY, Raoul

1877-1953 French

D.122

The early work of painter and decorative designer Dufy was strongly influenced by the bright, strong colours of the Fauves. Later, he designed dress fabrics for couturier Paul Poiret (see p.270) and textiles for the Lyons-based company Bianchini-Férier.

DUMAS, Rena

1937- Greek

Ø p.193

After completing her studies in Paris, in 1962 Dumas began working as a designer of leather goods for Hermès. She set up her own office in 1971, designing office, home, and shop interiors. Working in collaboration with Peter Coles (1954-85), she produced the

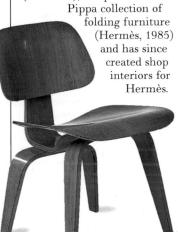

Charles Eames'

DCW dining

chair, c.1946

DUMBAR, Gert

1940 - Dutch

₱ p.230

A graphic designer and tutor, Dumbar studied painting and graphic arts before joining Tel Design Associates in The Hague in 1967. Tel created the internationally acclaimed corporate identity for the Nederlands Spoorwegan (Dutch Railways). In 1977, Dumbar left the group to set up his own practice. Working in association with Total Design (established 1963), Studio Dumbar produced the corporate identity for PTT, the Dutch Postal, Telegraph, and Telephone authority. Other commissions include the celebrated signage system

for the Rijksmuseum and the corporate identities for Westeinde Hospital in The Hague, and ANWB (Dutch Automobile Association).

DUNAND, Jean

1877-1942 Swiss

Dunand studied art in Geneva before moving to Paris, where he worked as a sculptor until 1902. He established his own metalwork studio in 1903. Best-known for his lacquer work, from 1912 he studied with the Japanese artist Seizo Sugawara, who also trained Eileen Gray (see p.263). He incorporated lacquering techniques into his metalwork designs, and later applied them to furniture, screens, and panels. Some of his finest Art Deco creations include the interior of the smoking room of the Ambassade Française at the Paris Expo in 1925, and lacquered panels for the Normandie ocean liner (1935).

d'URBINO, Donato

See de Pas, d'Urbino, Lomazzi

EAMES, Charles Ormond

1907-78 **American**

Ø p.19, 37

Architect-designer Charles Eames studied architecture at Washington University, before setting up in his own practice in St. Louis in 1930. In 1936, he was offered a fellowship at Cranbrook Academy of Art, Michigan, where he met Eero Saarinen (see p.271) and his future wife Ray Kaiser (see right). Saarinen and Eames designed a series of moulded plywood seats, which won the 1940 Organic Design in Home Furnishings competition at New York's Museum of Modern Art. In 1941, he and Ray moved to California. The couple were in partnership from 1944, creating furniture designs, which were mass produced by Herman Miller. They created several notable pieces, including the Lounge chair and ottoman (1956), and later moved into film production, photography, and exhibition design. Their client list included the US Government and IBM.

EAMES, Ray

1912-88 American

Ø p.37 Ray Eames (née Kaiser) collaborated with her husband Charles Eames (see left) on many of their magazines, exhibition, film, and furniture designs.

EARL, Harley

1893-1969 American

Ø p.20, 184−85

Earl was responsible for the styling of General Motors cars from 1927 until his retirement in 1959. His grounding in the glamorous world of Hollywood showed in his flamboyant styling. He was an innovator, introducing yearly model changes and the use of clay models for developing the shape of the bodywork. His most famous model is the Cadillac Eldorado (1959).

EBENDORF, Robert

c.1938 - American

Ebendorf is a jeweller whose early work, including coffee pots and umbrella handles, showed both American and Scandinavian influences. In contrast to his early pieces, made from precious and semiprecious materials such as silver, ebony, and moonstone, his jewellery from the 1980s was produced from a range of non-precious materials, including paper, photographs, Formica, and wood.

ECKMANN, Otto

1865-1902 German

Ø p.208

After starting out as a painter, Eckmann turned

his attention to the applied arts, producing illustrations for the magazines Pan and Jugend. In 1900, he created the Art Nouveau typeface Eckmann Schmuck, one of several designed for the Klingspor foundry, Offenbach. In addition to his work

as a graphic artist,

workshop, Eisenloeffel spent a year learning enamelling in Russia. The metalwares and ceramics that he produced for various

Shoe lasts from Ferragamo's studio

he also designed textiles, ceramics, and pieces of furniture.

Harley Earl

with a futuristic

prototype, early 1950s

EDISON, Thomas Alva

1847-1931 American

Ø p.61, 194

Edison is a key figure in the development of modern technology. Among his many inventions are the phonograph (1878), the incandescent light bulb (1879), and talking motion pictures (1912).

EICHLER, Fritz

1911-91 German

Ø p.57, 258

Eichler began his career in theatre set design. In 1954 he was employed by Artur Braun (see p.258) as a programme director. Together with the Braun design team, he was responsible for developing the austere functionalist style that has come to be associated with the company.

EISENLOEFFEL, Jan W.

1876-1957 Dutch

Ø p.82

After training in Amsterdam in the Hoeker en Zoon silver Dutch companies, including De Woning and De Distel, all demonstrate his liking for simple, industrial forms that could be mass produced.

ERTE (Romain de Tirtoff)

1892-1990 Russian Erté took his name from the French pronunciation of his initials, RT. After studying at the Académie Julian, Paris, he was employed as a fashion illustrator by Paul Poiret (see p.270). From 1915, he created drawings for the covers of Harper's Bazaar and designed theatrical costumes and sets. Working briefly in Hollywood, he designed sets for Cecil B. de Mille and Louis B. Mayer. Later, he achieved renown when a retrospective of his drawings was shown in New York and London.

ESSLINGER, Hartmut

1945- **German**

Ø p.200

Industrial designer Esslinger founded frogdesign, an industrial-design consultancy, in Altensteig in 1969. The firm's first client was Wega Radio, which was later bought out by Sony – establishing a presence for frogdesign in the Japanese market. Esslinger opened an office in California in 1982. His clients include Apple, for which he designed the Apple Macintosh (1984).

FARINA, Battista

1893-1966 Italian Before setting up his own shop in Turin in 1930, automobile designer "Pinin" Farina

visited the US to study Ford's production methods. His name is generally associated with the classic Italian makers, such as Alfa-Romeo and Ferrari, but he also designed for mass production. In 1961, the firm was renamed Pininfarina.

FATH, Jacques

1912-54 French

Ø p.143

Trained at drama school, Fath worked briefly as an actor before establishing a fashion house in 1937. His career as a couturier was interrupted by World War II, but he emerged in peacetime as a successful haute couture designer. In 1948, he entered

quality of mass-produced shoes and developed his own method of hand production, working directly from the wooden last (see left). In 1927, he returned to Italy, where he continued to produce exciting designs, popularizing the wedge heel in the 1930s. He received the Neiman-Marcus Award in 1947, the year he invented the "invisible shoe".

FERRARI-HARDOY, Jorge

1878-1976 Argentinian

Ø p.35

FERRIERI, Anna Castelli 1920- Italian

Plastic stacking armchairs for Kartell, 1986

Anna Ferrieri graduated in architecture from Politecnico

di Milano in 1943. She married Giulio Castelli the same

year and entered into the family business, Kartell, for

which she produced plastic furniture, tablewares, and

office in 1946, and from 1959 to 1973 worked with

modular storage systems. She set up her own architecture

architect-designer Ignazio Gardella (1905-) on furniture

and public housing. She has received numerous awards.

Ferrari-Hardoy worked in collaboration with two fellow architects, the Argentian Juan Kurchan (1913-75) and the Spaniard Antonio Bonet

which highlights human alienation in a technological environment, has also been used extensively in posters and advertisements.

FORD, Henry

1863-1947 American

Ø p.180

Apprenticed to a machinist in Detroit in 1878, by 1893 Ford had produced his first petroldriven car. In 1903, he founded the Ford Motor Company. The hugely successful Model T (see right) of 1908 was the first car to be mass produced on the assembly line. The emphasis shifted from function to styling with the introduction of the streamlined V8 in 1932. Ford was eventually succeeded by his son and grandson.

FORNASETTI, Piero

1913-88 Italian

Fornasetti is recognized for his individualistic decoration. He collaborated on a number of projects with Gio Ponti (see p.270), after Ponti saw his work exhibited at the Milan Triennale in 1940. Famous for his trompe-l'oeil designs, his most celebrated commissions is the Casino, San Remo (1950).

FORTUNY Y MADRAZO, Mariano

1871-1949 **Spanish**

Ø p.142

Working with hand-dyed silks and velvets, artist and dressmaker Fortuny made stunning Aesthetic-style dresses, coats, and capes. His most famous garment is the Delphos dress (1909), for which he employed his patented pleating method.

The bodysheathing dress maintained its pleats when twisted into a knot for storage.

FOSTER, Norman

1935 - British

Ø p.193

Foster is best-known as a high-tech architect, reponsible for the Sainsbury Centre for the Visual Arts, University of East Anglia, Norwich (1978), and the

261

FRANCK, Kaj

1911-89 Finnish

with Tecno (see below).

An important ceramics and glassware designer, Franck worked for both Arabia pottery and Nuutajärvi glassworks (absorbed by Wärtsilä in 1950) between 1945 and the late-1970s. Through his work, such as the Kilta tableware range (1952), he promoted a distinctly utilitarian aesthetic.

FRANK, Josef

1885-1967 **Austrian** Austrian-born designer Frank became a lecturer at the Künstgewerbeschule, Vienna in 1919. Between 1925 and 1934, he ran an interior design company called Haus und Garten. Moving to Sweden in 1934, he joined Svensk Tenn, where he designed furniture, textiles, and wallpaper. He was an early exponent of the Swedish Modern movement.

FRUTIGER, Adrian

1928 - Swiss

Ø p.210

Graphic designer Frutiger earned his reputation in 1957. when he launched the Univers typeface. Creator of over 20 typefaces, he has also worked on signage, including Charles de Gaulle airport, Paris, and as a

Hongkong and Shanghai Bank. Hong Kong (1979-85). He also designed the Nomos set of office furniture (1983-87) Ford Model T, 1908

FUKUDA, Shigeo

1932 - Japanese

The witty posters, sculptures. and mosaics of Shigeo Fukuda all demonstrate his playful approach to design. He achieved international acclaim for his posters and signage for the Osaka World Expo in 1970 and since then has exhibited in many group and one-man shows throughout the world.

FULLER, Richard **Buckminster**

1895-1983 American Radical architect and inventor Fuller trained in mathematics at Harvard and then at the Naval Academy, Maryland, where he began to develop his humanistic design concepts. His extensive research resulted in the Dymaxion house (1927) and car (1933). His foremost invention was the geodesic dome, which served as a model for future exhibition domes.

the American ready-to-wear market, creating biannual collections for Joseph Halpert. Fath was one of the first fashion houses to offer clothes in standardized sizes, which were sold through boutiques. In 1949, Fath received the prestigious Neiman-Marcus Award for his work. FERRAGAMO, Salvatore 1898-1960 Italian

Ø p.146

The "shoemaker to the stars", Ferragamo found his vocation early in life, setting up his own workshop in Bonito, Italy, at the age of 14. In 1914, he went to the US, where he opened a shop in Hollywood. He was appalled by the poor

(1913-89), to produce the Hardoy chair, also referred to as the Butterfly chair, in 1938. Its inexpensive manufacture made it a popular choice for reproduction by many manufacturers, including Knoll and Artek-Pascoe.

FERRIERI, Anna Castelli see panel above

FOLON, Jean-Michel

1934- Belgian

Ø p.229

Illustrator and graphic artist Folon has produced drawings for various American journals, including Time, Fortune, and The New Yorker. His work,

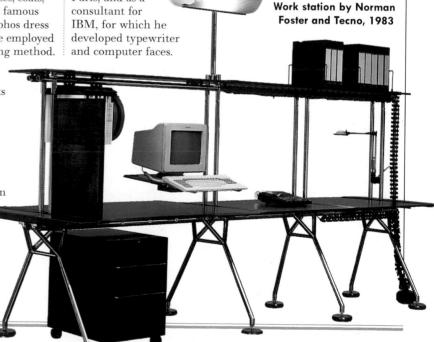

GALLIANO, John

1961 - British

@ p.145

Gibraltan-born fashion designer Galliano graduated from London's St Martin's School of Art in 1983. In his early collections, ethnic influence blended with his technique of spiral tailoring. When Hubert de Givenchy retired from his Paris couture house in 1995, Galliano became the first British fashion designer to head a French couture house.

GAMES, Abram

See panel below @ p.38,72

as well as his own exclusive label. His work, which often utilizes unusual materials, reveals the influence of London street style, particularly Punk. Gaultier has produced glamorous, nonconformist wear for men.

GEHRY, Frank O.

1929 - Canadian

Ø p.74

An internationally active architect and designer, Gehry has been prolific since the late-1970s. He studied architecture at the University of California, and Harvard Graduate School of Design, setting up on his own in 1962. Characterized by irregular, layered shapes and volumes, his buildings have been termed

advertisements. He received a Presidential Design Award in 1985 for his standardized transport related symbols.

GIACOSA, Dante

1905- Italian

D.184

One of Italy's greatest car designers, Giacosa joined Fiat in 1930. His Fiat 500A, launched in 1936, was the basis for several variations of this small car. He also created the Fiat 124, 128, and 130.

GILL, Eric

1882-1940 British

₽ p.209

Letter-cutter, illustrator, typeface designer, and writer, Gill studied at Chichester School of Art, and later under Edward Johnston (see p.264). After becoming involved with the Roman Catholic Church in 1913, he produced many religious illustrations. During the 1920s, Gill was commissioned by the Monotype Corporation, for whom he produced the typefaces Perpetua (1925-30) and Gill Sans (1928-30).

GIUGIARO, Giorgetto

1938- Italian

A prolific contributor to international car design, Giugiaro has produced over 100 designs for several major manufacturers. In 1968, he set up ItalDesign. One of the cars the company worked on was the Volkswagen Golf (1974). Giugiaro's consumer products include appliances for Sony, cameras for Nikon, and lighting for Luci.

1927 - French One of the most highly respected fashion designers to emerge from Paris, Givenchy studied at the Ecole des Beaux-Arts, and went on to work for the couture houses of Fath, Lelong, Piguet, and Schiaparelli. In 1952, he established his own house, garments. He created

Funny Face (1956), and GRANGE, Kenneth

Frank Gehry's Pito kettle for Alessi, 1988

Breakfast at Tiffany's (1961),

and later expanded into the

GLASER, Milton

1929 - American

Illustrator and graphic

in 1954 with Seymour

Although he is often

associated with 1960s'

Health Organization.

1959 - American

Founder of the design

Ø p.54

Chwast and Edward Sorel.

psychedelic graphic design,

he also created the Twergi

range of kitchenware for the

Italian design group Alessi,

and in 1987, an international

AIDS symbol for the World

GOLDMAN, Jonathan

consultancy GoldmanArts

in 1986, Goldman has been

sculptor. His novelty items

lamp (1980s), and a 91m

described as an environmental

include an inflatable Sawtooth

(300ft) ribbon for the opening

designer, Glaser co-founded

Push Pin Studio, New York,

Ø p.22

ready-to-wear clothing market.

1929 - British

Ø p.6, 7, 78, 79

A London-based industrial designer, Grange advocates that the design of a product should be intrinsic to its manufacture. His early creations include household appliances for Kenwood and the 1959 Brownie 44A for Kodak. He co-founded the design consultancy Pentagram in 1972. In the 1980s, he was influential in Japan, designing bathroom fittings for Inax and sewing machines for Maruzen. One of his most recent innovative products is his Silk Effects razor for women, developed for Wilkinson Sword and

launched by Schick in 1994.

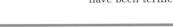

GAMES, Abram 1914- British A leading modernist graphic designer, Abram Games is remembered for the posters he produced for the British War Office during World War II. His ideal of "maximum meaning, minimum means" is expressed in the cohesion of stylized images and type. His more commercial designs include symbols for the 1951 Festival of Britain (designed in 1948), and

Commercial poster, 1958

GATTI, PAOLINI, TEODORO

BBC television (1952).

Established 1965 - Italian

Ø p.38

This design association was founded by the Italian trio Piero Gatti (1940-), Cesare Paolini (1937-), and Franco Teodoro (1939-). They acquired early recognition with their Sacco beanbag seating (1968-69).

GAULTIER, Jean-Paul

1952 - French

Ø p.105

After early contact with fashion designer Pierre Cardin (see p.257), Gaultier established himself as a freelance designer in 1976, creating ready-to-wear ranges deconstructivist. The fish is a recurrent theme, used in 1983 for his fish light, and in his Fish Dance restaurant in Kobe, Japan, 1987. The Vitra Design Museum in Germany (1989), and the Pito kettle (1988, see right) are among his works.

GEISMAR, Thomas

1931 - American

Geismar is most commonly associated with New York graphic design consultancy Charmayeff & Geismar Inc., which he co-founded in 1960. Best-known for corporate identity and exhibition design, the Mobil Oil logo (1964) and Xerox logo (1965) are among his works, as well as a number of exhibition

GIVENCHY, **Hubert Taffin de**

designing traditional, elegant Audrey Hepburn's wardrobes for the films

GRAVES, Michael 1934 - American

Ø p.44

A key protagonist of Postmodernism, Graves has been active as an architect and industrial designer. He graduated in architecture from Harvard University in 1959. From the late-1960s until 1977, he was a member

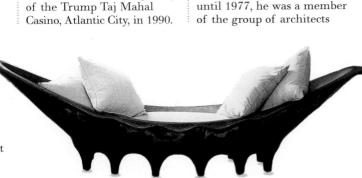

Eileen Gray's chaise longue for a private apartment, 1920s

known as the "New York Five". His many buildings include the Public Services Building in Portland, Oregon (1982) and the Disney World Dolphin Hotel (1989). Among his most celebrated pieces are the Plaza dressing table for Memphis (1981) and the Kettle with a Bird Whistle for Alessi (1983).

GRAY, Eileen

1878-1976 British

Ø p.44

This Irish-born architect and designer studied at the Slade School of Art in London from

GRUAU, René 1910- Italian

Fashion illustration, 1952

After an international education, Gruau settled in Paris after World War II. He contributed regular illustrations to Vogue magazine, but turned to poster and publicity design as fashion magazines began to make increasing use of photography.

1898 to 1902, then moved to Paris. There she developed skills in Japanese lacquerwork, a technique used to decorate her 1920s' Art Deco-styled chaise longue (see left). Gray's production of geometric furniture in aluminium and glass, such as her 1927 table, earned her much respect for her contribution to the Modern movement. Between 1926 and 1929, she designed a house in France for the architect Jean Badovici (1893-1956).

GROPIUS, Walter

1883-1969 German

Ø p.13, 84

A leading figure in modern design, Gropius established the Bauhaus, the most influential design school this century. He assisted Peter Behrens (see p.255) from 1908 to 1910, became a member of the Deutsche Werkbund in 1910, and in 1911 was one of the first to adopt the International Style with his Fagus factory in Germany. Director of the Weimar schools of fine and applied arts, he combined them in 1919 to form the Bauhaus, an exponent of unified arts. When it relocated in 1925, Gropius designed the new building. Nazi criticism forced him to England in 1934, where he designed furniture for Isokon. In 1937, he emigrated to the US. He taught at Harvard and, in 1945, founded The Architects' Collaborative (TAC) in Cambridge, Massachusetts.

GRUAU, René

See panel left p.155, 227

GUGELOT, Hans

1920-65 **Dutch**

Ø p.61

An industrial designer and architect, Gugelot was a key figure in reviving the functionalist ideology of the Bauhaus after World War II. Educated in Switzerland, he moved to Germany in 1954, where he became a designer for Braun. His chief works include Braun's Phonosuper record player (1956). From 1955 to 1965, he was head of product design at the Hochschule für Gestaltung in Ulm.

GUILD, Lurelle Van Arsdale

1898-c.1986 American

Ø p.72

Although he began his career in theatrical design, Guild is best-remembered for his industrial products. Among the most important is the Electrolux vacuum cleaner (1937). He produced several products for the Chase Brass and Copper Co. (see above).

GUIMARD, Hector

1867-1942 **French**

Ø p.11, 33

A key proponent of Art Nouveau, Guimard studied at the Ecole des Beaux-Arts in Paris. Inspired by the style of the Belgian Victor Horta (1861-1947), he produced architecture, interior designs, and furniture. Many of the buildings featured cast iron. Florid, curvilinear forms found in his entrances for the Paris Métro system (1900) typify the style that is simply known as "Guimard".

H

HAFNER, Dorothy

1952 - American

Primarily a ceramicist, Hafner's work is characterized by a lively, graphic style and vibrant colours. These are shown in her Roundabout punchbowl and ladle (1986, see right). A number of her pieces have been produced by Rosenthal Studio Line.

HALD, Edvard

1883-1980 Swedish

Hald's association with the

famous Swedish glassworks

Ø p.50

Orrefors began in 1917, and continued for the rest of his life, including time spent as its managing director. At the 1925 Paris Expo, Hald won a grand prize for his work. Embracing the features of Swedish Modern design, his engraved wares, some of it coloured, reveal a controlled. traditional influence. He also worked as a designer for the porcelain factories Rörstand (1917–24)

HAMNETT, Katharine

1948 - British

and Karlskrona

(1917-33).

A fashion designer whose collections take inspiration from utilitarian workwear, Hamnett founded her own company in 1979 after freelancing for various foreign firms. She is renowned for bringing political and ecological issues to the forefront of fashion. HEIBERG, Jean 1884—1976 Norwegian

Pp.126
Heiberg's training was as a painter, first in Munich, and then under Matisse, whose

influence is clearly visible in his paintings.

He was commissioned by the Swedish company L.M. Ericsson to produce a telephone design. It was instigated in 1931 and remained internationally the most common design until the 1950s.

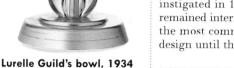

.....

HANDLER, Laura

1947− American **p.53**

Active as an industrial designer in Italy, as well as her native America, Handler produced designs for Sottsass Associati, and other Milanbased manufacturers. She designed an award-winning Cat's Eye candleholder (1991).

HAUSTEIN, Paul

1880-1944 **German**

Ø p.52

Active predominantly as an enamaller, Haustein also worked as a ceramicist, metalworker, graphic and furniture designer. He was a co-founder of the Darmstadt artists' colony in Germany in 1903. From 1905 until his death, he taught metalwork at the School of Applied Art in Stuttgart as well as producing silver- and metalware for various manufacturers.

HENNINGSEN, Poul

1895-1967 **Danish**

Ø p.54

Henningsen's PH ceiling and table lamp range, designed for Louis Poulsen in 1924, is his most celebrated work although he had won many prizes for earlier lighting designs. He initially trained as an architect, and later supported Modernism while employed as editor of the magazine Kritisk Revy (1926–28). His architectural works include houses, restaurants, and theatres.

HILTON, Matthew

1957 - British

Ø p.53

Best-known for his 1987
Antelope and Flipper side tables with animal legs, Hilton also designed high-tech products for the London design group CAPA. He established his own studio in 1984.

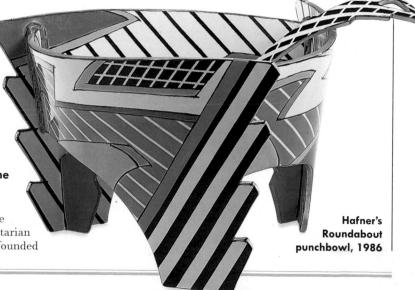

HOFFMANN, Josef Franz Maria

1870-1956 Czech/Austrian **p.**13, 32, 50, 92 Trained as an architect, Josef Hoffmann worked with Otto Wagner (1841–1918) between 1896 and 1899. He helped to found the Vienna Secession in 1897. Inspired by the work of Charles Rennie Mackintosh (see p.266) and C.R. Ashbee (see p.254), Hoffmann, Koloman Moser (see p.268), and Fritz Wärndorfer set up the Wiener Werkstätte in 1903 (see p.12). His architectural achievements include the Purkersdorf Sanatorium (1904) and the Palais Stoclet in Brussels (1905-11), on which he collaborated with Gustav Klimt (see p.265).

Brass box by Josef Hoffmann, 1915

HÖGLUND, Erik

1932- Swedish ₽ p.53, 88

Glassware designer Höglund was employed at Boda from 1953 to 1973. His designs include anthropomorphic candleholders and vases, bowls engraved with primitive figurative drawings, and handblown vessels with irregular bubbles (see right). Höglund's approach was unique in that it challenged the fashion for more formal glassware.

HOHLWEIN, Ludwig

1874-1949 German

@ p.225

Hohlwein studied architecture in Munich before abandoning this discipline to become a poster artist. In his early work, including a series of posters for the sports tailor Hermann Scherrer, he established a characteristic style that varied little over the next 40 years. Hohlwein created more than 3,000 posters during a career that spanned two world wars.

HULANICKI, Barbara

1936 - Polish/British Of Polish descent, Hulanicki moved to Britain in the 1940s. After studying at Brighton Art College, she worked briefly as a fashion illustrator. In 1963, she started a mail order fashion business aimed at teenagers. Encouraged by the response to these designs, she opened a boutique called Biba, which marketed a look that typified the 1960s. In 1969, Biba took over an Art Deco building on Kensington High Street, London. It is for this chic store, with its all-black interior, that Hulanicki is best-remembered.

> IE, Kho Liang 1927-75 Dutch

Ø p.109 Architect and designer Kho Liang Ie trained at the Rietveld Academy of Arts, the Netherlands. Later, he produced furniture designs for the Dutch company, Artifort.

His commissions have included the interior of the Schipol Airport, Amsterdam, and two rooms for the London home of Sir Robert and Lady Sainsbury.

INDIANA, Robert

1927 - American Ø p.25, 157

Artist and designer Robert Clarke renamed himself after his home state. His most famous work, shown in his first one-man show in New York (1962), is based on the word LOVE. The words HUG, ERR, and EAT have also inspired works.

IOSA GHINI, Massimo

1959 - Italian

A designer of graphics and objects, Iosa Ghini has produced furniture designs for companies such as Moroso (see right) and Memphis. Since 1985, he has acted as a consultant to RAI, the Italian broadcasting service and in 1988 designed the Bolidio discotheque in New York.

ISSIGONIS, Alec

1906-88 British

Ø p.185

Born in Turkey, Issigonis emigrated to Britain in 1922. After training as a engineer in London, he worked as a draughtsman at Rootes Motors in Coventry. In 1936, he joined Morris Motors, Oxford, for which he designed the Morris Minor (1948) and the celebrated Morris Mini (1959). The Mini, with its tiny wheels, transversely placed engine, and front-wheel drive, was a radical departure from conventional car design.

JACKSON, Dakota

1949 - American

Ø p.39

In the early-1970s, Jackson was commissioned by Yoko Ono to design some furniture for John Lennon. Since then, he has manufactured his own furniture, including the 'vik-ter range (1991).

JACOBSEN, Arne

1902-71 Danish Ø p.21, 36, 91

Born in Copenhagen, Jacobsen trained as an architect before opening his own practice in 1930. Influenced by the work of Gunnar Asplund (see p.254), Le Corbusier (see p.266), and Mies van der Rohe (see p.267), he was an early exponent of the modern style in Denmark. He worked as an architect and product designer, creating furniture for Fritz Hansen and tableware for Stelton (see right), among others. He earned wide acclaim for the SAS Hotel, Copenhagen (1956-60).

Decanter by Erik Höglund, 1950s

JEANNERET, Pierre

1896-1967 Swiss

Ø p.34, 40

Pierre Jeanneret, cousin of Le Corbusier (see p.266) moved to Paris in 1920. Together they designed various villas in the Parisian suburbs, before teaming up with Charlotte Perriand (see p.269) to create the company's iconic tubularsteel-framed furniture. Jeanneret produced some designs independently, such as the Scissor Chair (c.1947) for Knoll. After World War II, he collaborated on projects with Jean Prouvé (see p.270), as well as continuing his association with Le Corbusier.

JENSEN, Arthur Georg

1866-1935 Danish

Sofas from the New-tone range for Moroso by Massimo Iosa Ghini, 1989

Ø p.74, 156

Early in the century, Georg Jensen established the famous silver company that bears his name. Together with Johan Rohde (1856–1935), he designed a large proportion of the company's output, including jewellery, candlesticks, tea and coffee sets, cutlery, and

other luxury items. By 1924, Jensen had outlets in Berlin, Paris, London, and New York. When he retired in 1926, his family took over the firm.

JENSEN, Jakob

1926 - **Danish**

Ø p.61

Jensen graduated from and went on to beome chief designer for the Copenhagen School of Arts, Crafts, and Design, working under Sigvard Bernadotte from 1952 to 1959. In 1961, he set up a design consultancy; by the late-1960s, his clients included Bang & Olufsen, for which he designed the sleek Beogram 4000 (1972).

JOHNSTON, Edward

1872-1944 British

Ø p.208

A calligrapher and professor, Johnston is best-known for his typeface design for London Underground (1915). The sans serif alphabet served as a model for Gill Sans, the face created by his former pupil Eric Gill in 1928 (see p.262). Johnston also published classic calligraphy books, including Writing & Illuminating & Lettering (1906).

JONES, Terry

1945 - British

Jones worked on the *Good* Housekeeping magazine, before becoming art director of the British Vogue. His Not Another Punk Book, produced in 1977, represented a turning point in his career. In this title, he first employed instant design, using collage, photocopied distortions, and typewriter print to convey a sense of energy. In 1980, he launched i-D magazine, where he developed this approach. He has also worked in video production and as a consultant to Fiorucci.

Ferdinand Porsche's Stuttgart

1930s. He was responsible for

the styling of the original

Volkswagen Beetle (1939) and

the series of Porsche cars that

commenced with the Type

office (see p.270) in the

K

KÅGE, Algot Wilhelm

1889–1960 Swedish Trained as a painter, Kåge joined the Swedish Ceramic Company in Gustavsberg in 1917. There, he introduced a range of heat-resistant and stackable dinner sets, such as Pyro and Praktika (1930s); as well as more elegant and decorative pieces in the 1940s.

KAMALI, Norma

1945 - American

Inspired by London designers like Barbara Hulanicki (see p.264), Kamali opened a shop selling imported European fashions in 1967, quickly introducing her own line. In 1978, she established OMO (On My Own), the showcase for her innovative garments.

Arne Jacobsen's Cylinder line ice bucket for Stelton, 1967

She popularized the use of sweatshirting and Lycra for everyday wear.

KAN, Shui-Kay

1949 - British

Born in Hong Kong, Shui-Kay Kan studied and still works in Britain. In the mid-1970s, he established SKK Lighting. He is interested in new lighting techniques and has produced low-voltage and motorized systems. His 1988 Motorized Robotic Light was installed in the London Design Museum.

KAUFFER, Edward McKnight

see panel right p.225

KAWAKUBO, Rei

1942 - Japanese

Ø p.144

Having studied literature at Keio University, Tokyo, Rei Kawakubo joined the textile company Asahi Kasei. She founded Comme des Garçons in 1969. Her unconventional clothing, including wrapped, loosely structured garments, is based on Japanese workwear and ceremonial dress.

KENZO (Kenzo Takada)

1939 - Japanese

Ø p.145

Kenzo was one of the first male students to be admitted to the leading Tokyo fashion school, where he was awarded a prestigious prize in 1960. In 1965, he moved to Paris, designing for various fashion houses before establishing his own shop, Jungle Jap, in 1970. Kenzo draws inspiration from Japanese and ethnic costume, adapting the bright colours and dramatic shapes to suit Western tastes. By 1985, his international reputation was well established with shops in London, New York, and Milan.

KIESLER, Frederick

c.1890—1965 Austrian
An architect, sculptor and designer of furniture, stage sets, and interiors, Kiesler is best-known for his biomorphic designs, including Two-Part Nesting Tables (1935—38). In 1923, he joined the De Stijl group and, in the same year, developed the blueprints for his influential Endless House, which was never built. Kiesler moved to the US in 1926, where he continued to work on a variety of projects.

KING, Jessie Marion

1875-1949 **Scottish**

Ø p.222

King is known primarily for her book illustrations. Her name, together with that of Mackintosh (see p.266), is linked with the Glasgow School. From 1905, she designed silverware for Liberty, and fabrics and wallpaper for other clients. Inspired by Léon Bakst's drawings for the Ballets Russes, she integrated bright hues into her pastel palette.

KAUFFER, Edward McKnight 1890-1954

American/British

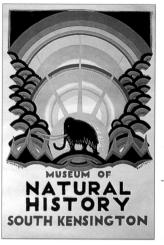

Museum poster, 1922

Edward Kauffer adopted the name McKnight in honour of the professor who sponsored his visit to Paris in 1913. In 1914, he moved to the UK, gaining his first commission as a poster designer from London Underground in 1915. His prolific output for clients including Shell and London Transport was greatly influenced by major artistic movements, such as Cubism, Art Deco. Vorticism, and Surrealism.

356 (1949) and ended with the Type 911 (1963).

KOPPEL, Henning

1918-81 **Danish**

Koppel trained as a sculptor in Denmark before World War I, but during the Occupation he worked in Stockholm for the Orrefors glassworks. On his return to Denmark in 1945, he began his long association with Georg Jensen (see p.264). For Jensen he produced some of his finest designs — clcgant, sculptural jewellery, flatware, and holloware. He produced ceramics for Bing Grøndahl from 1961 and glassware for Orrefors from 1971.

KURAMATA, Shiro

1934-91 **Japanese**

Ø p.24, 39

Kuramata worked for the Teikokukızai furniture factory and the interior design departments of several major Tokyo stores before setting up on his own in 1965. His unconventional approach to furniture design won him acclaim in the 1970s. His minimalist designs, executed in industrial materials, such as

KING, Perry A.

1938 - British

Ø p.199

An industrial designer, King undertook various projects for Olivetti and Praxis in Milan before teaming up with Ettore Sottsass (see p.273) in 1965. He worked with Sottsass on the design of the Valentine portable typewriter (1969). In collaboration with Spaniard Santiago Miranda (1947–), he designed typefaces for Olivetti. In 1975, King-Miranda became a formal partnership, concentrating on furniture, lighting, and graphic design.

KJAERHOLM, Poul

1929-80 **Danish**

Although he is known for his designs for mass-produced furniture, Kjaerholm trained in the traditional craft of cabinet-making. A proponent of the late International Style, he employed chromium and tubular steel in his furniture designs, which were made by Ejvind Kold Christensen and Hellerup, among others.

KLEIN, Calvin

1942- American

Inspired by Yves Saint Laurent (see p.272), Klein set up in business in 1968, specializing in classic designs in natural fabrics. His name is associated with jeans, which throughout the 1970s were sought after by the label-conscious. Klein is also known for his perfume, furs, shoes, and underwear.

decorative backdrops inspired by Art Nouveau.

KNOLL, Florence Schust

Painter and designer Klimt

of Arts and Crafts, and was

one of the founders of the

combined the stylized shapes

of Symbolism with rich.

Vienna Secession. He

studied at the Vienna School

1917- American

KLIMT, Gustav

Ø p.13

1862-1918 Austrian

Ø p.124

A furniture designer, Knoll was greatly influenced by the Saarinens (see p.271). In 1943, she joined Hans Knoll (1914-55) in his furniture business, where she headed an interior design service for Knoll customers. With her financial backing, they formed Knoll Associates (now Knoll International) in 1946. The firm manufactured many furniture classics, including designs by Bertoia (see p.255), Saarinen,

KOMENDA, Erwin

1904-66 **German**

Ø p.182, 187

An automobile engineer, Komenda was a designer for Daimler-Benz before joining

as well as Florence Knoll.

How High The Moon by Shiro Kuramata, 1986–87

metal-mesh (see above), steel cables, and plexiglass, combine Japanese severity with the softer elements of Western design. Important works in the field of interior design include a series of boutiques

include a series of boutiques for fashion designer Issey Miyake (see p.267) and the Seibu store, Tokyo (1987).

LAGERFELD, Karl

1938 - German

A fashion designer best-known for his flamboyant evening-wear and fur coats, Lagerfeld has been predominantly active in Paris. At the age of 14, he began working for the couturier Balmain, and later for Patou. In 1983, he became head of Chanel's ready-to-wear, and since 1984 has also worked under his own name.

LALIQUE, René

1860−1945 French p.11, 104

An important designer known for his figurative jewellery, in unusual combinations of base metals, stones, and enamel, and later for his glassware. He established Cristal Lalique in 1909, from where he produced vases (see below), bowls, perfume bottles, lighting, and other decorative glass designs produced by moulding methods. He was particularly prolific in producing glass, often for architecture, between the wars.

LAND, Edwin

1909 - American

₱ p.165

Physicist and businessman Edwin Land was educated at Harvard University. He is merited with the invention of the Polaroid-Land instant print-processing camera in 1947, and the Polaroid-Land SX70 in 1972, an instant colour-processing camera.

LAUREN, Ralph

1939 - American

Ø p.105

Born Ralph Lipschitz, Lauren had no formal training, but has become one of the most successful fashion designers in the US. Combining American prairie style with English tailoring, he creates a relaxed but elegant finish. His first menswear was for his company Polo in 1968. It has since expanded into womenswear.

LE CORBUSIER

1887-1965 **Swiss**

Ø p.34, 40

An instrumental figure in 20th-century architecture and design, Charles-Edouard

him early respect. His streamline for the Pennsylvania Railroad C Greyhound bus helped transform transport. In the 1960s, he designated the pseudonym Le Corbusier in the 1920s. His first major

piece was the Schwob house in Switzerland (1916). It indicated the purist, austere direction of Modernism, setting the style for his future works. In 1922, he

set up an architectural office with his cousin Pierre Jeanneret (see p.264). His book, Vers Une Architecture (1925), provided some of the fundamental theories of Modernism, which were embodied in his Villa Savoye (1929-31) in France. Mainly concerned with urban design, he also produced furniture, and is particularly known for his range of Confort armchairs and sofas during the late-1920s.

LENICA, Jan

1928 - Polish

Ø p.228

A graphic designer, Lenica studied architecture in Warsaw. In the 1950s and '60s, he designed posters and experimented with film animation. While his earlier works are in keeping with the Polish school of design, his later works, such as the film Adam 2 (1969), reveal a psychedelic influence.

LOEWY, Raymond 1893-1986 French/American

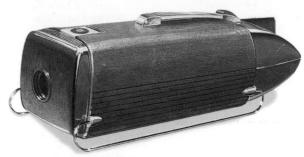

Electrolux cylinder vacuum cleaner, 1939

Loewy is often heralded as the originator of the industrial design profession in the US. He studied engineering in Paris, then emigrated to New York, where he flourished as a designer. His redesign of the 1929 Duplicator 66 for Gestetner, establishment of Raymond Loewy Associates in the same year, and design of the 1934 Coldspot Super Six fridge for Sears Roebuck earned him early respect. His streamlined 1937 S1 locomotive for the Pennsylvania Railroad Company and the US Greyhound bus helped transform the image of American transport. In the 1960s, he designed for NASA.

LISSITZKY, Lazar Markovich

1890—1941 Russian

Ø p.224

An innovative typographer, architect, and designer, architect, and designer, El Lissitzky followed Constructivist ideology. He was a key figure in adapting these theories to graphic design and internationalizing them through his teaching and travelling. He taught at VHkUTEMAS (see p.15). In 1925, he produced *The Isms of Art 1914–24*, in collaboration with German artist Hans Arp (1887–1966).

LLOYD, Marshall B.

1858—1927 American

Ø p.34

Lloyd patented a twisted craft paper fibre strengthened with wire that imitated the appearance of wicker. Put into production by the furniture company Lloyd Loom, this method of creating inexpensive furniture became extremely popular during the 1920s and '30s.

LOEWY, Raymond

See panel above p.68, 81, 121, 131, 164, 202

LOMAZZI

See de Pas, d'Urbino, Lomazzi

LYSELL, Ralf

1907 - Swedish

Ø p.127

Lysell was the industrial designer who worked with Hugo Blomberg (see p.256) on the development of the Ericofon telephone (1940s).

MACKINTOSH,

MACKINTOSH, Charles Rennie

1868-1928 Scottish

₽ p.32, 80, 93, 108, 192 Mackintosh was a leading protagonist of Art Nouveau architecture in Britain. His work is unique in its combination of geometric Celtic design and Japanese decoration. Born and educated in Glasgow, it was there that he executed one of his most definitive works, the Glasgow School of Art (1898-1909). In his early years, he often worked with his wife Margaret Macdonald (1865-1933), Frances Macdonald (1874-1921), and Herbert MacNair (1868-1953) as members of the Glasgow Four. In 1900, Mackintosh exhibited at the eighth Secession exhibition in Vienna. His architectural works were all in Britain.

MAGISTRETTI, Vico

1920 - Italian

Ø p.55

An architect and designer, Magistretti benefited from Italy's postwar reconstruction,

Magnussen's Thermos, 1977

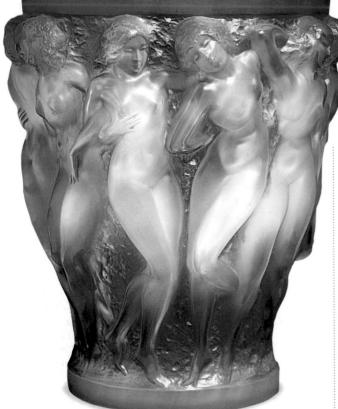

Lalique's Bacchantes Vase, c.1932

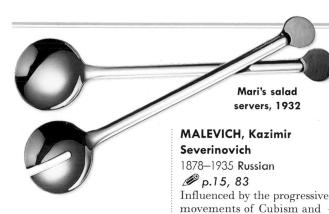

opening a studio in the 1950s. He developed the Selene chair for Artemide in the 1960s from ABS plastic, providing a new look for Italian plastic goods. His range of Sinbad chairs and sofas for Cassina (1981) emphasize the importance of structure.

MAGNUSSEN, Erik

1940 - Danish

Magnussen studied ceramics before establishing his own workshop, producing lighting, kitchenwares, and furniture. His range of containers for Stelton (1977, see left) were designed to be entirely functional. From 1978, he was employed at the Georg Jensen Sølvsmedie.

MAINBOCHER

1891-1976 American

Ø p.143

Born Main Rousseau Bocher, Mainbocher embarked on his career as a fashion designer in Paris, illustrating for Harper's Bazaar (1922). He founded his own couture house in 1930, designing classic, understated clothing, and was the first to create boned, strapless evening dresses in 1934. He retained his exclusive image by refusing the mass production of any of his designs.

MAJORELLE, Louis

1859-1926 French

Ø p.108

A leading exponent of Art Nouveau, Majorelle has become synonomous with the School of Nancy. He inherited his father's furniture business in 1879, updating the traditional styling of its products, and finishing them with naturalistic marquetries. Mass produced at low cost, these designs were affordable to many. After his factory was destroyed by fire in 1916, Majorelle's success dwindled.

modestly simple but elegant designs for everyday use. He won an award in 1957 from the Design Council for his celebrated Pride cutlery.

Mari's salad

servers, 1932

Constructivism, Malevich was

primarily an abstract artist.

by strong colours against a

white backgound, a style he

described as Suprematism. In

1920, he founded the Unovis

group, of which El Lissitzky

(see p.266) was also a member.

Later, he diverted to product

design, as well as architecture.

importance of communication

through design. A prevailing

interest in children's games

began with a wooden puzzle

1957. He continued to work

with Danese, experimenting

producing kitchen products

(see above). He also created

he created for Danese in

with ABS plastics and

the 1972 Sof Sof chair.

MARI, Enzo

1932 - Italy

Mari promoted the

@ p.197

His work is characterized

MENDINI, Alessandro

1931 - Italian

₽ p.38, 42, 125

After studying architecture in Milan, Mendini worked for Marcello Nizzoli (see p.268). He expounded radical design as editor of Casabella, an Italian magazine (1970-76). He has produced furniture for the design group Alchimia, shown at the Milan Furniture Fair (1981), and silverware for Alessi.

MIES VAN DER ROHE, Ludwig

1886-1969 German

Ø p.34

Mies van der Rohe was trained by his father as a stonemason, and from 1908 to 1911 he was apprenticed to Peter Behrens (see p.255). Many of his early architectural concepts featured steel and glass, but were only realized in the form of the International Style after he moved to the

US in 1938. In the 1930s, his tubular-steel

MIRANDA, Santiago

See Perry King

MIYAKE, Issey

1935 - Japanese

Ø p.145

Educated in graphic design in Tokyo, and fashion in Paris, Miyake founded couture house Issey Miyake International Inc. in 1971. He was among the first to exploit Eastern costume in the West, uniting natural fibres with traditional Japanese lines. He disregarded transient fashions in favour of durable designs (see below).

MOHOLY-NAGY, László

1895-1946 **Hungarian** Forced to abandon his law studies by World War I. Moholy-Nagy began painting on recovering from a war injury. He moved to Berlin in 1920, pursuing an interest in photography and the effects of light. After Walter Gropius (see p.263) saw his work exhibited, he invited him to teach at the Bauhaus. Active as a stage and exhibition designer from 1928 to 1933, he created the sets for the Kroll Opera in Berlin. He emigrated to the US in 1937, setting up a school in Chicago based on Bauhaus ideologies.

MOLLINO, Carlo

1905 - 73 Italy

Ø p.45,

Mollino's Varesio chair, c.1945

MORISON, Stanley

1889-1967 British

Ø p.210

The typographer and type historian Stanley Morison did not have any formal training in design. He acted as typographical advisor to the British Monotype Corporation from 1922 to 1967, during which time he directed the design of types Baskerville (1923), Gill Sans (1928), and Walbaum (1933), later using some of these more radical designs while working for the publisher Victor Gollancz as a book jacket designer. In 1922, he set up the typographic magazine The Fleuron, and from 1929 to 1959, acted as typographic advisor to The Times newspaper, creating its new face, Times New Roman in 1931-32.

MORRISON, Jasper

1959 - British

Ø p.39

Educated at the Royal College of Art from 1982 to 1985, Morrison is a London-based designer of individual, offbeat items of furniture and accessories. He co-founded NATO (Narrative Architecture Today), creating designs for Vitra and Aram Designs, among others. His works have been featured internationally in exhibitions, including the 1987 exhibition in Tokyo.

Ø p.122 Inspired by the patterns of wood engravings, Marx became a prolific fabric and wallpapers designer. She is

best-remembered for her upholstery design of London Underground seating (1930s), and was awarded Royal Designer for Industry in 1944. She also created wartime Utility furniture (1944-47) and book jackets for the British publisher Penguin (1950s).

MELLOR, David

1930 - British

p.80

Leading British kitchenware designer Mellor studied in Sheffield, where he founded a workshop in 1954. He is widely respected for his

92, 109 Mollino graduated in 1931 from his architectural studies in Issey Miyake Turin proceeding to design ensemble, the Turin riding school, 1994-95 Ippica, in 1937. His preference for organic furniture forms (see above), was sold epitomized by his internationally Arabesque table (1947), through the reflect the influence of German maker Spanish architect Antonio Thonet-Mundus. Gaudí (1852-1926). In the His Barcelona 1980s, a revival of interest chair (1929) is in 1950s' style resulted in one of his bestthe reproduction of many known works. of Mollino's designs.

MOSER, Koloman

1868-1918 Austrian Along with Gustav Klimt (see p.265), Josef Hoffmann (see p.264), Josef Maria Olbrich (see p.269), and others, Moser founded the Vienna Secession in 1897. Trained as a graphic artist and painter, he was involved in the launch of the group's journal Ver Sacrum in 1898. In the same year, he designed the stained glass and interior decoration for the Secession gallery, where the members work was exhibited several times a year. Moser executed furniture, ceramic, silver, and graphic designs for the Secession, as well as pieces for the Wiener Werkstätte, a commercial venture that he set up with Hoffmann in 1903. a student. The Djinn range (see below), which he created for Airborne in 1965, was used by Stanley Kubrick in the film 2001: A Space Odyssey. Mourgue has also worked on various domestic projects, including a mobile studio (1970), as well as acting as a consultant to Renault and Air France.

MUCHA, Alphonse

1860-1939 Czech

Ø p.222

Mucha began as a stage set designer in Vienna, moving to Munich in 1885 and Paris in 1887. Settling in Paris, he designed stamps and posters throughout the early-1890s, winning acclaim for a life-size poster of Sarah Bernhardt in

1932- German

Industrial designer Müller is best-known for the kitchen appliances (see right) and electric shavers that he created for Braun between 1955 and 1960. In 1960, he set up a design studio in Eschborn, Germany, specializing in appliances and graphics.

MÜLLER-BROCKMANN, Josef

1914 - Swiss

After studying and training in Zurich, Müller-Brockmann set up his own studio in 1936, concentrating on exhibition design, posters, and corporate graphics. A key figure in the promotion of Swiss International Style, he was a co-founder of the journal Neue Grafik (1958), which championed this approach. During the 1950s, he received international recognition for

a series of concert posters for the Zurich Tonhalle, and also created powerful public health and safety posters using photomontage.

From 1966, he worked with Paul Rand (see p.271) as

a consultant for IBM.

1907 - Italian The early work of artist and designer Munari, from

the 1920s and '30s, showed a strong Futurist influence. After World War II, he began designing products and toys. In 1957, he designed the Cube ashtray, the first of many products for Danese. He is a prolific writer, and has taught at both Harvard University and Milan Polytechnic.

1907-86 **American**

Ø p.41, 129

Architecture graduate Nelson

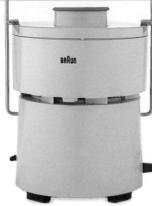

Müller's Multipress MP50 juicer for Braun, 1957

he was able to promote the Modernist architecture and design that he had witnessed in Europe. His Storagewall of 1945, shown in Life magazine, led to a long association with Herman Miller, for which he executed many furniture designs, including the 1961 Action Office. Though a productive designer, Nelson was perhaps most influential in his writing and teaching.

NIELSEN, Harald

1892-1977 Danish

Ø p.88

Nielsen joined Georg Jensen's Sølvsmedie as an apprentice in 1909, where he produced the Pyramid flatware service, one of the company's bestselling designs. When Georg Jensen died in 1935, Nielsen became artistic director, a position that he retained for almost 30 years. His jewellery and tableware designs are characterized by smooth, unadorned forms inspired by the Bauhaus.

NIZZOLI, Marcello

1887-1969 Italian

Ø p.199, 205

Nizzoli began as a painter, later turning to poster, exhibition, and textile design. During the 1920s and '30s, he collaborated with architects Giuseppe Terragni (1904-43) and Edoardo Persico (1900-36) on various exhibition and interior projects. In 1938, he was hired as a consultant by Olivetti, where he became the company's most influential product designer. His bestknown works include the

Lettera 22 portable typewriter (1950) and the Divisumma 24 adding machine (1956), both for Olivetti.

NOGUCHI, Isamu

1904-88 **American**

Ø p.17, 45

Born in Los Angeles, Noguchi trained as a cabinet-maker in Japan, returning to the US in 1918. During the 1920s and '30s, he worked as a sculptor, visiting Paris in 1927, where he studied under Constantine Brancusi (1876-1957). His first major product was the Radio Nurse of 1937 (see below), commissioned by Zenith. Throughout the 1940s and '50s, he developed a distinctive sculptural style, producing furniture designs for Herman Miller and Knoll, and lighting for Akari. His celebrated paper and bamboo lighting designs have been widely copied.

NOYES, Eliot Fette

see panel right

Ø p.199

NURMESNIEMI, Antti

1927 - Finnish

Ø p.72

After studying interior design in Helsinki, Nurmesniemi worked for architect Viljo Revell, where he designed the interiors of banks, restaurants, and hotels. On his return to Finland in 1956, he set up his own office. He has produced popular designs for furniture, household objects - including the Finel coffee pot (1957) and transport. A prestigious list of clients includes Artek, Merivaara, and Cassina.

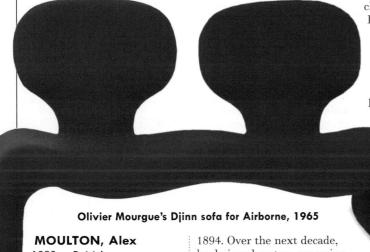

1920 - British Ø p.173, 185

An engineering graduate, during World War II Moulton worked as a researcher at the Bristol Aeroplane Company. Later, he joined his family's rubber-manufacturing firm, developing rubber suspension for cars. In collaboration with Alec Issigonis (see p.264), he designed the suspension for the Mini (1959). In the 1960s, Moulton developed an innovative range of bicycles.

MOURGUE, Olivier

1939 - French

Mourgue's colourful, gently curvaceous, biomorphic forms epitomize the design aesthetic of the 1960s. Trained in interior architecture and the decorative arts in Paris, he designed his first prototype chair for Airborne while still

he designed posters, magazine covers, packaging, textiles, and jewellery - all in a richly decorated Art Nouveau style. Returning to his homeland in 1922, he produced a series of 20 murals, Slav Epic, which depicted the history of Czechoslovakia.

MUIR, Jean

1933-1995 British Distinguished fashion designer Jean Muir served her apprenticeship at Liberty, London, before joining Jaeger in 1956. In 1962, she began to design under the Jane & Jane label, opening her own house in 1966. She is known for her classical, elegant, and superbly comfortable womenswear, made up in soft, flowing materials, such as silk jersey, crêpe, and suede. In 1983, she was awarded a CBE.

NELSON, George

won the Prix de Rome, which funded his visit to Europe in 1931. On his return to the US in 1933, he became an editor on Architectural Forum, where

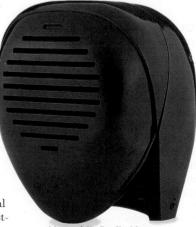

Noguchi's Radio Nurse

NOYES, Eliot Fette 1910-77 American

After studying architecture at Harvard, Noyes joined the Cambridge office of Walter Gropius (see p.262) and Marcel Breuer (see p.257). In 1940, he became a curator at the Museum of Modern Art, New York. After the war, he joined the design consultancy of Norman Bel Geddes (see p.255), starting his long association with IBM. In 1947, he set up on his own, retaining IBM as a client, and created the Model A typewriter, the first in a line of IBM products that established the company's corporate image. Another major client was Mobil, for which he designed the round petrol pump in 1964.

Mobil petrol pump, 1964

OLBRICH, Josef Maria

1867—1908 **Austrian**

Ø p.52

Having trained in architecture, Olbrich worked briefly for the Viennese architect Otto Wagner (1841 1918). He was a founding member of the Vienna Secession and, along with Gustav Klimt (see p.265), designed the Secession gallery. In 1899, he was invited by the Grand Duke of Hesse to join an artists' colony in Darmstadt, where he designed numerous exhibition halls and houses, as well as furniture, textiles, metal- and glassware.

OLINS, Wally

1930 - British

Ø p.215

Olins teamed up with graphic designer Michael Wolff (1933-) to form the Londonbased consultancy Wolff Olins in 1965. The company has created innovative corporate identity programmes that have radically transformed major companies. Important clients include ICI, Q8, P&O, and British Telecom. When Wolff left the company in 1983, Olins became chairman.

OLIVER, Vaughan

1957- British

Ø p.221

A typographer and graphic designer, Oliver is a prominent figure in record sleeve art. In 1981, along with photographer Nigel Grierson (1959 –), he formed a design studio called 23 Envelope, which was renamed v23 in 1988 when Oliver went freelance. He is best-known for his album sleeves for independent record label 4AD.

PANTON, Verner

1926- **Danish**

₱ p.22, 37, 123

After studying in Copenhagen, Panton worked briefly with Arne Jacobsen (see p.264) before establishing a studio in Switzerland in 1955. His work covers the design spectrum, including architecture, textiles, furniture, lighting (see right), and exhibitions. His most famous design, a cantilevered, plastic chair, produced by Herman Miller from 1967, was the first of its kind.

PAOLINI, Cesare see Gatti, Paolini, Teodoro

PAPANEK, Victor

1925 – Austrian/American Born in Vienna, Papanek emigrated to the US in 1939, where he studied architecture under Frank Lloyd Wright (see p.274). From 1964, he ran his own consultancy and lectured widely. Through his teaching and writing, most strongly in his book Design for the Real World (1971), he criticized design's slavery to commercialism and the futile waste of resources, winning favour with the emerging ecological movement.

PATOU, Jean

1880-1936 French

After a false start, caused by the outbreak of World War I, Patou opened his fashion house to immediate acclaim in 1919. Like his rival Chanel, Patou realized the marketing potential of simple clothing for the increasingly active woman. Among Patou's clientele were actress Mary Pickford and French tennis star Suzanne Lenglen.

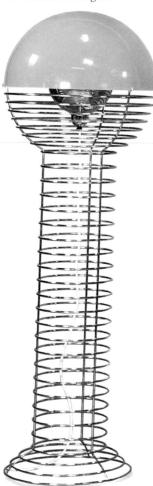

Panton's Wire Lamp, 1969

PECHE, Dagobert

1887-1923 Austrian

D.47

After studying architecture in Vienna, Pêche established himself as a freelance designer, creating wallpaper, textiles, and ceramics. In 1915, he joined the Wiener Werkstätte, developing an ornamental style quite distinct from the geometry of work by Hoffmann (see p.264) and Moser (see p.268). His designs for the Werkstätte include silver, textiles, furniture, ceramics, and glassware.

PERET (Pere Torrent)

1945 - Spanish

Ø p.231

Peret began as an illustrator and graphic designer in Barcelona, moving to Paris in 1970, where he worked in a freelance capacity for Citroën and Air France, among others. Returning to Barcelona in 1978, he created cultural posters for the city council and the regional government of Catalonia.

PERRIAND, Charlotte

1903 - French

Ø p.34, 40

A graduate in decorative arts, Perriand exhibited her metal furniture at the 1927 Salon d'Automne, where it attracted the attention of Le Corbusier (see p.266). It marked the beginning of their productive collaboration, together with Pierre Jeanneret (see p.264), which lasted ten years. Acting as an industrial design advisor in Japan (1940-42), she mounted two exhibitions on French design. On her return to France, she continued her association with Jeanneret, as well as independent work.

PESCE, Gaetano

1939 - Italian

p.38, 42, 248

Architect, designer, and artist Pesce is known for his radical approach to design. In the early-1960s, he worked on various experimental projects involving programmed and kinetic art. In 1968, he began to explore furniture design,

producing the Up series of chairs, manufactured by B&B Italia in 1969. He is known for his multidisciplinary approach - his Tramonto a New York, a sofa he designed for Italian furniture company Cassina, (1980) is a good example of this. Pesce has worked on projects in Brazil, Japan, Europe, and the US, as well as teaching extensively.

PETERS, Michael

1941- British

Design entrepreneur Peters combines quality design with business acumen. He established Michael Peters & Partners in 1970, handling packaging designs for clients such as Winsor & Newton Inks, and Seagram. He is now chairman of a new company called Michael Peters Ltd.

PETERSEN, Arne

1922 - Danish

Ø p.91

After serving as an apprentice in the gold and silver workshops of C.C. Herman, Copenhagen, Petersen joined Georg Jensen Sølvsmedie in 1948. From 1976, he worked in the holloware department.

PEZETTA, Roberto

1946 - **Italian**

D p.69

Pezetta worked for Zoppas and Nordica, before joining the domestic appliance company Zanussi in the mid-1970s. In 1984, he was made head of the industrial design section. His best-known design is the Wizard refrigerator (1987).

POIRET, Paul

1879-1944 French

Ø p.142

Influential fashion designer, Poiret pioneered the use of the brassière. In returning to the loose fit of the Empireline, he freed women from the discomfort of the corset. After training at the houses of Doucet and Worth, he opened his own salon in 1904, designing lines which clearly show the influence of oriental costume. In 1911, he was the first couturier to launch his own perfume, and expand into other areas. He greatly encouraged creativity and spontaneity in students, and in 1911 founded the Ecole Martine decorative arts school.

POLI, Flavio

1900 - Italian

Ø p.50

An award-winning glassware designer, Poli joined the glass manufacturer Seguso Vetri d'Arte in the 1930s, becoming its director in 1963. The thick materials and vibrant colours that characterize his work are evident in his bowls and vases (1960s), made by Danese.

PONTI, Giovanni

1891-1979 Italian

Ø p.98

Since the 1920s, Gio Ponti has contributed to the icons of Italian design. He studied architecture at Milan Polytechnic, and founded the magazine *Domus* in 1928, through which he promoted Modernism. He co-founded a studio in 1927, seeking to achieve compatibility between tradition and industrial production. The Pirelli Tower in Milan (1956) is considered to be his finest architectural work, while the Superleggera chair for Cassina (see left) has become ubiquitous seating for Italian cafés, compromising between convention and innovation.

PORSCHE, Ferdinand "Butzi"

1935- **German**

Ø p.55, 187

One of three designers in the Porsche family, the grandson of car designer Ferdinand Ferry Porsche (1875–1951), who founded Porsche in 1911, was nicknamed "Butzi". The 1963 Porsche 911 is his key car design. He established his own studio in 1972, and in the 1980s, created furniture and lighting, including a range in 1985 for the company Luci.

PRICE, Anthony

1945 – British

Ø p.221

Educated in fashion at the Royal College of Art, London, Price was a prolific designer of 1970s' fashions. He is often associated with Bryan Ferry and the Rolling Stones, for whom he designed costumes, sets, and record covers. Since 1979, he has worked under his own name, continuing contact with media and rock stars.

PROUVE, Jean

1901-1984 French

Metalwork designer Prouvé was the son of Victor Prouvé (1858-1943), a key figure of the Nancy School. He opened a workshop in 1923, designing furniture made of bent sheet steel, suitable for industrial production. He created metal furnishings for Le Corbusier's buildings (see p.266) in 1925, and in 1937, co-designed the Roland Garros flying club, acclaimed as the first truly industrialized building. In the 1950s, Prouvé explored the possibilities for massproduced, prefabricated housing, schools, and offices.

Mary Quant

PUCCI, Emilio

1914- Italian

A fashion designer who has concentrated on sportswear, Pucci opened Emilio, his own house, in 1950. He created boldly patterned, brightly coloured silk jersey dresses, as casualwear for women. His international status earned him the Neiman-Marcus Award in 1954.

PUIFORCAT, Jean

1897-1945 French

Ø p.82

Puiforcat apprenticed to his father as a silversmith, and studied at the Central School of Arts and Crafts in London. He founded a workshop in 1921, producing clean-lined, unadorned silverware with contrasting materials, such as semi-precious stones and rare wood. The forms of his later works are based on careful mathematical calculations.

Q

QUANT, Mary

1934 - British

Ø p.155

The name Mary Quant (see above) has become synonymous with London in the 1950s and '60s. She opened the boutique Bazaar in 1955, responding to the youthful optimism of the time with ready-towear fashions for teenagers. Quant helped popularize the mini-skirt in the 1960s, also introducing brightly coloured tights. Identified by her daisy motif, Quant's range has since expanded to include make-up and accessories.

QUISTGAARD, Jens

1919 - Danish

D p.91

Educated as a silversmith in an apprenticeship to Georg Jensen (see p.264), Quistgaard co-founded Dansk International Designs with Ted Nierenberg in 1954. That year, he was awarded the Lunning Prize for his enamelled cast-iron cooking pots, designed for the Danish manufacturer De Forenede Jerstøberier.

R

RABANNE, Paco

1934 – Spanish See panel below

RACE, Ernest

1913-64 British

Ø p.36

An architect and designer of international reputation, Race took his inspiration from 18th-century craftsmanship. He founded Race Furniture in 1946, setting a precedent for the linear look created with steel rods. This is apparent in his 1951 Antelope and Gazelle chairs, displayed at the 1951 Festival of Britaian. In the 1950s and '60s, he received various awards, including Royal Designer for Industry in England 1953, and several at the Milan Triennales.

RAMBOW, Gunter

1938 - **German**

Ø p.231

Rambow co-founded a graphic design group with Gerhard Lienemeyer (1938-) in 1960. This was renamed Rambow/Lienemeyer/van de Sand, when Michael van de Sand (1945-) became a partner. The surreal effects of photomontage are evident in their award-winning 1978 theatre poster for a production of Othello. The design group also created a corporate identity programme for the German publisher S. Fischer Verlag (1976-83).

RABANNE, Paco 1934 - Spanish

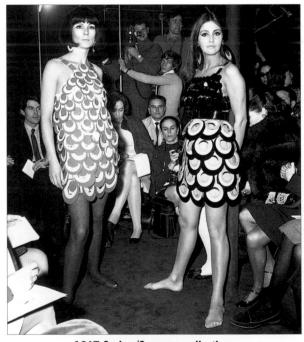

1967 Spring/Summer collection

This Spanish-born designer of avant-garde fashions was active in France. From 1960 to 1964, he designed fashion accessories for Balenciaga (see p.255), Givenchy (see p.262), and Dior (see p.259). In 1966, he launched a renowned range of body jewellery. The dresses shown above consist of plastic discs linked with metal chains.

RAMS, Dieter

1932 - German

Ø p.57, 61

An industrial designer and architect, Rams played a pivotal role as a designer for the German manufacturer of durables, Braun. He joined in 1955, and by 1988 was the company's director. Together, Rams and Hans Gugelot (see p.263) developed a functionalist style (see right) that set a criterion for other producers. Among his most celebrated works are his SK4 Record Player (1956), and his KM 321 Kitchen Machine (1957). During the 1950s, he contributed to new forms of lighting, which instigated a change in interior design.

RAMSHAW, Wendy

1939 - British

Following a training in illustration and fabric design, Ramshaw established herself as a jeweller. She gained recognition in the 1970s with her works in precious metals, and has since experimented with alternative materials, including paper and plastics.

RAND, Paul

1914 - American

Ø p.213

Influential graphic designer Paul Rand is acclaimed for his adaptation of Modernist design philosophies to suit graphic design. His corporate identity programme for IBM (1956) set a style for future trademarks, and his influence has also been marked in advertising and editorial design; from 1935 to 1941, he directed magazines Apparel Arts and Esquire. His text Thoughts on Design (1947), and Paul Rand: A Designer's Art (1985) are well respected among graphic designers.

REEVES, Ruth

1892-1966 American

Ø p.122

A painter and textile designer, Reeves studied under the artist Fernand Léger (1881–1955) in Paris. She is known for her printed fabrics and rugs, which show similarities to her Cubist paintings. From 1931, she worked as a consultant for W. and J. Sloane's furniture

A poster by Rambow, 1995

store in New York, which printed her famed Manhattan wallpaper (1931). Reeves was inspired by her extensive travels, including visits to Guatemala in 1934 and India in the 1950s.

REICH, Tibor

1916-1996 Hungarian

Ø p.123

This textile designer united his native background with his formal education to achieve a unique style. His woven fabrics are inspired by the coloured ribbons of peasant costume, while showing elements of Modernism. In the 1930s, he settled in England, producing woven materials in Stratford, and from the 1950s, also printed fabrics. His theory that "nature designs best" is visible in his 1957 Fotexur range of fabrics, rugs, and ceramics. In 1966, Reich created the upholstery for Concorde, the first supersonic plane.

RHODES, Zandra

1942 - British

Rhodes graduated in textiles from the Royal College of Art, London, in the 1960s. Active as a fashion designer, her work reveals the influence of Pop Art. Combining her own textiles and fashions, she creates individual, romantic clothing influenced by her travels, featuring shells, feathers, and zebra-motifs.

RIE, Lucie

1902 - Austrian

The ceramicist Lucie Rie was born Lucie Marie Gomperz. Rich in ornamentation, her works embody the antithesis of Modernism. She emigrated to London in 1938, where she established a pottery and button-making workshop. Her ceramics are recognizable by their cross-hatched sgraffito decoration, and subtly coloured glazes, or textured white-tin surface. Rie has won various awards, and shown her works at several exhibitions.

RIEMERSCHMID, Richard

1868-1957 German

Progressive designer and architect Riemerschmid was one of the first designers to adjust his works to industrial production. In 1887, he cofounded Munich's Verninigte Werkstätten für Kunst im Handwerk.

producing simple metalworks. He designed a variety of goods entirely suitable for machine manufacture. including his Maschinenmöbel (1905). Among his architectural work is Germany's first garden city at Hellerau (1907–13). From 1912 to 1924, he directed the

RIETVELD, Gerrit

Munich Kunstgewerbeschule.

1888-1964 Dutch

Ø p.33

Architect and designer Gerrit Rietveld is best-known for his association with the De Stijl movement. The linear aesthetic with which his work is synonomous is expressed in his Red-and-Blue chair (1917-18), the Schröder house in Holland (1924), and his low-cost Zig-Zag chair for Metz & Company department store (1934, see right). Although he favoured wood as a material, Rietveld also created some experimental tubular-steel furniture during the 1920s. In the 1950s and '60s, he was predominantly active as an architect and lecturer.

271

RODCHENKO, Aleksandr

1891-1956 Russian

A leading Constructivist who was active as a painter and designer, Rodchenko brought the aesthetics of the machine age to these fields. He collaborated with fellow Constructivists Kasimir Malevich (see p.267), and Vladimir Tatlin (1885–1953) from 1915 and, in 1921, co-founded the First Working Group of Constructivists. In the 1920s, he designed posters for the government, cinema, and journals *LEF* and *Novyi LEF*.

ROSSI, Aldo

1931 - Italian

Ø p.73, 87

A Post-modernist architect and designer, Rossi graduated from Milan Polytechnic in 1959. Formal and unornamented, his school library at Fagnano Olona in

Dieter Rams' fan heater for Braun, 1969

Italy (1972-76), typically draws inspiration from 18thcentury neo-classicism. Rossi's product designs for Alessi are commonly based on architecture, such as his 1979 tea and coffee service, which is a scaled-down version of his floating Teatro del Mondo in Venice (1979).

RUHLMANN, Jacques - Emile

1869-1933 French

Ø p.44, 82

Ruhlmann is known for his luxury Art Deco furniture and use of exotic materials. He first exhibited in 1913 at the Paris Salon d'Automne. and later played a significant role in the 1925 Paris Expo, designing the Hotel du Collectionneur, which has been hailed as a high-point in Art Deco design. His furniture for the Maharajah of Indore in the

1920s and '30s, and his 1930 Soleil bed of rosewood veneer are typical of his furniture.

RUSSELL, Gordon

1892-1980 British

A proponent of the craft ethic, Russell began his education by repairing antique furniture for his father's business. In 1929, he established Gordon Russell Ltd, working on designs of mass-produced radio cabinets for Murphy Ltd (1930s), and later a line of Utility furniture. In 1949. he became the director of the Council of Industrial Design.

SAARINEN, Eero

1910-61 Finnish/American

Ø p.35, 93

Saarinen's designs embrace a diverse selection of styles, from the organic to the strictly geometric. Educated in Paris and New York, he was active mainly in the US. In the early 1960s, he designed the Dulles Airport, Washington, and the TWA terminal at Kennedy Airport, New York. He is also renowned for his use of bent plywood and moulded plastics, the latter used for his Tulip chairs of 1956.

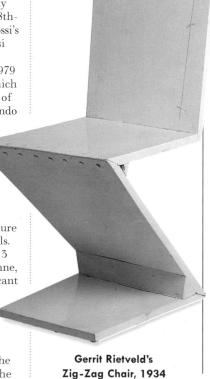

SABATTINI, Lino

1925- Italian

One of Italy's most inventive silversmiths, Sabattini is known for his fluid silverware. but he has also produced glass and ceramics. From 1956 to 1963, he was design director of French company Christofle, for whom he produced the Como tea service (1960). In 1964, he set up his own silver company in Italy.

SAINT LAURENT, Yves

1936 - French

Ø p.144

Algerian-born Saint Laurent won the International Wool Secretariat design contest in 1954 with a cocktail dress. The following year, he began work for Christian Dior (see p.259), and in 1957 he took over the great couture house on Dior's death. After fighting in the Algerian war, Saint Laurent opened his own

Sabattini's Estro silver

sauceboat, 1976

house in 1962. His early

collections were influenced

by the Left Bank and the

art world, most notably by

the work of Piet Mondrian

(1966). In 1966, he opened

the Rive Gauche boutiques

Saint Laurent has designed

film and theatre costumes as,

well as menswear, perfumes,

As head of the textile design

studio at the Swedish fabric

company Nordiska from 1937

to 1971, Sampe designed and

commissioned many printed

favoured an abstract geometric

style. In 1972, she set up her own studio specializing in

and woven textiles. She

fabrics and interiors.

(evidenced in the 1965

collection) and Pop Art

for ready-to-wear designs.

and household goods.

SAMPE, Astrid

1909 - Swedish

Ø p.123

1932 - German

@ p.55, 57, 127

After working in Germany as a designer for Mercedes-Benz, Sapper moved to Milan in 1957. There, he worked first for Gio Ponti (see p.270) and then the department store La Rinascente. Many of Sapper's most interesting designs have been created with Marco Zanuso (see p.275) with whom he began collaborating in 1960. Their work includes televisions and radios for Brionvega, and the Grillo telephone (1965). Among Sapper's other works are the Tizio lamp for Artemide (1972), kettles for Alessi, and car designs for Fiat. Since 1980, he has been a design consultant to IBM.

SARPANEVA, Timo

1926 - Finnish

A leading figure in modern

those for the Iittala factory.

Scandinavian design, Sarpaneva has produced textiles, graphics, ceramics, and metalware. However, he is best-known for his glass designs, particularly

1912-69 **Swedish**

Ø p.131

An industrial designer, Sason designed several cars for the Swedish company Saab (see above), including the Saab 92, 96, and 99. He also acted as consultant designer for Hasselblad and Electrolux.

SAVIGNAC, Raymond

1907- French

Ø p.196, 227

A former assistant to the great French poster designer A.M. Cassandre (see p. 258), Savignac produced theatrical set designs and costumes, as well as posters. He was adept at choosing a single, often humorous, image to convey the message of his posters.

SCHIAPARELLI, Elsa

1890 - 1973 Italian

₿ p.105, 143

Fashion designer Schiaparelli enjoyed phenomenal success in Paris during the 1930s.

A Sixten Sason car design for Saab, 1947

SHIRE, Peter

Ø p.27

1947 - American

One of the many designers

who produced pieces for the

Italian Memphis group, Shire

contributed brightly coloured

Bel Air armchair (1982), and

the Big Sur couch (1986). He

has also designed silverware

and glassware for other

Italian companies.

lamps, tables, a teapot, the

She started out by selling sweaters knitted by Armenian women. Later, she created interesting fabrics and garments, many decorated with Surrealist-inspired features. Schiaparelli's most famous innovation was "shocking pink", a far more vibrant colour than those used by other couturiers. In 1940, she moved to the US, and although she reopened in Paris in 1945, she did not

SCHRECKENGOST, Viktor

1906 - American

Ø p.17, 50

Schreckengost's ceramics were heavily influenced by Viennese pottery. In 1930, while working at the Cowan Pottery Studio, he created a set of punch bowls for Eleanor Roosevelt. The bright blue bowls, which combined words and contemporary images, were later produced commercially. After Cowan closed in 1931, Schreckengost worked for a variety of other ceramic and industrial companies.

SERRURIER-BOVY, Gustave

1858-1910 **Belgian**

After initially working as an architect, Serrurier-Bovy began making furniture influenced by the Arts and Crafts movement. His Silex range of inexpensive selfassembly furniture was introduced in 1902. It featured wooden bedroom

SINCLAIR, Clive

1940 - British

Sinclair worked as a technical journalist before setting up Sinclair Radionics in 1962. He developed miniaturized electronic goods, including the first pocket calculator (1972) and a miniature television (1977). In 1980, he launched the ZX80, the first of a series of home computers. His C5 electric car (1985) failed to sell.

ŠÍPEK, Bořek

1949 - Czech

Ø p.49, 81, 125

Originally from Prague, Šípek studied architecture in Hamburg, taught in Hanover and Essen, and now works in Amsterdam. The design of his Bambi chair (1983) is typical of his individual poetic approach to functional items. For Vitra, he created the Ota Otanek chair (1988), Wardrobe (1989-91), and a metal waste paper basket (1989). Other works include tableware, glassware, and accessories.

recapture her former glory.

Ø p.124, 128

furniture, tables, and chairs, along with metalwork vases and lights.

Ettore Sottsass's Casablanca sideboard for Memphis, 1981

SOGNOT, Louis

1892-1970 French

Ø p.108

An architect and furniture designer, Sognot often worked with Charlotte Alix (1897-) designing interiors and metal and glass furniture.

SOTTSASS, Ettore

1917 – Austrian/Italian **P** p.124, 192, 199 One of the best-known names in modern design, Sottsass began work as an architect, opening a design studio in Milan in 1947. In 1957, he became consultant designer to Olivetti for which he produced various pieces of office equipment and furniture. He exhibited work with Studio Alchimia in 1979, then set up Sottsass Associati in 1980. The following year,

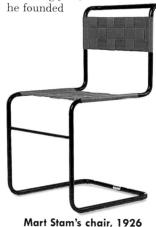

the Memphis group, which became a leader of the Postmodernist movement. His own designs for Memphis include sideboards (see left), seating, tables, and plates. He continues to design consumer products and exhibitions.

STAM, Mart

1899-1986 Dutch After studying drawing, Stam worked in architectural practices in the Netherlands, Germany, and Switzerland, and as a town planner in the Soviet Union. He is usually remembered as the designer of the first tubular-steel cantilevered chair (see above).

STARCK, Philippe

See panel above

₱ p.26, 99, 101, 179, 193

STARCK, Philippe 1949 - French

Celebrated as one of the most exciting designers of the late-20th century, Starck shot to fame when he refurbished President Mitterrand's private rooms in the Elysée Palace (1982). Other interior designs include the Café Costes in Paris and the Royalton hotel in New York (both 1984). Starck's architectural projects range from the Nani Nani office building in Tokyo (1990) and the Angle in Antwerp (1991) to La Rue Starck in Paris. He has designed many pieces of furniture, much of it made from pressed metal, as well as products as diverse as motorcycles, lighting, clocks, lemon squeezers, and toothbrushes.

Ashtray, 1988

STICKLEY, Gustav

Juicy Salif, c. 1990

1857-1942 American

Ø p.10

Stickley was the best-known American exponent of the Arts and Crafts movement. In 1901, he launched The Craftsman magazine to popularize the furniture made in his workshops using traditional construction methods. Stickley's company went bankrupt in 1915.

STÖLZL, Gunta

1897-1983 **German** Ø p.122

Prominent German textile designer Stölzl directed the weaving workshop at the Bauhaus, Dessau, from 1927 to 1931. In that year, she set up a textile studio in Zurich with two ex-colleagues from the Bauhaus.

STRAUB, Marianne

1909 - Swiss/British

Ø p.123

Straub played a leading role in revitalizing the Welsh textile industry in the 1930s. Then, whilst working for British firms Helios and Warner & Sons, she developed handwoven fabrics for mass production. Her famous Surrey textile was created for the 1951 Festival of Britain.

SUMMERS, Gerald

1899-1967 British

Ø p.35

In 1929, Summers set up a company called Makers of Simple Furniture for which he designed moulded plywood furniture similar to that of Alvar Aalto (see p.254). He is best-known for the lounge chair he created from one piece of plywood (1933-34).

TALLON, Roger

1929 - French

€ p.214

Industrial designer Tallon was one of France's first independent designers. His work includes furniture, lighting, and watches. Among his prestigious clients have been SNCF, General Motors, Daum, Lipp, and Erco.

TANAKA, Ikko

1930 - Japanese

Ø p.230

One of the foremost Japanese graphic and exhibition designers, Tanaka has produced some outstanding advertising, cultural, and environmental posters.

TEAGUE, Walter Dorwin

1883-1960 **American**

Ø p.89, 164

Along with Raymond Loewy (see p.266) and Norman Bel Geddes (see p.255), Teague was a pioneer professional industrial designer, and was one of the first to adopt streamlined styling. His many clients included Eastman Kodak, Corning Glass Works, Ford, Texaco, and Boeing. He designed pavilions for the 1939 New York World's Fair.

TEODORO, Franco

See Gatti, Paolini, Teodoro

THONET, Michael

1796-1871 Austrian

Ø p.32, 92

Thonet's influence extended long after his death through the designs of the furniture company he founded in 1853. Its bentwood chairs have become classics of 20thcentury design. In the 1920s, the company began producing tubular-steel furniture.

THUN, Matteo

1952 – Austrian/Italian

Ø p.81, 125

A partner in Sottsass Associati from 1980 to 1984, Thun was also a co-founder of Memphis. Although he has designed furniture, he is known for his ceramics and computer-aided manufacturing.

TIFFANY, Louis Comfort

1848-1933 American

Ø p.46

A well-known decorative artist of the early-20thcentury, Tiffany set up an interior decorating firm in 1879, the Tiffany Glass Company in 1885, and Tiffany Studios in 1890. He designed pottery, jewellery, metalwork, furniture, lamps, and windows. His Favrile glass (see below) was hugely successful worldwide.

TSHICHOLD, Jan

1902-74 German

Ø p.211

Typographer Tshichold was the principle champion of the New Typography movement during the 1920s and '30s. He later adopted a more classical style. He also designed books.

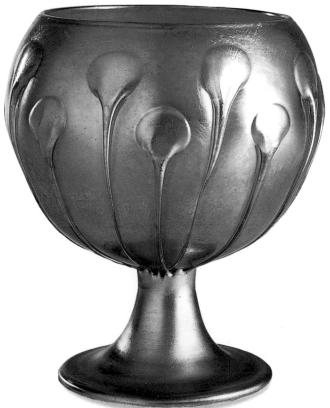

A Favrile glass goblet by Louis Comfort Tiffany, c.1900

TUSQUETS BLANCA, Oscar

1941 - Spanish

Ø p.85

Tusquets trained as a painter, architect, and designer in Barcelona. In 1965, along with fellow students Lluís Clotet (1941-), Pep Bonet (1941-), and Christian Cirici (1941-), he formed the radical design and architecture group, Studio PER. In 1972, in collaboration with Lluís Clotet, he produced the controversial Belvedere de Regàs, which is generally regarded as one of the first Post-modernist buildings. In 1973, Studio PER and other design offices formed B.d. Ediciones de Diseño to produce avant-garde designs. Tusquets created a tea and coffee set for Alessi in 1983.

UMEDA, Masanori

Umeda studied design in

Tokyo. He worked at Studio

Castiglioni, Milan, until 1969,

joining Olivetti as a design

consultant in 1970. His best-

known piece is the Tawaraya

boxing-ring bed, produced for

Memphis in 1981. Returning

to Tokyo in 1986, he founded

U-Meta Design, specializing

in abstract furniture, crockery,

and interior designs.

(Valentino Garavani)

Valentino studied fashion in

Milan and Paris, returning

to Rome in 1959, where he set

up his own fashion house. His

designs were in such demand

that in 1969, he opened a

VALENTINO,

1932- Italian

1941 - Japanese

followed in 1972 by a range of menswear. In the 1970s, he expanded his range to include accessories and perfume.

VENINI, Paolo

1895-1959 Italian

Ø p.48

Venetian law graduate Venini became a partner, together with Giacomo Cappellin (1887-1968), in a Murano glassmaking business in 1921. Initially concentrating on ornamental glass, they began to show more modern pieces at the Monza Biennale in 1923 and later at the Milan Triennale. Venini assumed sole ownership in 1925. He worked with designers such as Gio Ponti (see p.256) and Massimo Vignelli (see right).

Wagenfeld's Kubus modular storage set, 1938

WAGENFELD, Wilhelm

Entering the Weimar Bauhaus

in 1923, Wagenfeld studied

under László Moholy-Nagy

there, teaching in the metal

workshop until 1927, when

he went freelance. Concerned

with function, economy, and

purity, Wagenfeld designed

utilitarian ceramics, metal-

and glassware (see above) for

companies such as Rosenthal

and the Jenaer Glassworks.

(see p.267). He remained

1900-90 German

VIGELAND, Tone

1938 - Norwegian

1934- Italian

Husband and wife Massimo (1931–) and Lella Vignelli have introduced a European sophistication into American design through the graphics and products that they have produced since settling in the US in 1965. Working initially for Unimark International, in 1971 they founded Vignelli Associates. Massimo has been largely responsible for the graphic output, including Bloomingdale's corporate image and signage for the Washington subway system; whilst Lella has headed the furniture and product design branch (see left).

VIGNELLI, Massimo

1944 - French

p.81

Ø p.157

One of Norway's foremost jewellery designers, Vigeland set up her own studio in 1961. Her striking designs evoke her Scandinavian heritage.

VIGNELLI, Lella

Ø p.51

see Vignelli, Lella

VITRAC, Jean-Pierre

Vitrac set up in business in 1974, with offices in Milan, New York, and Tokyo. The company gained a reputation for exploring innovative design concepts, producing furniture, tableware, lighting, and sports equipment.

WARHOL, Andy

1928-87 American

P.220

Although famed for his role in Pop Art, Warhol also created advertisements for Vogue and Harpers Bazaar and record sleeves for Columbia Records. He was awarded the Annual Art Director's Club Medal in 1956 and '57 for his I. Miller shoe and hat advertisement. His paintings and films drew on themes from the commercial world.

WEBER, Kem

1889-1963 **German**

Ø p.128

In 1914, Karl Emanuel Martin (KEM) Weber went to assist on Germany's exhibit in the Panama-Pacific International Exposition in San Francisco. Trapped by the outbreak of war, he settled in the US. In 1927, he established himself as an industrial designer in Hollywood. Weber developed a distinctive style, openly embracing Modernism.

WEGNER, Hans

1914- Danish

Ø p.93

Trained first as a cabinetmaker and later as a furniture designer, Wegner worked in the office of Arne Jacobsen

Dinner service by Vignelli Associates, 1986

VENTURI, Robert 1925 - American

Ø p.85

In his 1966 book Complexity and Contradiction in Modern Architecture Venturi laid down the basic tenets of Postmodernism. Although bestknown for his architectural achievements, including the Sainsbury Wing extension for the National Gallery, London (1988), he has also designed a tea and coffee set for Alessi (1983) and furniture for Knoll (1984).

VERSACE, Gianni

1946- Italian

Versace learned his tailoring skills from his mother, who was a dressmaker. From 1972, he worked as a freelancer, producing a collection of women's ready-to-wear clothes under his own name in 1978. A menswear range followed in 1979. Versace is known for his original use of materials, particularly a soft metal fabric that he created for his 1983 collection.

WRIGHT, Frank Lloyd 1867-1949 American

Office for the owner of Kaufmann's department store, 1937

Primarily remembered as America's most creative architect, Wright was also an important design theorist. Working at the architectural office of Louis Sullivan (1856–1924), he was first exposed to the concept of Functionalism. His interest in Japanese architecture led to the development of his own style of work, which he called "organic architecture". This was characteristically low and simple and made use of natural materials. He designed 800 buildings, 380 of which were realized.

boutique for ready-to-wear women's clothing. This was

(see p.264) from 1940 to 1943, when he established his own studio. In 1940, he began his long and illustrious association with furniture maker Johannes Hansen, which produced his famous piece, The Chair, in 1949. Wegner's designs, mostly executed in natural materials, are characterized by their elegance and visual simplicity.

WEIL, Daniel

1953 - Argentinian Ø p.57

Born and trained as an architect in Buenos Aires, innovative industrial designer Weil went to London in 1978. He received recognition for a series of clocks, radios, and lights that he designed in 1981 as part of his degree show for the Royal College of Art, London. Together with Gerard Taylor, he has worked on various interior and product designs for Sottsass Associati, Knoll, and Alessi.

WEINGART, Wolfgang

1941- **German**

As a typography teacher at the Basle School of Arts and Crafts since 1968, Weingart has been instrumental in overturning the conventional Swiss graphics approach. He rejected strict adherence to the grid and introduced wide type spacing, step rules, and mixing of type weights. He is credited with bringing New Wave graphics to the US via his extensive teaching.

WEISS, Rheinhold

1934- **German**

Ø p.107 Weiss remained at the Hochschule für Gestaltung, Ulm, as associate director of the product design section, after studying there. The products that he created for Braun in the 1960s reflect both his training at Ulm and Braun's Functionalist aesthetic. In

1967, he moved to Chicago,

setting up a studio in 1970.

WESTWOOD, Vivienne

1941 - British

Ø p.145

Generally recognized as the most influential and original British fashion designer of

the 1970s and '80s, Westwood has played an important role in reasserting London on the international fashion stage. Inspired by the street style of rebellious urban youth and historical and ethnic costume, she has created a series of outrageous collections.

WEWERKA, Stefan

1928- **German**

Ø p.67

Artist, architect, film-maker, and designer Wewerka worked initially as an architect and sculptor. He made his debut as a furniture designer in 1974, when he was commissioned by Tecta to design a classroom chair for its trade fair stand. Since then, he has produced a number of asymmetrical furniture designs for Tecta and from 1981, irregularly shaped clothing, which he constructs on the body.

WIENER, Edward (Ed)

1918 - American

Ø p.156

Wiener began working as a jeweller in 1946, establishing himself in New York in 1947. Spirals, figures, and fish are familiar motifs in his work.

Iroquois carafe by Russel Wright, 1950

ZAPF, Hermann 1918- German

Optima typeface, 1958

An outstanding typeface designer, Zapf's work spans five decades. Self-taught from the writings of Rudolf Koch (1876–1934) and Edward Johnston (see p.264), he began his career at Paul Koch's foundry in Frankfurt. It was for the Stempel foundry, where he worked from about 1940, that he created his finest typefaces, such as Palatino (1949) and Optima (1958).

WILSON, Wes

1937 - American

@ p.229

Underground cartoonist Wes Wilson was a chief exponent of Psychedelia. Drawing on Secessionist lettering, Art Nouveau patterning, and East Indian motifs, he produced numerous posters for West Coast rock concerts, principally at the Fillmore and Avalon venues in San Francisco.

WIRKKALA, Tapio

1915-85 Finnish

Ø p.89

One of the finest postwar Scandinavian designers, Wirkkala won international acclaim for his entries for the 1951 Milan Triennale. His glassware, produced by Iittala from 1946 to 1985, reflected his grounding in sculpture and his interest in organic forms. His famous Kantarelli vases, created in 1946, typify this approach. He also worked on a freelance basis, creating glassware for Venini, ceramics for Rosenthal, and lighting for Airam.

WORTH, Jean Philippe

1853-1924 French

Ø p.104

When his father, Englishman Charles Frederick Worth, died in 1895, Jean Philippe assumed responsibility for the house of Worth. Jean Philippe handled the creative output, whilst his brother Gaston (1856–1926) provided the business acumen, hiring designers such as Paul Poiret (see p.270). Retiring in 1910, Jean Philippe was

succeeded by his nephew, who kept the name of Worth in the fore-front of fashion during the 1920s. The house of Worth finally closed in 1954.

WRIGHT, Frank Lloyd

See panel left

Ø p.86

WRIGHT, Russel

1904-76 **American** Ø p.80, 86, 89

Wright was born and raised as a Quaker in Lebanon, Ohio. His functional designs reflect his puritanical outlook. He began in theatre design, but by 1930, he had established a studio in New York, producing metalware. He introduced his hugely successful Modern Living furniture line, which was mass produced by Conant-Ball and sold through Macy's store, in 1935. Wright is best-known for his ceramics (see left), particularly the American Modern dinnerware manufactured by Steubenville Pottery from 1939.

YAMAMOTO, Yohji

1943 - Japanese

Yamamoto studied at Kcio University and later at the prestigious Bunka College of Fashion in Tokyo. He founded his own company in 1972, showing his first collection in 1976. Like many Japanese fashion designers, Yamamoto concentrates on daywear. His garments are typified by loose, asymmetrical forms.

YOKOO, Tadanori

1936 - Japanese

Ø p.228

Working as a freelance graphic designer, Yokoo's striking posters from the 1960s and 70s earned him international recognition. Mixing Western images with Eastern graphics, he explored the impact of pop culture on Japanese society.

ZANUSO, Marco

1916- **Italian**

Ø p.127

Zanuso studied architecture at Milan Polytechnic, where he later taught. He established his own design office in 1945. He is known for employing innovative materials, such as foam rubber and sheet metal,

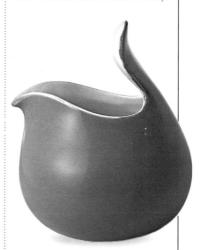

Pitcher by Zeisel, 1946

in his furniture designs for Arlex, among others. From 1958, he collaborated with Richard Sapper (see p.272) on various projects for Brionvega and Siemens.

ZAPF, Hermann

See panel

Ø p.210

ZEISEL, Eva

1906 - Hungarian

Ø p.86

A Hungarian-born ceramicist, Zeisel worked extensively in Europe before settling in the US in 1938. Her early work reflects the prevailing trend for geometric patterns, but she adopted the emerging style of organic Modernism (see above) with her move to the US.

GLOSSARY

ABS plastic

An acrylonitrile-butadiene-styrene thermoplastic with superior ductility, high-impact strength, good colourability, and a high gloss, making it suitable for moulded and decorative objects. It is most commonly used in electrical goods, telephone handsets, and furniture.

Aesthetic movement

An artistic movement that evolved in the 1880s and was devoted to "art for art's sake". Leading to the Arts and Crafts movement, it adopted an extravagant ideal of beauty and led to freer expression in art and design.

Anti-design

A movement emerging in the late-1960s that rejected established design theory. It reacted to the rise of consumerism in the 1950s and '60s, which was thought to promote "good design" to enhance sales. Anti-design sought to redefine design through its garish colours and unconventional shapes and proportions.

Art Deco

A decorative style, its name originated from the 1925 Paris Exposition Internationale des Arts Décoratifs et Industriels Modernes. Its influences were diverse, from Cubism to Egyptian art to an appreciation of modern machinery. Characterized by simple geometric patterns, sharp edges, and bright colours, the style was applied to a wide range of disciplines.

Art Nouveau

An international decorative style that began in Europe in the 1880s and reached the height of its popularity by 1900. Based on forms of plant-life, the style created a new unity across the visual arts. It is characterized by the whiplash curve, suggestive of organic fluidity.

Arts and Crafts movement

An English and American movement, first established in England in 1882 and named after the Arts and Crafts Exhibition Society. In its prime, between 1888 and 1910, it sought to revive the ideal of the hand-crafted object in an industrial age, a notion that had both social and aesthetic implications. Characterized by medieval and Gothic references, its products were often robust and simply constructed.

Austerity

A period during World War II when governments in Europe, Japan, and the US limited the use of strategic materials and instead commissioned a range of consumer products using basic or new materials.

Avant-garde

Meaning "the vanguard", a group of innovators. In art and design, the term refers to developments in the use of materials and styles.

Bakelite

The trade name for a thermosetting plastic, Phenol-Formaldehyde, invented and patented by Leo Baekeland in 1907. An early, brittle plastic, its streamlining qualities, cheapness, and similarity to wood made it ideal for consumer products such as radios and televisions.

Bauhaus

An influential art school founded in 1919 by Walter Gropius, which ran until 1933, when it was closed by the Nazis. One of its aims was to forge links between art and industry. In the 1920s, the Bauhaus became the leading intellectual and creative centre of design, playing a key role in the development of Modernism.

biomorphic design

A style of design in which an object is styled to imitate the appearance of a living organism.

Brussels Expo, 1958

A world's fair that was dominated by the Atomium, a huge structure built specifically for the exhibition, which accurately represented an atomic molecular structure.

cantilever

An engineering term to describe a projecting bracket that supports a load. The concept of a cantilever has been applied by innovative 20th-century designers to furniture, producing some highly original, modern chairs.

Classicism

A design style based on abstract principles of organization and order found in Greek and Roman antiquity. The style is simple, harmonious, and well-proportioned.

Compasso d'Oro

Established in 1954, this design award for excellence is presented every year by the Italian chain store *La Rinascente* to Italian designers for outstanding, often domestic, products.

Constructivism

A movement that emerged in Russia after the 1917 Russian Revolution. Partly influenced by Cubism and Futurism, it ignored fine art in favour of applied art: design for mass production was an important ideal. Its largely abstract, "sculptural" works were assembled rather than painted or carved, influencing design in the West.

Cubism

Developed in France in 1907 by Pablo Picasso and Georges Braque, Cubism was a reaction against the optical realism of Impressionism. Images were depicted in geometrical form from multiple viewpoints but displayed on one plane on the canvas. Though short-lived, the movement had a major influence on 20th-century art and design.

De Stijl

A multi-discipline Dutch Modernist movement founded in 1917 by Theo van Doesburg. Its name derives from the *De Stijl* journal, meaning "the style". It used abstract geometric forms, with neutral and primary colours in place of natural form, in the search for a visual language to express the new machine aesthetic.

Deconstructivism

A term that emerged in the 1980s to describe visually complex forms with geometrically arranged areas of vibrant colours. Most designs never progressed beyond the stage of plans or models.

determinism

A philosophical theory that humans do not act out of free will, but are directed by external forces.

eclecticism

The term for borrowing from, often combining, a variety of historical sources. This practice was prevalent between 1900 and 1950, and later re-emerged in Post-modernism.

ergonomic design

A scientific approach to the relationship between humans and their environment. Products are designed to suit the human form.

Favrile glass

The trade name registered in 1894 for a high-quality glass produced by Louis Comfort Tiffany.

Festival of Britain, 1951

This festival reflected a new, postwar British approach to architecture and industrial design, characterized by light metal structures and modern materials.

Functionalism

Louis Sullivan coined the phrase "form follows function" in 1896. The term embodied the belief that an object's function is of primary importance in determining its appearance.

Futurism

An Italian movement launched in 1909 by Filippo Tommaso Marinetti. It extolled the virtues of modernity, demanding the inclusion of new technology and dynamism in art.

Glasgow School

A group led by the innovative Scottish architect and designer Charles Rennie Mackintosh. His interpretation of Art Nouveau in the 1890s and early-1900s resulted in a linear, less ornamental style

graphic design

A generic term for photography, drawing, typography, and printing.

high-tech

An architectural and design style that rejects decorative elements in favour of industrial equipment.

International Style

An architectural style adopted world-wide that epitomized the simple, functional approach of Modernism. Leading exponents were Walter Gropius, Mies van der Rohe, and Le Corbusier, and it was characterized by new materials such as steel, reinforced concrete, and plate glass windows.

Jugendstil

Meaning "young style", a term used in Austria, Germany, and Scandinavian countries for a style closely related to Art Nouveau.

kinetic art

A form of art that depends on movement for its effect.

kitsch

A critical term used to describe pretentious, cheap, ugly, or sentimental work. The style has flourished since the rejection of Modernism by some designers in the 1960s. Gillo Dirfles' 1969 Kitsch: An Anthology of Bad Taste is the definitive book on the subject.

machine aesthetic

A term describing the appearance of an object that has been determined by its manufacturing process.

Milan Triennale

An art exhibition held every three years in Milan, it is a showcase for modern designs, generally Italian.

Modernism

Not representative of one group, but a general reaction in art, design, technology, and society in the 20th century against traditional styles. Emphasized the simple, functional aspect of forms without decoration. Its aim was to produce high-quality designs for a mass population.

motif

A distinctive feature or dominant idea. Also an ornament identifying a maker or model.

Nancy School

The school of craftsmen set up in Nancy, France, by Art Nouveau exponent Emile Gallé in 1890 to promote naturalism in design.

New York World's Fair, 1939

The theme of this exhibition was "Building the World of Tomorrow". It was dominated by the American concept of streamlining, revealed in the cars, model buildings, and futuristic products on show. For the first time, the decorative arts were overshadowed by industrial designs strongly influenced by Modernism.

Op Art

An abstract movement that developed in the 1960s and exploited various optical effects. Illusions of movement were produced by graphic processes or by overlapping patterns.

organic design

A style of design that echoes the curvilinearity of natural forms. In recent years, it has been aided by the improvements in plastics and computer technology in production.

pâte-de-verre

A glass-making technique that involves grinding down glass and reforming it in a mould.

Paris Expo, 1925

This exhibition, also known as Exposition Internationale des Arts Décoratifs et Industriels Modernes, focused on the decorative arts and first introduced the Art Deco style.

Pop Art

An abbreviation of Popular Art. The movement grew in the 1950s and '60s, drawing its inspiration from aspects of commercial culture such as packaging, advertising, and comics. Its irreverent images were based on consumerism, and its exponents, such as Andy Warhol, were opposed to contemporary aesthetic standards.

Post-modernism

In rejecting Modernism, with its innovations that alienated the masses, the Post-modernists relied on historical references. The movement became increasingly influential through the late-1960s, and can be characterized by a rejection of the logic and simplicity of the Modernists. Instead, designers used an eclectic range of references, styles, and eras.

Psychedelia

An influential 1960s' style that sought inspiration from mindexpanding hallucinogenic drugs for its bright, bold, often abstract designs.

Punk

A British street culture movement that developed in the 1970s.

Rationalism

An Italian movement rejecting Futurism that made efficient use of resources, space, and visual impact.

Romanticism

Containing the distinctive qualities or spirit of the Romantic movement. Considered a state of mind rather than a style, it encompassed diverse artists, whose use of grandeur and the picturesque aimed to invoke a powerful emotional response.

sgraffito

A ceramic decorative technique in which a different, underlying colour is revealed by scratching through the surface of a material.

signage

The arrangement or design of graphic images, often involving text, in a sign that is intended to convey information to the public.

Social Realism

Expressing social or political tendencies as part of a practical approach in art and design.

Stile Liberty (or Stile Floreale)

Term used in Italy for Art Nouveau, deriving its name from the British decorative arts retailer, Liberty & Co., which sold the designs of its progressive craftsmen in Italy. The style was revived in design as Neo-Liberty in the 1960s.

Streamlining

Acrodynamic experiments to reduce wind resistance on aircraft in America were subsequently applied to cars and other design work in the 1930s and '40s, giving objects gentle curves free of projections. Equated with functional excellence, the style was also used for purely visual effects, and by the 1950s often appeared in a highly exaggerated form.

Suprematism

Developed by Kazimir Malevich in Russia, this concept was concerned with the reduction of forms to a simple geometric arrangement in pure colours to represent the "supremacy of pure emotion".

Surrealism

Surrealists sought to go beyond the accepted conventions of reality and explore the subconscious mind. Representations were presented as depictions of a dreamworld, and objects were deliberately constructed in strange conjunctions. The play on the meanings of objects was picked up by the Anti-design movement.

Utility

Furniture and textiles produced in Britain between 1941 and 1951 in response to the economies of war.

Vienna Secession

Considered the Austrian version of Art Nouveau, the movement was founded in 1897 when a group of artists and designers seceded from the Vienna Academy. It utilized natural images and curving forms, but its designs were more geometric than those of French and Belgian Art Nouveau.

vitreous china

A type of china so fine, hard, and transparent it is almost glass-like.

Vorticism

An aggressive movement between 1912 and 1915 that attacked sentimentality in favour of violence, energy, and machinery. Bold and abstract, it drew from Cubism and Futurism, often creating angular machine-like objects.

Wiener Werkstätte

A co-operative group of workshops that grew out of the Vienna Secession in 1903. Incorporating artists, designers, and craftsmen, it flourished as a centre of progressive design until 1932. Although initially rectilinear, it later developed a more curvilinear, eclectic style.

zoomorphism

A style of designing objects that imitate or represent animal forms.

INDEX

Aalto, Aino, 254 Aalto, Alvar, 254 furniture, 17 Paimio chair, 34 Savov vase, 48 Aarnio, Eero, 37, 254 ABC Skootamota, 174 Acer Aspire computer, acrylic, 19 Action Man, 116, 117 AD 65 radio, 258 adding machines, 204-05 Adidas, 137, 162 Adolph, Peter, 115 advertising, 22 packaging, 232-51 AEG (Allgemeine Elektricitäts-Gesellschaft), 13 corporate identity, 212 fan, 194 hair dryer, 106 AEG Telefunken, 62 aerodynamics, 16, 181 aerosols, 28 Aertex, 135 Aesthetic movement, 11, 276 Africa, 28 African art, 14 Aga, 66 Aicher, Otl, 21, 254 "Air Clip" clippers, 107 Air France, 81 Airborne, 268 aircraft: aerodynamics, 16 Blériot, 10, 11 Concorde, 22, 29 superjets, 29 Wright brothers, 10 alarm clocks, 128, 129 Albers, Anni, 254 Albers, Josef, 13, 254 Alchimia see Studio Alchimia Alessi: cafetière, 73 clocks, 129 "Kettle with a Birdshaped Whistle", 74, 75 Pito kettle, 262 tea service, 85 Alias, 256

candlesticks, 53 foil, 235 Alumo watch, 151 Amana SRD526SW refrigerator, 69 Ambasz, Emilio, 254 Amea Twin jacuzzi, 99 American football, 163 American Modern cutlery, 80 American Modern dinner service, 86, 87 American Telephone and Telegraph, 126 AMi Continental jukebox, 169 Amstrad PC1512 computer, 201 Anderson, Gunner Aagaard, 22 Andreasen, Henning, Anglepoise lamp, 54, 55 Ant chair, 21, 36 Antelope chair, 21, 36 anthropometrics, 17 Apelli & Varesio, 45, 92 Apple Computers: corporate identity, 215 Macintosh, 26, 200 Aprilia Moto 65 motorcycle, 179 Aqualisa, 98 Arabesque table, 45 Arad, Ron, 254 Big Easy Red Sofa, 43 furniture, 27 Rover Chair, 254 Three Thirds of a Table, 45 Arai, Junichi, 254 Arcadian Tea Rooms, Glasgow, 222 architecture: Art Deco, 14 Modernism, 13 Archizoom Associati, 41 Armani, Giorgio, 141, 161, 254 Armitage Shanks, 98 Armstrong, Neil, 20 Arnhem International Film Week (1961), 228 Art Deco, 14-15, 276 bathrooms, 96, 97 beds, 108 cameras, 164 candlesticks, 52 ceramics, 83 clocks, 128

desks, 193

jewellery, 156

drinks accessories, 90

lighting, 54 magazine covers, 217 packaging, 236-39 radios, 57 wallpaper borders, 121 watches, 150 Art Nouveau, 10, 11, 12, 23, 276 bathrooms, 97 beds, 108 cupboards, 124 drinks accessories, 90 furniture, 33, 93 glassware, 88, 89 lighting, 54 magazine covers, 216 packaging, 232, 234, perfume bottles, 104 posters, 222, 229 prams, 110 vases, 46 L'Art Nouveau, Paris, 11 Artemide, 21, 55 Arts and Crafts movement, 10, 11, 12, 18, 276 candlesticks, 52 furniture, 109 magazine covers, 216 posters, 222 tea sets, 82 Artzt, Walter, 136 Vespa scooters, 19, 175, 255 Ascot hats, 148 Ashbee, Charles Robert, 254 Ashley, Laura, 121, 255 ashtrays, 273 Asplund, Gunnar, 254 assembly lines, 12 Astral Email, 227 Atfield, Jane, 29, 124, 125 Atlantic Records, 220 Atom Wall Clock, 129 Atomium, Brussels Expo (1958), 129 Auburn 851 Speedster, Audi Quattro Sport, 189 austerity designs, 18 Austin, 115 Austin Mini Cooper, 185 Austria: Art Nouveau, 11 Vienna Secession, 11, 12, 13, 23 Autoped scooter, 174

B B3 chair, 33 Baby Born, 117 Baby Daisy vacuum cleaner, 130 baby dolls, 116, 117 Babygro, 136 Baccarat, 104 Bacchantes Vase, 266 Back to the Future, 188 Baekeland, Leo, 17, 276 Bag Radio, 57 Bahnsen, Uwe, 189, 254 Baier, Fred, 193, 255 Baillodin, Claude, 151 La Baïonnette, 216 Baird, John Logie, 19, 58 Bakelite, 14, 17, 19, 276 hair dryers, 106 jewellery, 156 radios, 56 telephones, 126 televisions, 58 Bakker, Gijs, 157, 255 Balans chair, 193 Balenciaga, Cristobal, 144, 255 Ball, Douglas, 255 Ball chair, 37 ball-point pens, 197 Balla, Giacomo, 12 Ballets Russes, 14, 154 Ballmer, Walter, 214 balls, footballs, 163 Balmain, Pierre, 255 Bandolero desk fan, 194 Bang & Olufsen, 60 Barbie doll, 116, 117 Barcelona chair, 34 Barcelona International Exhibition (1929), 34 Barcelona Olympic Games (1992), 215 Barnack, Oskar, 164, 255 baseball caps, 137, 148 Basie, Count, 15 basins, 11, 97-9 Bass, Saul, 227, 255 bathing suits, 160 bathrooms, 96-103 razors, 102-03 toothbrushes, 100-01 baths, 97-9 Battaglin bicycle, 173 Bauhaus, 12, 13, 15, 20 chairs, 257, 276 magazine covers, 216 posters, 224 textiles, 122

fabric, 258 Bayer, Herbert, 208, 216, 255 BayGen Freeplay radio, Baylis, Trevor, 28 bead shoes, 146 Beatles, 141, 220 Beau Brownie camera, 164 Beck, Henry, 17, 255 Bedine, Martine, 27, 255 beds, 108-09 divan beds, 40 Behrens, Peter, 255 AEG corporate identity, 13, 106, 212 copper water kettle, 74 desk fan, 194 Bel Geddes, Norman, 17, 91, 255 Belgium, Art Nouveau, 11 Belgravia hat, 149 Bell, Alexander Graham, 29, 126 bell-bottom trousers, 136 Bell Centennial typeface, 211 Bell Directories, 211 Bell Telephone Laboratories, 21 Bell 300 telephone, 17 Bellini, Mario, 255 Class shower, 99 Cupola dinner service, 87 Olivetti Divisumma 18, 25, 205 Belvedere: basin, 99 bath, 98 toilet, 98 Benetton, 231 Benito, Eduardo, 15 Bennett, Ward, 255 Benson and Hedges, 230 Bentley R-type Continental, 182 bentwood furniture, 14, 32, 92 Beogram 4000 gramophone, 60, 61 Berliner, Emile, 60 Bermuda Dansette, 60 Bernard, Pierre, 230 Bernhardt, Sarah, 222 berry hat, 149 Bertoia, Harry, 21, 36,

Bertone, Flaminio, 182,

Boda, 53, 89

256 Bertone, Giuseppe, 256 Bezzera, Luigi, 73 Bialetti, Alberto, 72 Bialetti, Alfonso, 72 Bianchini-Férier, 122 Bianconi, Fulvio, 48 Biba, 148, 264 Bibendum, Monsieur, Bibliothèque Nationale, Paris, 231 Bic Biro, 23, 197 Bicentennial Exhibition for "The Human and The Citizens' Rights", 231 Bich, Baron, 102, 104, 197 bicycles, 172-03 Bieffeplast, 194 Big Easy Red sofa, 43 bikinis, 160, 161 Bill, Max, 20 Binder, Josef, 224 Bing, 112 Bing, Samuel, 11 Biomorphic design, 276 Biomorphic table, 45 Biró, László, 197 biros, 23 Birth of the Cool, 220 Bistro table and bar stool, 92 Bizarre coffee set, 83 Björk, 221 Black, Misha, 256 "black box syndrome", Black Magic chocolates, 239, 249 Blahnik, Manolo, 256 Blake, Peter, 220, 256 Blanco y Negro, 216 Blériot, Louis, 10, 11 block-printed wallpaper, 120 Blomberg, Hugo, 127, 256 Blossom Garden wallpaper, 120 blotting paper, 196 Blow Armchair, 23 Blue Lines, 221 Blue Note Records, 220 BMW, 213 BMW R32 motorcycle, 176 board games, 114 boaters, 148 Boby trolley, 194 Bocasile, Gino, 225, 256 Bocca sofa, 42

Alison, Filippo, 73, 254

aluminium:

Avakian, Amran, 220

typefaces, 208, 211

Bauhaus furnishing

Body Shop, 250 Boeing 247, 16 Boeri, Cini, 256 Boffi, 66 Böhmerland motorcycle, 176 Bonal, 225 Bond, James, 151 bone china, tea sets, 84 Bonet, Antonio, 35 Bonetto, Rodolfo, 256 boots, 146, 147 football, 162 Booty, Donald Jr., 205, 256 Bordeaux lamp, 259 borders, wallpaper, 121 Burgfeldt, George, 116 Borsani, Fulgenzio, 192 Borsani, Osvaldo, 40, 192, 256 Börtzells, A., 223 Botta, Mario, 93, 256 bottle openers, 91 bottles: Coca-Cola, 12, 213 packaging, 249 perfume bottles, 104-05 Boué, Michel, 256 Boulanger, Pierre, 256 Bourjois, 154 Bowler, John, 148 bowler hats, 148 bowls, 50-51, 263 boxes, 264 Boyd, John, 149 Bradshaw, Granville, branded goods, packaging, 233 Brandt, Marianne, 256 Branzi, Andrea, 27, 256 Braque, Georges, 14 bras, 139 brass: candlesticks, 52 tea sets, 82 Brassière, 138 Braun, 20, 77 "black box syndrome", fan heater, 271 hair dryer, 107 Multipractic, 79 Multipress MP50 juicer, 268 Phonosuper record player, 60, 61 razors, 103 SK 25 radio, 57 Braun, Artur, 57, 256-57 Breer, Carl, 16, 181, 257 Breuer, Marcel, 257

Edelstahl container, plywood furniture, 17 Wassily chair, 13, 33 Breville Sandwich Toaster, 77 Brionvega, 21 Ls 502 radio, 57 Britain: Art Deco. 14 Arts and Crafts movement, 10 Punk, 27 Utility scheme, 18, 109 Broadhead, Caroline, Brodovitch, Alexey, 257 Brody, Neville, 211, 219, 257 Bromley, Pamela, 149 bronze figures, 14 vases, 48 brooches, 156 Brooks, Tina, 220 "Brothel Creepers", 147 Brown, Julian, 129 Brown, P., 220 Brownell, Frank, 164 Brownie camera, 15, 164 Bruna, Dick, 247 Brussels Expo (1958), 129, 276 BT videophone, 127 bubble bath, 250 Bubble candlesticks, 52 buckles, 156 Budapest Gasworks, 226 Bugatti, Ettore, 180 Bugatti Type 35, 180 buggies, 111 Buick Roadmaster, 184 Bulova Accutron watch. 150 Bulow-Hübe, Vivianna Torun, 157, 257 bunkbeds, 109 bureau, mahogany, 192 Burrows, Mike, 172 Burylin, Sergei Petrovich, 257 buses, 17 Bush, 19 Bush TV12, 58 Butterfly chair, 35

C
Cabbage Patch Kids,
117
cabinets, 125
Cadillac, 180
Cadillac Convertible,

257

Cartier, 128

55, 258

Varese, 92

Cartier, Louis, 257

Casa Cataneo Agra,

Casablanca sideboard,

Carwardine, George, 54,

21, 184 Café Tofa, 246 cafetières, 73 calculators, 25, 204-05 calendar, everlasting, Calici Natale goblets, 89 California Peach Cup, Calvo, Miguel, 49 camcorders, 59 cameras, 15, 164-65 Campbell, Sarah, 123, 257 Campbell's soup, 23 Canapé LC2 (Petit Confort) sofa, 40 Candlestick telephone, candlesticks, 52-53 cane furniture, 34 Canon: faxphone 8, 203 PC-3 portable copier, cans, drinks, 245, 249 Capitol Records, 220 caps, 148 Captain Beefhart, 229 Capucci, Roberto, 257 carafes, 275 Carder, Frederick, 257 Cardin, Pierre, 257 Beatles jackets, 141 "Space age" clothes, 22, 144 Carlson, Chester, 203 Carlton sideboard, 24, Carlu, Jean, 227, 257 Carnaby Street, 141 Carothers, Wallace H., Carpenter Electric Co., cars, 180-89, 272 advertisements, 233 aerodynamics, 16 electric, 28 1950s, 20, 21 pedal cars, 115 solar, 28 sports cars, 25 toy, 112, 113 Carter, Howard, 14 Carter, Matthew, 211,

272 Casio: digital watch, 151 pocket calculator, 205 Cassandre, A.M., 225, Cassina, 19 Castiglioni, Achille, 21, 37, 258 Castiglioni, Pier Giacomo, 21, 37 Castleton China, Inc., Cat's eye candlestick, 53 CD-ROMs, 26, 201 CDs (compact discs), 26, Cedar Tree wallpaper, Cellophane film, 235, 238 cellular telephones, 26 celluloid dolls, 116 Celtic art, 11 ceramics: bowls, 50, 51 dinner services, 86-07 Post-modernism, 27 Suprematist, 15 tea sets, 83-85 vases, 46-47 cereals, 247 chairs, 32-39 Ant Chair, 21, 36 Antelope Chair, 36 Arts and Crafts movement, 10 Ball Chair, 37 Barcelona Chair, 34 Bauhaus tubular-steel cinema chair, 257 Butterfly Chair, 35 DAR chair, 19 DCW dining chair, 260 Diamond Chair, 21, 36 dining chairs, 92-93 Little Beaver armchair, 38 Lloyd Loom, 34 Mart Stam, 273 Miss Blanche Chair, 39 office chairs, 192-93 Paimio Chair, 34 plastic, 19, 22 Proust's armchair, 38 Red-and-blue chair, 33 Rover Chair, 254 Sacco, 38 Sitzmaschine, 32 stacking chairs, 37, 193 steel, 21 De Stijl, 12

Thinking Man's Chair, Thonet, 14, 32 Umbrella Chair, 269 Up 5 Donna Chair, 38 Varesio Chair, 267 'vik-ter chair, 39 Wassily Chair, 13, 33 Womb Chair, 35 Zig-Zag Chair, 271 chaise longues, 34, 262 chambersticks, 52 Champagne, 227 Chanel, Gabrielle (Coco), 15, 105, 143, Chanel Nº 5 perfume, costume jewellery, 156, 157 swimwear, 160 Chantal, 169 Chariot bath, 97 Charleston (dance), 14-15 Chase Brass and Copper Company, 52, 91 Chashnik, Ilia Grigorevich, 15, 83, 258 Chéret, Jules, 222 Chermayeff, Ivan, 258 Chestnut Hill House, Pennsylvania, 24 Chevrolet Impala, 185 Chevron moquette, 122 Chia, Sandro, 125 Chicago, 15 children's tape machines, childrenswear, 134-37 China, 29 chlorofluorocarbons (CFCs), 28 Christiansen, Ole and Godtfred Kirk, 113 Chronopak clocks, 129 Chrysler Airflow, 16, 181 Chrysler building, New York, 14 cigarette cards, 232 cigarette packs, 17, 236, 238, 240, 242, 243 cinema: influence on fashion, 135 Odeon cinemas, 14 posters, 227 cisterns, toilets, 96 Citroën: 2CV, 182

DS, 185

Traction Avant, 181

Citroën, André, 181

City bath, 97 City of Salin train, 16 Clash, The, 221 Class taps, 255 Clavel, Gérard-Paris, Clemente, Francesco, 125 Cliff, Clarice, 83, 86, 258 clippers, electric, 107 cloche hats, 138, 148 clocks, 128-29 clockwork: radio, 28 robots, 113 ships, 112 trains, 112 Close to the Edge, 259 cloth caps, 148 clothing, 133-49 childrenswear, 134-37 hats, 148-49 haute couture, 142-45 men's daywear, 140-41 "New Look", 18, 139, 142, 161 1920s, 15 1960s, 22, 23 Punk, 27 shoes, 146-47 swimwear, 160-61 women's daywear, 138 - 39Cluedo, 115 CND (Campaign for Nuclear Disarmament), Coates, Nigel, 258 Coates, Wells, 204, 258 radios, 14, 56 coats, children's, 135 Coca-Cola: bottles, 12, 213 corporate identity, 212, 213 drinks cans, 245, 249 Cockerell, Fritz, 177 cocktail shakers, 90 cocktail watches, 150 coffee makers, 72-73 coffee sets, 82-83 coffee tables, 44-45 Colani, Luigi, 85, 258 Cold War, 20, 29 Coldspot Super Six refrigerator, 17, 68 Cole, E.K. Ltd, 58 Coles, Peter, 193 collapsible bicycles, 173 Collett Dickenson Pearce, 230 Collier, Susan, 123, 258

Collier Campbell, 122,

270

Superleggera Chair,

123 Colliers, 216 Colombo, Joe, 23, 258 Bistro table and bar stool, 92 Boby trolley, 194 compact kitchen, 66 Optic alarm clock, 129 Comme des Garçons, compact discs (CDs), 26, 61 compacts, make-up, 154 Compagnie d'Esthetique Industrielle (CEI), 81 Compasso d'Oro, 50, 276 computers, 26, 27, 28, 200-01 games, 114, 115 calculators, 204 "CONA" coffee maker, 72 Concorde, 22, 29 confectionery wrappers, Conklin Cresent filler pen, 152 Connell, Paul, 221 Conran, Terence, 123, Consolidated Lamp and Glass Company, 47 constructional toys, 112 Constructivists, 12, 15, 90, 225 consumerism, 20, 22 packaging, 243, 250 convenience food, 237, convertible pushchairs, cookers, 66-67 Cooper, Susie, 258 copper: kettles, 74 lighting, 54 Coral Fotexur textile, 123 Le Corbusier, 266 Canapé LC2 (Petit Confort), 40 chaise longue, 34 L'Esprit Nouveau pavilion, 14 Cordero, Toni, 108, 109, 259 corkscrews, 91 Corning Glass Company, 87, 88 corporate identity, 13, 212 - 15correspondent shoes, 146 corsets, 138, 232

cosmetics, 154-55 Cosmopolitan, 218, 219 costume jewellery, 156, 157 Côte d'Azur textile, 123 cots, 109 Coubertin, Pierre de, 215 Council of Industrial Design, 123 Courrèges, André, 22, 23, 144, 259 couture, 142-45 Crane candlestick, 53 Crapper taps, 96 Cray Y-MP computer, 200 Cream, 220 Creation Records, 221 Creazioni Cavari razor, 102 Crême Eclipse, 234 crepe sole shoes, 147 Crocodillo Sparkling Wine, 246 crystal sets, 56 Cubism, 122, 276 influence on Art Deco, 14, 47 posters, 224, 225 cupboards, 124 Cupola "Strada" dinner service, 87 Cushman Auto-Glide scooter, 174, 175 cutlery, 27, 80-81 cycles, 172-73 Cylinder line ice bucket, Cymric ware, 129

D

D70 divan bed, 40 Dahlia necklace, 157 Dalen, Gustav, 66 Dalí, Salvador, 42, 105, 143 Dallas mixer tap, 99 Dan Dare, 21 dance, Charleston, 14-15 Danese, 197 DAR chair, 19 Dark Side of the Moon, Darrow, Charles B., 114 D'Ascanio, Corradino, 254 Daum, 51 Davis, Miles, 220 Day, Lucienne, 259 Day, Robin, 259

daywear:

women's, 138-39 DCW dining chair, 260 De Bretteville, Sheila Levant, 259 De Dion-Bouton Model Q, 180 De Lucchi, Michele, 259 chairs, 258 fan prototype, 24 Kristall side table, 45 and Memphis, 27 Sofa Lido, 43 toaster prototype, 25 De Pas, d'Urbino, Lomazzi, 23, 259 De Pas, Jonathan, 259 De Souza, Katherine, 84 Dean, James, 20, 141 Dean, Roger, 220, 259 decanters, 89, 264 deerstalker hats, 148 Deganello, Paolo, 259 Delaunay, Sonia, 259 Delirium watch, 151 DeLorean, John, 188 DeLorean DMC12, 188 Delphon, Jacob, 97 denim jeans, 137 Denmark, 21 Denon Stacking System D-90, 61 Depression, 138 Derby, Lord, 148 derby hats, 148 Design Council, 80 Design Ideas, 53 Design Panel (Britain), 18, 109 designers, 254-75 desk accessories, 196-97 desk lamps, 55 Deskey, Donald, 15, 44, 259 Deskey-Vollmer, 44 desks, 192–3 Dessau Bauhaus, 13 Detroit, 51 DeVille, Nicholas, 221 Diaghilev, Sergei, 14, 154 Diam, 81 Diamond chair, 21, 36 Diana, Princess of Wales, 149 dictaphones, 195 dictation machines, 194, 195 Diehl, 194 digital watches, 150, 151 dining rooms, 80-93 cutlery, 80-81

men's, 140-41

92-93 dinner services, 86-87 drinks accessories, 90 - 91glassware, 88-89 tea and coffee sets, 82 - 85Dinky cars, 113 dinner services, 86–87, 274 Dior, Christian, 259 "New Look", 18, 139, 142, 161 disabled people, 27 Diskin, Steve, 129 disposable cutlery, 81 disposable razors, 102 Disraeli Gears, 220 Ditzel, Nanna, 193 divan beds, 40 diver's watches, 151 Djinn sofa, 268 DNA perfume bottle, 105 Dr. Martens shoes, 147 Doesburg, Theo van, 230 dolls, 116-17 Donegani, Dante, 102 Donna chair, 38 Dopyera brothers, 166 Dorn, Marion Victoria, 259 Douglas DCI, 16 dragonfly bowl, 50 dragonfly lamp, 54 drape suit, 141 dresses, 138 Dreyfuss, Henry, 17, 259 "Air Clip", 107 Kenmore Toperator, 70 telephone, 16, 126 drinks accessories, 90-1 drinks cans, 245, 249 Driscoll, Clara, 54 Drop tea service, 85 Du Pasquier, Natalie, 123, 259 Du Pont, 138 Dualit toaster, 77 Duchamp, Marcel, 37 Dufy, Raoul, 122, 260 Duke of Edinburgh's Design Award, 123 Dumas, Rena, 193, 260 Dumbar, Gert, 230, 260 Dunand, Jean, 260 Dunkley pram, 110 duplicators, 16, 202 D'Urbino, Donato, 259

E

E-1027 adjustable table, E-Type Jaguar, 180, 186 Eames, Charles, 32, 36, 44, 260 DAR chair, 19 lounge chair and foot stool, 37 Eames, Ray, 32, 260 DAR chair, 19 lounge chair and foot stool, 37 Earl, Harley, 20, 63, 260 Cadillac Eldorado Convertible, 21, 184 earthenware: bowls, 51 dinner services, 86 Eastman Kodak, 164 Eastwood, Clint, 21 Eat/Drink cutlery, 27

Ebendorf, Robert, 260 Ebihara, Daniel, 91 Eckmann, Otto, 208, 260 Eckmann Schmuck typeface, 208 Eclisse lamp, 55 Ecole de Nancy, 108

ecology, 28

Edir hair dryer, 106 Edison, Thomas Alva, Graphophone, 61 light bulbs, 52 Protechnic Ediphone,

Edelstahl containers,

Voicewriter, 195 Edward, Prince, 134 Edward VII, King of England, 149 Egyptian art, 14, 23 Eichler, Fritz, 57, 256,

Eisenloeffel, Jan W., 82, 260

Ekco: Model AD 65 radio, 56 Type U122 radio, 57 electric appliances:

clippers, 107 clocks, 128 computers, 200-01cookers, 66-67 fax machines, 202-03

food processors, 78-79 guitars, 166-67 hair dryers, 106-07 kettles, 74 photocopiers, 202-03

razors, 102-03 refrigerators, 68-69 toasters, 76-77 toothbrushes, 101 typewriters, 198–99 vacuum cleaners, 130 - 31washing machines, 70 - 71electricity, 12–13

Electrolux: vacuum cleaners, 131, electronic mail (e-mail),

electronics, transistors, 21

Elffers, Dick, 228

Ellermeier, Konrad, 195 Embassy glasses, 88 EMI Records, 221

Empire State Building, New York, 14 Emporio Armani, 254 English Electric Liberator washing machine, 71

ENIAC (Electronic

Numerical Integrator and Calculator), 200 Ergonomi Design Gruppen, 27

ergonomics, 16, 17, 27, 28, 276 Ericofon, 126, 127

Ericsson, L.M., 26, 126 Erté, 260 espresso coffee

machines, 72, 73 Esslinger, Hartmut, 260 Estridge, Philip, 200 Estro silver sauceboat,

272 everlasting calendar, 197

Every Week, 216 Excelsior Autocycles, 12 Excelsior 20T motorcycle, 176

Exposition Internationale des Arts Décoratifs et Industriels Modernes, Paris (1925), 14, 217 eye make-up, 154

F

Fabergé, 82 Fabian, Walter, 197 fabrics see textiles The Face, 211, 219 factories, mass production, 12

dining furniture,

Dylan, Bob, 22

Dyson Dual Cyclone

vacuum cleaner, 131

Factory F2 desk tool, Factory Records, 220, 221 Fair Isle pullover, 135 fake fur hat, 149 fan heaters, 271 fans, desk, 194 Fantin-Latour, Henri, 221 Farina, Battista, 260-61 Farina, "Pinin", 21 Il Faro "Finestra" dinner service, 87 fashion see clothes fashion illustration, 263 Fat Chance "Yo Eddy" off-road racer bicycle, Fath, Jacques, 143, 261 Favrile glass, 46, 88, 273 fax machines, 26, 202-03 Felt Toy Company, 112 Fender, Leo, 166, 167 Fender Stratocaster guitar, 166, 167 Ferguson Videostar, 59 Ferragamo, Salvatore, 146, 260, 261 Ferrari, 25 365 GT4 Berlinetta Boxer, 25 Dino 246GT, 188 Ferrari, Alfredino, 188 Ferrari, Enzo, 186 Ferrari-Hardoy, Jorge, 35, 261 Ferrieri, Anna Castelli, Ferry, Bryan, 221 Festival of Britain (1951), 36, 123 Festival Pattern Group, 123 Fiat, 19 Fiat 500, 180, 184 fibre-tip pens, 197 fibreglass chairs, 19, 35, 37 Fields, W.C., 220 Figaro Illustré, 216 figures, Art Deco, 14 film posters, 227 Filumena 2 coffee maker, 72, 73 Finel coffee pot, 72 Fink, Peter, 105 Finland, 21, 88 Fisher, Gary, 173 Fishtail tennis racket, 162 Flagg, J.M., 223 "flappers", 15

flared trousers, 136, 141

Flexi vase, 49 flocked wallpaper, 120 Fluocaril toothbrush, 100, 101 flush toilets, 96, 98 fob watches, 150 Foley, Kevin, 100 Folle APS, 196 Folle staplers, 196 Folon, Jean-Michel, 229, 261 food processors, 78-79 football boots, 162 footballs, 163 Ford, Henry, 12, 261 Ford Motor Company, Cortina, 189 Cosworth, 189 Jeep, 182 mass production, 12 Model T, 12, 180, 261 Mustang, 187 Sierra, 189 forks, 80-81 Fornasetti, Piero, 261 Forte dei Marmi, 225 Fortuny y Madrazo, Mariano, 142, 261 Foster, John, 51 Foster, Norman, 193, Fotexur textile, 123 fountain pens, 152-53 4AD, 221 four-wheel drive cars, France, Art Nouveau, Francis, Fred, 113 Francis-Joseph I, Emperor, 223 Franck, Kaj, 17, 261 Frank, Josef, 261 freezers, 69 fridges, 17, 28, 68-69 Friz, Max, 176 frock coats, 140 frogdesign, 200 Frutiger, Adrian, 210, 261 Fuerst, Edwin, 88 Fujiko, 24 Fukuda, Shigeo, 261 Fuller, Paul, 168, 169 Fuller, Richard Buckminster, 261 Funck, Dr., 147 furniture, 12

Art Deco, 14

Arts and Crafts

movement, 10

Bauhaus, 13 beds, 108-09 bentwood, 14 chairs, 32–39 coffec tables, 44–45 dining, 92–93 plastic, 19, 22 Post-modernism, 24 recycling, 27 side tables, 44–45 sofas, 40–43, 264, 268 steel, 21 Utility scheme, 18, 109 Futura typeface, 209 Futurists, 12, 224

Gibson Mandolin-

Co., 166

166

Guitar Manufacturing

Gibson Style O guitar,

Gill Sans typeface, 209

Gillette, King Camp,

Gillette Safety Razor

Giugiaro, Giorgio, 188,

Glaser, Milton, 22, 218,

Glasgow School, 11,

Company, 103

Givenchy, Hubert

Taffin de, 262

222, 276

glassware, 88-9

bottles, 249

bowls, 50, 51

goblets, 273

lighting, 54

104-05

Pyrex, 87

perfume bottles,

vases, 19, 26, 46-49

glasses, sunglasses, 161

candlesticks, 52, 53

Gitanes, 238

262

262

Gill, Eric, 209, 262

Gill, Ruth, 242

Gillette, 102

G Gabon textile, 123 Gagarin, Yuri, 20 Gaggia, Achille, 73 Gallé, Emile, 11 Galliano, John, 145, 262 Gameboy, 115 games, 114-15 Games, Abram, 72, 226, Garamond typeface, 211 Garbo, Greta, 155 gas stoves, 66 Gate, Simon, 48 Gatti, Paolini, Teodoro, 23, 262 Gatti, Piero, 38, 262 Gaudí, Antonio, 45 Gaultier, Jean Paul, 105, 161, 262 Gecophone, 56 Gehry, Frank O., 38, Geismar, Thomas, 262

General Motors, 20,

Pontiac GTO, 188

Bauhaus, 12, 13, 15, 20

International Style,

Schönheit der Arbeit

Gestetner duplicating

machine, 16, 202

ghetto blasters, 63

Giacosa, Dante, 262

Gibson, Orville, 166

Gibson Les Paul Gold

Gibson Double-12

Top guitar, 167

guitar, 167

Ghost, 169

G.I. Joe, 117

George VI, King of

England, 156

Jugendstil, 11

programme, 18

181, 185

Germany:

20 - 21

"Global Tools" design group, 42 "global village", 26 Globe taps, 96 gloves, 139 goblets, 273 Goblin Teasmade, 75 gold watches, 151 Goldeneye, 151 Goldman, Jonathan, 54, 262 GoldmanArts, 54 "Golfball" typewriters, 198, 199 Goodman, Benny, 15 Goofy Foot skateboard, 163 Gould, C.H., 196 Goult, André, 193 Goya y Lucientes, Francisco José, 213 Graham, Martha, 156 gramophones, 60 Grand Confort Petite Modèle armchair, 40 grandfather clocks, 128 Grange, Kenneth, 6-7, 79, 102, 262 graphics, 207-51 corporate identity, 212 - 15

magazine covers, 216-19 packaging, 232-51 posters, 222-31 Punk, 27 record covers, 220-21 typefaces, 208-11 graphite tennis rackets, 162 Graphophone, 61 Grapus, 230 Graves, Michael, 27, 75, 262 - 63Gray, Eileen, 44, 262, 263 Greenwich House, 48 Greteman, Sonia, 231 Greyhound buses, 17 Grillo telephone, 23, 127 Gropius, Walter, 13, 84, 263 Gruau, René, 155, 227, Guéridon en palissandre table, 44 Guerlain, Pierre, 104 Gugelot, Hans, 21, 61, 263 Guild, Lurelle Van Arsdale, 72, 263 Guild, Tricia, 87 guilds, Arts and Crafts movement, 10, 12 Guimard, Hector, 263 ceramic vase, 46 Paris Métro, 11 side chair, 33 guitars, 166-67 Gulf Oil, 215 Gutenberg, Johannes, 210

Η Hafner, Dorothy, 263 Hagen-Pathé, 224 hair dryers, 106-07 Hald, Edvard, 48, 50, 263 Haley, Reuben, 47 halogen lamps, 55 Haloid, 203 Halston, 149 Hamley Bros., 114 Hammond typewriters, 198 Hamnett, Katharine, Handkerchief vase, 19, Handler, Laura, 53, 263 Hansen, Fritz, 93 Hardie, George, 221 Harley-Davidson, 176

Evolution FLTC Tour Glide Classic motorcycle, 179 Knucklehead 61EL, Harmony Company of Chicago, 166 Harrods, 110 Harvey Nichols, 250 Hasbro, 113, 117 Hassel, John, 223 Hasselblad, Victor, 165 Hasselblad 500 camera, 165 hats, 148-49 children's, 134 men's, 140 women's, 138 Haustein, Paul, 52, 263 haute couture, 142-45 Hawking, Stephen, 27 Hawkins, 77 Hawkins, L.G. & Co., 106 Haworth, Jann, 220 Heiberg, Jean, 126, 204, Heim, Jacques, 161 Heinz, 233, 241 Helix clock, 129 Heller Designs, 51 Helsinki Savoy Hotel, Hemingway, Wayne and Gerardine, 147 Henningsen, Poul, 54, Hepburn, Audrey, 155 Hermès, 193 Hershey bars, 236 Hetzel, Max, 150 L'heure bleue perfume, Hijikata, Hirokatsu, 228 Hilton, Matthew, 53, 263 Hipgnosis, 221 hippie movement, 136, 139, 228 Hisa Gloria De Luxe pram, 110 Hitachi KH-434E radio, 57 Hitler, Adolf, 56, 182, 230 HMV HDI hair dryer, 106 hobs, 67 Hochschule für Gestaltung, Ulm, 20 - 21Hoffmann, Josef, 120, 223, 264

Purkersdorf chair, 92

silver bowls, 13, 50 Sitzmaschine, 32 Wiener Werkstätte, 12, Höglund, Erik, 53, 89, 264 Hohlwein, Ludwig, 225, Holdcroft, Harold, 84 Holiday, Billie, 15 Holtom, Gerald, 213 Homberg hats, 149 Homemaker dinner service, 87 Hommage à Madonna cutlery, 80, 81 Hommes, 219 Honda, 25 CB750 motorcycle, 178 50 Super Cub motorcycle, 178 Hoover: Dustette, 131 Model 0307 washing machine, 71 700 vacuum cleaner, 130 Hoover, William, 130 **Hoover Suction** Sweeper Company, 130 Hornby, Frank, 112 House Tornado, 221 How High the Moon, 265 Hubble telescope, 29 Hulanicki, Barbara, 264 Hunter, R.F. Ltd, 164 Hunting textile, 122 Husqvarna TC610 motorcycle, 179 hydrodynamics, 16

i-D magazine, 27, 219 IBM, 26 computers, 200, 201 typewriters, 198, 199 ice buckets, 91, 265 ICI, 215 Ideal-Standard, 98, 99, 255 Idillio "Bokara" dinner service, 87 Ie, Kho Liang, 108, 109, Iittala glassworks, 88 Imaizumi, Yoshihisa and Kohji, 197 Immediate Records, 220 Imperial Hotel, Tokyo, Impressionism, 38 Indian Chief

motorcycle, 178 Indian Papoose scooter, 175 Indiana, Robert, 23, 157, 264 Indore, Maharajah of, 108 Information Superhighway, 29 Ingram Street Tearooms, Glasgow, 80, 93 ink, fountain pens, 152 - 53insulated cupboards, 69 International Arts and Crafts Exhibition, Turin (1902), 82 International Style, 20-21, 22Internet, 29 "invisible shoe", 146 Iosa Ghini, Massimo, 264 Iroquois carafe, 275 Island Records, 221 Issigonis, Alec, 185, 264 Italy: Futurists, 12 Memphis, 27 Post-modernism, 24 postwar design, 19, 21, 23 sports cars, 25 Stile Liberty, 11 Itten, Johannes, 122 ivory, 14

J

Jabot perfume, 105 jackets, 138, 140, 141 Jackson, Dakota, 39, 264 Jacobs, Mary Phelps, Jacobsen, Arne, 264 Ant chair, 21, 36 bottle opener, 91 Cylinder line ice bucket, 265 Jacques, 114 Jacuzzi, Roy, 99 jacuzzis, 99 Jaguar, 25 E-type, 180, 186 James, Edward, 42 Japan: austerity designs, 18 cars, 25 fashion, 145 motorbikes, 25 tea sets, 83 jazz, 15 Jazz bowl, 50 Jazz lamp, 55

Jeanneret, Pierre, 34, 40, 264 jeans, 136, 137, 141 Jeep, 182 Jensen, Georg, 264 decanter, 89 hot water kettle, 74 jewellery, 156 Jensen, Jakob, 61, 264 jewellery, 156-57 Art Nouveau, 11 Pop Art, 23 Jobs, Steve, 200, 215 Johns, Jasper, 23 Johnson, Clarence, 184 Johnston, Edward, 208, 209, 264 Jones, Terry, 27, 219, 264 jug kettles, 75 Jugendstil, 11 Juicy Salif, 273 jukeboxes, 20, 168-69 Juwel Elastic Stapler, 196 JVC, 23, 59

K

17, 265

Kåge, Algot Wilhelm,

Kallus, Joseph, 116 Kamali, Norma, 265 Kan, Shui-Kay, 265 Kandinsky, Wassily, 13, Kansai International Airport, 29 Karhula Glassworks, 48 Kartell, 194, 261 Kauffer, Edward McKnight, 224, 225, Kaufmann's department store, 274 Kawakubo, Rei, 144, 265 Kawasaki, 25 ZZ-R1100 motorcycle, Kayser, Engelberg, 90 Kelly, Charlie, 173 Kempe, Margot, 48 Kenmore Toperator washing machine, 70 Kennedy, Jackie, 149 Kent, Ronald, 51 Kenwood Chef, 78-79 Kenwood Coolwall toaster, 77 Kenzo (Kenzo Takada), 145, 265 "Kettle with a Bird-shaped Whistle",

74, 75

kettles, 13, 74-75, 262 Kewpie dolls, 116 Kiesler, Frederick, 265 King, Jessie M., 222, 265 King, Perry A., 199, 265 Kirby, Jack, 25 Kitchen Tree, 67 Kitchener, Lord, 223 kitchens, 65-79 coffee makers, 72-73 cookers, 66-67 food processors, 78-79 kettles, 74-75 refrigerators, 68-69 toasters, 76-77 washing machines, 70-71 KitKat, 229 kitsch, 43 Kjaerholm, Poul, 265 Klee, Paul, 13, 122 Klein, Calvin, 265 Klimt, Gustav, 223, 265 Portrait of a Lady, 13 Klingpor, 208 Knapp, W.A., 204 knee boots, 146 knives, 27, 80-81 Knoll, 93, 124 Knoll, Florence Schust, 124, 265 Knoll, Hans, 124 Ko-Yoshiya, 113 Kobe Workers' Music Council, 228 Kobylestskaya, Zinaida, Kodak, 15, 164 Komenda, Erwin, 265 Konecsni, Georg, 226 Kono, Takashi, 227 Koppel, Henning, 265 Kotyuk, Ben, 105 Kristall side table, 45 Kruse, Käthe, 116 Kubus modular storage, 274 Kuramata, Shiro, 24, 39, 265 Kurchan, Juan, 35 Kuwait Petroleum, 215 Kyoto Petals wallpaper, 121

La Pietra, Ugo, 125 Ladies' Humber bicycle, 172 Ladybird, 137 Lagerfeld, Karl, 266 Lalique, René, 266

jewellery, 11

glassware, 14 perfume bottles, 104 Lamborghini, 25 Countach, 25 Miura, 180, 186 Lamborghini, Ferrucio, Lambretta, 174, 175 LD150, 174 lamps, 54, 259, 269 Lamy pens, 197 Lancia, 25 Land, Edwin, 165, 266 Lasser digital watch, 151 Lauren, Ralph, 105, 266 Lawson Time Inc., 128 Le Corbusier see Corbusier Leete, Alfred, 223 Léger, Fernand, 122 Lego, 112, 113 Leibovitz, Annie, 151 Leica, 15, 164 leisure, 159-69 cameras, 164-65 guitars, 166-67 jukeboxes, 168-69 sports equipment, 162 - 63swimwear, 160-61 Leitz, 164 Lelong, Lucien, 105 Lenica, Jan. 228, 266 Leonora hat, 149 Lettera typewriter, 199 Leupin, Herbert, 227 Lever Company, 238 lever taps, 96, 99 Libbey Glass Co., 88 Liberty, Arthur Lasenby, 129, 222 Liberty & Co., 129, 222 Lichtenstein, Roy, 23, 229 Liebisch, Albin, 176 lighting, 54-55 candlesticks, 52-53 Limousette pram, 110 Lindstrand, Vicke, 48 liners, ocean, 16 lipstick, 154, 155 El Lissitzky, 15, 224, 266 Little Beaver armchair, living rooms, 31-63 bowls, 50-51 candlesticks, 52-53 chairs, 32-39 coffee tables, 44-45

lighting, 54-55

radios, 56-57

side tables, 44-45

music systems, 60-61

sofas, 40-43 tape machines, 62-63 television, 58-59 vases, 46-49 Lloyd, Marshall B., 34, Lloyd Loom furniture. Lobmeyr, 47 Loewy, Raymond, 17, 204, 266 cameras, 164 Coca-Cola dispenser, cutlery, 81 Gestetner duplicating machine, 16, 202 Lucky Strike cigarettes, 240 refrigerator, 68 wallpaper, 121 Löffler, Berthold, 223 logos, 212-15 Lomazzi, Paolo, 259 London and North Eastern Railways, 209 London Calling, 221 London Transport, 122, London Underground, 17, 208 Look, 218 Louis 20 stacking chairs, 27, 193 lounge chair, 37 lounge suits, 140 LOVE ring, 23, 157 Lowry, Ray, 221 Lucky Strike cigarettes, 17, 240 Lüdin, 227 Luftwaffe, 213 Lycra, 139, 161 Lysell, Ralf, 127, 266

 \mathbf{M} Maaru glasses, 88 McConnico, Hilton, 51 McDonalds restaurants, 214 machine aesthetic, 12 Mackintosh, Charles Rennie, 11, 13, 92, 222, 266 beds, 108 cutlery, 80 high-backed chair, 32, mahogany bureau, 192 Maclaren, Owen Finlay, Maclaren buggies, 111 McMillen, Louis, 84

McNutt, Mildred Coughlin, 121 Mad Circle skateboard, 163 Made of Waste shelving, 124, 125 magazine covers, 15, 216 - 19magic lanterns, 112 Magimix, 79 Magistretti, Vico, 55, 266 - 67Magnetophon, 62 Magnussen, Erik, 266, 267 Magritte, René, 229 Mainbocher, 143, 267 Majorelle, Louis, 108, 267 make-up, 154-55 Malevich, Kazimir, 258, ceramics, 15, 82, 83 The Man with the Golden Arm, 227 mangles, 70 Manhattan textile, 122 mantel clocks, 128 maps, London Underground, 17 Marburger, 121 Mari, Enzo, 267 everlasting calendar, Pago Pago vase, 46, 49 Marinetti, Filippo, 12 Mariscal, Javier, 27 Marloth, Herbert, 106 Marseille, Armand, 116 Marshmallow sofa, 41 Marx, Enid, 122, 267 mass consumerism, 22 mass production, 12 Massive Attack, 221 matchboxes, 238, 240, 242 Matisse, Henri, 50 Matsui STR323 tape recorder, 63 Matsushita, 59 Mattel, 117 Mazda RX7, 187 Meccano, 112, 113 medallions, 161 Megola Racing Model, 177 Melior typeface, 210 Mellor, David, 80, 267 Memphis, 27, 44 Casablanca sideboard, chairs, 258 Kristall side table, 45

lamps, 259

razors, 102 Sofa Lido, 43 storage, 124 textiles, 123 Mendini, Alessandro, 267 "Mobile Infinito", 125 Proust's armchair, 38 Sofa Kandissi, 42 men's daywear, 140-41 $Mercedes\text{-}Benz\ 300SL$ ("Gullwing"), 183 Metlicovitz, Leopoldo, 222 Métro, Paris, 11 Metropolitan gas stove, 66 Mezzadro stool, 37 Michelin Man, 212 Mickey Mouse, 230 Mickey Mouse telephone, 127 Mickey Mouse watch, microchips, 25, 201, 204 microwave ovens, 67 Miehe, Franáois, 230 Miele Novotronic washing machine, 71 Mies van der Rohe, Ludwig, 13, 34, 267 Milan Furniture Fair (1981), 27Milan International Exhibition (1906), 222 Miles, Reid, 220 milk, 249 Miller, Herman, 19 Miller (Herman) Clock Company, 129 Miller (Herman) Furniture Company, 41, 45 Millions, 216 Mini cars, 22 Mini Cooper, 185 mini kitchen, 66 Mini Minor, 185 Ministry of Information (Britain), 229 miniskirts, 22, 23, 139 Mira-X, 123 Miró, Joan, 48 Miss Blanche chair, 39 Mitchell, Bill, 185 mixer taps, 96, 99 Miyake, Issey, 145, 267 Mobil petrol pump, 269 "Mobile Infinito", 125 mobile telephones, 26 Mock, Elmer, 151 Model T Ford, 12, 180,

models, 112-13

modems, 26 Modernism, 10, 12, 23 architecture, 13 and British Design Panel, 18 Exposition Internationale des Arts Décoratifs et Industriels Modernes, Paris (1925), 14, 15 International Style, 20 - 21lighting, 54 and Post-modernism, 24 posters, 226 rejection of, 22 "Mods", 174, 175 modular storage, 274 Moholy-Nagy, László, 267 Moka Express coffee maker, 72 Mollino, Carlo, 44, 267 Arabesque table, 45 beds, 108, 109 bentwood chair, 92 Mondrian, Piet, 33, 144 Monopoly, 114 Monotype Corporation, 209, 210 Monroe, Marilyn, 104, 220 Montblanc 149 Masterpiece pen, 153 Montreal Protocol (1987), 28Moon landings, 20, 22, Moore, Henry, 45 Moore, Roger, 186 moquette fabric, 122 Moretti (Carlo) Studio, Morison, Stanley, 209, 210, 267 morning suits, 140 Moroso, 264 Morris, William, 10, 12, 128, 222 Morris and Co., 10 Morris Mini Minor, 185 Morrison, Jasper, 39, Moser, Koloman, 268 Vienna Secession, 223 Wiener Werkstätte, 12, 47 motocross, 179 motorcycles, 12, 25, 176 - 79

mountain bikes, 173 Mourgue, Olivier, 268 movable type, 210 Mucha, Alphonse, 222, 233, 268 Muir, Jean, 268 Mullard television, 58 Müller, Gerd Alfred, 268 Müller, Jacques, 151 Müller-Brockmann, Josef, 229, 268 Multiplex typewriter, 198 Multipress MP50 juicer, 268 Munari, Bruno, 268 Munch, Edvard, 228 Murano, 48, 88, 89 Musée de l'Affiche, Paris, 230 Musée des Arts Decoratifs, Paris, 229 Museum dinner service, 86 Museum of Modern Art, New York, 19, 86 music: compact discs, 26, 61 guitars, 166-67 jazz, 15 jukeboxes, 20, 168-69 music systems, 60-61 record covers, 220 rock 'n' roll, 20, 168 Muthesius, Eckart, 108 My Dream Baby, 116 My First Sony, 63

Napier, 90 NASA (National Aeronautics and Space Administration), 26, Nash Manufacturing Inc., 163 Nash (Michael) Associates, 221 National Style O guitar, necklaces, 156-57 Needle shower, 96 Neff B1441 oven and hob, 67 Nehru collar, 141 Nelson, George, 41, 129, Nenuphar bed, 108 Neophone, 126 Netherlands, De Stijl,

196 Neue Grafik, 229 die neue linie, 216 Nevada bowl, 51 "New Look", 18, 139, 142, 161 New Order, 221 New Orleans, 15 "New Romantic" look, 145 New-tone sofas, 264 New World cooker, 67 New York, 14 New York World's Fair (1939), 17, 88 Nielsen, Harald, 89, 268 Nike, 137, 215 Nikon, 25, 164, 165 Nintendo, 115 Nippon Design Centre, 228 Nippon Kogaku, 165 Nircosta metal, 14 Nixon, Richard, 243 Nizzoli, Marcello, 21, 268 Olivetti Divisumma 24 calculator, 205 Olivetti typewriters, Noah's arks, 112 Nobel, 215 Noguchi, Isamu, 45, 268 biomorphic table, 45 Radio Nurse, 17, 268 Noh drama, 230 Nomos desk, 193 Non Plus Ultra razor, Nordiska Kompaniet, 123 Noritake, 86 Novarese, Aldo, 211 Nowland and Schladermundt, 90 Noyes, Eliot Fette, 199, 269 NSM Nostalgia Gold jukebox, 169 Nurmesniemi, Antti, 72, 268 nurseries: dolls, 116-17 games and outdoor

Oakley Jackets, 161 obsolescence, 20, 22, 28 Odeon Casino, 223

toys, 114-15

112-13

nylon, 19, 138

prams, 110-11

toys and models,

Odeon cinemas, 14 Ofen Liidin, 227 offices, 191-205 adding machines, 204-05 computers, 200-01 desk accessories, 196-97 desks and chairs, 192-93 equipment, 194-95 fax machines, 202-03 photocopiers, 202-03 typewriters, 198-99 Offset, 208 O'Galop, Mr., 212 Ogdens' Nut Gone Flake, 220 O'Halloran, James, 100 Oil crisis (1973), 25 Olbrich, Josef Maria, 52, 223, 269 Old Country Roses tea service, 82, 84 Olins, Wally, 269 Oliver, Vaughan, 221, 269 Olivetti, 19, 21 corporate identity, 214 Divisumma 18 calculator, 25, 205 Divisumma 24 calculator, 205 office chair, 192 typewriters, 199 Olympic Games: Barcelona, 215 Stockholm, 223 Winter Olympics, 225 Olympus cameras, 25, 165 Omega watches, 151 Omo, 240 One Little Indian, 221 Oneas, 96 O'Neill, Rose, 116 Op Art, 22, 136, 139, 277 Open Two bottle opener, 91 opera hats, 148 Optic clock, 129 Optima typeface, 210, L'Oreal, 106 Original Appalachian Artworks Inc., 117

Oris Big Crown watch,

Orrefors Glasbruk, 48,

50, 88

Otto, Carl, 195

outdoor clothing,

children's, 135

outdoor toys, 114-15

12, 15

Neudstadter, Arnold,

Moulton, Alex, 173,

Mount, Reginald, 229

185, 268

ovens, 66-67 Oyster watch, 150 OZ magazine, 218 ozone layer, 28

P packaging, 28, 104, 232 - 51PAF, 55 Pago Pago vase, 49 Paimio chair, 34 paintings: Cubism, 14 Pop Art, 23 Vienna Secession, 13 Palatino typeface, 210 Palmolive, 224 palmtop computers, 201 Panama hats, 134 Panasonic: ghetto blaster, 63 NV-HD650 video, 59 Panton, Verner, 269 Black-and-white textile, 22 Spectrum textile, 123 stacking chair, 37 Paolini, Cesare, 38, 262 Papanek, Victor, 269 Paper Dress Show (1967), 228paperclips, 196 Paris, 11, 18, 145 Paris Match, 218 Paris Métro, 11 Parker, George S., 153 Parker Pen Company, 152, 153 51 pen, 152 61 pen, 153 180 pen, 153 Duofold pen, 153 Lucky Curve pen, 152, Pearly Vacumatic pen, Parlophone, 220 partners' desk, 193 Pasold family, 137 patchwork, 136 Pathé gramophone, 60 Pathfinder pedal car, 115 Patou, Jean, 269 Peacock vase, 46 Pêche, Dagobert, 47, 269 Pedestal chair, 93 pencil sharpeners, 196 Penfield, Edward, 216 ball-point, 197 fibre-tip, 197 fountain, 152-53

Pentel, 197 Pepsi Cola, 28 percolators, 72 Peret (Pere Torrent), 231, 269 perfume bottles, 104-05 Perpetua typeface, 209 Perriand, Charlotte, 34. 40, 269 Perrier, 227, 233, 251 personal computers (PCs), 26 personal stereos, 62 Perspex, 19 Pesce, Gaetano, 269 Tramonto a New York sofa, 42 Up 5 Donna chair, 38 Peter Rabbit's Race Game, 114 Peters, Michael, 269 Petersen, Arne, 91, 269 petrol pumps, 269 Peugeot, 173 pewter: candlesticks, 52 clocks, 129 Peynet, 243 Pezetta, Roberto, 69, 269 P H Artichoke lamp, 54 Philips: cassette recorders, 62, CD-ROMs, 26, 201 compact disc players, N-1500 video, 59 Philips Dictation Systems, 195 Philips Ladyshave Aqua razor, 102 Philips Philishave, 103 photocopiers, 194, 202-03 photography, 15, 164-65 Piaggio, 19 Piano, Renzo, 29 Picasso, Pablo, 14 Pick, Frank, 122 Picture Post, 216 pillbox hats, 149 Ping Pong, 114 Pink Cadillac, 21 Pink Floyd, 221 Pippa folding desk and chair, 193 Pirate collection, 27 pitchers, 90, 275 Pito kettle, 262 Pizzanelli, Serruccio,

222

Plank, Ernst, 112

planned obsolescence, 20

plastics, 19 Bakelite, 17 bowls, 51 cutlery, 80, 81 furniture, 37 packaging, 251 toothbrushes, 100 vases, 49 platform shoes, 146, 147 platinum, 14 Playmobil, 113 Plessey, 127 Plus Corporation, 197 plus-fours, 140 plywood furniture, 34, 35, 36, 37, 92 pocket calculators, 205 Pocket Memo dictaphone, 195 Poiret, Paul, 122, 142, 145, 270 Polaroid SX-70 camera, Poli, Flavio, 50, 270 Polydor, 220 polyethylene, 19 Polyphon music machine, 168 polyurethane, chairs, 38 Ponti, Gio, 21, 98, 121, 270 Pontiac GTO, 188 Ponty, Max, 238 Pop Art, 23, 277 pop culture, 141 Popova, Lyubov, 15 porcelain: bowls, 50 dinner services, 86-87 tea sets, 83-85 Porsche, 25 Porsche 911, 187 Porsche, Ferdinand, 16, 55, 182, 187, 270 Post, 221 Post-modernism, 23, 24-25 cutlery, 80 Memphis, 27 posters, 16, 18, 22, 105, 222-31, 271 Potter, Beatrix, 114 pottery see ceramics Poulsen, Louis & Co., 54 Poulsen, Valdemar, 62 Power Corruption and Lies, 221 Power Rangers, 113 Pracas, Victor M., 117 prams, 110-11 Pratt, Anthony, 115

220, 221 Prestcold refrigerators, Price, Anthony, 221, 270 Pride cutlery, 80 Primal Scream, 221 Procter and Gamble. propaganda posters, 226 Protos washtub, 70 Proust's armchair, 38 Prouvé, Jean, 270 Psion Series 3 computer, psychedelia, 22-23 packaging, 247 posters, 228 record sleeves, 220 Pucci, Emilio, 270 Puiforcat, Jean, 82, 270 pullovers, 135 Punch, 218 Punk, 27, 145, 219 Purkersdorf chair, 92 Purma Special camera, 164 pushchairs, 111 PVC, 19 Pye radio, 57 Pye Toaster, 77 Pyrex, 87

Q8, 215 QuadMark PassPort portable copier, 203 Quant, Mary, 23, 148, 155, 270 Quarta chair, 256 quartz clocks, 128 quartz watches, 150, Quinta chair, 93 Quistgaard, Jens, 91, Quod Design Company, Qwip 1200 fax machine, 203

R

Rabanne, Paco, 270 Race, Ernest, 21, 36, racing cars, 180 radio, 19, 21, 28, 56-57, 256, 258 Radio in the Bag, 57 Radio City Music Hall, New York, 15 Radio Nurse, 17, 268 Radius toothbrush, 100

166

Rickenbacker Electro

Spanish guitar, 166

Ridgeway Potteries, 87

Rie, Lucie, 271

Riemerschmid.

Richard, 271

Rieben, John, 229

Rietveld, Gerrit, 271

railways: corporate identity, 214 streamlining, 16 train sets, 112 Ramazzotti, 225 Rambow, Gunter, 231, Rams, Dieter, 271 "black box syndrome", Braun Phonosuper SK55, 61 Super RT 20 radio, 57 Ramshaw, Wendy, 271 Rand, Paul, 213, 271 Rank Xerox, 203 rationing, World War II, Rauschenberg, Robert, 229 Ray Bans, 161 Raygun, 219 rayon, clothes, 138 razors, 102-03 RCA, 220 Reard, Louis, 161 Rebel Without a Cause, record covers, 22, 27, 220-21, 259 record players, 60 Recta typeface, 211 recycling, 27, 28-29 Red-and-blue chair, 33 Red Army, 224 Red or Dead, 147 Reed and Barton, 52 reel-to-reel tape machines, 62 Reeves, Ruth, 122, 271 refrigerators, 17, 28, 68-69 Reich, Tibor, 123, 271 Reid, Jamie, 27 Remington, 198 Renault Espace, 180, Renner, Paul, 209 reptile skin shoes, 146 Rexite, 129 Rheinische Gummiund Celluloid-Fabrik, Rhodes, Zandra, 271 Rickenbacker, Adolph,

Red-and-blue chair, 12, 32, 33 Rinso, 238, 241, 243 Ritz-Italora, 129 Rix, Felice, 120 Robby the Robot, 113 Roberts, Xavier, 117 Robinson, Frank, 213 Robot desk, 193 robots, 25 toy, 113 rock 'n' roll music, 20, Rock-Ola Regis 1495 jukebox, 169 Rock-Ola Tempo 1475 iukebox, 169 "Rockers", 175 Rockwell, Norman, 216 Rococo style, 11 Rodchenko, Aleksandr, 15, 271 Rolex, 150 Rolleiflex 2.8F camera, 165 Rollerblades, 163 Rolling Stones, 220 Rolls Duo-Matic washing machine, 70, Rolls Royce 40/50 ("Silver Ghost"), 180 - 81Rolodex, 196 Rookwood, 47 Roosevelt, Theodore, Root Glass Company, Rose, Nigel, 230 Rosenthal, 84, 85, 87 Rossi, Aldo, 73, 86, 87, Roundabout punchbowl, Rover Chair, 254 Rowenta Express kettle, Rowntree, 237, 238, 248 Roxy Music, 221 Le Roy Soleil perfume, Royal Ascot, 148 Royal Bar-Lock typewriter, 198 Royal Copenhagen Porcelain Factory, 50 Royal Doulton, 82, 84

Royal Festival Hall,

Royale Newport pram,

Ruba Rombic vase, 47

London, 36

Ruby vase, 49

Preiss, Ferdinand, 14

Preminger, Otto, 227

Presley, Elvis, 20, 23,

Rudhard Foundary, 208
Ruhlmann, JacquesEmile, 14, 44, 271
Russell, Gordon, 18, 109, 271
Russia:
ceramics, 85
Cold War, 20
Constructivists, 12, 15, 90
posters, 224, 226
social realism, 90
Suprematism, 15, 83
Rynite, 129

S Saab, 20, 272 Saarinen, Eero, 19, 271 Tulip Group chair, 93 Womb chair, 35 Sabattini, Lino, 272 Sabattini coffee maker, 72, 73 Sabon typeface, 211 Sacco chair, 23, 32, 38 Safari sofa, 41 sailor suits, 134 The Saint, 186 Saint Laurent, Yves, 123, 144, 272 St Roch, Jean-Louis, 22 salad servers, 267 Sampe, Astrid, 123, 272 sandals, 135 Sanderson & Sons, 120, sandwich toasters, 77 sans serif typefaces, 208 Santachiara, Denis, 125 Sant'Elia, Antonio, 12 Sapper, Richard, 272 Brionvega Ls 502 radio, 57 Grillo telephone, 23, 127 Tizio lamp, 55 Sarpaneva, Timo, 272 Sason, Sixten, 131, 165, 272 Sassoon, Vidal, 107 satellites, 26 Sato, Kazuko, 125 Saturday Evening Post, 216 sauceboats, 272 Savignac, Raymond, 196, 227, 272 Saville, Peter, 219, 221 Savoy vase, 48 Sawaya & Moroni,

Sayer, Malcolm, 186

Scalextric cars, 113

Scandinavia, 17, 21 Scharfenberg, George, Schawinsky, X., 214 Schiaparelli, Elsa, 143, 272 costume jewellery, 156, 157 perfume, 105 Schick, Colonel Jacob, 102 Schilling, Stephan, 116 Schindler, Jim, 214 Schnackenberg, Walter, 223, 224 Schönheit der Arbeit programme, 18 Schreckengost, Viktor, 17, 50, 272 Schubert adding machine, 204 Schueller, Eugene, 106 sconces, 53 scooters, 19, 174-75 Scotland, Glasgow School, 11 Screamadelica, 221 Seamaster watch, 151 Sears, 70, 194 Sears Roebuck, 68 Secession see Vienna Secession Sedgwick County Zoo, 231 Seeburg KD200 jukebox, 168 Seeney, Enid, 87 Seiko Kinetic watch, Selecta portable gramophone, 60 Seneca, Federico, 225 Sgt. Pepper's Lonely Hearts Club Band, 220 serif typefaces, 208 Serrurier-Bovy, Gustave, 124, 128, 272 Settimanale, 125 7up, 226 Sèvres, 46 Sex Pistols, 27 Shagriarskiy, S., 234 Shanks, 96 Sharp, 25 Sharp, Martin, 218, 220 Shaw, Artie, 15 Sheaffer, 152, 153 Sheaffer Pen for Men, 153

Shell Oil, 17, 212, 225

clockwork, 112

ships:

Shenango Company, 86

solar cars, 28

Sony, 21, 25

camcorders, 59

ocean liners, 16 Shirayamadani, Kataro, Shire, Peter, 27, 272 shirts, 141 shoes, 146-47, 260 children's, 134, 135, track shoes, 162 trainers, 137 showers, 96, 98, 99 side tables, 44-45 sideboards, 24, 124, 272 Siemens, 126 Siemens-Schuckertwerke AG. 106 silicon chips, 25 silver: bowls, 13, 50 clocks, 129 jewellery, 156-57 kettles, 74 tea sets, 82, 85 vases, 47 Silversides Greyhound buses, 17 Simplex Scooter, 175 Simplon Tunnel, 222 Sinclair, Clive, 205, 272 Singer, 194 Šípek, Bořek, 272 cutlery, 81 "Mobile Infinito" wardrobe, 125 Ruby vase, 49 Sitzmaschine, 32 Six Views Collection, textiles, 123 SK 25 radio, 256 skateboards, 163 Skegness Is So Bracing, 223 Skeleton telephone, 126 Sloane, W. & J., 122 SLR (single lens reflex) cameras, 164 Small Faces, The, 220 Smeg SP16 refrigerator, Smith, Penny, 221 SNCF, 214 soccer boots, 162 Sociable Tandem, 173 social realism, 90 Società Nebiolo, 211 soda siphons, 91 Sofa Kandissi, 42 Sofa Lido, 43 sofas, 40-43, 264, 268 Sognot, Louis, 108, 273 Sol Dainty pram, 110

CD-ROMs, 201 children's tape machines, 63 compact disc players, corporate identity, 214 Playstation, 115 radios, 56 televisions, 59 Walkman, 25, 62 Sospir bed, 108, 109 Sottini, 98 Sottsass, Ettore, 21, 273 Carlton sideboard, 24, Casablanca sideboard, 272 Memphis, 27 office chair, 192 Studio Alchimia, 125 Valentine typewriter, 23, 199 Soule, Louis H., 242 Soviet Union see Russia Sowden, George, 27 Space Hopper, 115 space programme, 20, 21 Spangler, Murray, 130 Spanish Civil War, 216, 224, 225 Spectrum textile, 123 Speedmaster watch, 151 Spencer, Percy LeBaron, Spicciolato, Ernesto, 103 spoons, 80-81 sports cars, 25 sports equipment, 162 - 63Sputnik 1, 20 Squeezit bottle opener, SSQ-3000 typewriter, 199 stacking chairs, 37, 93 Stahl, Louis, 120 Stam, Mart, 273 staplers, 196 Star vacuum cleaner, 130 Starck, Philippe, 273 bathroom suites, 99 Louis 20 stacking chair, 27, 193 motorcycle, 179 toothbrushes, 100, 101 vase, 26 State Porcelain Factory (Russia), 15, 83 steel furniture, 21, 33, 34, 35 Steiff teddy bear, 112

guitar, 167 Stelton, 265 stenographers, 195 Stepanova, Varvara, 15 stereos, 25, 62 Steubenville Pottery, 86 Stickley, Gustav, 10, 273 Sticky Fingers, 220 De Stijl, 12, 15, 33 posters, 224, 230 Stile Floreale, 222 Stile Liberty, 11, 222 stiletto heels, 146, 147 Stockholm Olympic Games (1912), 223 stockings, 138 Stoecker, Karl, 221 Stokke, 193 Stolwerck, 236 Stölzl, Gunta, 122, 273 stoneware vases, 47 stools, 37, 92 storage, 124-25, 274 office, 194 Stratocaster guitar, 166, 167 Straub, Marianne, 123, straw hats, 148, 149 streamlining, 16-17 Strite, Charles, 76 Strummer, Joe, 221 Studio Alchimia, 27 "Mobile Infinito", 125 Proust's armchair, 38 Sofa Kandissi, 42 Studio 65, 42 Subbuteo, 115 Sugar, Alan, 201 suits: Chanel, 143 men's, 140, 141 Summers, Gerald, 35, 273 Sunbeam: Mixmaster, 78 Model T-9 toaster, 76 sunglasses, 161 sunrise motif, 239 Super RT 20 radio, 57 superjets, 29 Superleggera Chair, 270 Superman, 247 supermarkets, "own brand" packs, 247 Suprematism, 15, 83 Supreme hair dryer, 106 Surrey textile, 123 Suzuki, 25 Swatch, 150, 151 Snowbuck, 161

Twinphone, 127

Swayze, Patrick, 169

sweat-tops, 137 Sweden, 21, 27, 88 Swedish Modern, 17 Swedish textile, 123 Swid Powell, 85 swimwear, 160–61 Swivel chair, 192 Sykes, Charles, 180 Synthesis 45 office chair, 192

 \mathbf{T} T-bar shoes, 146 T-shirts, 141 tables coffee tables, 44-45 dining tables, 92-93 side tables, 44-45 TAC (The Architects Collaborative) tea service, 84 Tales from Topographic Oceans, 220 Tallon, Roger, 214, 273 Tanaka, Ikko, 230, 273 tandems, 173 tape machines, 62-63, 195 taps, 96, 99 tea, 246, 250 tea-makers, 75 tea sets, 82-85 Teague, Walter Dorwin, 16, 17, 273 cameras, 164 Embassy glasses, 88 Teamline 1100s bicycle, Tecno, 192, 193, 261 Tecno SpA Design company, 40 Tecta, 67 teddy bears, 112 Teddy boys, 141 Telegraphone, 62 telephones, 16, 17, 23, 126 27 fax machines, 202-03 mobile phones, 26 telescopes, 29 television, 19, 21, 23, 58-59 Television wallpaper, 121 Televisor, 58 Temple, Shirley, 135 tennis rackets, 162 Teodoro, Franco, 38, 262 Tesi table, 93 "Tetrapak", 246, 249 Texas Instruments, 25

Textile Design Studio,

Steinberger, Ned, 167

Steinberger Bass

Nordiska Kompaniet, 123 textiles, 122-23 see also clothing Theme Formal goblets, Thermos, 90, 259, 266 Thinking Man's chair, 39 Thomson-Houston Company, 68 Thonet, Michael, 32, 273 Thonet Brothers, 92 Thonke, Ernst, 151 Three Thirds of a Table, 45 Throwing Muses, 221 Thun, Matteo, 273 Hommage à Madonna cutlery, 80, 81 Memphis, 27 Settimanale cabinet, 125 Thunderbirds, 113 Tiffany, Louis Comfort, 273 glass, 11, 88 lamps, 54 Peacock vase, 46 Tiffany Studios, 54 tights, 139 Time, 218 The Times, 210 Times bath, 97 Times New Roman typeface, 210 Tinguely, Jean, 121 Tizio lamp, 55 Toast-O-Lator, 76 toasters, 25, 76-77 Tobralco dress, 135 toilets, 96, 98 Tokyo International Trade Fair (1956), 227 Tokyo Telecommunications Engineering Corporation, 21 toothbrushes, 100-01 top hats, 148 Toscani, Oliviero, 231 Toulouse-Lautrec, Henri de, 222, 223 toys, 21, 112-13 outdoor, 114-15 TPX Bias company, 196 track shoes, 162 Tractor fabric, 257 train sets, 112 training shoes, 137

transformer robots, 113 transistors, 21, 200 transport, 170–89 bicycles, 172-73 cars, 180-89 motorcycles, 176-79 scooters, 174-75 travel toothbrushes, 101 Tri-ang, 113 Trías, José M., 215 Triumph cars, 25 Triumph Speed Twin motorcycle, 177 Trivial Pursuit, 114, 115 trolleys, 194 trousers, 136, 139, 140, 141 True Blue, 220 trunks, swimming, 161 Tshichold, Jan, 211, 273 tubular-steel furniture, 33, 34, 35 Tudric ware, 129 Tulip Group chair, 93 Tupper, Earl, 19 Tupperware, 19 Turner, Edward, 177 Turner, Fred, 214 Tusquets Blanca, Oscar, 85, 274 Tutankhamun, 14 23 Envelope, 221 twin-tub washing machines, 70, 71 Typeface Six, 211 typefaces, 208-11 typewriters, 23, 194, 198-99 Tyrolean dolls, 116

Umbrella Chair, 269 Umeda, Masanori, 274 underwear, women's, 139 Underwood, Clarence, 224 unisex clothing, 139 United States of America: Arts and Crafts movement, 10 austerity designs, 18 Cold War, 20 streamlining, 16-17 Univers typeface, 210 universal design, 27 Universal toaster, 76 Universal typeface, 208 universe, 29 UPS (United Parcel Service), 213 Urchin IL36 lamp, 54

US Army jeep, 182 Utility scheme (Britain), 18 clothes, 138 furniture, 109

Vaaler, Johann, 196

vacuum pitchers, 90

Val Saint Lambert, 89

Valentine typewriter,

Valentino, 161, 274

Van Alen, William, 14

Vanity Fair, 216, 218

Van de Velde, Henry, 11

vacuum cleaners,

130-31, 266

V

v23, 221

23, 199

Varesio chair, 267 vases, 19, 26, 46-49, 266 Velcro, 137 Velim paper wrapper, 240 velvet hats, 148 Venetian glass, 88, 89 Venice International Exhibition (1907), 222 Venini, Paolo, 19, 48, 274 Venturi, Robert, 24, 85, 274 Ver Sacrum, 12 Vercingetorige alarm clock, 129 Versace, Giovanni, 274 Vertes, Marcel, 105 Vespa, 19, 174, 175, 255 Grand Sport 160 scooter, 175 Vest Pocket Autographic camera, 15 Victor adding machine, video cassette recorders, videophones, 127 Videosphere, 23, 59 Vienna Secession, 11, 12, 13, 23, 277 posters, 222, 223, 229 Vigeland, Tone, 157, 274 Vignelli, Lella, 50, 51, 274 Vignelli, Massimo, 50, Vignelli Associates, 274 'vik-ter chair, 39 Village tea set, 85 Vincent Black Shadow Series C motorcycle, 179

Vitra, 125 Vitrac, Jean-Pierre, 81, 274 Vive la Liberté wallpaper, 121 VKhUTEMAS, 15, 90 Vogue, 15, 218, 219 Volksempfänger VE 301 radio, 56 Volkswagen: Beetle, 182 Golf GTi, 188 Vollmer, Phillip, 44 Volvo PS1800, 186

W Waddingtons, 115 Wagenfeld, Wilhelm, 274 waistcoats, 140 Walker and Hall, 80 Walker Art Centre, Minneapolis, 230 Walkman, 25, 62 wallhangings, 122 wallpaper, 120-21 Wallpaper Manufacturers' Association, 121 Waltham watch, 150 wardrobes, 125 Warhol, Andy, 229, 274 paintings, 23 Sticky Fingers record cover, 220 Warne, F. and Co., 114 Warner & Sons, 123 Wärtsilä, 72 wash basins, 11, 97-99 washing machines, 70 - 71washtubs, 70 Wassily chair, 13, 33 watches, 150-51 Waterman, 152 Eye-dropper pen, 152 waterproof watches, 150 Watson, J.B., 224 Wear-Ever coffee pot, Weber, Kem, 128, 274 Wegner, Hans, 93, 274 - 75Weil, Daniel, 27, 57, Weingart, Wolfgang, 275 Weiss, Reinhold, 107, 275 Werner brothers, 176 West, Mae, 42, 105 Westwood, Vivienne,

Pirate collection, 27, 145 watches, 151 Wewerka, Stefan, 67, 275 whirlpool baths, 99 whistling kettles, 75 Whitaker, Bob, 220 Wiener, Ed, 156, 275 Wiener Werkstätte, 12, 47, 50, 52, 120, 277 Wightwick Manor, Wolverhampton, 10 Wilder, Billy, 37 Protector Razor, 102 pottery, 83 275

Wilkinson Sword Wilkinson's Burslem Willy's, 182 Wilson, Wes, 22, 229, Windcheetah Monocoque bicycle, 172 wine, 246 wine glasses, 89 winklepickers, 147 Winter Olympics, 225 Wire Lamp, 269 Wirkkala, Tapio, 88, 275 WMF, 81 Wolff Olins, 215, 269 Woman and Beauty, 218 Womb chair, 19, 35 women's daywear, 138 - 39women's journals, 216, 218 work station, 261 workshops, Arts and

Crafts movement, 10 World War I: children's clothing, 134 Luftwaffe, 213 packaging, 234 posters, 223 watches, 150 women's clothing, 138 World War II, 18, 19 children's clothing, 135 clothes, 138 magazine covers, 216, 217 make-up, 154 packaging, 240-41 posters, 226 Utility scheme, 18, 109, 138

watches, 150

Worth, 104, 142

Worth, Jean Philippe,

Wozniak, Steve, 200

Wozzeck, 228 Wright, Frank Lloyd, 86, 274 Wright, Russel, 275 American Modern cutlery, 80 American Modern dinner service, 86, 87 glassware, 88 Wright brothers, 10 wristwatches, 150-51 Wunderlich, Paul, 87 Wurlitzer jukeboxes, 168, 169 Wurstlin, Michael, 115

 \mathbf{X}

Xerox 914 photocopier, 203

Y

Yamaha, 25 Yamaha TC800D cassette recorder, 62 Yamamoto, Yohji, 275 Yang, 87 Yes, 220 Yokoo, Tadanori, 228, 275 The Young Man, 216 youth market, 20 clothes, 135 cosmetics, 155 psychedelia, 22-23

 \mathbf{Z}

Zanotta, 38, 92 Zanuso, Marco, 21, 275 Brionvega Ls 502 radio, 57 Grillo telephone, 23, 127 Zanussi Wizard refrigerator, 69 Zapf, 117 Zapf, Hermann, 210, Zapf Book typeface, 210 Zapf International typeface, 210 Zeisel, Eva, 86, 275 Zelco "phorm" calculator, 205 Zenobia, 104 Zephyr clock, 128 Zig-Zag Chair, 271 Zuber et Cie, 120

trains see railways

sofa, 42

Tramonto a New York

275

ACKNOWLEDGMENTS

Picture Credits

Abbreviations: a=above b=below c=centre l=left r=right t=top

Alvar Aalto Foundation: p34bl, p48b Acer UK Ltd.: p28tr, p201br ©ADAGP, Paris, and DACS, London, 1996: **p11**tr, **p104**c, **p225**tc, **p227**tl, **p266**l Adidas Archive: p162crb, br Advertising Archives: p155tr, p157tr AEG: p106cl, p212br Aga-Rayburn: p66r AKG London: p13tr, p155tcr ALIAS: pp92–93b, p256t Alessi spa Italy: p85c; Design by Philippe Starck, 1991: p273tl; Design by Michael Graves, 1984: pp74-75c Alternative Plans: p66t Amstrad/Michael Joyce Consultants: Apple Macintosh/Bite Communications Ltd.: p200tl, bl Aqualisa Products Ltd.: p98tr Arcaid: Richard Bryant: p10t, p24t; Dennis Gilbert: p29cl; Peter Mauss/Esto: Giorgio Armani/Mana GA Press Office: p254tr©ARS, NY and DACS, London 1996: p274b . Laura Ashley: p255br Atelier de Création Graphique Pierre Bernard: p230l Atrium Ltd.: p43b, p264br Bang & Olufsen: p61bc The Bathroom Works: p255tr Bass Yager Associates: p227cl Bauhaus Archive: p122c BayGen Power (Europe) Ltd.: p28cl Benetton/Modus Publicity: p231bl Bieffeplast: p125tc Courtesy of Bonhams Fine Arts Auctioneers, London: p67c, p93t, p109tr, p109c, p125cr, p269b RGA Bott Ltd.: p69br Andrea Branzi: p41b Bridgeman Art Library: Bonhams, London: p150t, cra, p268l; Fine Art Society: p192t; JCK Archive: p121 bl; Musée d'Orsay, Paris: p108t; Neue Galerie, Linz: p13t; Private Collection/Clarice Cliff ${\mathbb R}$ and Bizarre TM are trademarks of Josiah Wedgwood & Sons Limited/All design rights are reserved: p83tr; Private Collection: p139tr, p262l; By courtesy of the Board of Trustees of the V&A, London: 274b Courtesy of Torsten Bröhan, Düsseldorf: Neill Bruce/Peter Roberts Collection: p260tBT Archives: p126t, cl BT Museum: p126c, p127tr BT Pictures: p127br Camera Press: p149tr Chanel: back jacket tr; p104t Jean-Loup Charmet: p214clb Christies Images: p11tr, p14l, p44cl, p45br, p92c, p124tl, p128l, p129tl, p193tr, p192bl, p224cl, p266l, p267tr, p272b CND: p213br The design of the Contour bottle is reproduced by kind permission of The

Coca-Cola Company. "Coca-Cola", Coke,

and the design of the contour bottle are

registered trademarks of the Coca-Cola

Company: front jacket flap, spine, p12l, p213t, p245cl, p249tcl Collection of the New-York Historical Society: p9bl Collier Campbell: p123br, p258b Colorsport: p215b Corbis-Bettmann/UPI: p270br © DACS, 1996: back jacket c; p14l, p33t, p34tl, p40t, p74tl, p105tl, p122l, c, p157br, p195cl, p196tr, p208br, p223bl, p224cl, p225cr, p227cb, p228c, p229tr, p271b© Design Council: p69cr Dupont Information Service: p138t Ergonomi: p271 M. Espues y Peret Asociados SCP, Barcelona: p231tr E.T. Archive: p18tr Mary Evans Picture Library: p12b, p194trEWA: p22tr Museo Salvatore Ferragamo/Aurelia Public Relations: p146br, p260b Fiell International Ltd: p19l Gallaher Ltd.: p230br Frank O. Gehry & Associates Inc: pp38-39c Giraudon: **p52**tr Milton Glaser Inc.: p22bl The Ronald Grant Archive: front jacket Greteman Group: p231br Manufactured since 1955 by Fritz Hansen A/S. Allerødvej 8, DK-3450, Allerød, Denmark; tel: +45 48172300, fax: +45 48171948: **p36**br C.P. Hart Group/Halston PR Ltd: p96tc, p99crHasbro: p117bl Approved and Licenseu by John Hoffmann Stiftung-Vaduz: p13br, Approved and Licensed by Josef p32r, p50cl, p92l, p264l Angelo Hornak Library: p14tr Hulton Getty: p20bl, pp22–23b, p109tl, p135tl, p143tr, p155tl, p156br, p175tl, p200tr© Hunterian Art Gallery, University of Glasgow: p108br, Mackintosh Collection: Courtesy of International Business Machines Corporation: p200c ICI Corporate Slidebank: p215ca Ideal Standard Ltd.: p98tc Ikko Tanaka Design Studio: p230t Inskip/Pepsi-Cola International: p28b Kartell, Milan: p2611 Katz: p141tl Kenzo: p145tr Eero Saarinen Womb Chair, Courtesy of Knoll: **p35**br J.F. Hardoy Chair, Courtesy of Knoll Archives: p35cr Käthe Kruse: pp116–117t Kuramata Design Office: p24l, p39tr, Kuwait Petroleum (GB) Limited: **p214**tr Ladybird/Coats Viyella: p137t London Transport Museum: p17tl, p126br, p208bl Michele de Lucchi: p24cr, p25tr, p43t Mark Hall Cycle Museum: p172cr Barbie ® photography reproduced with kind permission of Mattel Toys: p117tr McDonald's Restaurants Ltd.: p214c Memphis, Milan: pp44–45c photo: Studio Aldo Ballo, p123cb photo: Studio Azzurro,

p259br photo: Robert Gennari

Alessandro Mendini: p38bl, p42c

Miele/Elizabeth Hindmarch PR: p71br

Issey Miyake: p145br, p267b Alex Moulton Bicycles: p173tr National Library of Scotland/Reproduced by permission of Stewartry District Council and the E.A. Hornel Trust: p2221 National Motor Museum, Beaulieu: p180cl, p181tr, p182tr, p189tr Neff UK/ RSCG Conran Design: p67r George Nelson Associates: p41t Peter Newark's American Pictures: p16b Nike UK Ltd.: p215cb Olivetti UK Limited: p214bl Omega: p151tr The Robert Opie Collection: p15tl, p16ct, p18cr, p34tr, p60bl, p60br, p66b, p70cr, p87tr, p105tr, p110c, p121tc, p130ct, p131tr, p154ct, p172tr, p185tl, p198c, p207, p212bl, p222tı, p223bl, bı, tı, p224bl, br, tr, p225tl, c, br, p226bl, cl, t, p229er, br, p256cl, p265t Panasonic: p59crb Verner Panton: p22tl; p36c, p269b Parker Pen Company: p153tr Pepsi-Cola International: p245c Gaetano Pesce: p38tr, p42bl, p269cr; p248bcPhilips: **p59**tr, **p61**br, **p62**tl, **p63**tr Popperfoto/Stuart Forster: p148tr Mary Quant, Europe: p270t Gunter Rambow Graphik Design: p231tl, Retrograph Archive Ltd.: p154tr, p155ctl, p196tr, p213ct, p217tr, p217br, p222c, br, p223tl, p224c, p225tc, cr, bl, p226br, p227tl, p227tr, c, br, cb, p228, p229tl, tr, bl, p262l, p263l Rex: p141tr Rowenta: p75br Sawaya & Moroni, Milan: p109b Scala/Museo Statale Russo, Leningrad: Science & Society Picture Library: p711, cr, p199tr Sears, Roebuck & Co.: p68tl, p70b Seiko: p151br Shell UK Limited: p212t SMEG/Phyllis Oberman Consultants: pp68-69c Smithsonian Institution: p67t Sony: back jacket tl, p59tl, bl, p63bl, p201tl, p214t Sony Computer Entertainment, Europe: p115bcSotheby's, London: p108bl Ettore Sottsass: p128r, p192br Studio Dumbar/photo: Lex van Pieterson: p230br Design Studio 65 (1970) Designers: F. Audrito, A. Garizio, G. Paci, A. Pozzo, A. Sampaniotou, M. Schiappa, F. Tartaglia: Superstock: **p69**tr Swatch/Marianne Egli Communications: p127c, p151tl, ctl, ctr, p161ct, p223cb Swid Powell: p85br Tecno: p40b, p193cl, p261br Tecta: p67c, p124cl Gebrüder Thonet GmbH: p32t Topham Picture Source: p181 UPS: 213bl By courtesy of the Board of Trustees of the Victoria and Albert Museum, London: p24l, p45cr, p122l, p122tr, p123ct, p142, **p143**tl, l, c, **p144**, **p145**l, c Courtesy of Virgin Records: **p220**cr, p221ccr Vitra Ltd.: back jacket flap; p125r, p193br, p265r Collection Vitra Design Museum, Weil am Rhein, Germany: p10l, p21tr, p32r, p32t, p33t, p34tl, bl, c, p35tr, cr, br, p36tl, br, c, pp36-37c, p37br, p38tr, bl, pp38-39, p39tl, tr, p40b, p41t, b, p42tl, bl,

 $\begin{array}{l} pp42-43c,\ p43tr,\ p192br,\ p254bl,\ p259cr;\\ p273cl;\ p270l\\ Volkswagen:\ front\ jacket\ flap\\ W.M.C.N.A.:\ p179tr\\ Peter\ Williams:\ pp126-127c,\ p131tr,\\ p202r,\ p257l,\ p266t,\ p269tl,\ p272t\\ Xerox:\ p203tl\\ Zapf\ Creations:\ p117br. \end{array}$

The following were photographed at Cooper-Hewitt, National Design Museum, Smithsonian Institution: p1r: Gift of Georg Jensen, Sølvsmedie A/S p2cl: Museum Purchase through the Decorative Arts Association Acquisition Fund p2-3c: Gift of Rodman A. Herren p3cl: Gift of Mel Byars p4r: Gift of Julia Haiblen p5l: Gift of Carlo Moretti p8c: Gift of Mel Byars p13br: Ely Jacques Kahn p15c: The Henry and Ludmilla Shapiro Collection, Partial Gift of Purchase through the Decorative Arts Association Acquisition Fund and Smithsonian Collections Acquisition Program p16cr: Museum Purchase through the Decorative Arts Association Acquisition Fund p17tr: Gift of Mrs. Homer D. Kripke; bl: Gift of Mel Byars p19br: Gift of Christian Rohlfing p23br: Gift of Deane Granoff **p25**tl: Gift of Barry Friedman and Patricia Pastor p26br: Gift of Clotilde Bacri p27tr: Gift of Denis Gallion and Daniel Morris p30l: Gift of Garry Laredo p33bl: Gift of Mme. Hector Guimard; br: Gift of Gary Laredo p36cl: Gift of Knoll International p37tl: Gift of Robert Blaich; tr: Gift of International Contract Furnishings, Inc. p38tl: Gift of ICF, Inc. New York p39br: Gift from the Collection of Zoe and Pierce Jackson p44c: Museum Purchase through the Decorative Arts Association Acquisition Fund p46l: Gift of Mme. Hector Guimard; r: Gift of Stanley Siegel p47bl: Gift of Ely Jacques Kahn; tl: Gift of Marcia and William Goodman; ct: Gift of Danese Milano cr: Purchased in memory of Georgiana L. McClellan; r: Museum Purchase through the James Ford Fund; p48bl: Gift of Harmon Goldstone; tr: Gift of Mrs. Jefferson Patterson **pp48–49**c: Gift of Christian Rohlfing p49ct: Gift of Danese Milano; r: Museum Purchase through the James Ford Fund; b: Gift of Gallery 91 p50bl: Museum Purchase; cl: Gift of Ely Jacques Kahn; tl: Gift; of Denis Gallion and Daniel Morris; pp50-51cb: Gift of Mrs. Homer D. Kripke; ct: Gift of the Italian Government p51tl: Gift of Robert and Frances Diebboll; tr: Gift of Lella and Massimo Vignelli; cr: Gift of Robert Kent; br: Gift of Mel Byars p52bl: Gift of Vivianno Torun Bülow-Hübe and Royal Copenhagen; cl: Gift of Denis Gallion and Daniel Morris; br: Gift of Julia and Fred Haiblen p53cl: Gift of Design Ideas; tl: Gift of Harry Dennis, Jr.; c: Gift of Mel Byars p54bl: Museum Purchase through the Eleanor G. Hewitt Fund; tl: Gift of Margaret Carnegie Miller pp54-55c: Museum Purchase p55c: Gift of Anglepoise, Ltd.; tr: Gift of Mel Byars; br: Gift of Coch & Lowy p56bl: Gift of Barry Friedman and Patricia Pastor p57cbl, ctl: Gift of Barry Friedman and Patricia Pastor; cr. Gift of Max and Barbara Pine p61bl: Gift of Barry Friedman and Patricia Pastor p62cl:

Gift of John W. Fell p64l: Gift of Württembergische Metallwarenfabrik AG p72bl: Gift of Antti Nurmesniemi; cl: Gift of Mel Byars pp72-73c: Gift of Maura Santoro p74bl: Anonymous Gift; tl: Museum Purchase through the Decorative Arts Association Acquisition Fund made possible by a gift from Theodore Dell p76tl: Museum Purchase through the Decorative Arts Association Acquisition Fund pp77-77c: Museum Purchase through the Decorative Arts Association Acquisition Fund pp78-79c: Museum Purchase through the Decorative Arts Association Acquisition Fund p80cl: Gift of Russel Wright; r: Gift of Mel Byars p81cb: Gift of Württembergische Metallwarenfabrik AG; l: Gift of Stephen and Dorothy Globus; t: Gift of J. P. Vitrac Design; r: Museum Purchase through the Decorative Arts Association Acquisition Fund p82tr: Museum Purchase pp82-83c: Museum Purchase through the Decorative Arts Association Acquisition Fund p83cl, tl: The Henry and Ludmilla Shapiro Collection, Partial Gift and Purchase through the Decorative Arts Association Acquisition Fund and Smithsonian Collections Acquisition Program; br: Museum Purchase through the Decorative Arts Association Acquisition Fund back jacket cr, pp84-85c: Gift of Rosenthal Glas and Porzellan AG p85tr: Gift of Rosenthal Glas and Porzellan AG p86bl: Gift of Russel Wright; cl: Gift of Roger Kennedy; br: Gift of Paul F. Walter p87bl: Anonymous Gift p88bl: Gift of Carlo Moretti; tl: Gift of Justin G. Schiller; tcl: Gift of Mrs. Jefferson Patterson; ctr: Gift of Harry Dennis, Jr.; r, c: Gift of Mr. and Mrs. Burton Tremaine and Mrs. John McGrew p89tl: Gift of Iittala Glassworks tr: Museum Purchase through the Sir Arthur Bryan Fund; b: Gift of Paul F. Walter p90bl: Anonymous Gift; tl: The Henry and Ludmilla Shapiro Collection, Partial Gift and Purchase through the Decorative Arts Association Acquisition Fund and Smithsonian Collections Acquisition Program; c: Gift of Rodman A. Herren pp90-91c: Gift of Paul F. Walter p91tl: Gift of Mel Byars; ctl: Gift of Peter Condu; ct: Gift of Mel Byars; c: Gift of Gallery 91; br: Gift of Dansk Designs, Ltd.; tr: Gift of Paul F. Walter p92l: Purchased with Combined Funds and Crane and Co. p100r: Anonymous Gift p101c: Gift of Julia Haiblen p102bc: Gift of Barry Friedman & Patricia Pastor **p103**bc: Gift of Diane and Mauro Genneretti, Italianissimo, Inc.; p104bl: Anonymous Gift p105tl: Gift of Monique Fink in memory of Peter Fink; ct: Gift of Primary Design Galleries p107: tl: Anonymous Gift: tr: Gift of Henry Dreyfuss p118l: Gift of Mel Byars p120l: Gift of Mr. Henry Spencer p121c: Museum purchase p126bl: Museum Purchase through the Decorative Arts Association Acquisition Fund p127ct: Gift of Becker, Incorporated p128cr: Gift of Mr. and Mrs. Arthur Wiesenberger; br: Museum Purchase through the Decorative Arts Association Acquisition Fund p129cl: Gift of Barry Friedman and Patricia Pastor; tr: Gift of Mel Byars,

cr: Gift of REXITE. b: Gift of Ivy Ross and Robert Ebendorf in memory of Herbert Ross p156cl, tl: Museum Purchase through the Decorative Arts Association Acquisition Fund; tc: Gift of Sally Israel in Memory of Fredericka Steinbach; cb: Gift of Michele Wiener pp156-157c: Gift of Deane Granoff p157bl: Museum Purchase made possible in part by the Decorative Arts Association Acquisition Fund; tl: Gift of Vivianna Torun Bülow-Hübe and Royal Copenhagen; br: Museum Purchase through the Decorative Arts Assocation Acquisition Fund; cr: Gift of Deane Granoff p164cl: Gift of Barry Friedman and Patricia Pastor; br: Gift of Mr. and Mrs. Maurice Zubatkin front jacket cr, p1911: Gift of the Arango Design Foundation p193ct: Gift of Hermes, SA p194cr: Anonymous Gift; br: Gift of Philips Dictation System USA p196bl: Gift of Arango Design Foundation and Steelcase Design Partnership; tl Gift of Rodman A. Herren pp196-197c: Gift of Rolodex Corporation p197tl: Gift of Max and Barbara Pine; tr (three pens): Gift of Arango Design Foundation and Steelcase Design Partnership br: Courtesy of Plus Corporation of America p198bl: Museum Purchase through the Decorative Arts Association Acquisition Fund; br: Gift of Barry Friedman and Patricia Pastor back jacket br, pp198-199c: Gift of Barry Friedman and Patricia Pastor p199c: Gift of Mel Byars p203bl: Gift of Olentangy Associates; cr. Gift of QuadMark p204t: Gift of Max & Barbara Pine pp204-205c: Gift of Barry Friedman and Patricia Pastor p205tl, tr: Gift of Barry Friedman and Patricia Pastor; br: Gift of the Arango Design Foundation p252l: Gift of Paul F. Walter p256br: Gift of Barry Friedman and Patricia Pastor p259bl: Gift of Paul F. Walter p260cl: Anonymous Gift p263tr: Gift of Mel Byars, br: Gift of Dorothy Hafner p264cl: Gift of Mr. Phelps Warren; tr: Gift of Harry Dennis, Jr. p265cl: Gift of A/S Stelton p266br: Gift of A/S Stelton p267tl: Gift of Smart Design, Inc. p268tr: Gift of Barry Friedman and Patricia Pastor; br: Gift of Mel Byars p271br: Museum Purchase through the Decorative Arts Association Acquisition Fund p272l: Gift of Lino Sabattini p273tl: Gift of Joseph L. Morris; tr: Gift of Clotilde Bacri; br: Gift of Joseph L. Morris p274t: Museum Purchase; cl: Gift of Lella and Massimo Vignelli p275bl: Gift of Dalmar Tifft; cr: Gift of Paul F. Walter.

Every effort has been made to trace the copyright holders. Dorling Kindersley apologizes for any unintentional omissions, and would be pleased, if any such case should arise, to add an appropriate acknowledgment in future editions.

Dorling Kindersley would like to thank the following for the kind loan of props for photography:

ABC Business Machines: p199br; Simon Alderson, Twentieth Century Design: p22tl, p23tr, p45tr, p57br, p59c, p123bl, tr, p124bl, p193tcl; Algerian Coffee Stores: p72tl, r, p73tr, br, pp74-75c, p262tr; Angels and Bermans: p139cl, c, p140l, cl, c, cr, p148cl, p149 cl; Laura Ashley: p121r; Jane Atfield, Made of Waste: p29r, p125bc; The Back Shop: p193bl; BBC Costume Store: p136l (boots and coat), cr, c; Andrea Black, Artistic Licence: p140-43 (make-up); Pamela Bromley: p149cb, br: The Business, 0181 963 0668: front jacket br, p5r, p139cr; Butler & Wilson: p5r (jewellery), p139cr; Joe Carroll, Rare Camera Company: front jacket flap ctl, p15b, p163tl, bl, p164bl, tl, cb, br, tr, cr; The Contemporary Wardrobe: front jacket tl, back jacket cbl, p147tl, ct, tr, p148ct; Cos Prop: back jacket cbl, p138l, cl, c, cr, r; p139l, p148ct; Classic Restorations: pp181-82c; Roy E. Craig: p188br; Garry Derby, American '50s Car Hire: pp184-85c; The Duffer of St. George: p163ct; D.H. Evans: p61br, p77cbr, br, pp102-03c, p107c, p271c; Max & Beverly Floyd: p187bl; Freuds: p4l, p93r; Ghost: p139r; Jack Hampshire Baby Carriage Collection: p110bl, cl, tl, pp110-11c; c/o Hendon Way Motors: pp186–87c; Phil Hester: p186bl; D Howarth: back jacket cb, p188cl; Nick Hughes & Tim Smith: p182tl; Ideal Standard: p98l, pp98–99c, p99br, tr; Jenny Jordan: pp138-139, pp154-155 (make-up); The Juke Box Showroom, RS Leisure, 0181-451 6124/5: p168c, p169tr, cr, br; Austin Kaye & Co. Ltd.: **p150**cl, c, cr, r, **p151**l, c, cr; Lawleys Ltd.: p84t; The London Toy and Model Museum, Paddington, London: p112tl, ctl, cbl, bl, br, pp112-13c, p113l, ct, tr, c, cr, br, p114bl, tl, tr, pp114-15c, p115tl, br; Anna Lubbock: pp134-37 (make-up); Graham Mancha, Design for Modern Living: p34cl, p40t, p44bl, p92r, p93cl, p195bl; Carlo Manzi Rentals: p2, p140b, r, p146bl, p148tl; Dr. Martens: p133l, p147br; The Robert Opie Collection, The Museum of Advertising & Packaging, Gloucester, England: front jacket cl, back jacket bl, cc, p4cl, p8r, p17br, p19tr, p20tr, p21l, cr, p56tl, p57bl, tl, tr, p58cl, pp58-59c, pp60-61c, pp62-63c, p66cl, pp66-67c, p68bl, cl, p70tl, tr, p71tr, p75tr, p77tr, p78bl, p91cbr, p100l (six toothbrushes), p101tl, p102l, tc, p104cb, br, p106t, c, bl, p119c, p130l, c, r, p131br, p159, p164tr, p168tl, bl, r, p169l, p194l, p195cl, p198cl, pp232-51; Dennie Pasion: pp138–139, pp158–159 (hair styling); Penfriend: front jacket ctl, p1cl, pp152-53 (all pens); Pentagram Design Limited, London: front jacket cb, p6, p103br; AJ Pozner (Hendon Way Motors): p189bl; Kevin Price, Volvo Enthusiasts Club: p186br; Reckless Records: p220cl; Red or Dead: p147bl, cb; Tibor Reich Collection, Stratford-upon-Avon: p123tl; Road Runner: p163b; Rosenthal: pp86-87c, p87cr, br; Courtesy of Peter Rutt: pp188-89c; Gad Sassower, Decodence, 13 The Mall, 359 Upper Street, Islington, London N1 0PD: p1r, p56r, p76bl, p195r; Slam City Skates: p163l, c; St. Bride Printing Library: p208t, pp208-09ct, cb; p209cb, br, p210l, b, c, t, br, p211tl, cr, cl; Sunglass Hut: p161tl, cl; Le Tout Petit Musée/Nick Thompson, director Sussex 2CV Ltd: p182cl; Tom Turkington (Hendon Way Motors): p185tr; Irene Turner: p187br; The Water Monopoly, 16/18 Lonsdale Rd, London NW6: p11br, p95l, c, r, p96l, p97bl, cl, tl, ct, r; "57th Heaven" Steve West's 1957 Buick Roadmaster; Janet & Roger Westcott: p184bl; Wig Specialities: p138l, cl, c, cr, r, p139c, cr, p154l, c, p155c; Margaret Wicks: p134tl, tr, bl, bcl, bcr, br, p135l, cl, cr, r; Courtesy of Mr. Willem van Aalst: p182bl; Lawrence Zeegen: p11, p12l, p213cr.

Cooper-Hewitt, National Design Museum, Smithsonian Institute is grateful to the following staff for their generous support on this project: Linda Dunne, Assistant Director for Administration; Brad Nugent, Head of Photo Services; Greg Heringshaw, Technician, Wallcoverings Department; Cynthia Trope, Technician, Department of Applied Arts and Industrial Design; Todd A. Olson, Assistant, Department of Applied Arts and Industrial Design; Cordelia Rose, Registrar; Steven Langehough, Associate Registrar; Larry Silver, art handler; Honor Mosher, art handler.

Thanks are also due to:

Hugo Wilson, Laurent Marceau, The British Dental Association, and VolksWorld Magazine for their help and advice; Helen Castle, Adrian Craddock, DNH Camcorder Repairers, Victoria Elvines, Gloria & John Jacobson, Nicky Munro, and Andrew Pucher for the loan of props; models Sarah Foster, David Gillingwater, Emily Gorton, Thomas Green, Hayley Miles, Susannah Marriott, Jacqueline Phillips, David Terrey, Ryan Thomas, and Patricia Wright; and Susannah Steel, particularly for her help with the packaging section. Additional thanks to Kirstie Hills, Caroline Hunt, Claire Legeman, Neil Lockley, Heather McCarry, Claire Naylor, Julie Oughton, Claire Pegrum, Nicola Powling, Catherine Shearman, Nichola Thomasson, Tracy Timson, and Joanna Warwick.

Additional photography

Lynton Gardiner; Clive Streeter; Gary Ombler; Sarah Ashun; Dean Belcher; Terence Sarluis; and Jonathan Keenan.

Author's acknowledgments

I particularly thank the staff at Dorling Kindersley, who have shown dedication, and have encouraged and guided me with enthusiasm. I am especially grateful to Janice Lacock, who has managed the project with skill and commitment. I thank Carla De Abreu, Louise Candlish, Stephen Croucher, Jo Evans, Tracy Hambleton-Miles, Claire Pegrum, Jane Sarluis, Susannah Steel, Dawn Terrey, and David T. Walton for their remarkable efforts. Finally at DK, a special thanks to Sean Moore for his support and advice. My thanks also to Deborah Sampson Shinn at Cooper-Hewitt Museum, New York; Mike Ashworth and David Ellis at the London Transport Museum; Peter Barnet; The Victoria and Albert Museum, London; Hamish MacGillivray at the London Toy and Model Museum; Robert Opie; the Vitra Musuem; Julia Tambini; Patricia Wright; Sandra Millichip; Hal Haines; Shirley Finch; and Stephen Le Flohic.